Only in New York

500 Photos · 500 Moments

Only in New York

By the Photography Staff of *The New York Times*

Introduction
By David W. Dunlap

David W. Dunlap was a metro reporter for The Times *from 1981 to 2017.*

You've already looked through the pictures. You understand they're meant to be seen as diptychs. But some pairings eluded you on first glance.

That's O.K. You're supposed to do more than look just once. The juxtapositions invite you to savor the photos. Spend time with them. They'll reward your close study, often with a laugh.

What, for instance, has a crated giraffe to do with the Roosevelt Island tram? *(pp. 248-249.)* Well, you might think of the theme as "The Transportation of Mammals Over Bodies of Water, Standing in Cramped Boxes Held Aloft by Slender Cables."

The glinting subway train and a couple of old-time baseball players? *(pp. 104-105.)* Zoom in a bit. That train shares a number with Mickey Mantle of the Yankees, who is standing with Yogi Berra and Casey Stengel in Shea Stadium. Which you reached on the No. 7 train.

Multiple meanings abound. Yes, the graduates of the Police Academy will soon be handing out tickets. *(pg. 86)* But a second glance reveals showers in both photos.

Colors may be just one of the facets the pictures have in common. *(pp. 44-45.)* Watch for patterns. *(pp. 26-27.)* And shapes. *(pp. 326-327.)* Form. *(pp. 48-49.)* Function *(pp. 208-209.)* Be alert for irony. *(pp. 90-91.)* And the occasional pun. *(pg. 150.)* Or a message on one page that applies equally to the other. *(pg. 372.) Only in New York* highlights the threads that hold this city of contrasts together.

It also celebrates the contemporary photojournalists who have made *The Times* a Pulitzer-winning leader in visual presentation. Equally important, it honors earlier generations of photographers who labored creatively and tirelessly when *The Times* had a reputation—often well deserved—for being indifferent to good photography.

Years ago, these photographers created an astonishing body of work. *The Times* may not have used it to best advantage at the time. But the company was, at least, smart enough to hang on to millions of prints, negatives, contact sheets, and computer files.

When we opened the archive and started laying out the pages for this book, we found that certain pictures had an affinity for one another—regardless of when they were taken or where or by whom. Paradoxically, each photograph came into sharper focus when set into a diptych.

Wordlessly, the pairings began telling stories of their own.

They spoke across time. They described a city that exists on many planes simultaneously: energetic and brutal, compassionate and cruel, creative and desperate, eccentric and conformist, impatient and steady, exuberant and serene, tragic and funny, elegant and shabby, cosmopolitan and insular, crowded and lonely.

New York is not always an assault on the senses. It can reveal itself subtly, too. All that's required is that you look.

And look again.

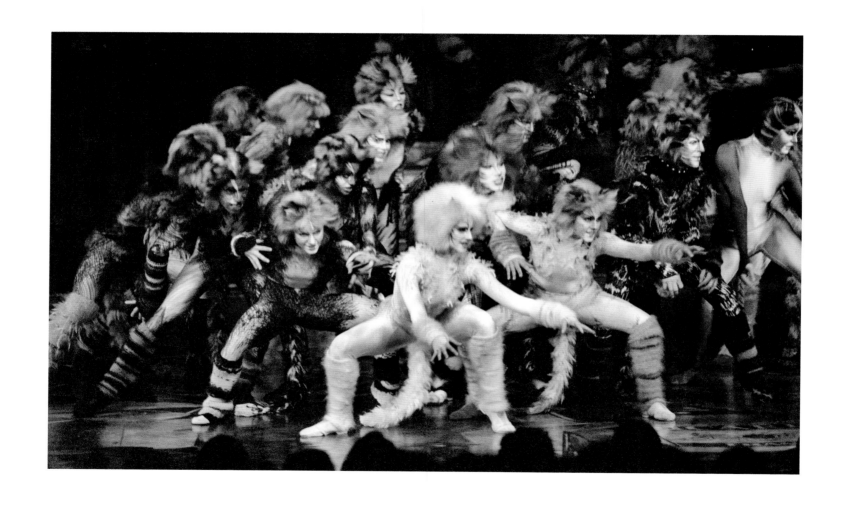

Cats at the Winter Garden Theater, 1997
Sara Krulwich

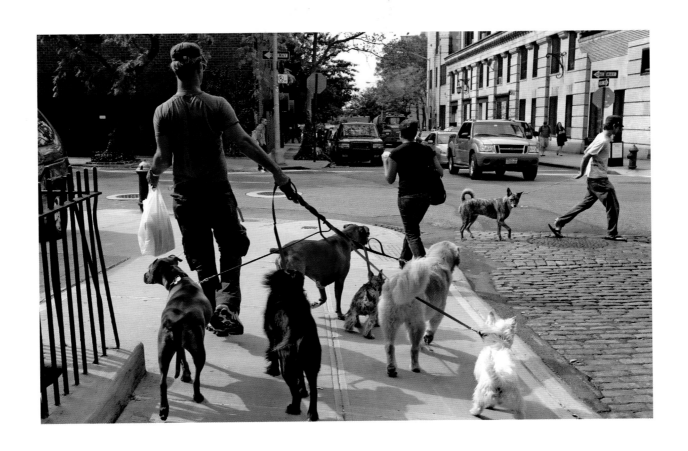

Dogs on the leash, Washington and Bank Streets, Manhattan, 2016
Nicole Bengiveno

Souvenirs, Vesey and Church Streets, Manhattan, 2016
Todd Heisler

Lady Liberty, Battery Park, 2013
Suzanne DeChillo

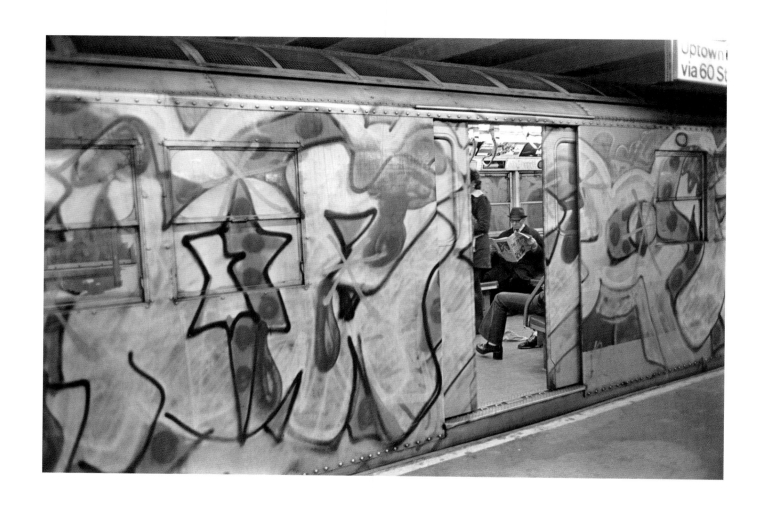

Underground Manhattan, 1976
Neal Boenzi

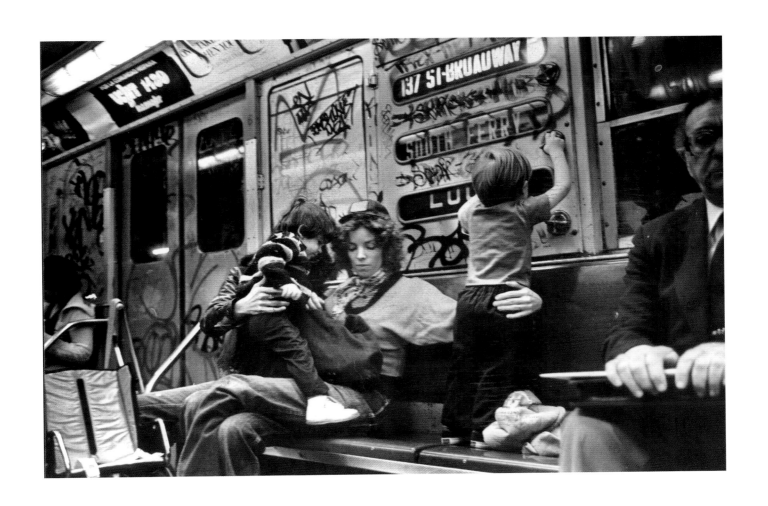

No. 1 Train, 1979
Neal Boenzi

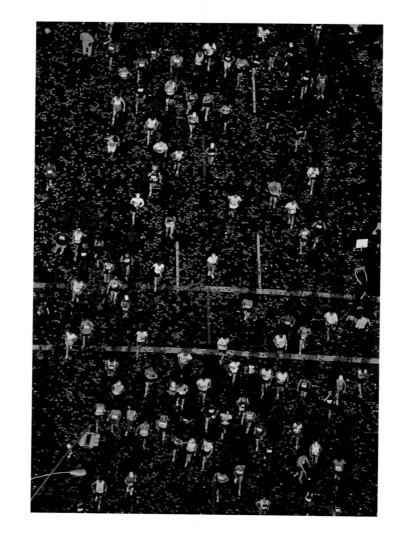

New York City Marathon, 106th Street and Fifth Avenue, Manhattan, 2005
Vincent Laforet

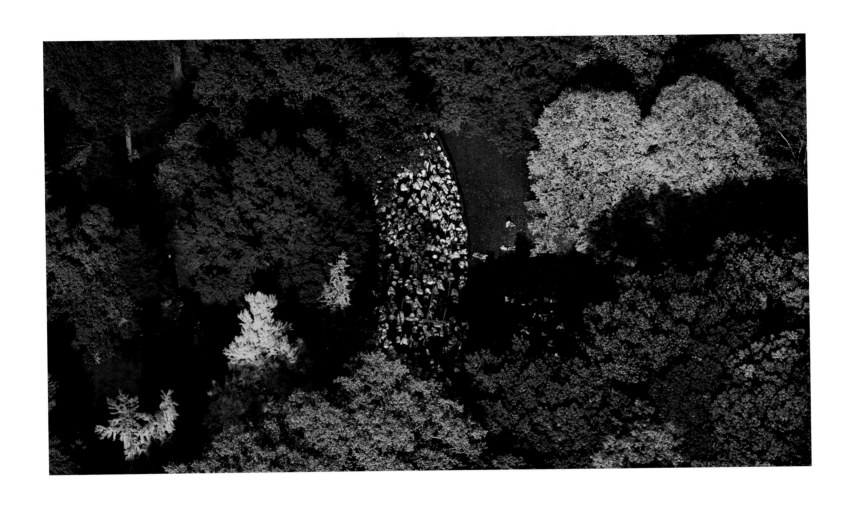

New York City Marathon finishers, Central Park, 2005
Vincent Laforet

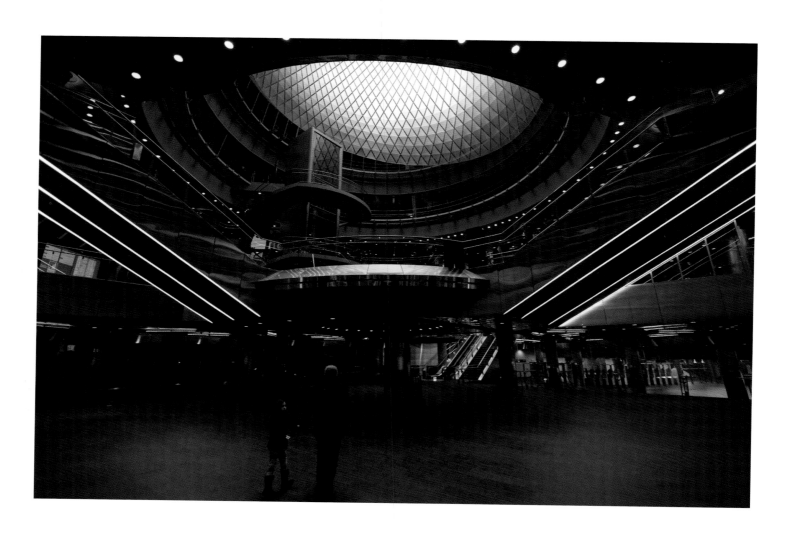

Fulton Center, Manhattan, 2014
Damon Winter

World Trade Center Transportation Hub, Manhattan, 2016
Richard Perry

15

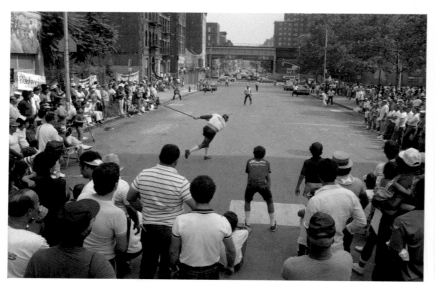

Stickball world series, East Harlem, 1984
Joyce Dopkeen

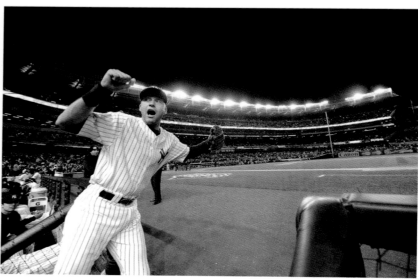

Derek Jeter, Yankee Stadium, 2009
Barton Silverman

"Driving down deserted Fifth Avenue late one night," writes Brent C. Brolin, "my wife and I were startled to see a man on the sidewalk getting ready to throw something into the entrance of the Aeroflot offices (the Russian airline). Wary of a bomb blast, we drove by cautiously on the far side of the street. As we passed the doorway we were relieved to recognize two of New York's finest; one was pitching wadded paper bags; the other, partially hidden in the doorway, was batting them back with his billy club."

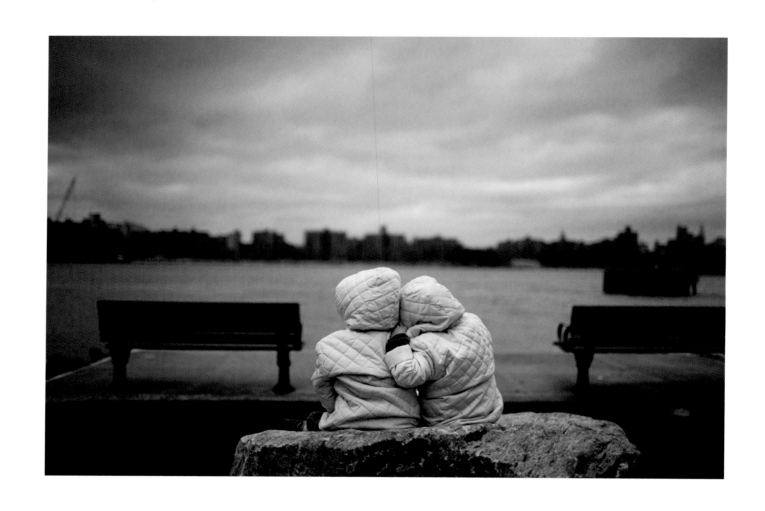

Grand Ferry Park, Williamsburg, Brooklyn, 2008
Damon Winter

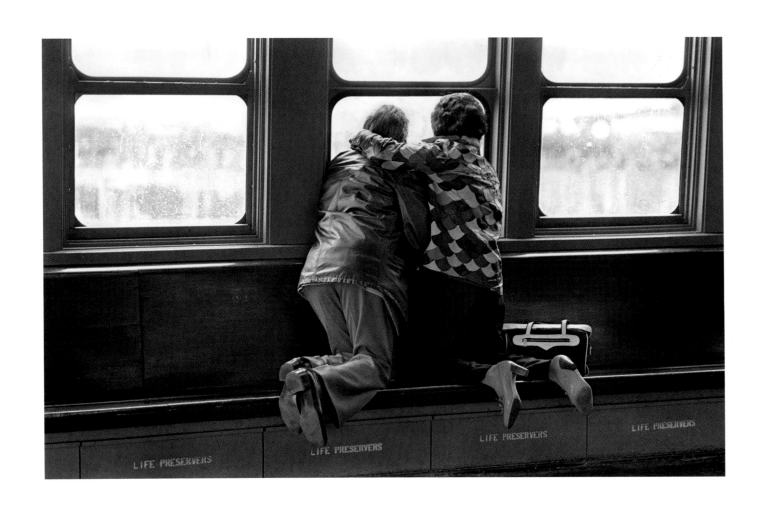

Staten Island Ferry, New York Harbor, 1979
Neal Boenzi

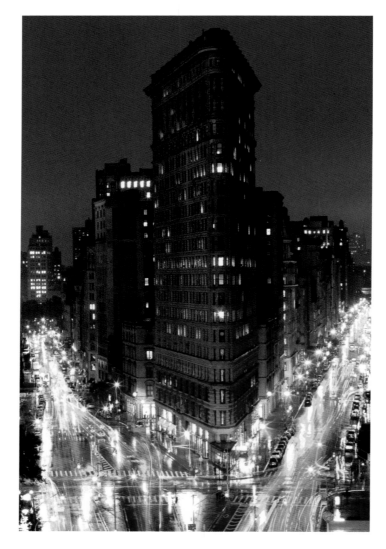

Flatiron Building, Manhattan, 2002
Vincent Laforet

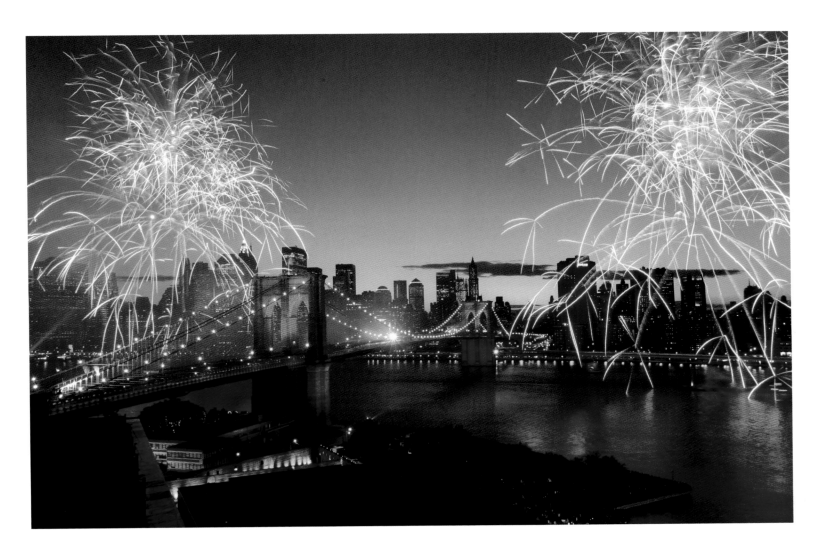

Celebrating the Brooklyn Bridge's 125th, East River, 2008

Josh Haner

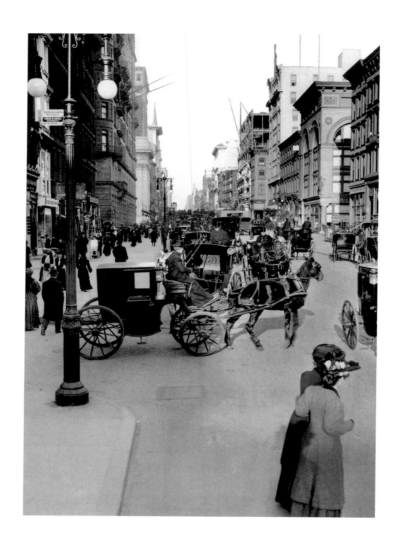

Carriages on Fifth Avenue near 32nd Street, 1917
The New York Times

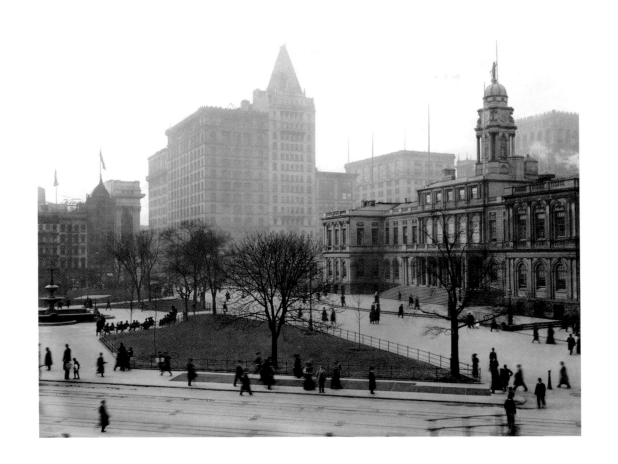

City Hall Park, 1913

The New York Times

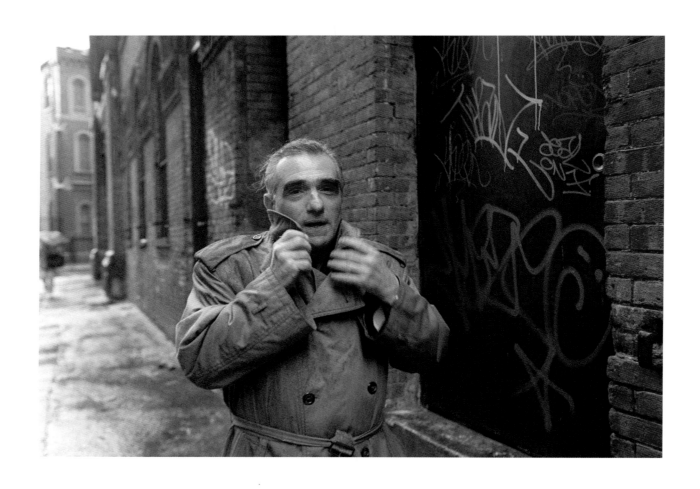

Martin Scorsese, Jersey Alley, SoHo, 1988
Sara Krulwich

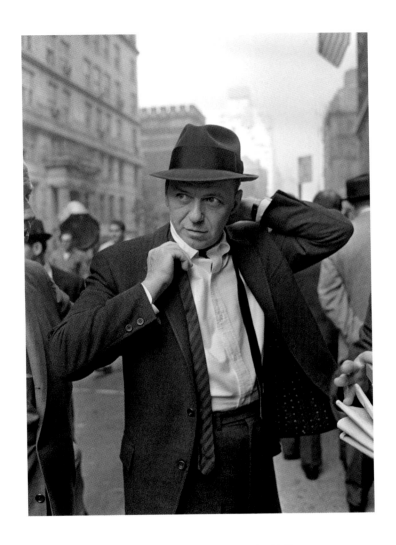

Frank Sinatra, Upper East Side, 1967
Neal Boenzi

Upper West Side, 2009
Ruth Fremson

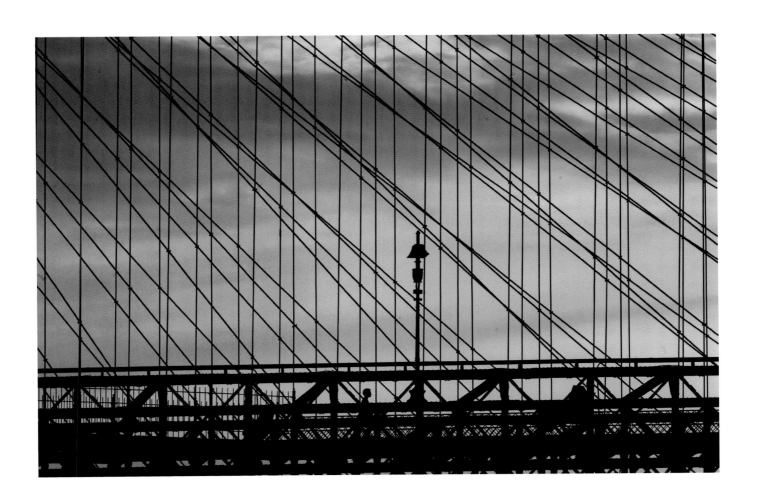

Brooklyn Bridge, from Manhattan, 2011
Librado Romero

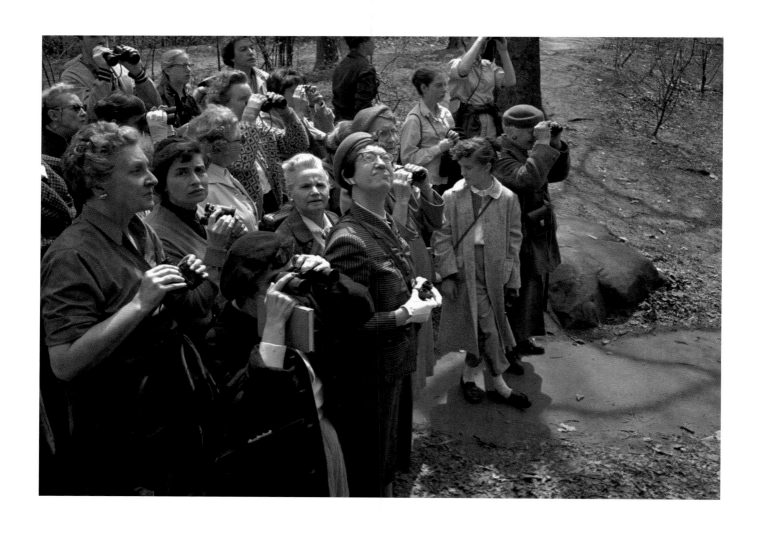

Ornithology devotees, Central Park Ramble, 1960
Robert Walker

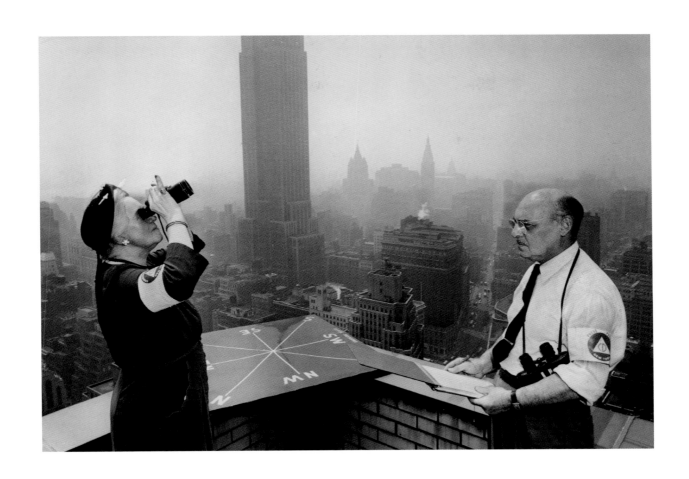

Civil Defense Air Raid Drill, Midtown Manhattan, 1952
Larry C. Morris

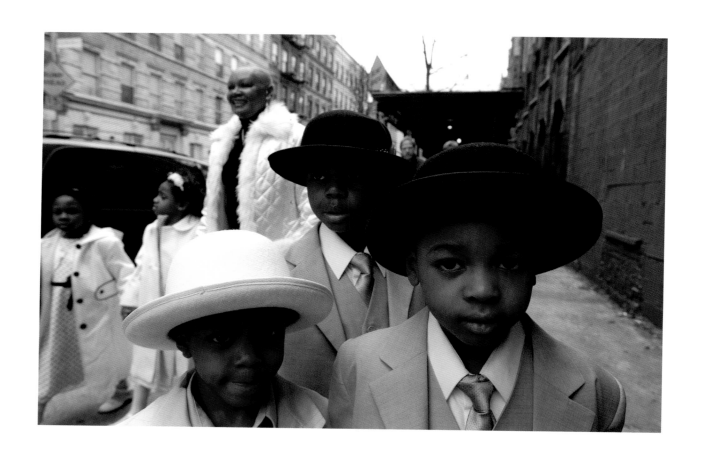

Easter Sunday, Abyssinian Baptist Church, Harlem, 2007
Ozier Muhammad

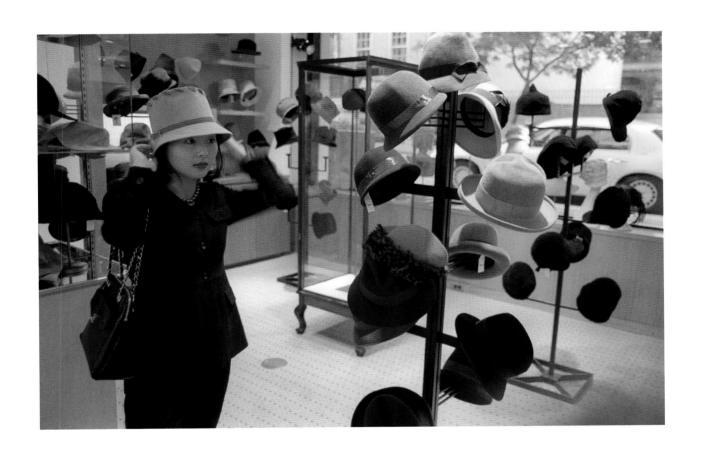

At Barneys, Midtown Manhattan, 1998
Edward Keating

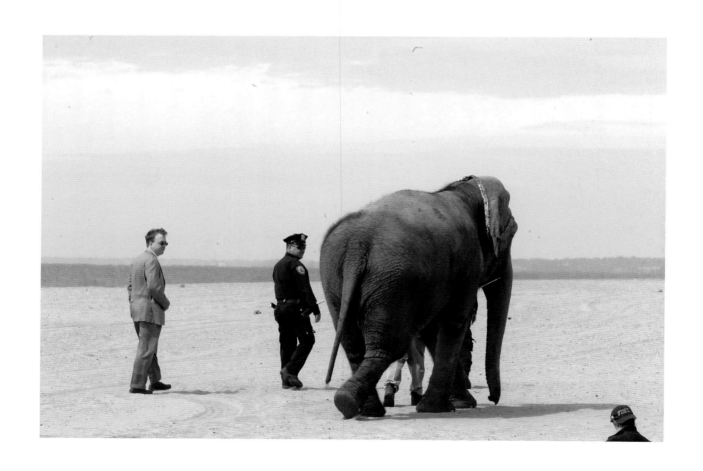

Minnie the elephant, Coney Island, 2009
Ruby Washington

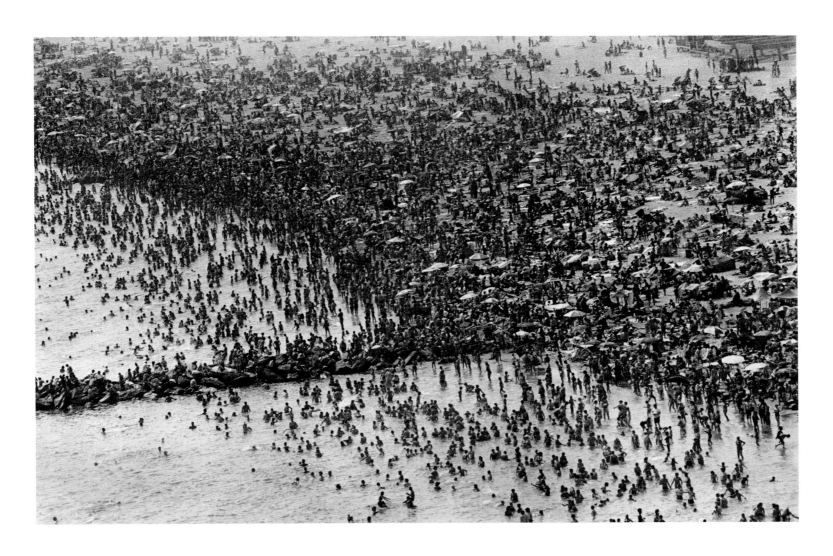

On the beach, Coney Island, 1975
William E. Sauro

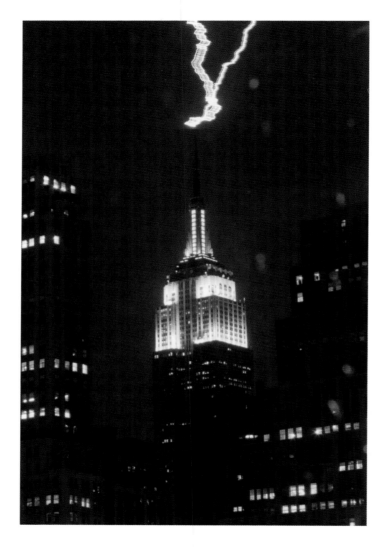

Empire State Building, 1997
Chang W. Lee

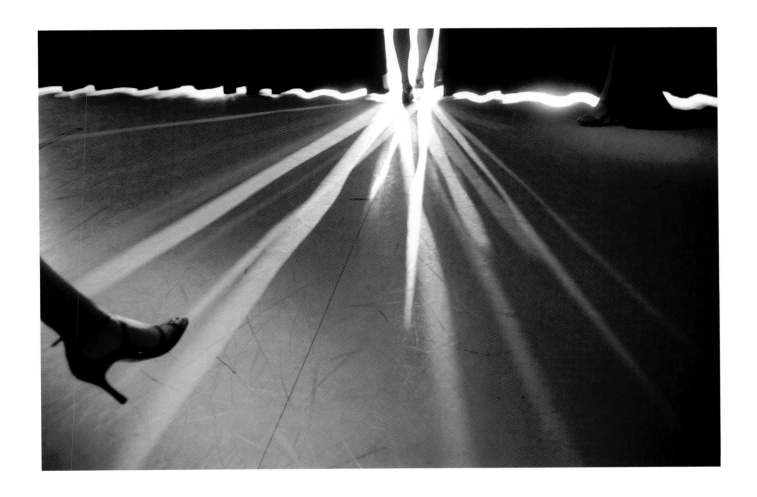

Miss New York City Pageant, Midtown Manhattan, 2007
Richard Perry

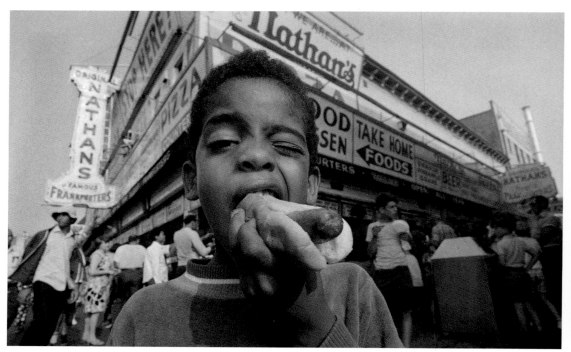

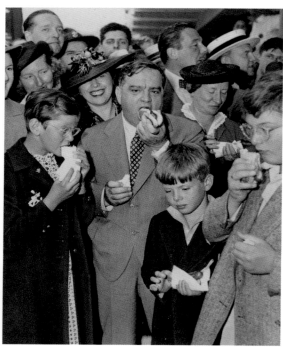

James Lewis Jr., Coney Island, 1970
Barton Silverman

Mayor Fiorello La Guardia and family,
World's Fair, Flushing Meadows, Queens, 1939
The New York Times

Sign seen by Cy Schleifer in the window of a luncheonette on Avenue A near 11th Street:
FRANKFURTERS AVEC BEANS

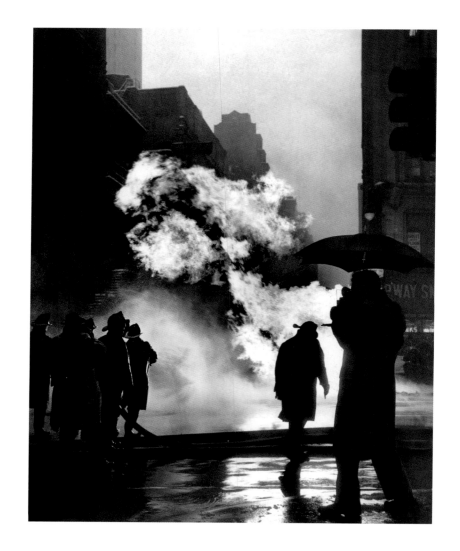

Fire explosion, Broadway and 40th Street, 1957
Meyer Liebowitz

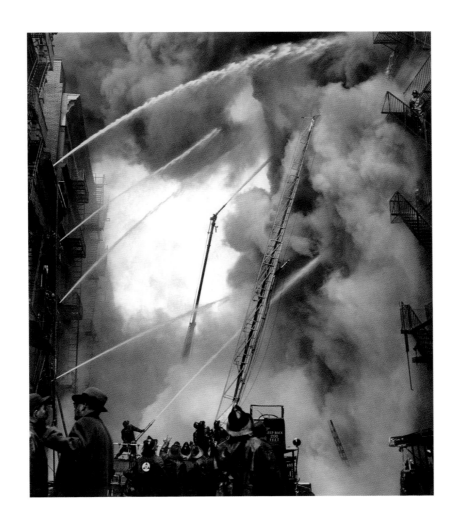

Five-alarmer, Spring and Greene Streets, 1957
Carl T. Gossett Jr.

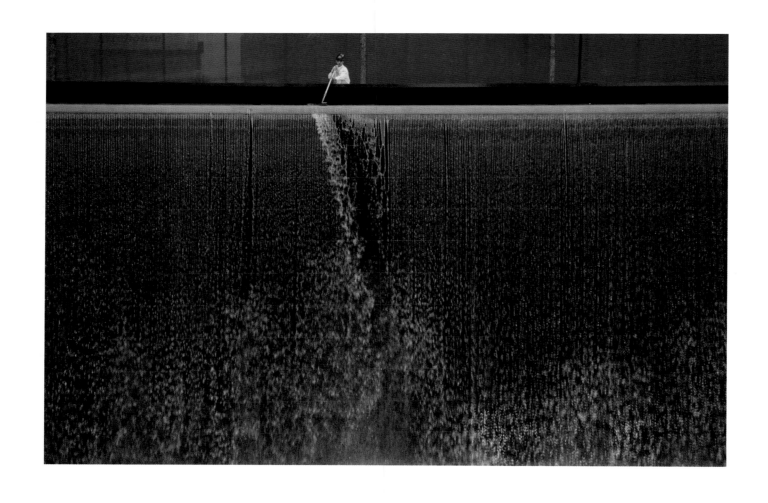

North Fountain, 9/11 Memorial, World Trade Center complex, 2011

Damon Winter

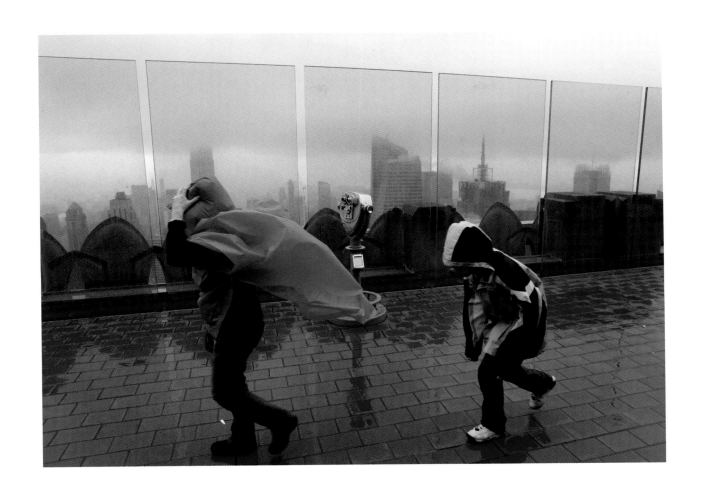

Observation Deck, Rockefeller Center, 2010
Richard Perry

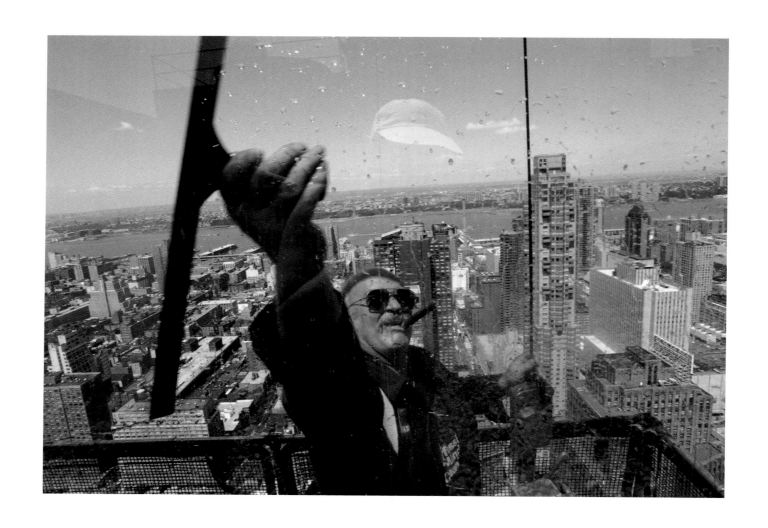

Frank Kind on the 46th Floor, 888 Seventh Avenue, 1995
Andrea Møhin

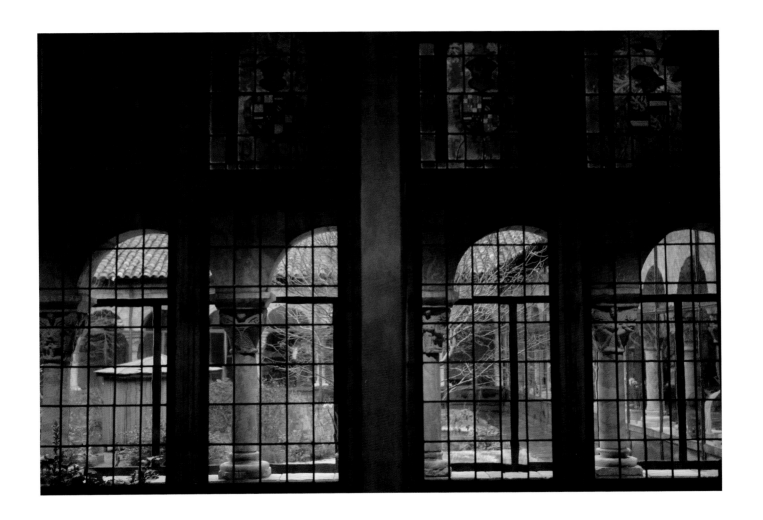

The Cloisters, Fort Tryon Park, 2002
Damon Winter

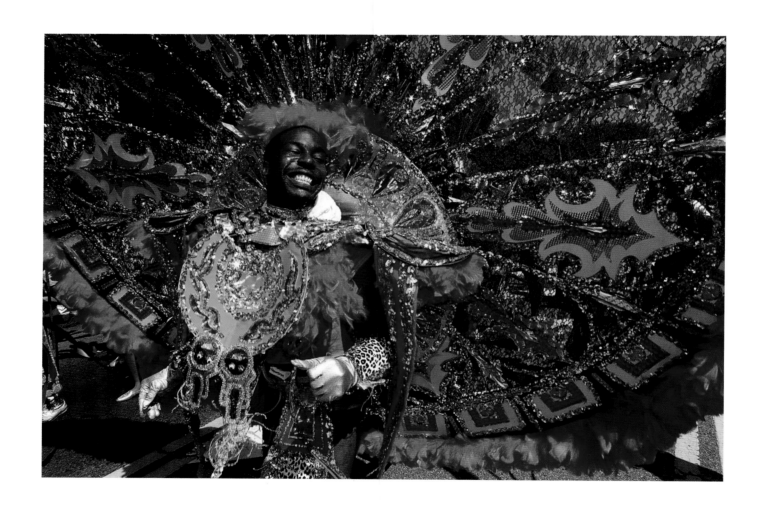

West Indies Day Parade, Brooklyn, 2001
Vincent Laforet

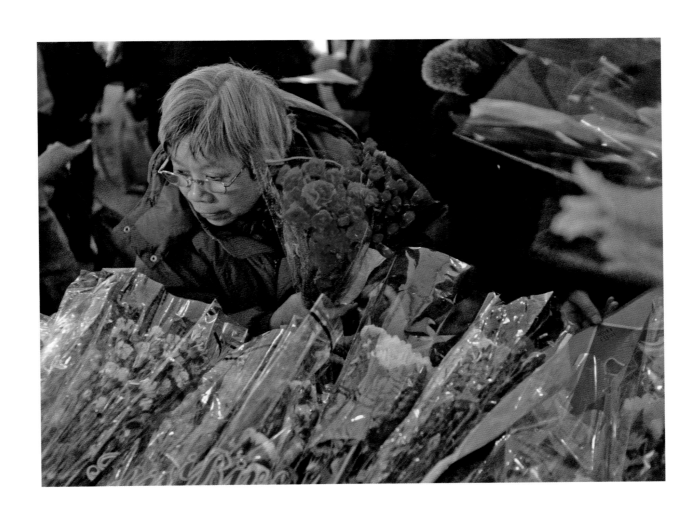

Chinese New Year Flower Market, Columbus Park, Chinatown, 2006
Marilynn K. Yee

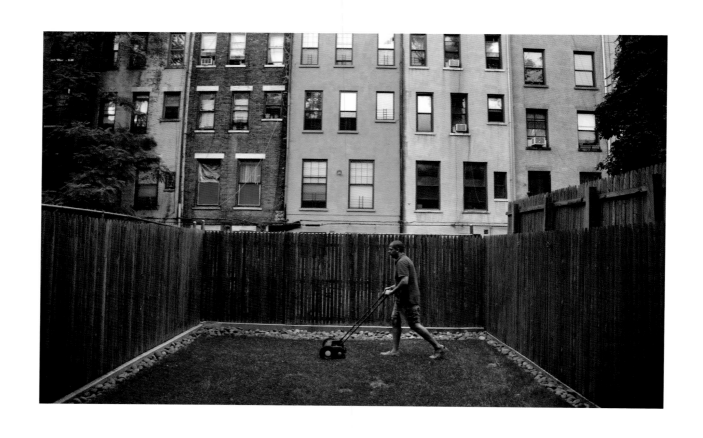

Mark Pinn trims the lawn, Harlem, 2008
Todd Heisler

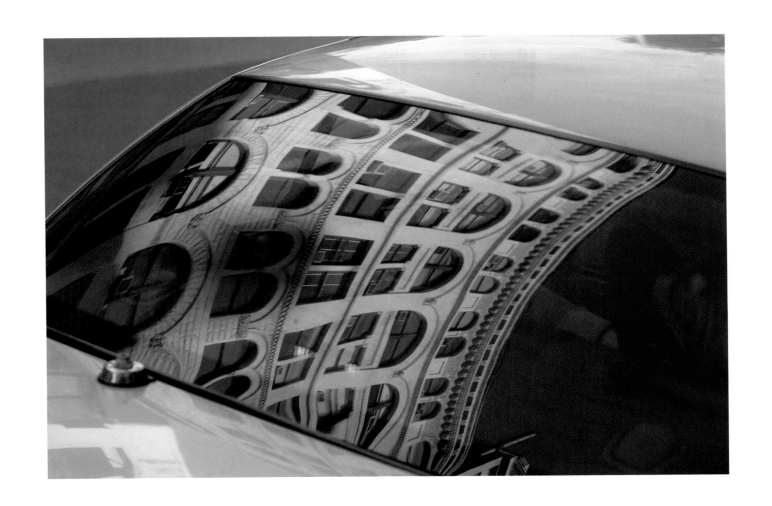

14th Street, 2006

Nicole Bengiveno

L.G. Khambache Sherpa prepares for a charity crawl, Brooklyn, 2005
Tyler Hicks

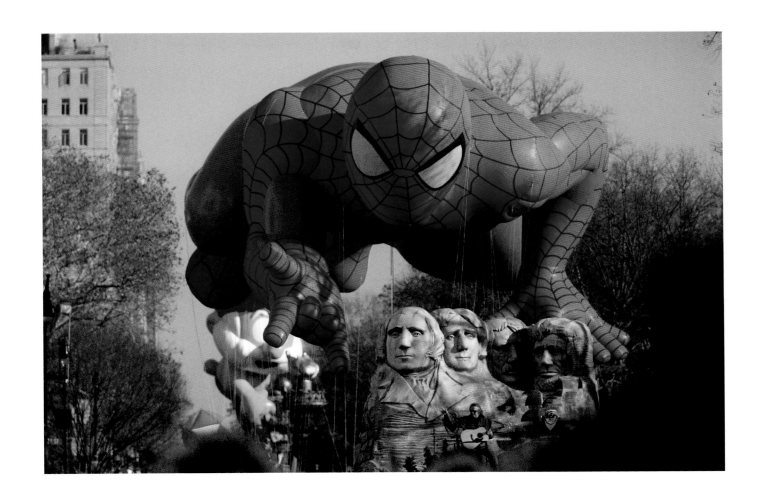

Spiderman on Thanksgiving Day, Central Park West, 2012
Suzanne DeChillo

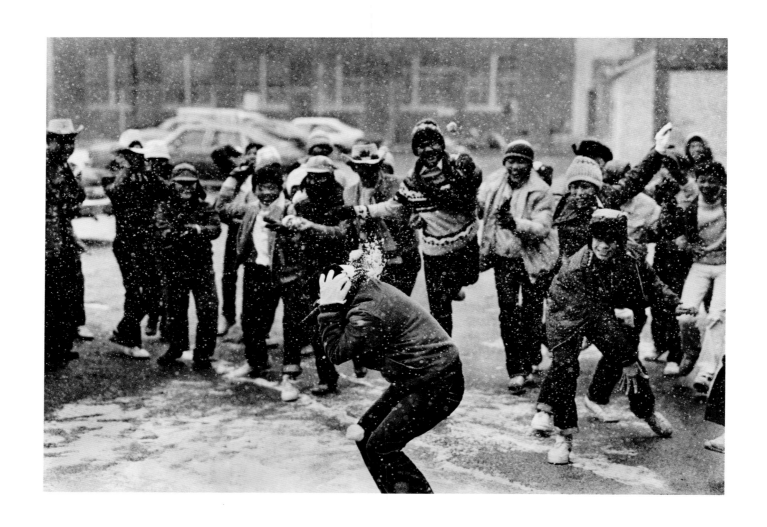

Out-of-town musicians in the snow, St. Patrick's Day Parade route, 1982
Neal Boenzi

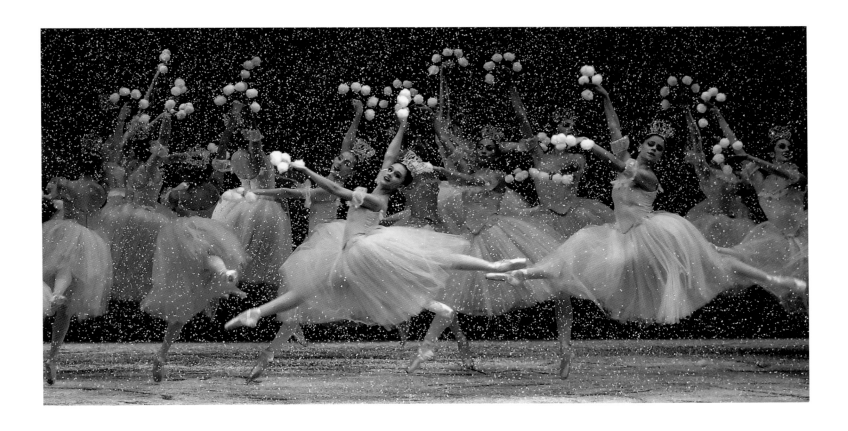

New York City Ballet dancers in *The Nutcracker*, Lincoln Center, 2011
Andrea Mohin

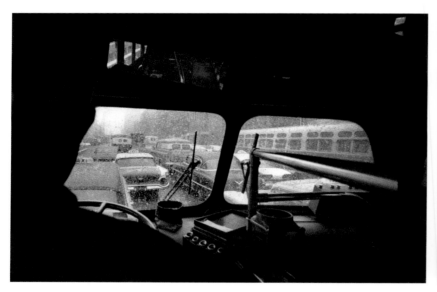

Crosstown bus, Manhattan, 1960
Sam Falk

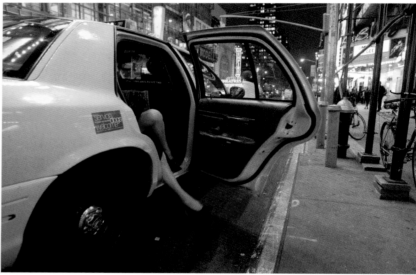

Theater District, Manhattan, 2003
James Estrin

R. Chester Redhead is waiting for the No. 1 bus on 86th Street and Madison Avenue. When it finally arrives, the woman in front of Mr. Redhead hands the driver a transfer. "Lady," he says, "this transfer is from yesterday." "That tells you how long I've been waiting for this bus," she replies.

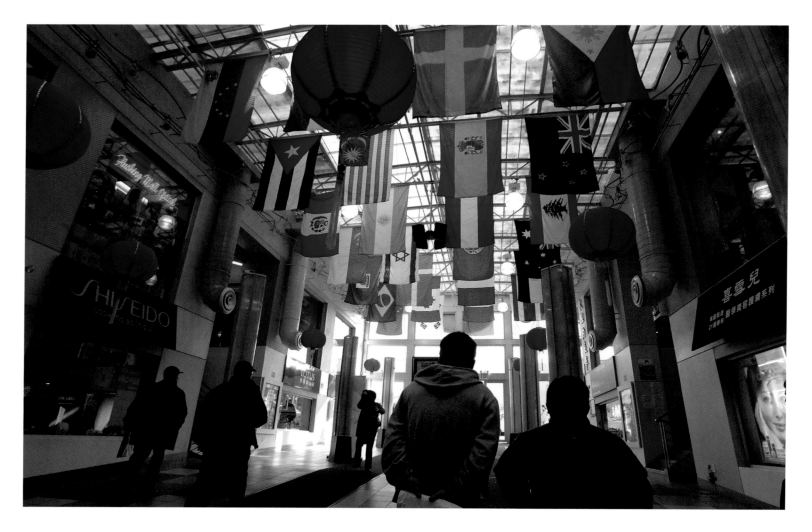

Flushing Mall, Queens, 2006
Nicole Bengiveno

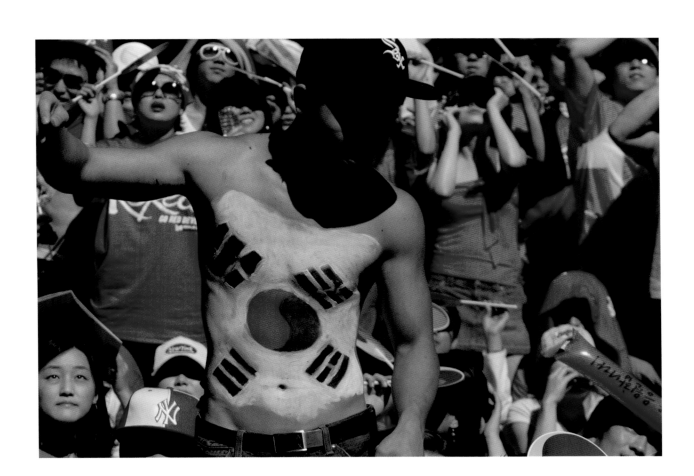

World Cup celebrants, Little Korea, Manhattan, 2006
Angel Franco

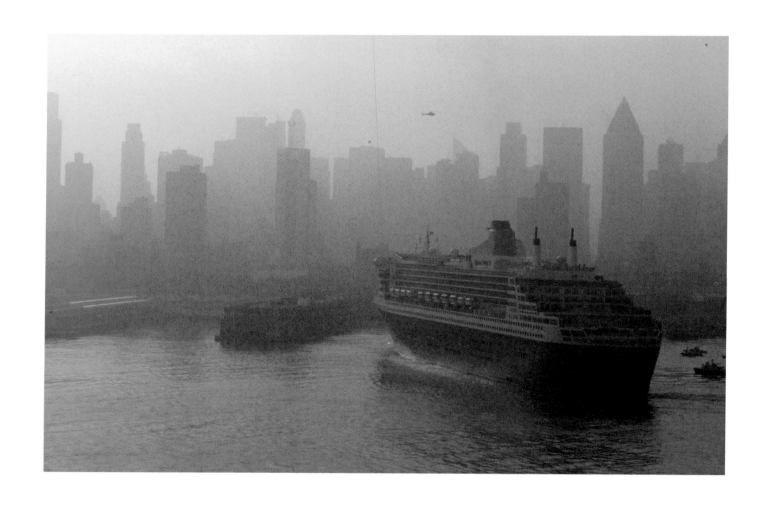

Queen Mary 2 arrives, New York Harbor, 2004
Fred R. Conrad

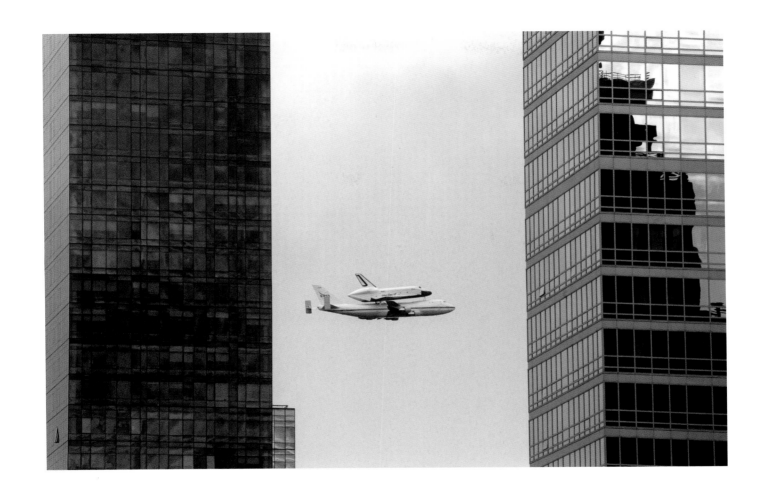

Space shuttle fly-by, Midtown Manhattan, 2012
Dan Neville

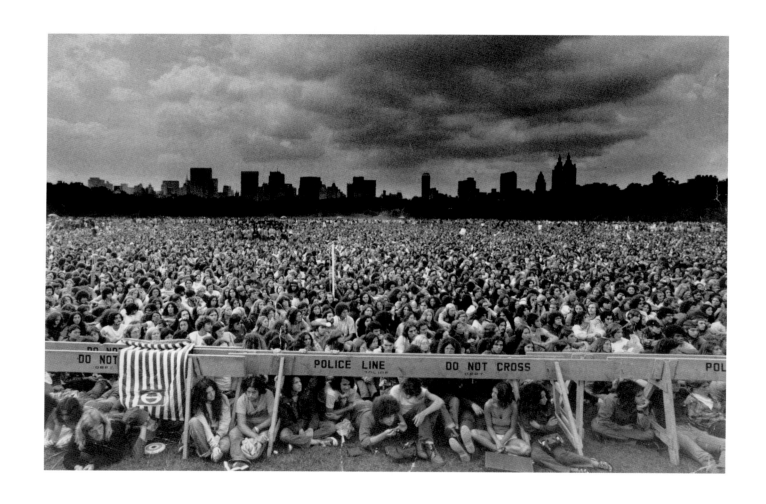

Jefferson Airplane fans, Great Lawn, Central Park, 1972
Don Hogan Charles

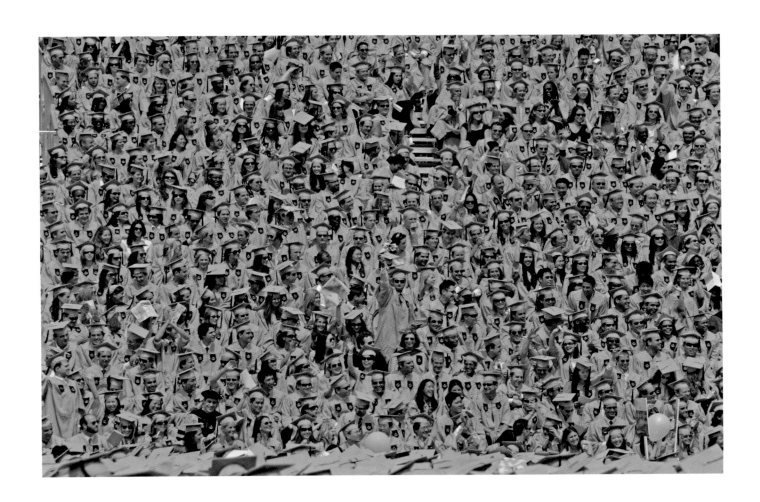

Columbia University Commencement, Manhattan, 2007
Librado Romero

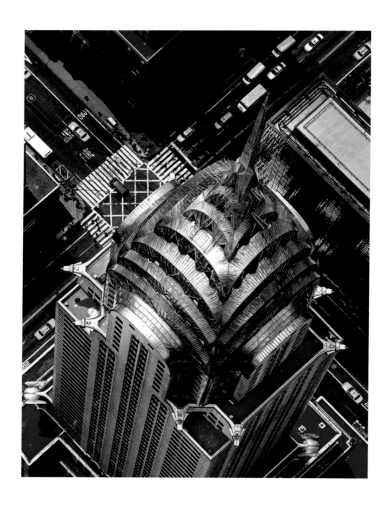

Chrysler Building, Midtown Manhattan, 2003
Vincent Laforet

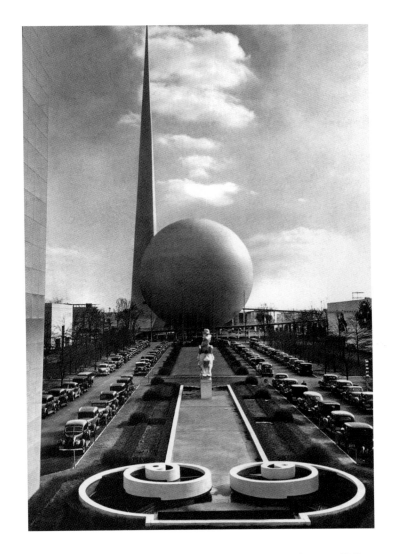

The Trylon and Perisphere, World's Fair, Flushing, Queens, 1939
William C. Eckenberg

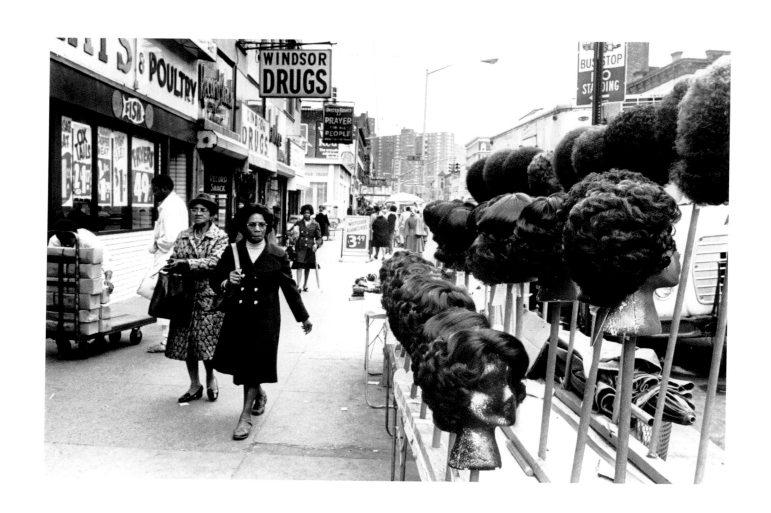

125th Street, Harlem, 1975
Meyer Liebowitz

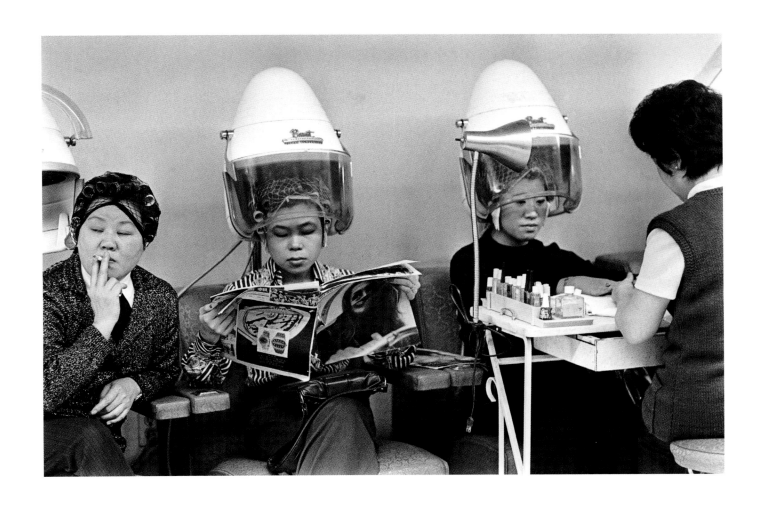

Shanghai Beauty Shop, Lower Manhattan, 1974
Neal Boenzi

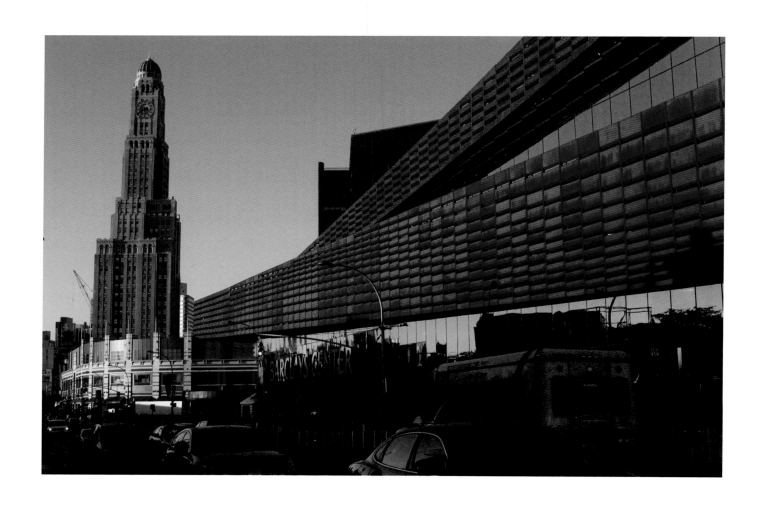

Barclays Center, Brooklyn, 2012
Richard Perry

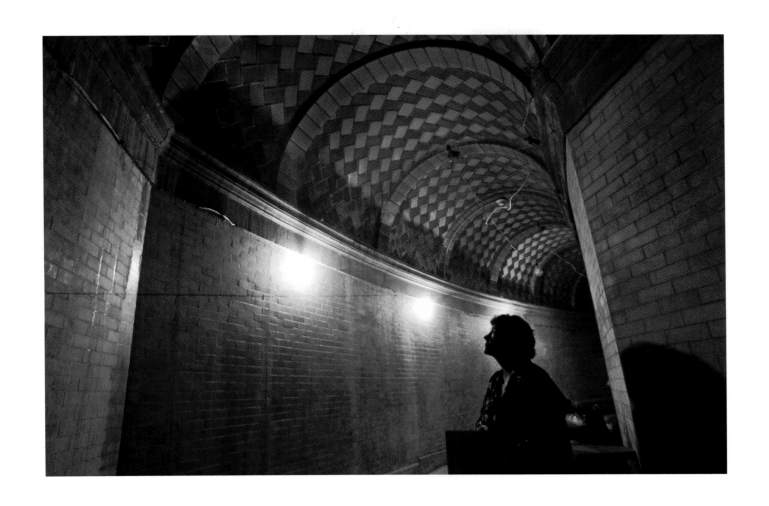

Beneath the Gould Library, Bronx Community College, 2004
Suzanne DeChillo

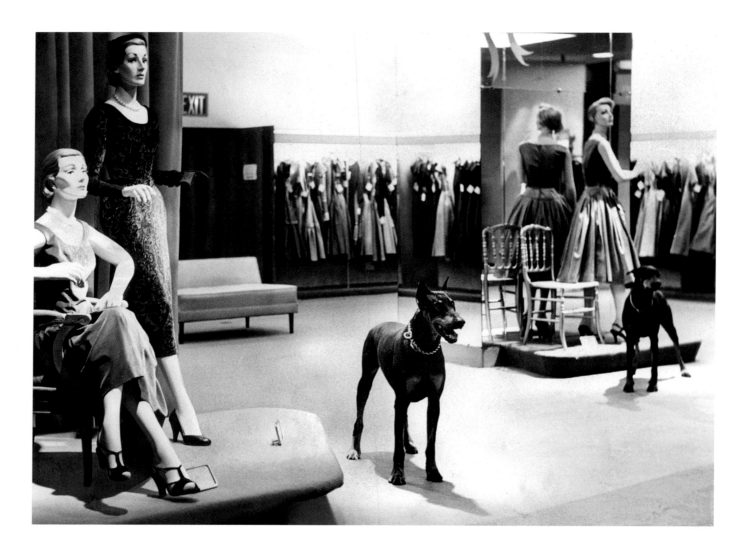

Standing guard at Macy's, 1955

Larry C. Morris

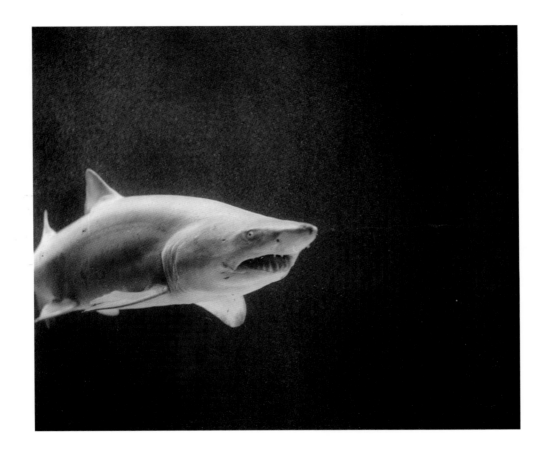

New York Aquarium, Coney Island, 1960
Sam Falk

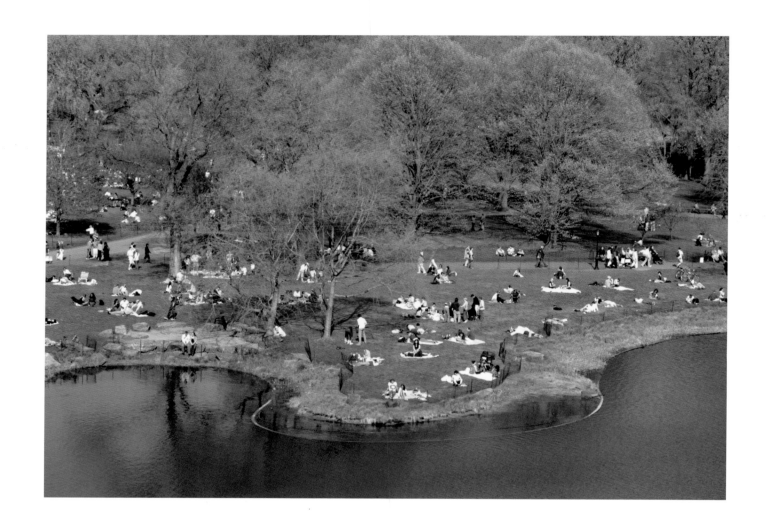

Turtle Pond, Central Park, 2006
Ruth Fremson

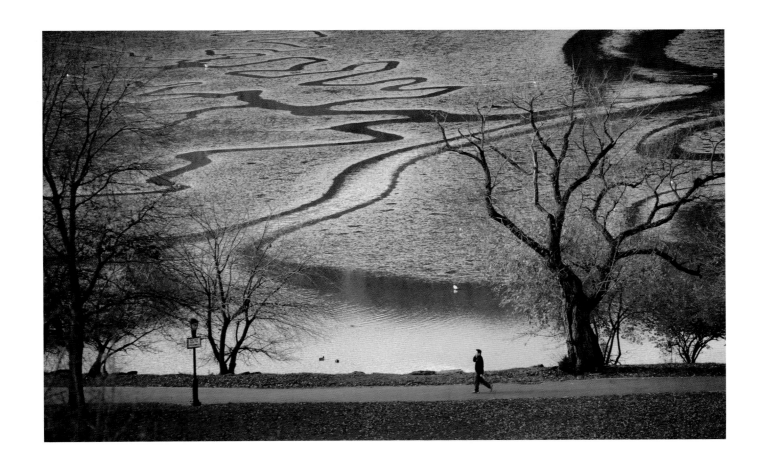

Inwood Hill Park, Upper Manhattan, 2009
Suzanne DeChillo

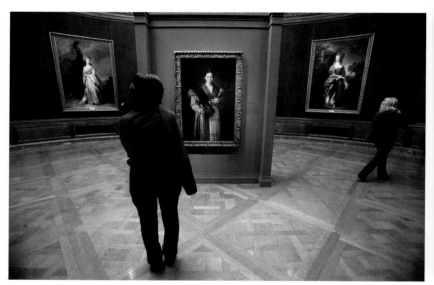

The Frick Collection, Upper East Side, 2008
Librado Romero

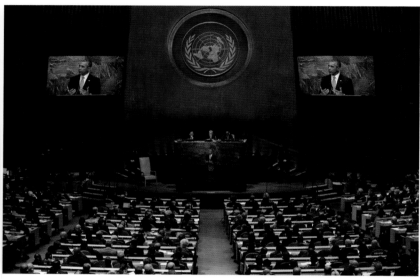

President Barack Obama, United Nations General Assembly, 2015
Damon Winter

Dear Diary:

During the United Nations summit conference, my husband and I were looking for a taxi on Second Avenue and 45th Street for what seemed like an eternity. While waiting, we chatted with a young police officer on duty. He suggested that we walk to Third Avenue, even though my husband has to use a cane. We followed his advice and halfway down the block, I spotted a cab with its lights on and flagged it down. To our amazement, who should step out but the very same officer. He had hailed the cab and brought it around for us. Who says the police are not caring and considerate?

Barbara Kleinberg

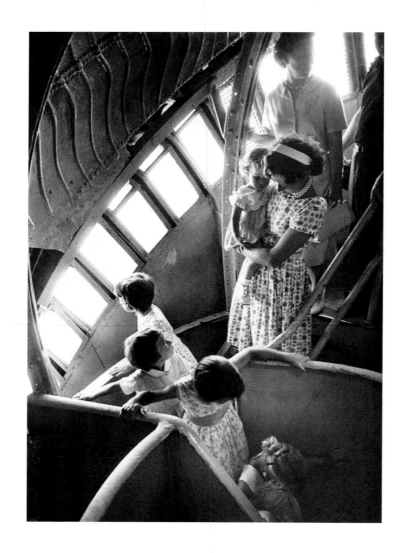

Inside Lady Liberty's Crown, Liberty Island, 1962
Neal Boenzi

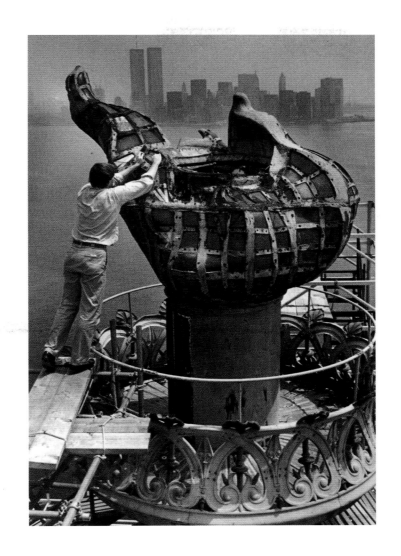

Restoring the torch, Liberty Island, 1986
Keith Meyers

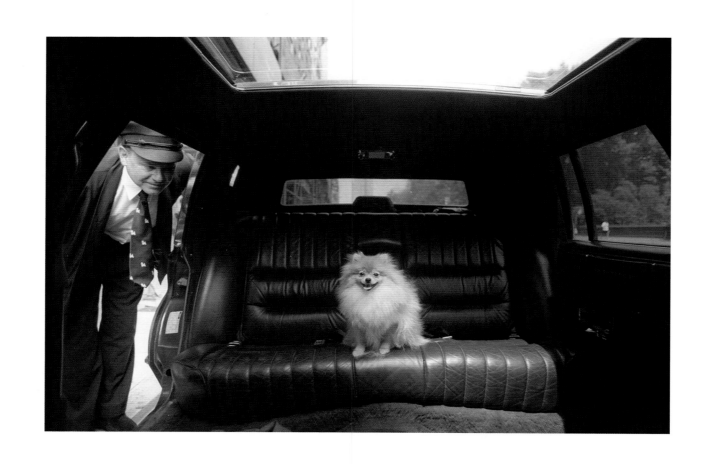

Guineviere in a limo, Manhattan, 1997
Andrea Mohin

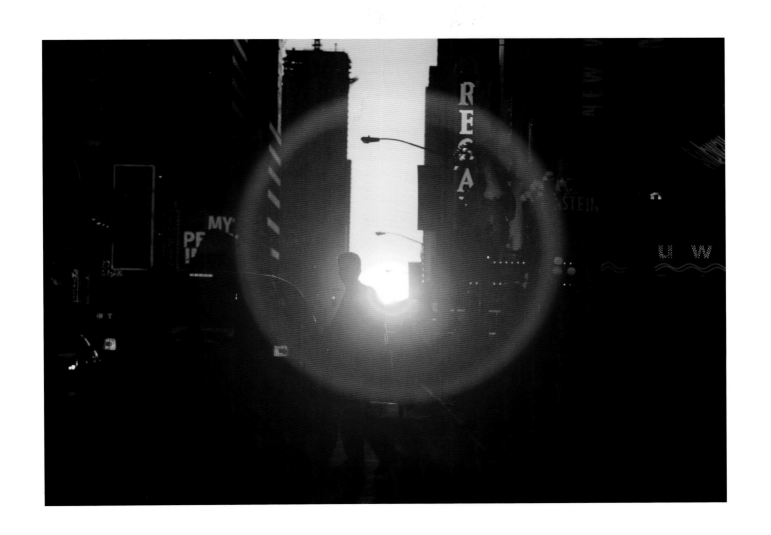

West 42nd Street, Manhattan, 2008
Chang W. Lee

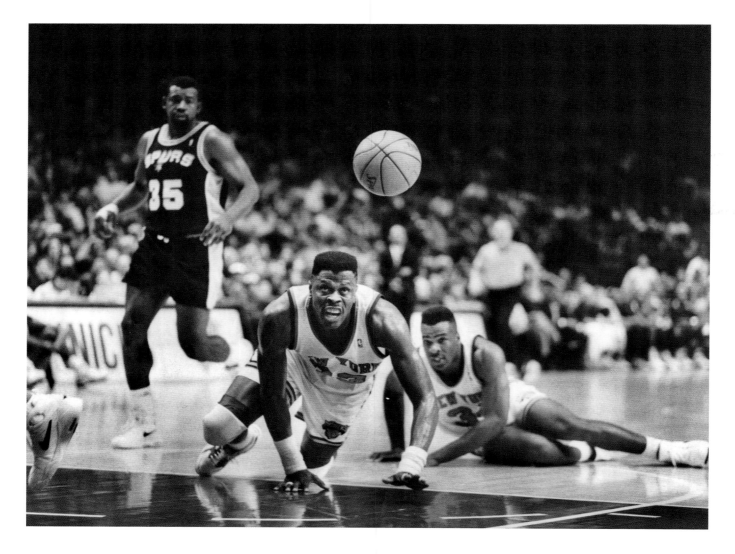

Patrick Ewing and Charles Oakley scrambling, Madison Square Garden, 1993
Barton Silverman

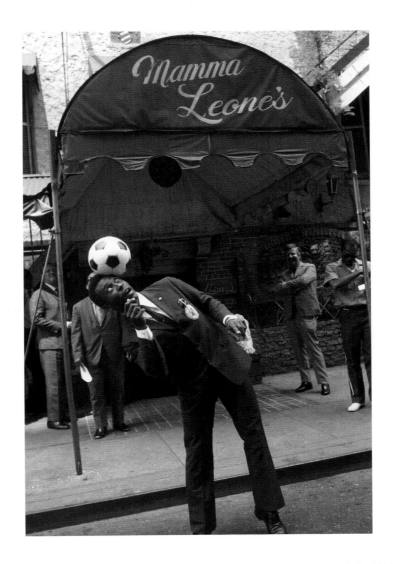

Edson Arantes do Nascimento, aka Pele, Midtown Manhattan, West Side, 1971
Meyer Liebowitz

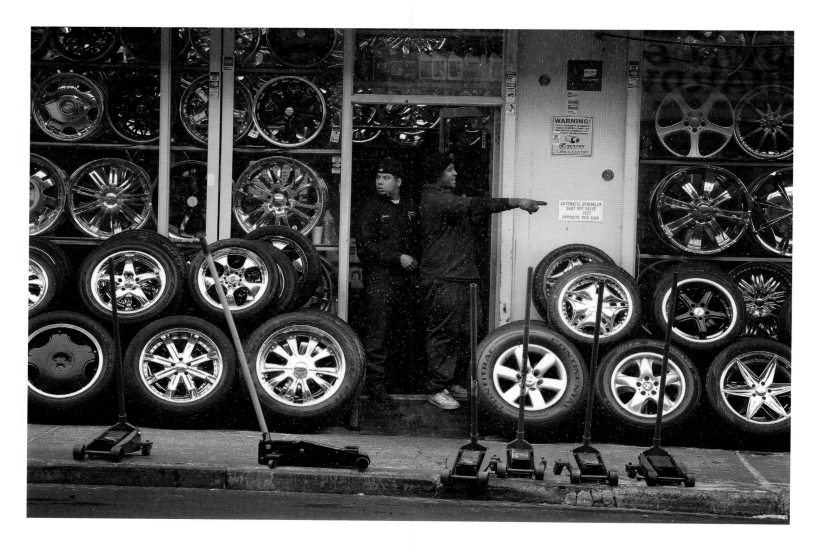

Westchester Corp. Tires and Wheels Center, Bronx, 2009
Nicole Bengiveno

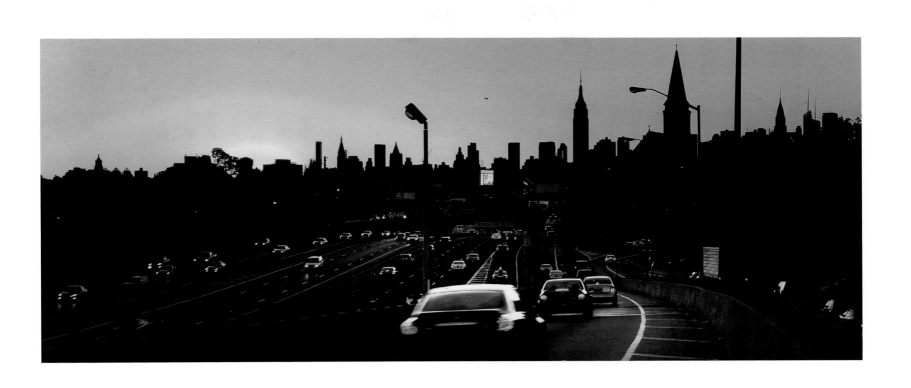

Long Island Expressway, Queens, 2013
Barton Silverman

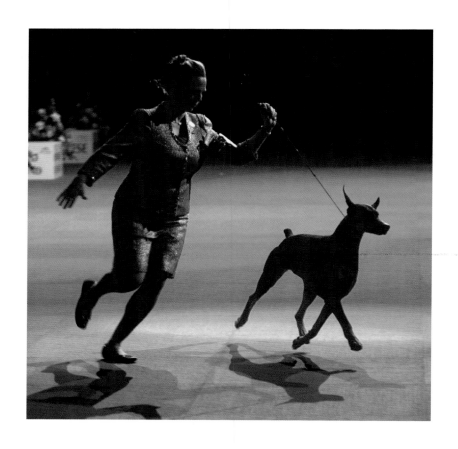

Westminster Kennel Club Dog Show, Madison Square Garden, 2012
Barton Silverman

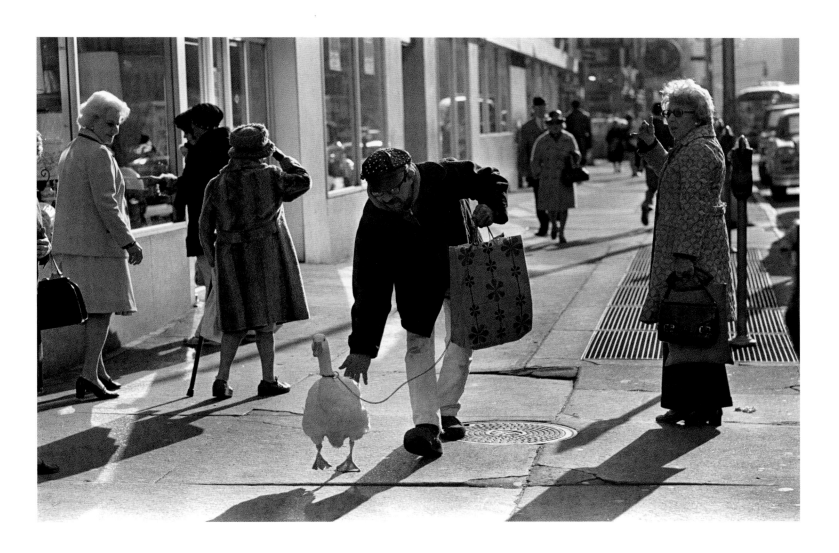

Gertrude goes for a walk, Eighth Avenue, Midtown Manhattan, 1974
Neal Boenzi

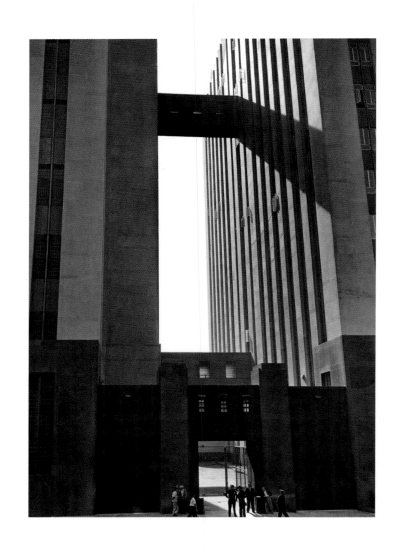

Manhattan Detention Complex, White Street, 1941
The New York Times

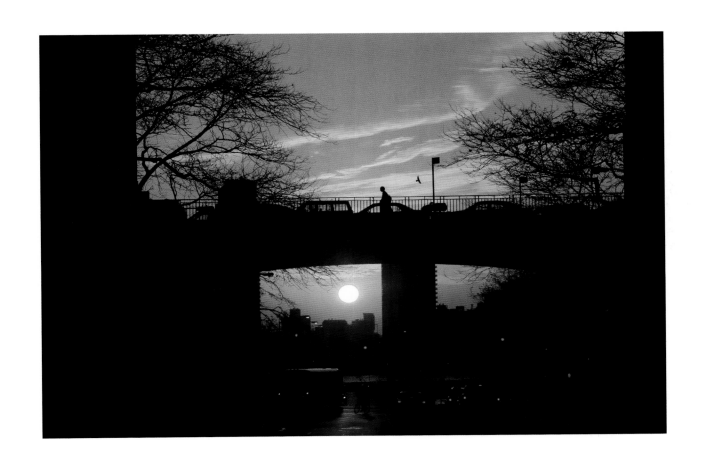

Tudor City, East 42nd, 2010
Earl Wilson

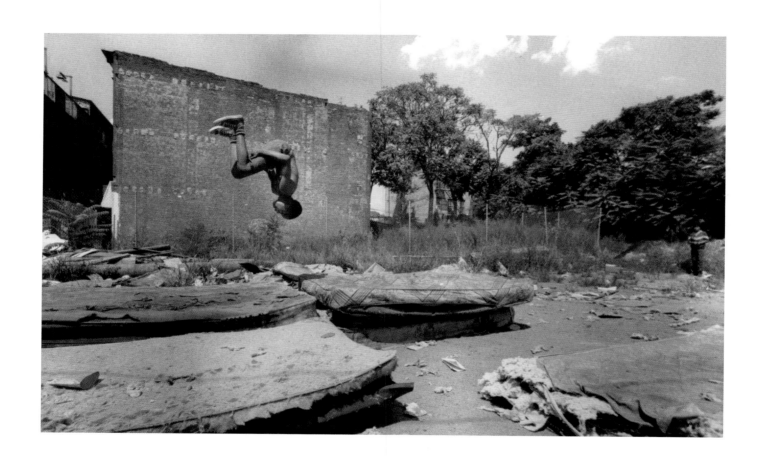

Earl Prince, 14, Brooklyn, 1987

Fred R. Conrad

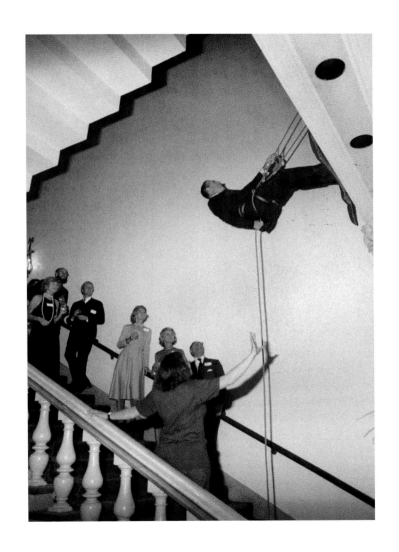

Outward Bound benefit, Plaza Hotel, 1976
Chester Higgins Jr.

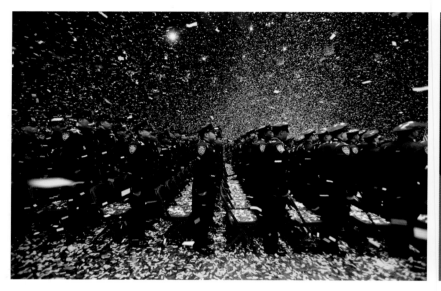

Police Academy graduation, Madison Square Garden, 2006
Nicole Bengiveno

Federal Plaza, 2014
Ozier Muhammad

"Do you ever ask why rules and penalties do not work in New York City?" writes Richard Reilly. "Recently I was waiting on a street corner in midtown for an associate. During my wait, a police tow truck hooked up one of many cars illegally parked in a tow-away zone. During the operation, a frustrated driver who had given up looking for a parking place pulled up alongside the car being towed and waited. After the tow truck pulled the offending car out of its place, the waiting driver pulled up, backed into the empty space, turned off the motor, left the car and walked away.

"He had found his parking space."

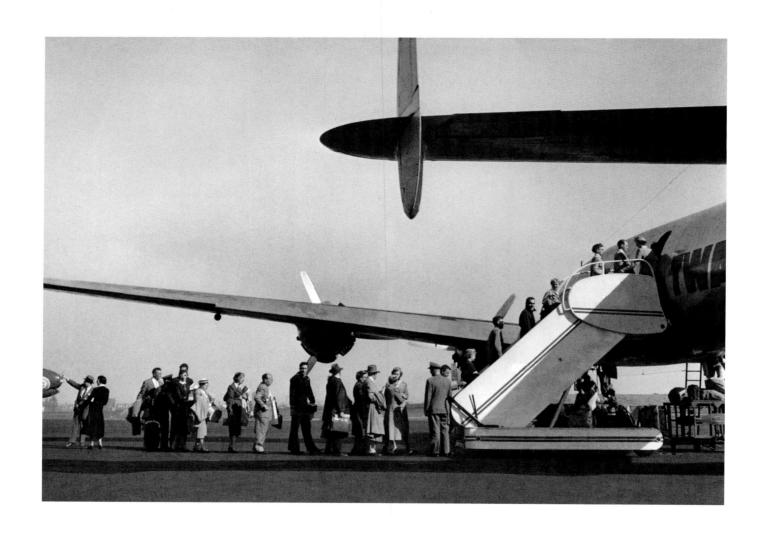

Boarding a TWA Constellation, Idlewild Airport, Queens, 1954
Sam Falk

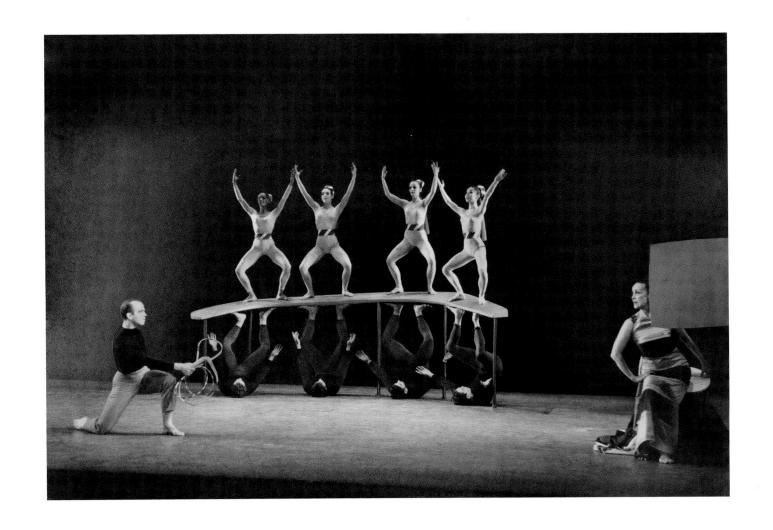

Martha Graham and dancers rehearse *Acrobats of God*, 54th Street Theatre, 1960
Sam Falk

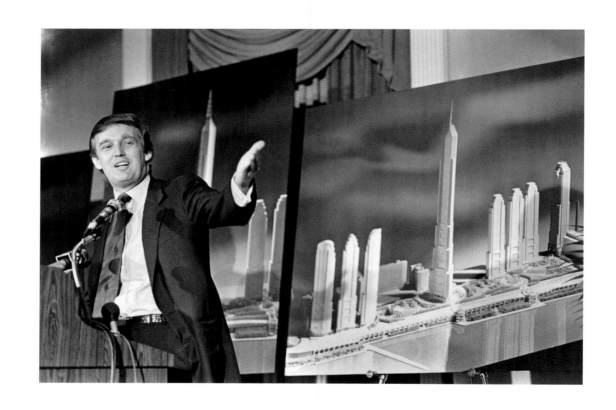

Donald J. Trump, Midtown Manhattan, 1985
Neal Boenzi

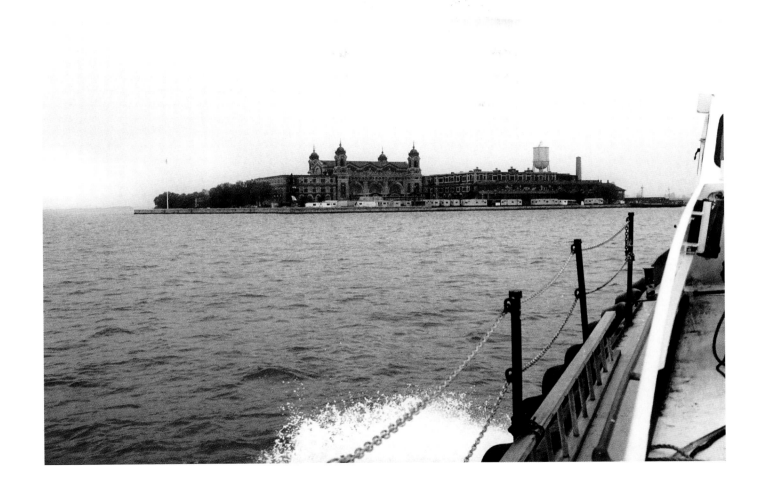

Ellis Island, 1989
Marilynn K. Yee

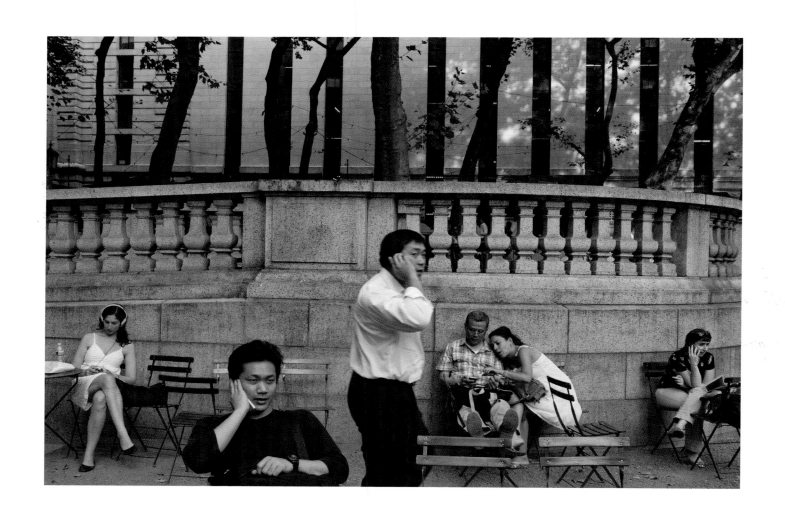

The talk of Bryant Park, 2012

Damon Winter

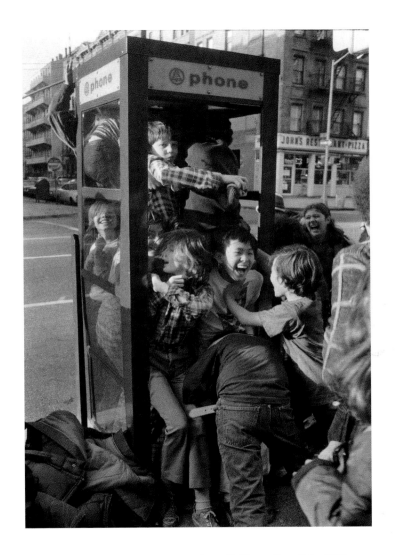

P.S.158 sixth-graders answer the call, Upper East Side, 1975
Meyer Liebowitz

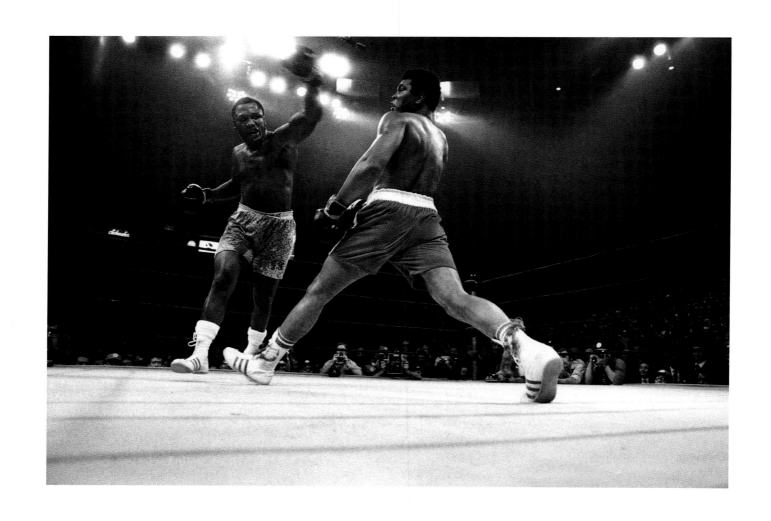

Joe Frazier and Muhammad Ali, Madison Square Garden, 1971
Larry C. Morris

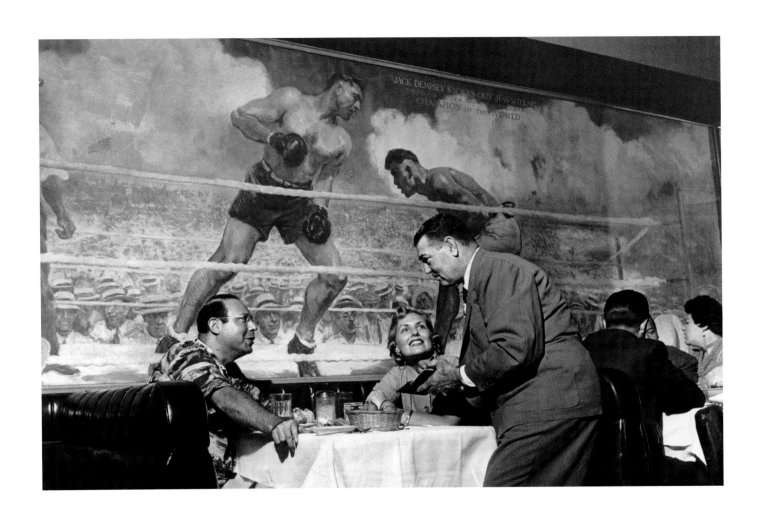

Jack Dempsey greets diners at his restaurant on Broadway, 1954
Sam Falk

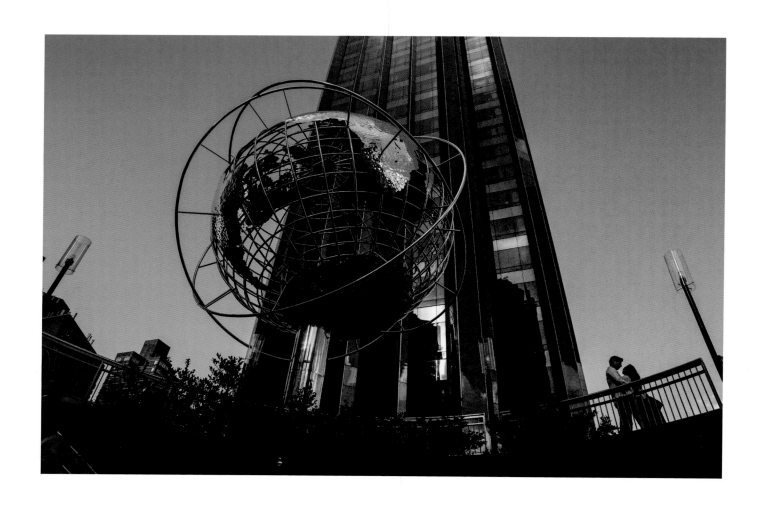

View from the subway entrance, Columbus Circle, 2016
Todd Heisler

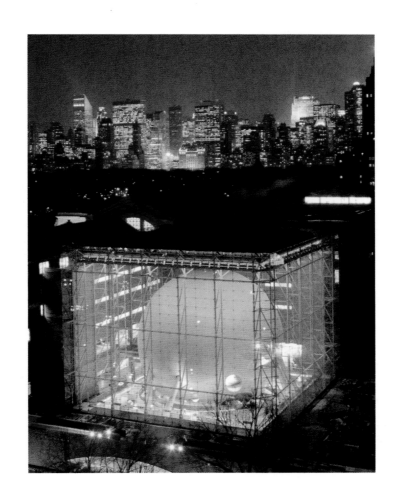

Hayden Planetarium, Central Park West, 2000
Sara Krulwich

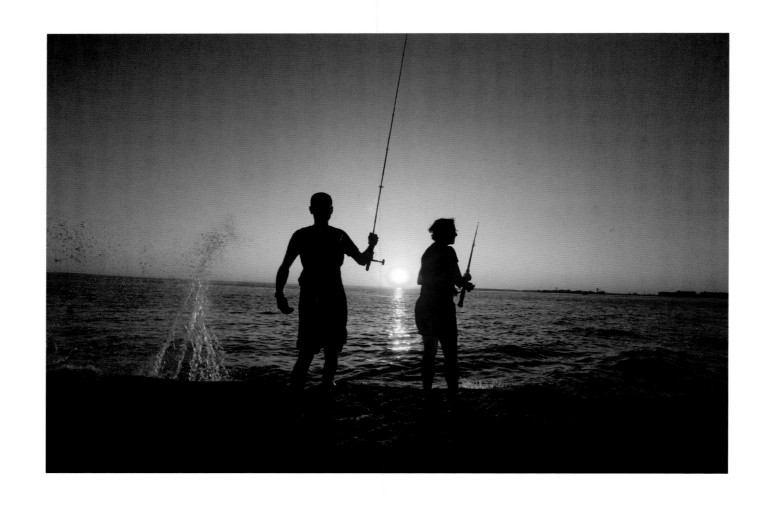

Breezy Point, Queens, 2008
Suzanne DeChillo

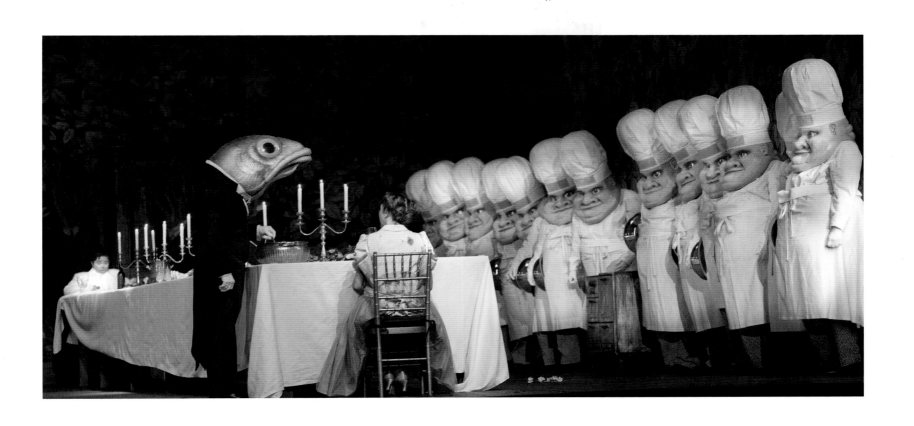

Hansel and Gretel, Metropolitan Opera House, 2017
Sara Krulwich

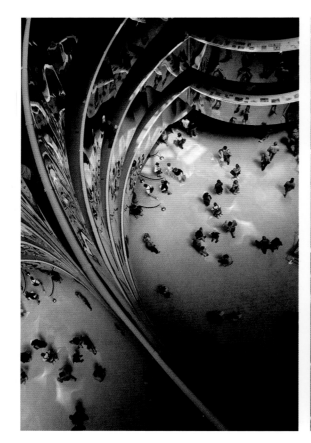

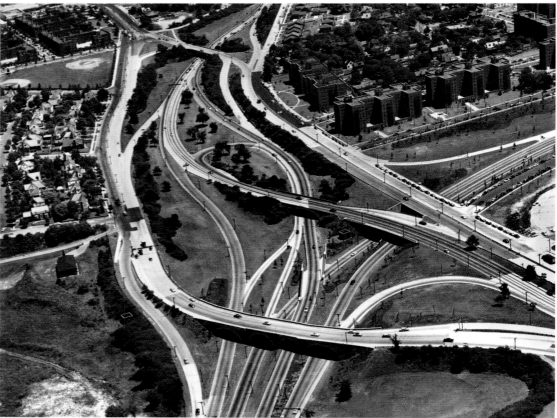

Guggenheim Museum, Upper East Side, 1998
Edward Keating

Grand Central Parkway and Van Wyck Expressway, Queens, 1955
Meyer Liebowitz

Overheard by Deborah A. Goldberg at the Guggenheim Museum during the recent *Art of the Motorcycle* exhibition: "I always thought this would make a good garage."

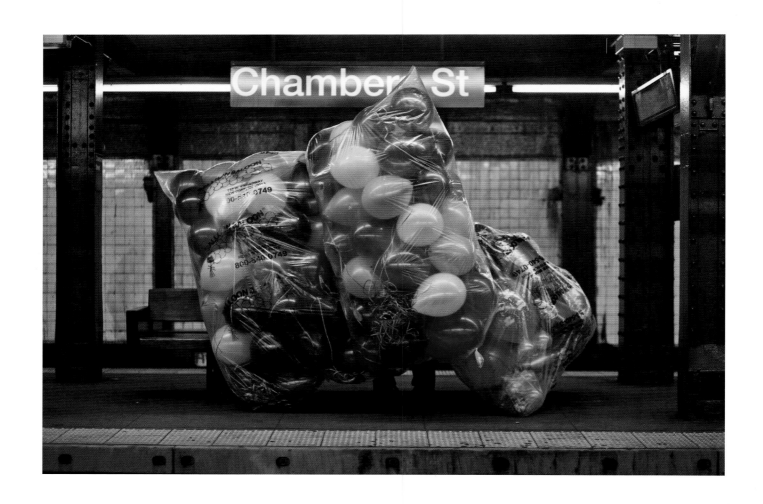

Chambers Street subway station, 2011
Fred R. Conrad

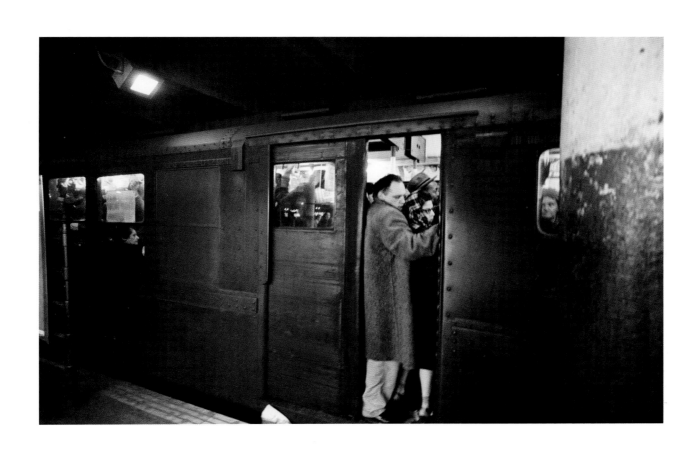

Exact location unknown, 1960
Sam Falk

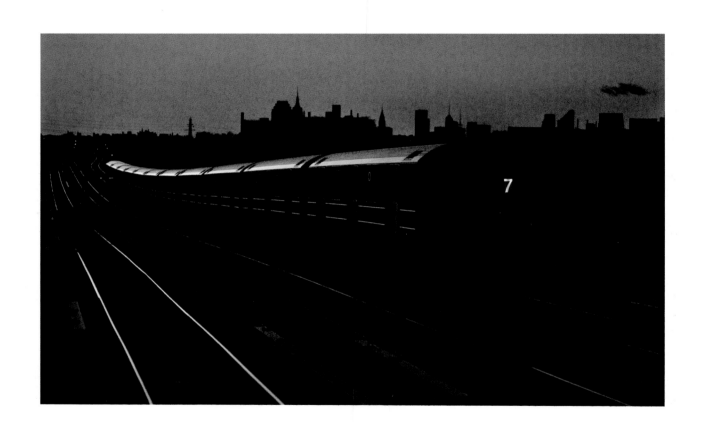

No. 7 Train, 69th Street Station, Queens, 2010
Chang W. Lee

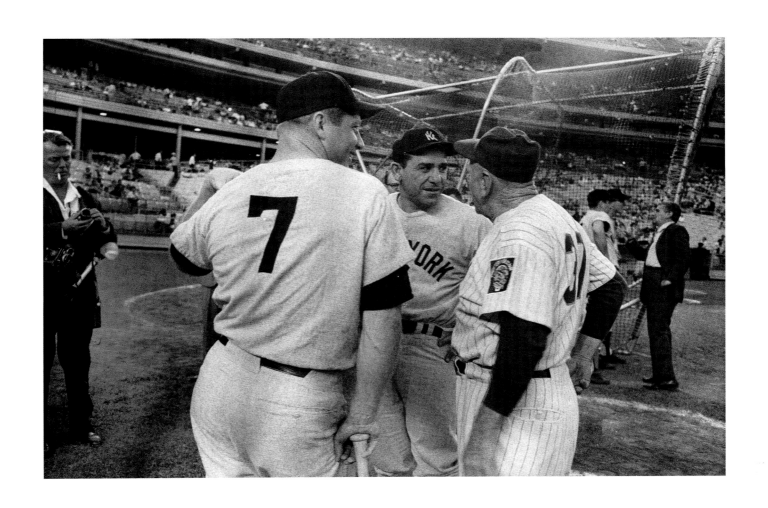

Mickey Mantle, Yogi Berra, and Casey Stengel, Shea Stadium, 1964
Larry C. Morris

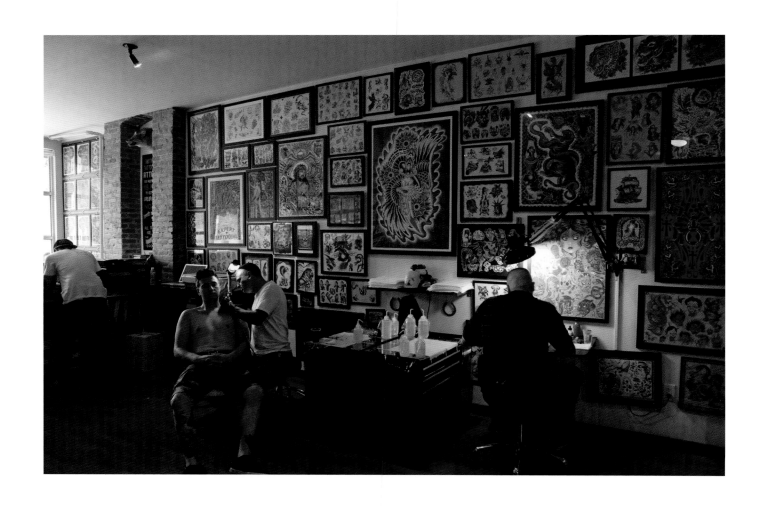

Smith Street Tattoo Parlour, Brooklyn, 2013
Nicole Bengiveno

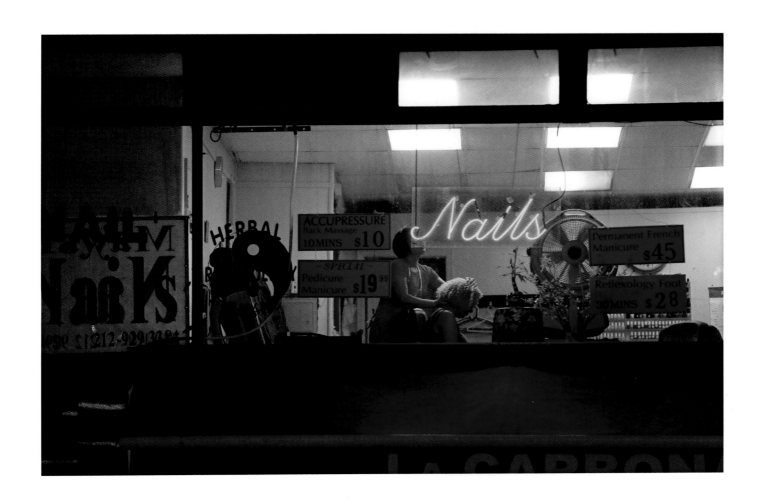

May's Nails Salon, West 14th Street, 2014
Nicole Bengiveno

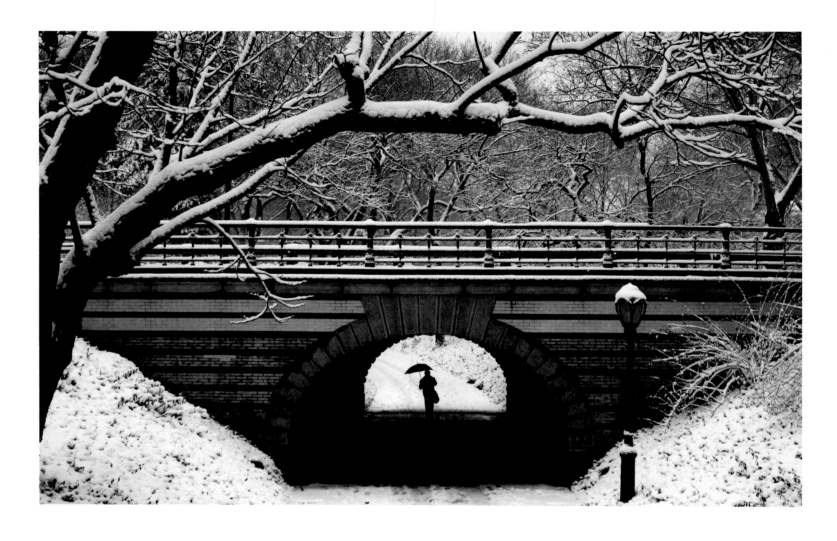

Central Park, 2008
Todd Heisler

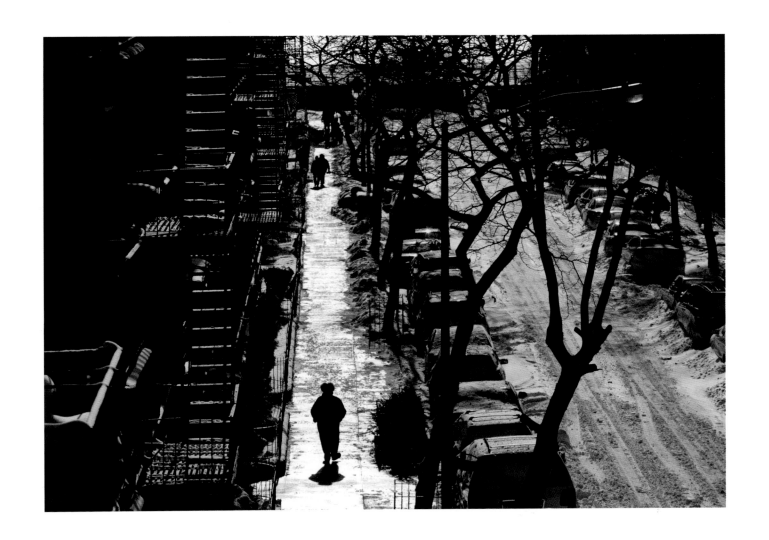

Brighton Beach, Brooklyn, 2014
Todd Heisler

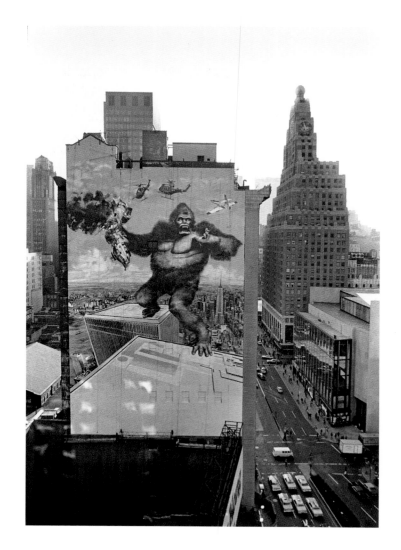

West 47th Street, Manhattan, 1976
D. Gorton

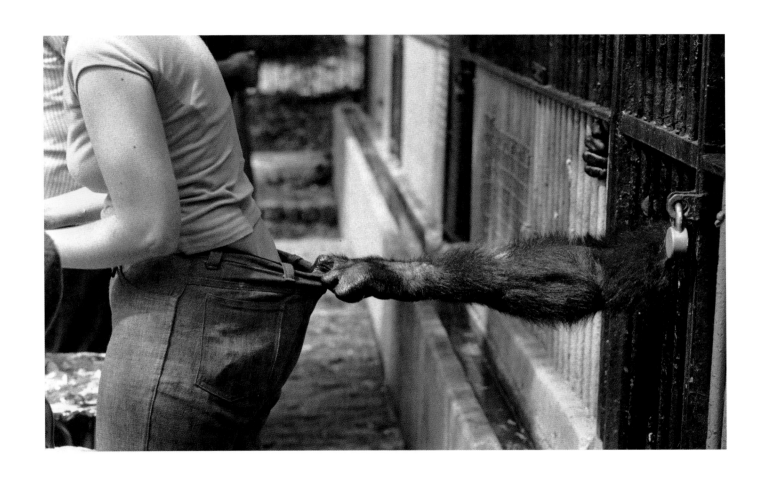

Bronx Zoo, 1977
John Sotomayor

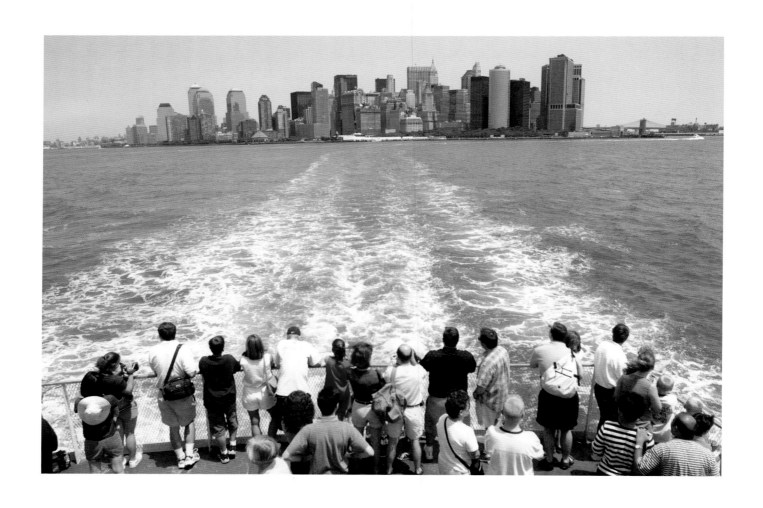

Ellis Island bound, New York Harbor, 2002
Edward Keating

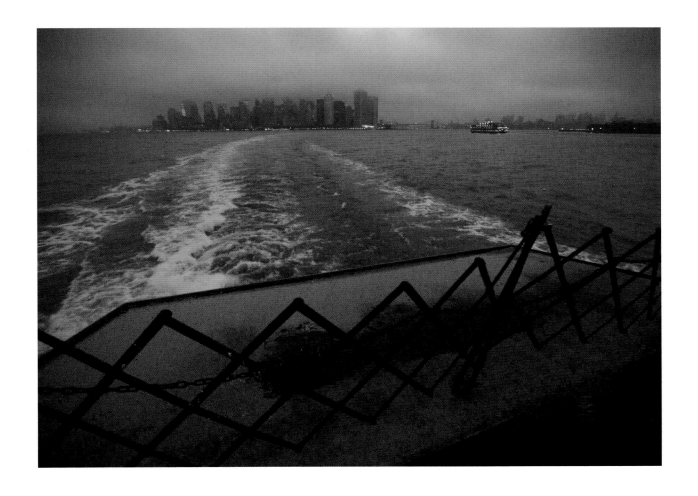

Staten Island bound, New York Harbor, 2010
Librado Romero

The Let There Be Neon Studio, Manhattan, 2010
Ruth Fremson

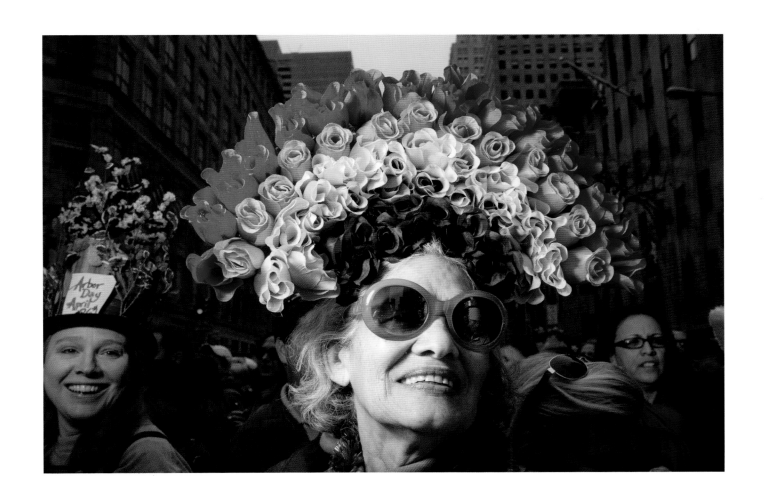

Easter Parade, Fifth Avenue, 2013
Fred R. Conrad

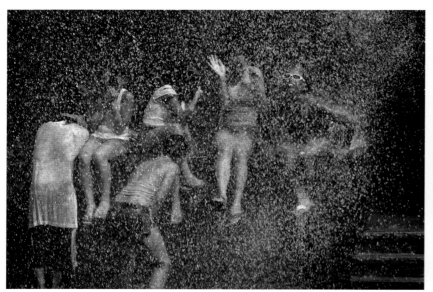

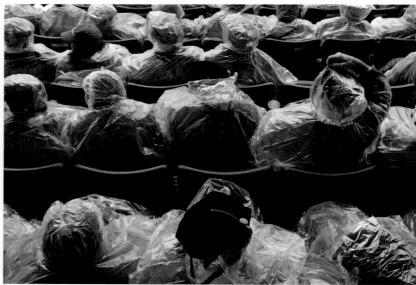

Morris Avenue, Bronx, 2006
Richard Perry

New York University Commencement,
Yankee Stadium, 2010
Richard Perry

THE CITY'S A STAGE

where people acting in their daily lives
are more interesting than performance artists
who strive
to get our attention
by dousing their bodies with substances
I won't mention.

Ed Rossman

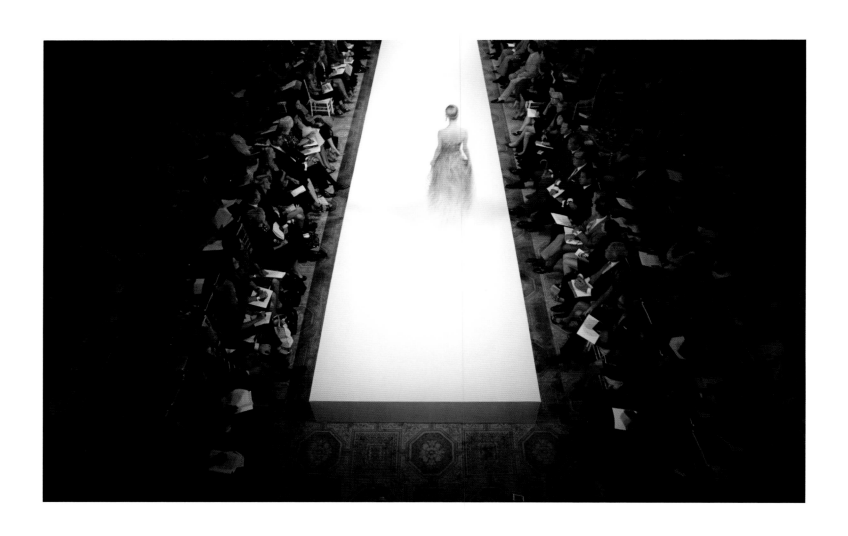

Oscar de la Renta show, Park Avenue, 2009
Damon Winter

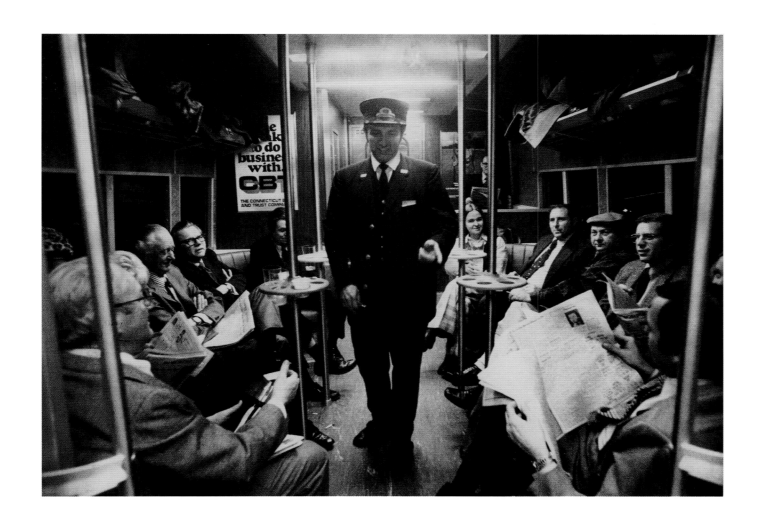

Metro North out of Grand Central Terminal, Date unknown
Larry C. Morris

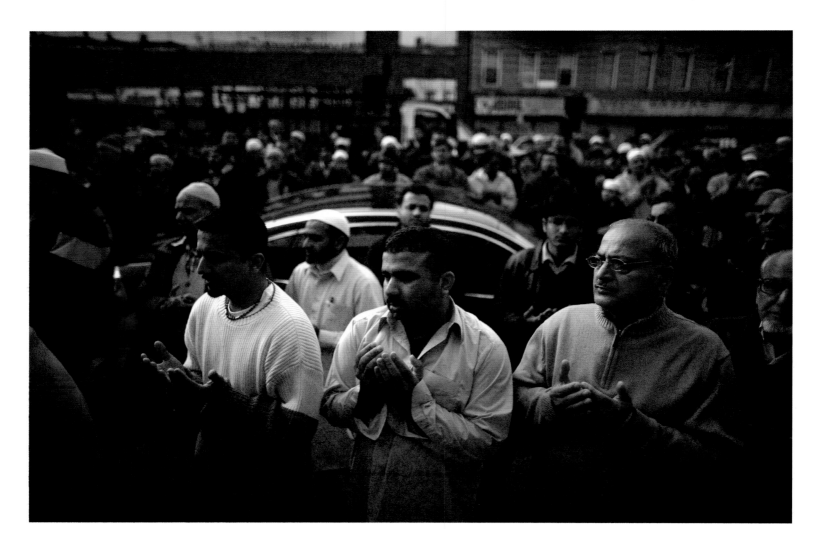

Mourning Benazir Bhutto, Makki Mosque, Brooklyn, 2007
Chang W. Lee

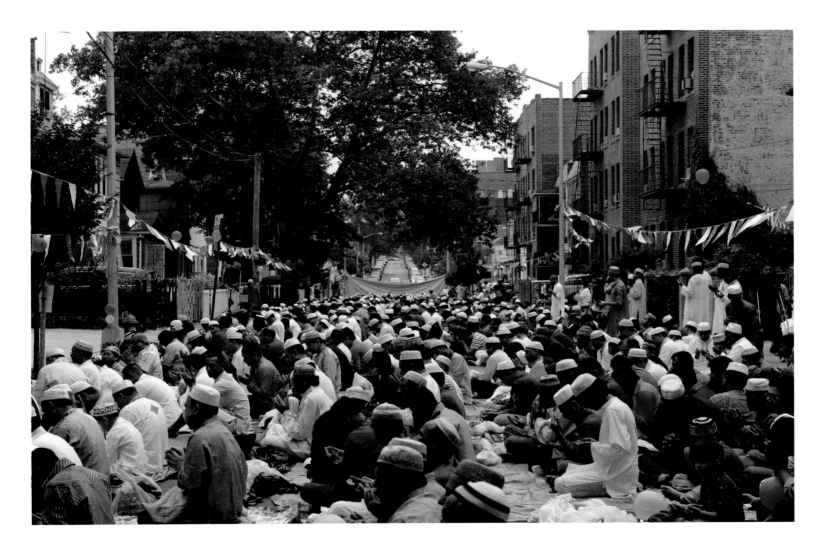

Marking the end of Ramadan, Queens, 2013
Angel Franco

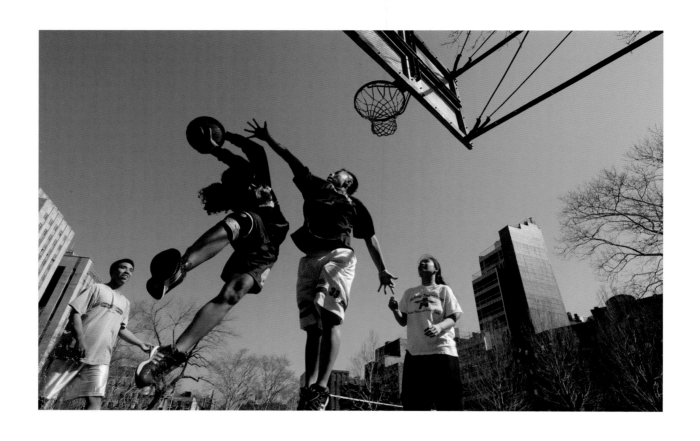

Columbus Park, Chinatown, 2010
Ruth Fremson

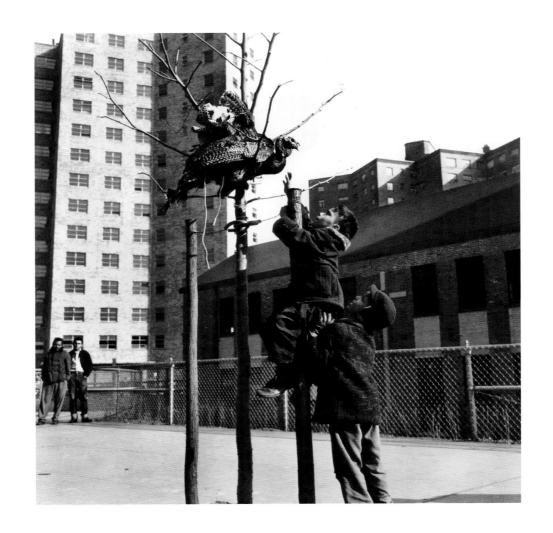

Rescuing a turkey race competitor, Grand Street Settlement, Manhattan, 1958
Arthur Brower

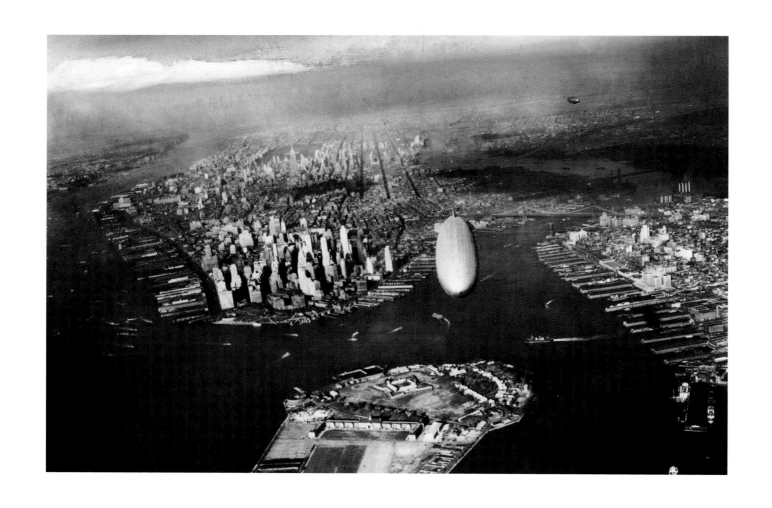

USS *Akron* airship, 1931
The New York Times

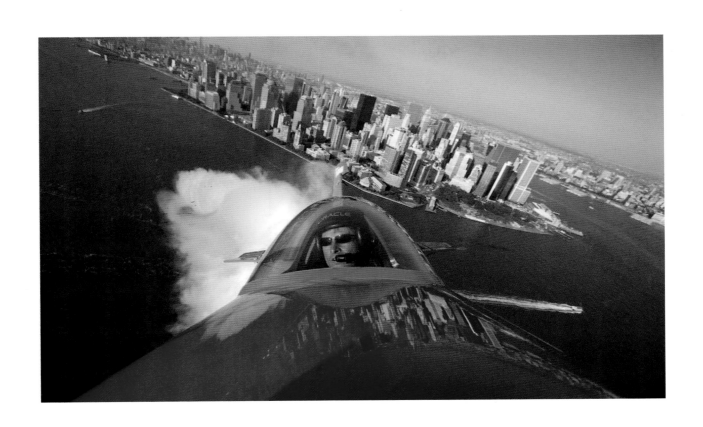

Stunt pilot Sean D. Tucker on a practice run, 2007
Vincent Laforet

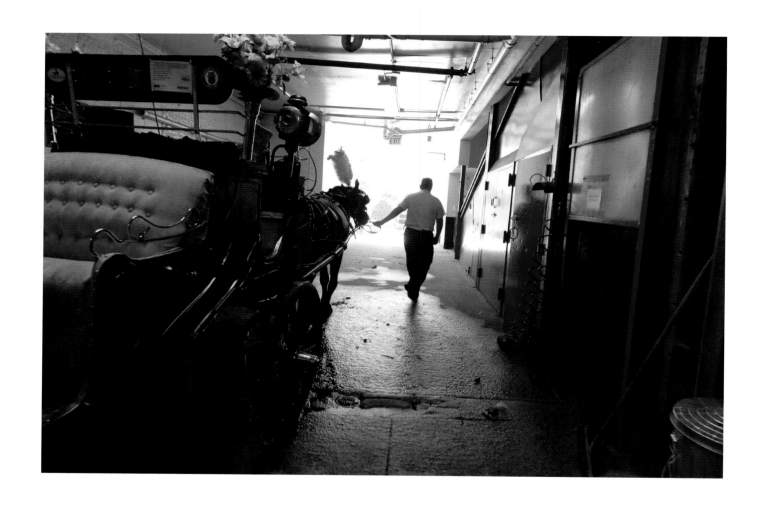

Tyson the carriage horse, Manhattan, 2015
Michelle V. Agins

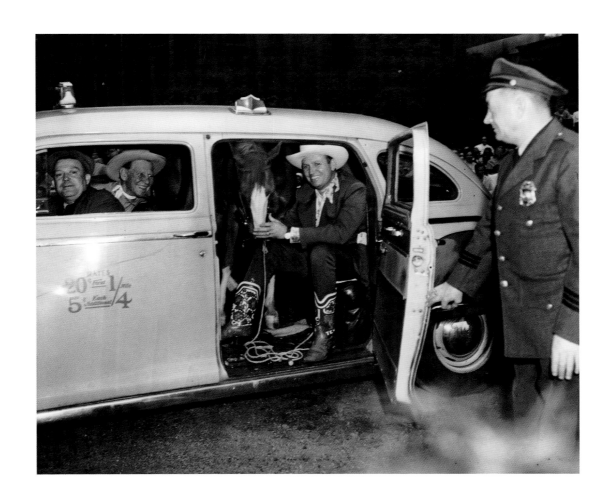

Gene Autry and Champion go for a ride, Manhattan, 1948
William C. Eckenberg

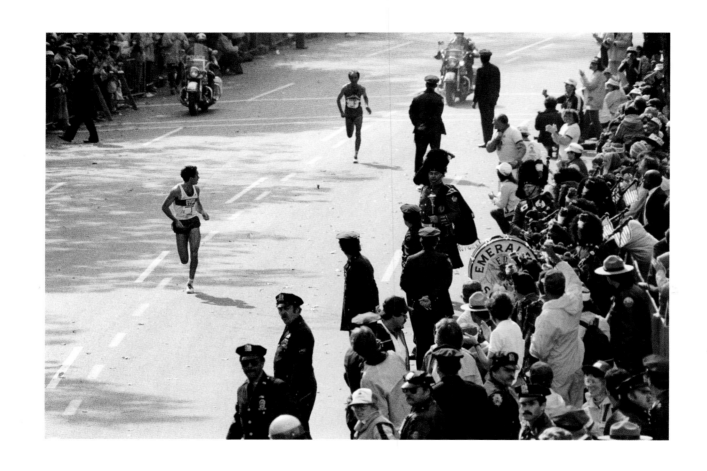

Alberto Salazar wins the New York City Marathon, 1982

Marilynn K. Yee

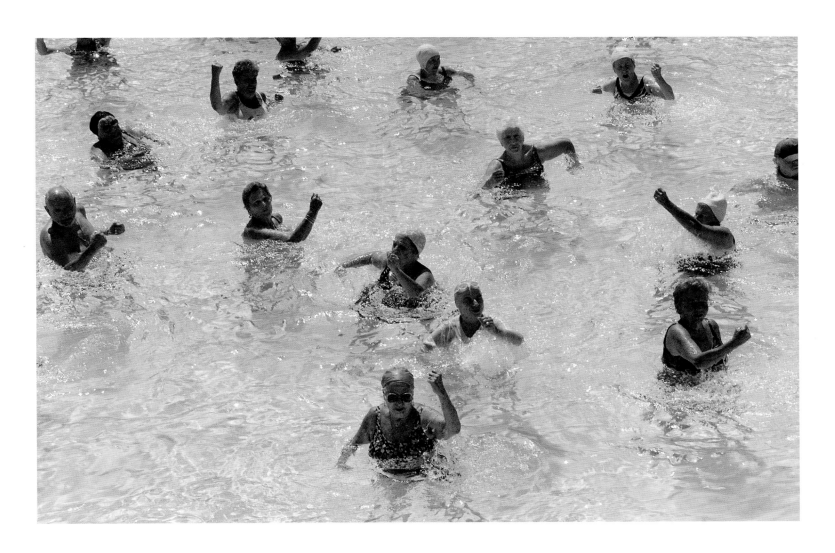

Aquatic aerobics, Astoria, Queens, 2001
Ruth Fremson

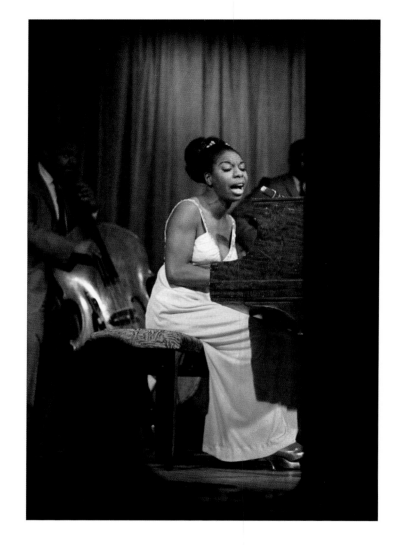

Nina Simone at The Village Gate, 1965
Sam Falk

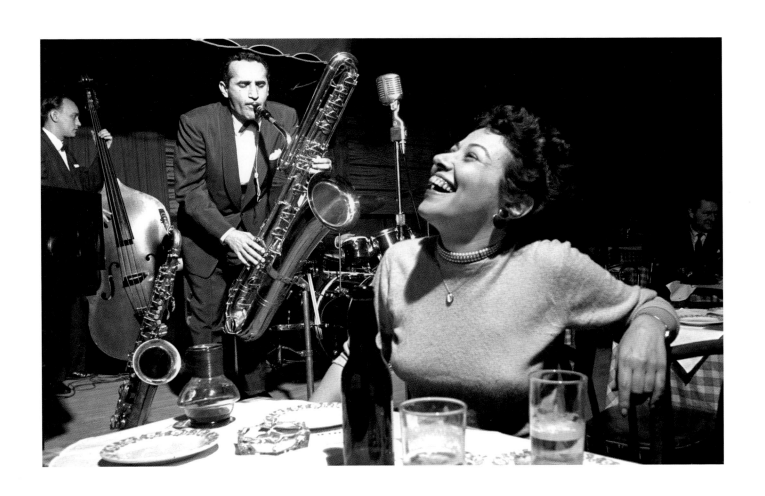

Loving what she hears, Venue unknown, 1954
Sam Falk

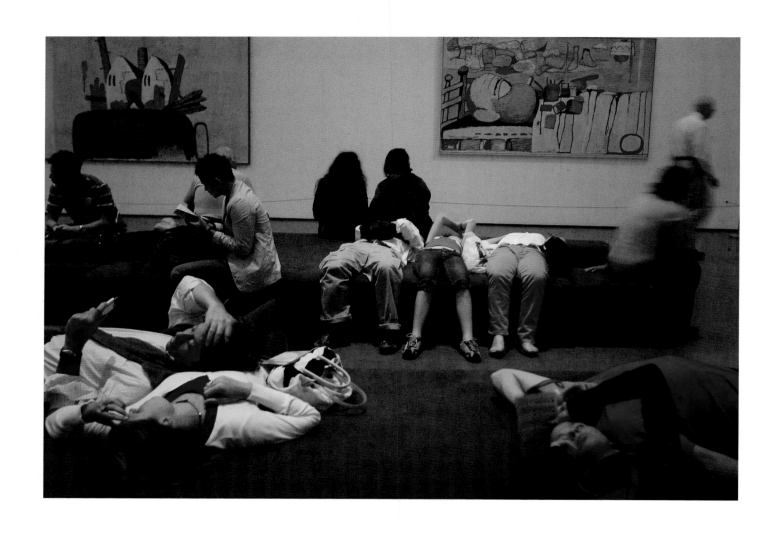

Masterpiece fatigue, Museum of Modern Art, 2008
Nicole Bengiveno

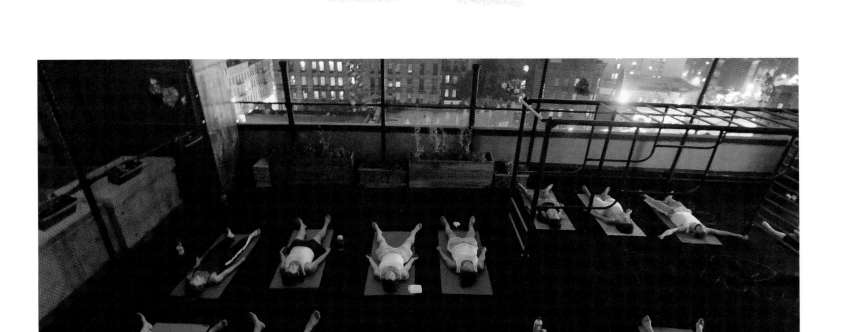

Yoga on the roof, Manhattan, 2005
James Estrin

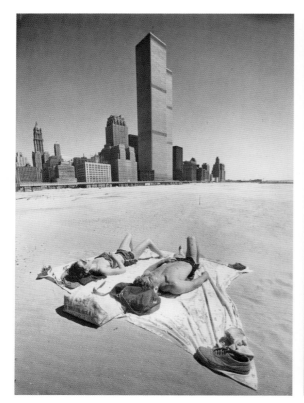

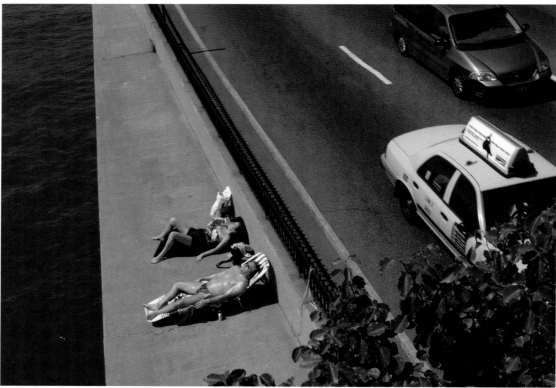

Tanning at the landfill, Battery Park City, 1977
Fred R. Conrad

. . . and the F.D.R., Manhattan, 2000
James Estrin

Overheard by Harvey E. Phillips on a street in Greenwich Village, young man to his companion: "Oh, I've stopped going to the Hamptons. It's too much like going uptown."

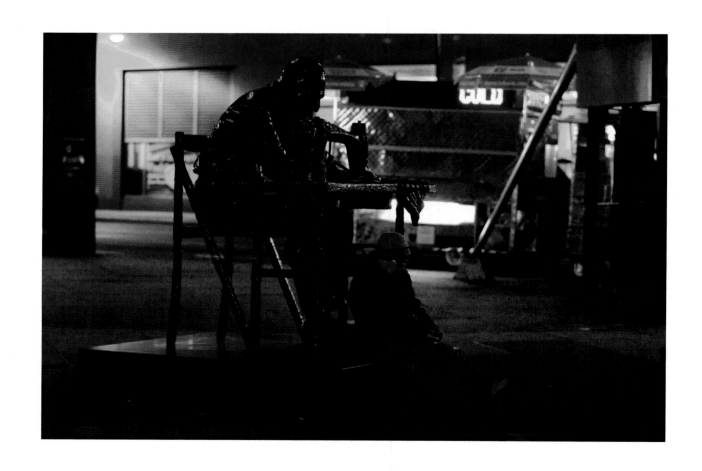

The Garment Worker, Fashion District, Manhattan, 2012
Librado Romero

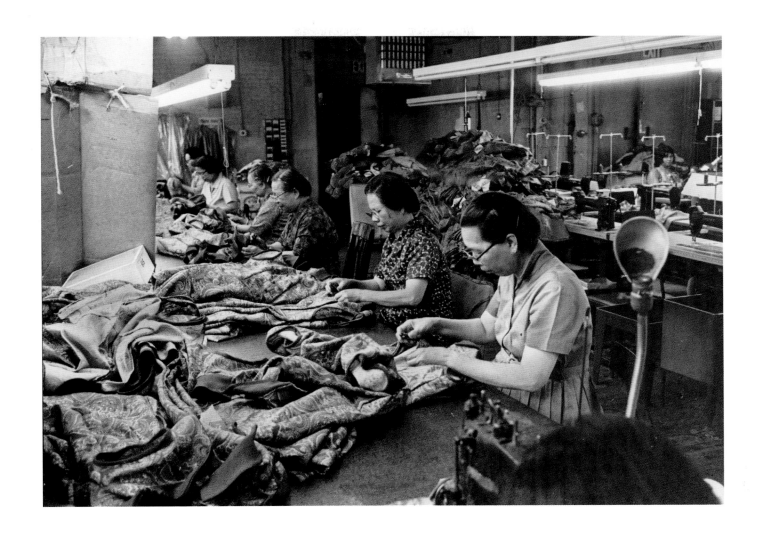

Garment factory workers, Chinatown, 1967
Arthur Brower

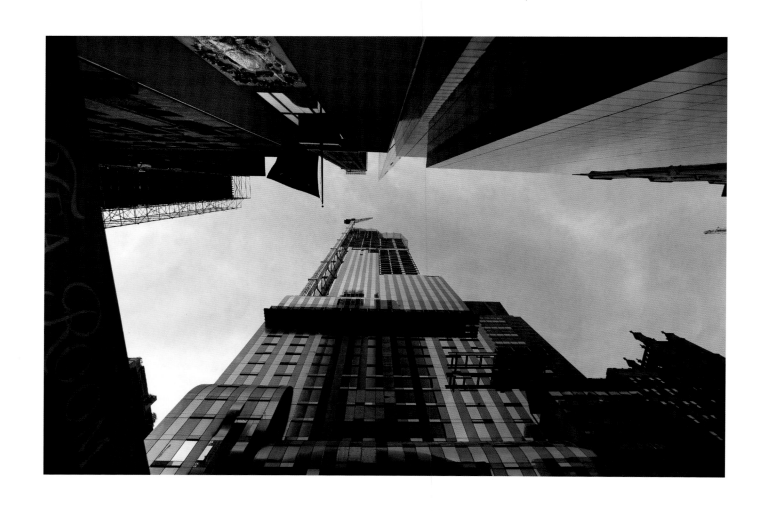

The 90-story One57 building, Midtown Manhattan, 2012

Chang W. Lee

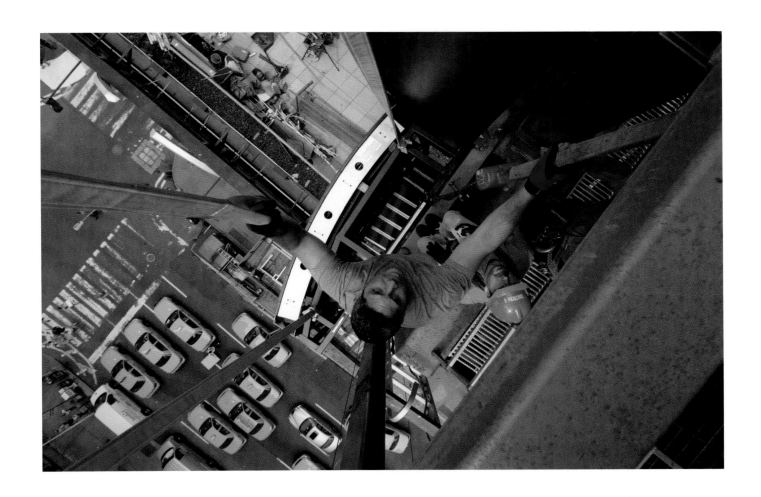

Installation of a Coke sign, Duffy Square, Broadway, 2004
Fred R. Conrad

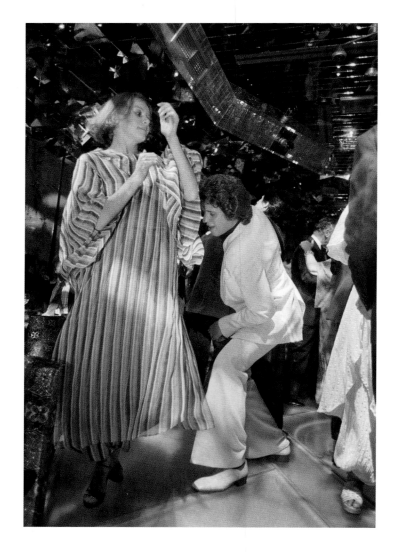

Saturday Night Fever before the movie, Regine's Disco, Manhattan, 1976
Larry C. Morris

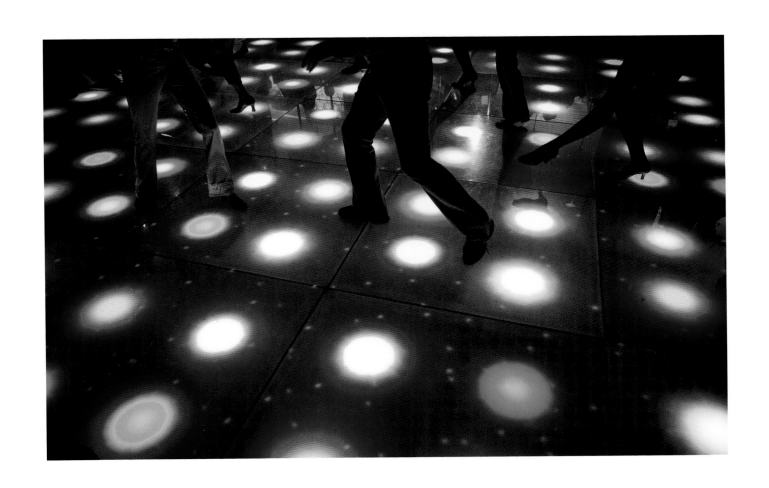

. . . and long after, Odyssey Disco, Bay Ridge, Brooklyn, 2017
Damon Winter

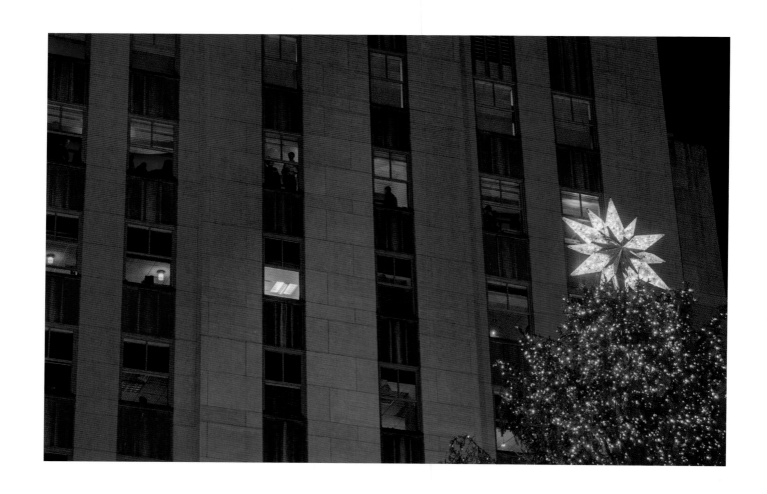

Rockefeller Center, 2017
Hiroko Masuike

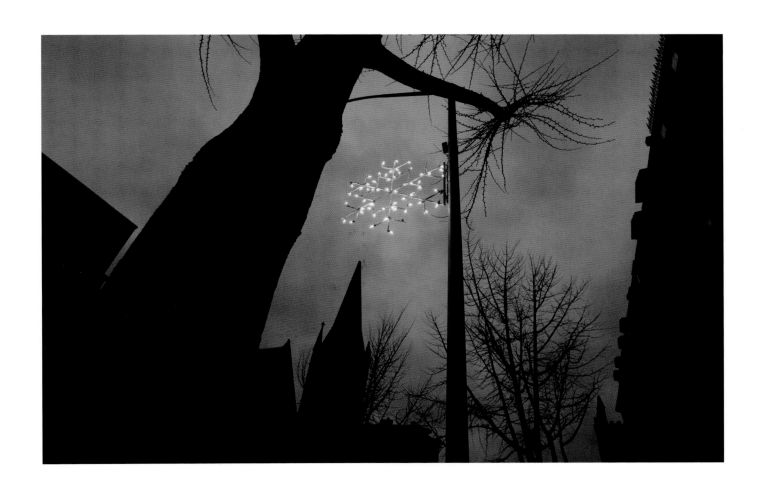

Park Slope, Brooklyn, 2010
Ruth Fremson

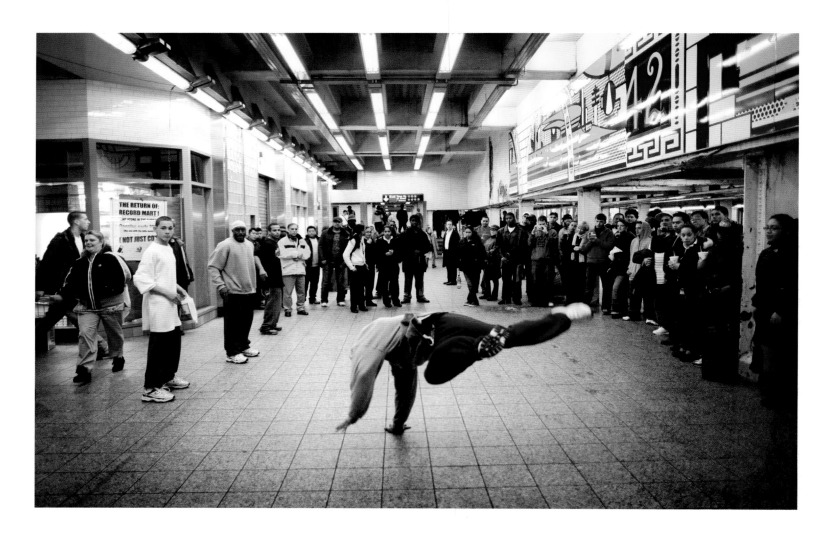

Doug Walker and the New York City Float Committee, Times Square, 2007
Damon Winter

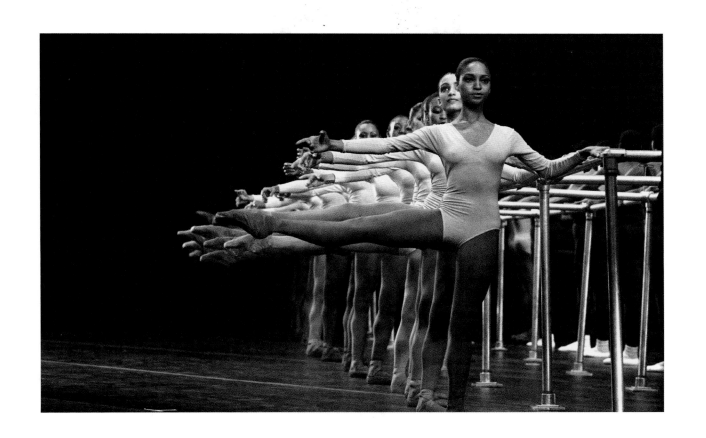

Dance Theatre of Harlem at City Center, Manhattan, 1984
Keith Meyers

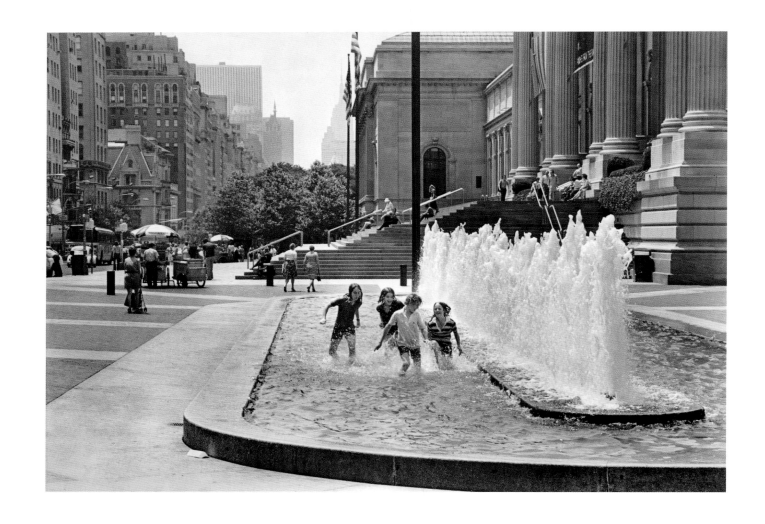

Metropolitan Museum of Art, 1976

Neal Boenzi

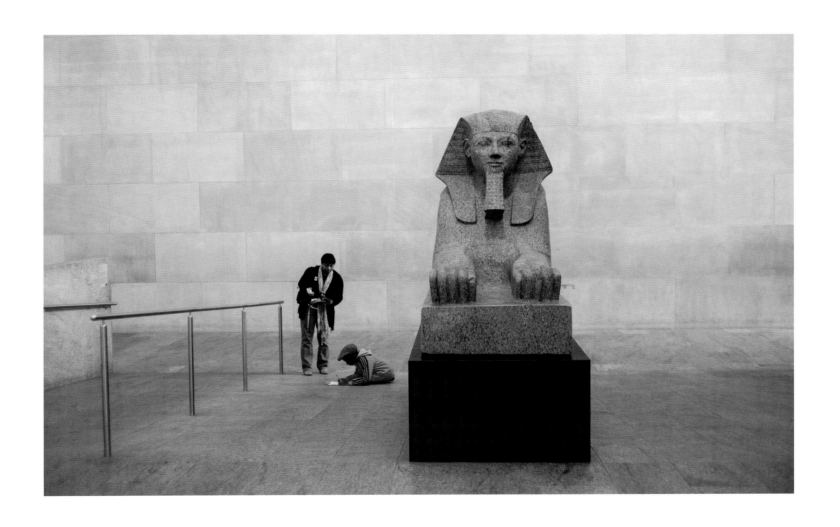

Sphinx of Hatshepsut, Metropolitan Museum of Art, 2015
Todd Heisler

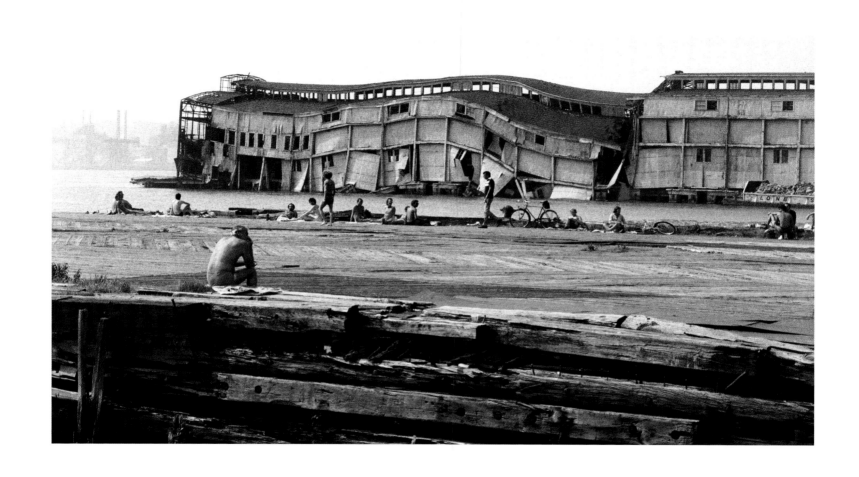

The downtown piers, Bethune Street and the Hudson River, 1978
Paul Hosefros

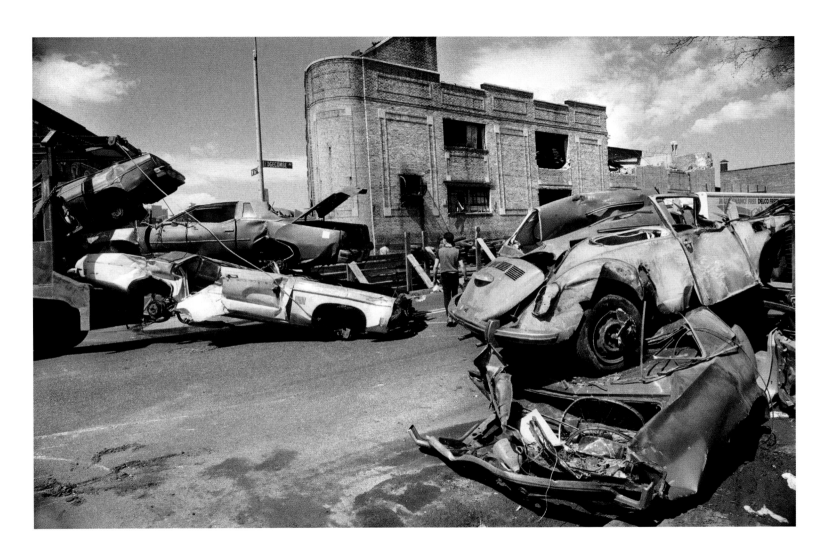

Upper Manhattan, 1987
Neal Boenzi

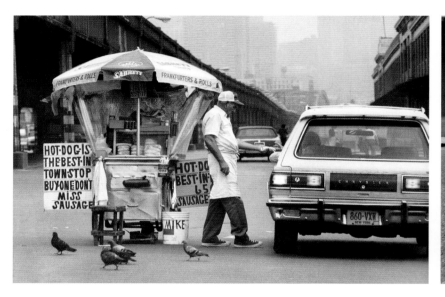

Christopher Street, 1981
William E. Sauro

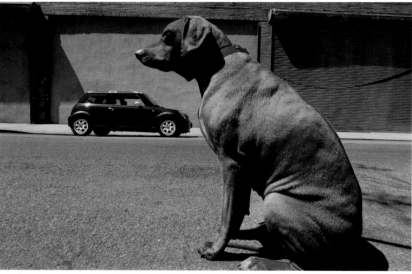

Greenwich Street, 2002
Nicole Bengiveno

CITY DOGS

City dogs
Are so polite
Seldom bite
Laugh at dangers
Sniff at strangers
Eat croissants
Love *enfants*
Marrow bones
Ice-cream cones
Feathered migrants
Fire hydrants.

PEGGY KEILUS

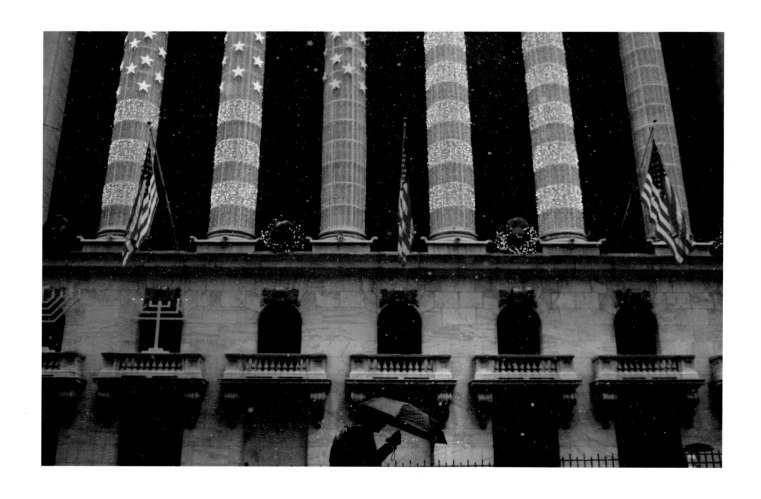

The New York Stock Exchange, Lower Manhattan, 2008
Todd Heisler

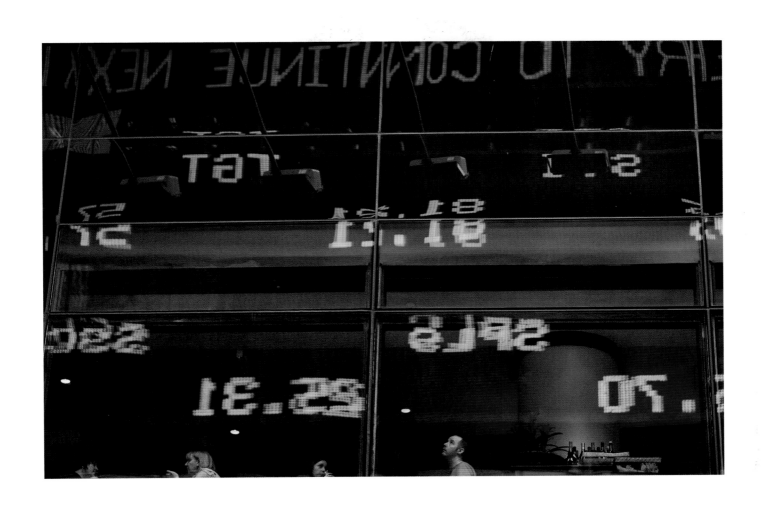

Times Square, 2008
Nicole Bengiveno

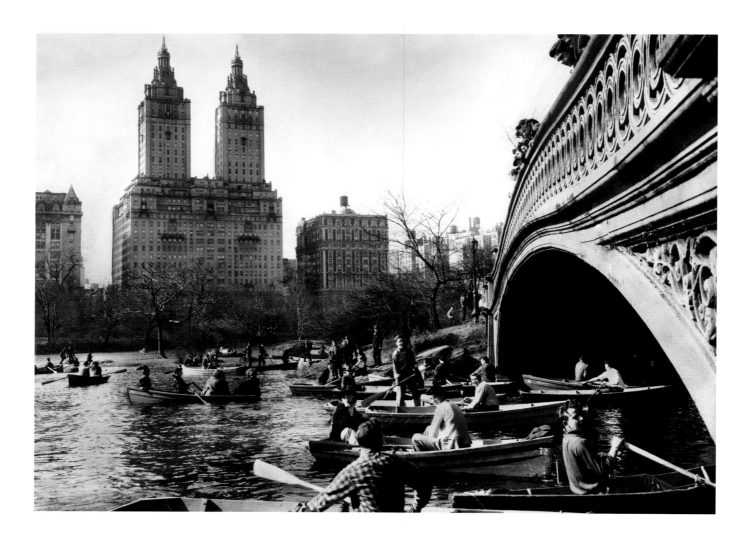

Central Park, 1955
Ernie Sisto

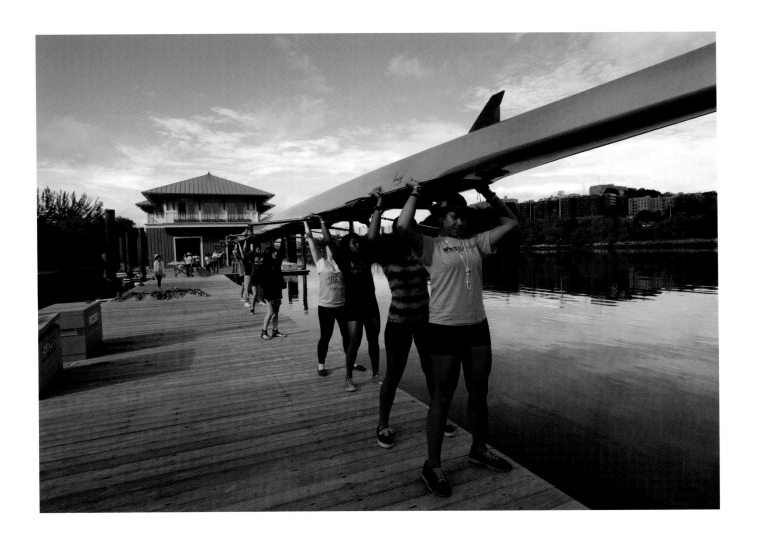

Peter J. Sharp Boathouse, East River, Manhattan, 2012

James Estrin

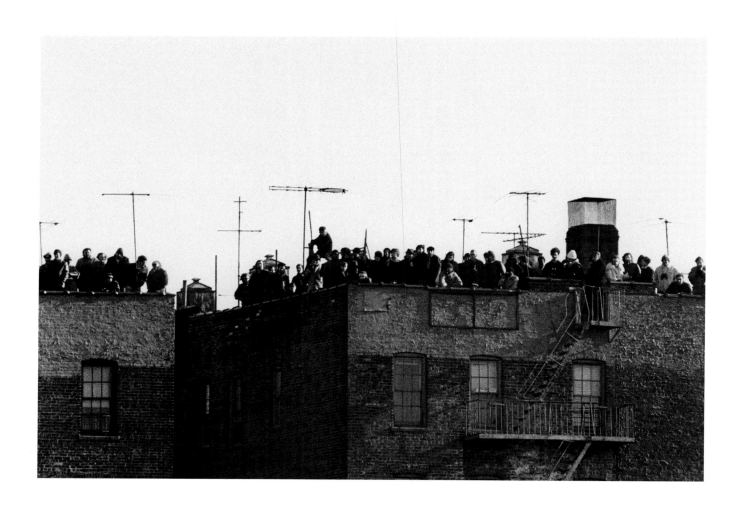

**New York Giants' football fans watch their team from
a nearby rooftop, Bronx, 1970**
Ernie Sisto

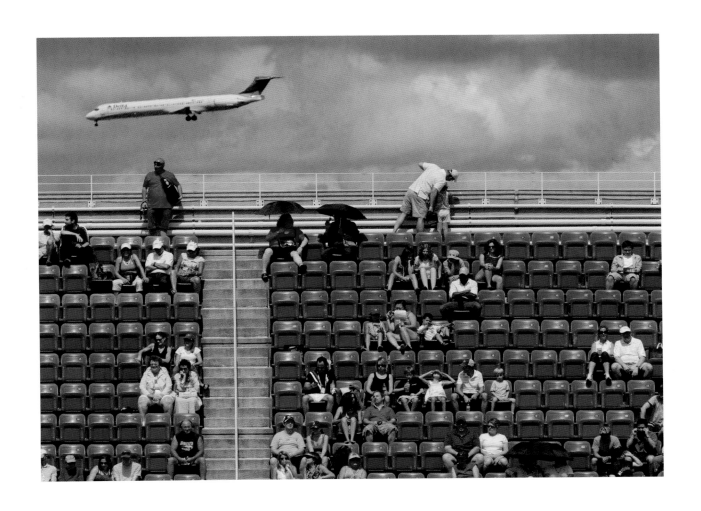

U.S. Open, Day 1, Arthur Ashe Stadium, Queens, 2009
Richard Perry

Midtown Manhattan as snow falls, 2006
Chang W. Lee

Metro North train passing through Riverdale, Bronx, 2012
Librado Romero

East River State Park, Williamsburg, Brooklyn, 2015
Damon Winter

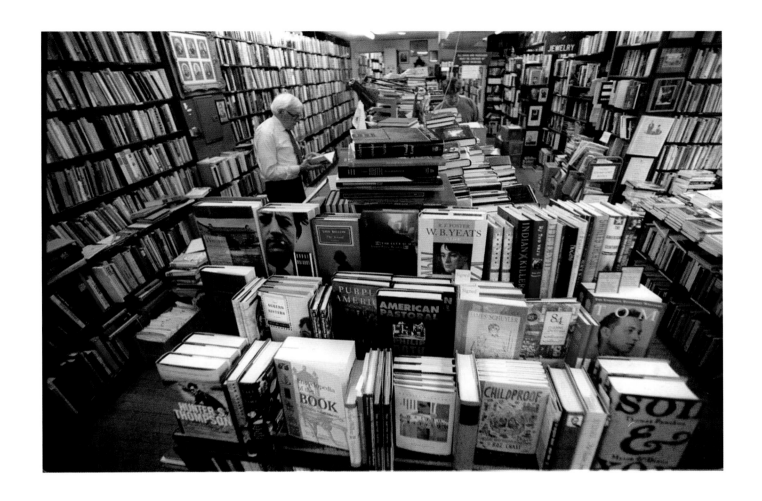

The Gotham Book Mart, R.I.P., West 47th Street, 1997
Joyce Dopkeen

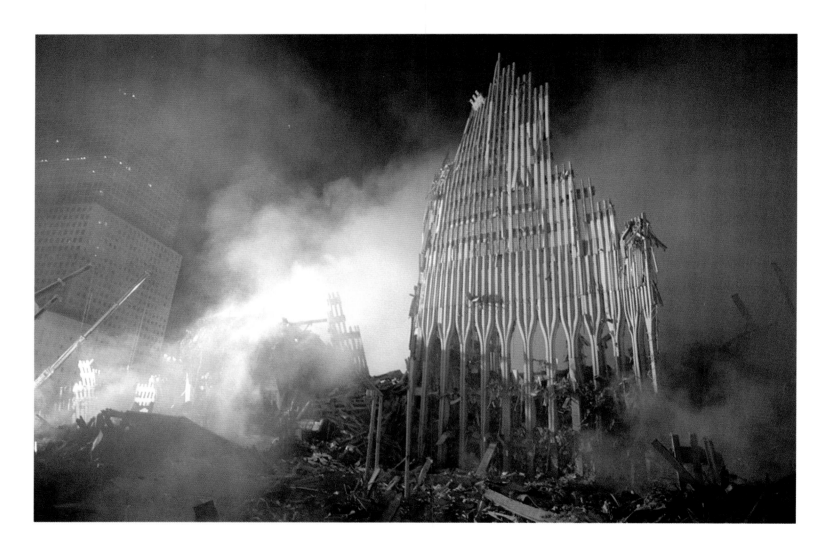

World Trade Center, 2001
Tyler Hicks

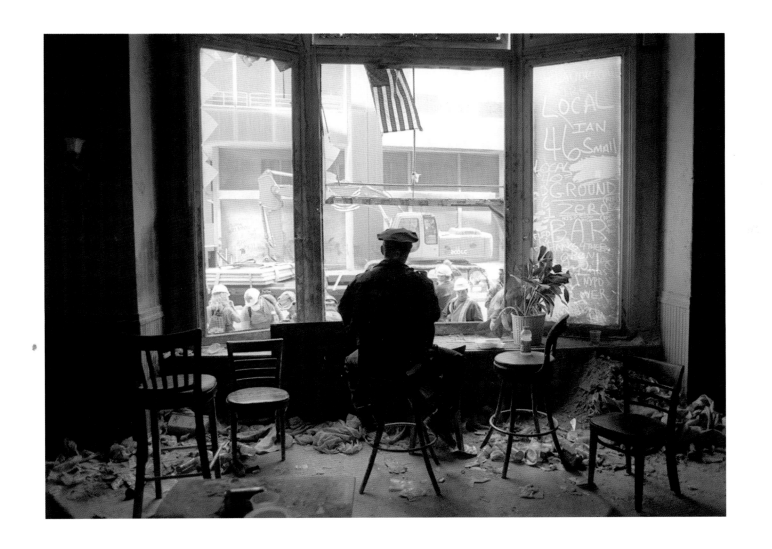

St. Charlie's bar and restaurant, Albany Street, Lower Manhattan, 2001
Tyler Hicks

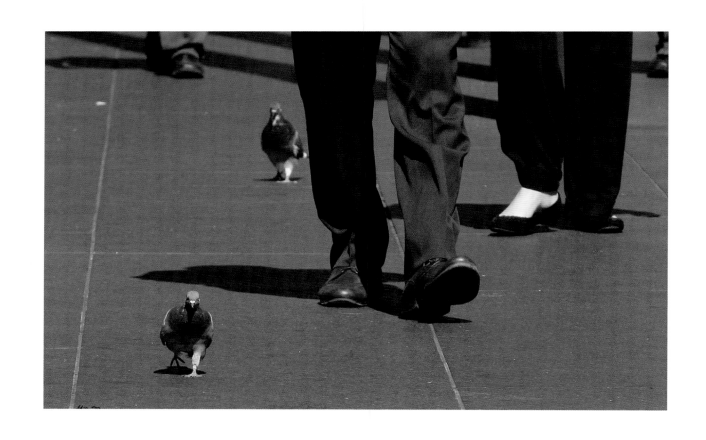

Avenue of the Americas, Midtown Manhattan, 2010
Ruth Fremson

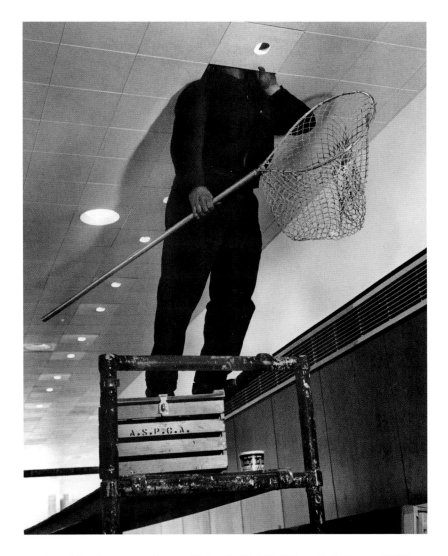

Searching for errant pigeons, Union Carbide Building, Park Avenue, 1960
Ernie Sisto

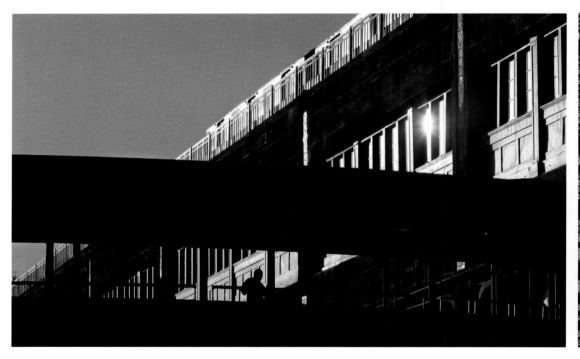

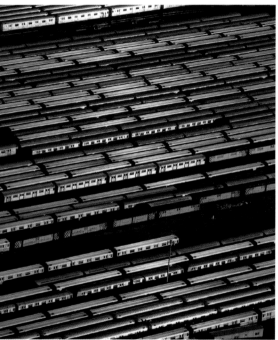

Queens Plaza Street, Queens, 2006
Richard Perry

Brooklyn MTA rail yard, Coney Island, 2005
Vincent Laforet

Dear Diary:

Riding on a crowded F train between Manhattan and Queens, I stood near a woman and her young son. As the train pulled out of the last station in Manhattan, the woman started to explain to her son that we were passing through a tunnel under the East River. When the train arrived at their first stop in Queens, she had just finished her commentary on the trip, saying, ". . . and here we are in Queens: and that's why they call us bridge and tunnel people."

SUSAN LEVEN-WEINBERG

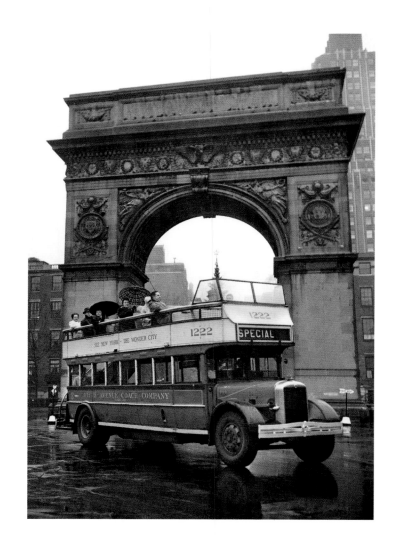

Fifth Avenue and Washington Square Park, 1946
Ernie Sisto

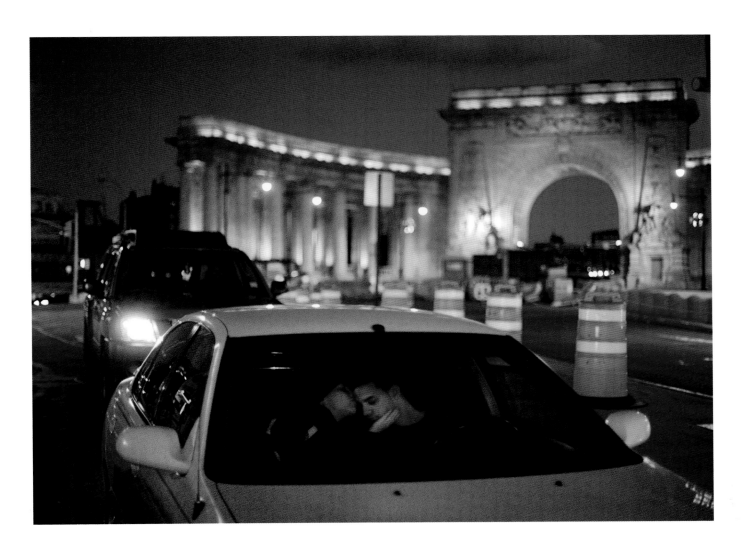

Canal Street at the foot of the Manhattan Bridge, 2007
Todd Heisler

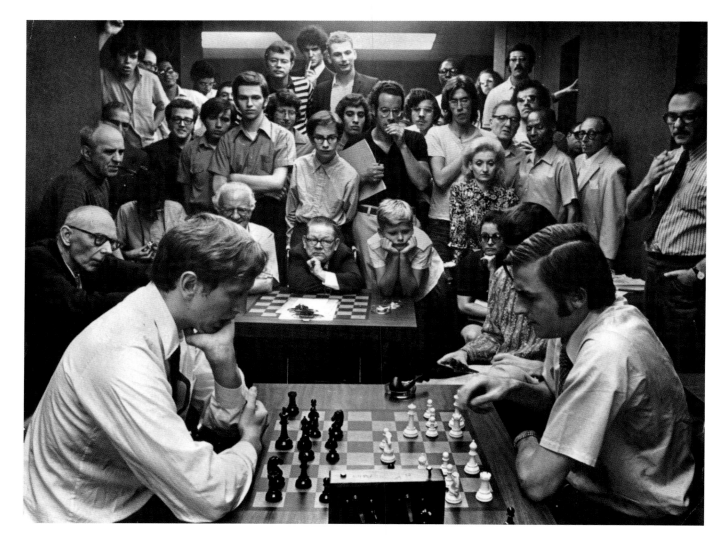

Bobby Fischer and Andrew Soltis, Manhattan Chess Club, 1971
Larry C. Morris

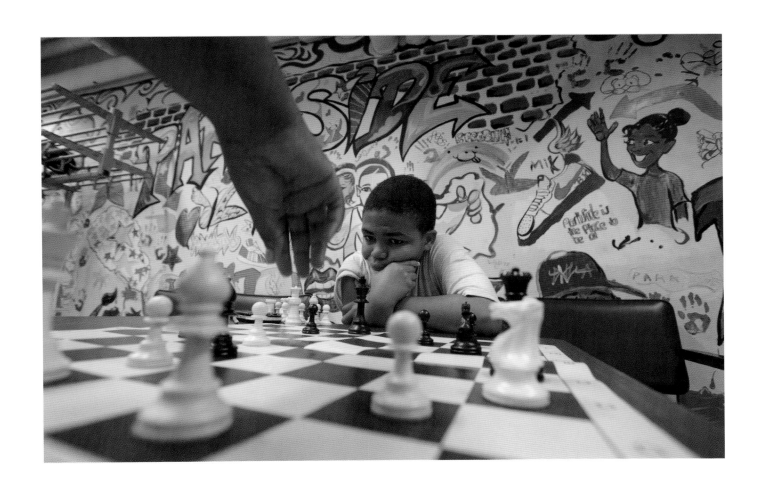

Ishmael Sylle, 12, Parkside Community Center, Bronx, 2008
James Estrin

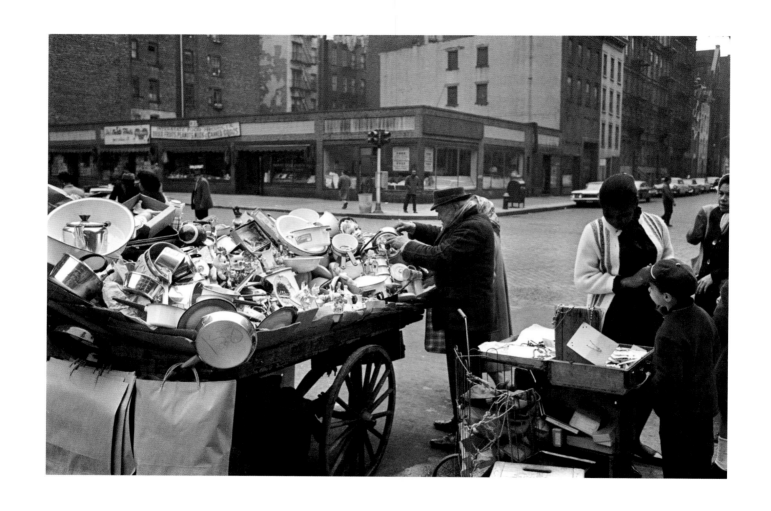

Lower East Side, 1962
Meyer Liebowitz

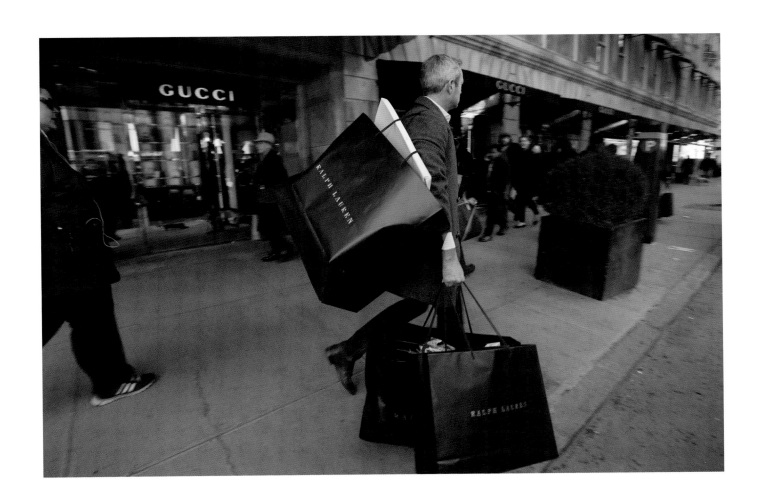

Upper East Side, 2015
Hiroko Masuike

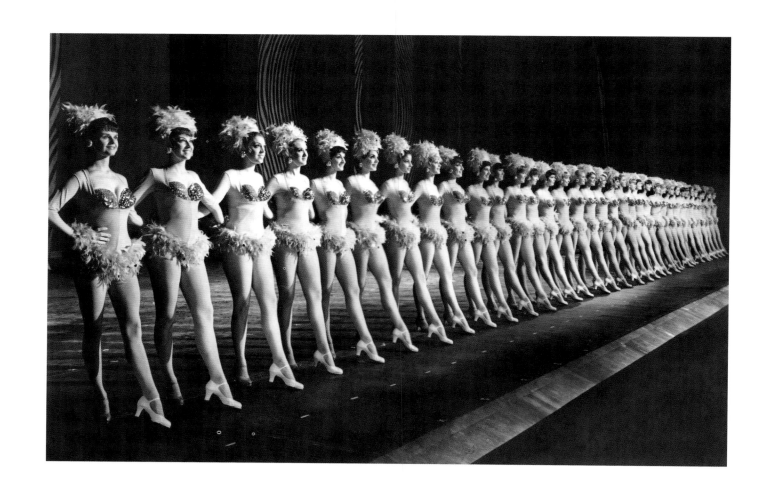

The Rockettes, Radio City Music Hall, 1930s
The New York Times

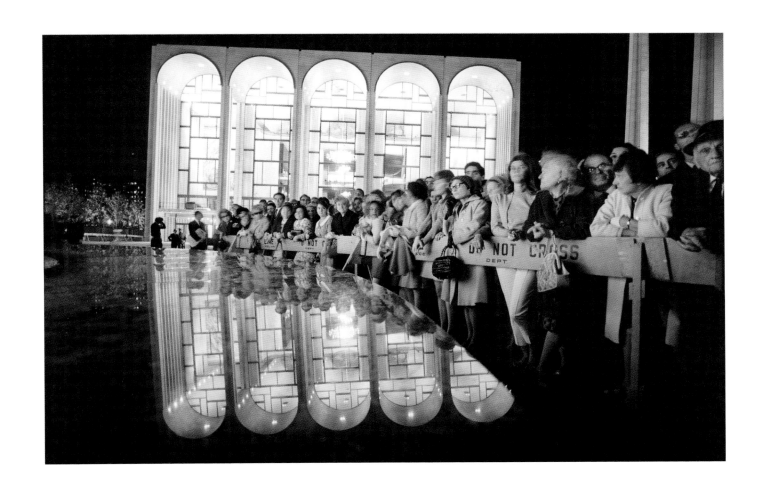

Opening of the new Metropolitan Opera House, Lincoln Center, 1966
Jack Manning

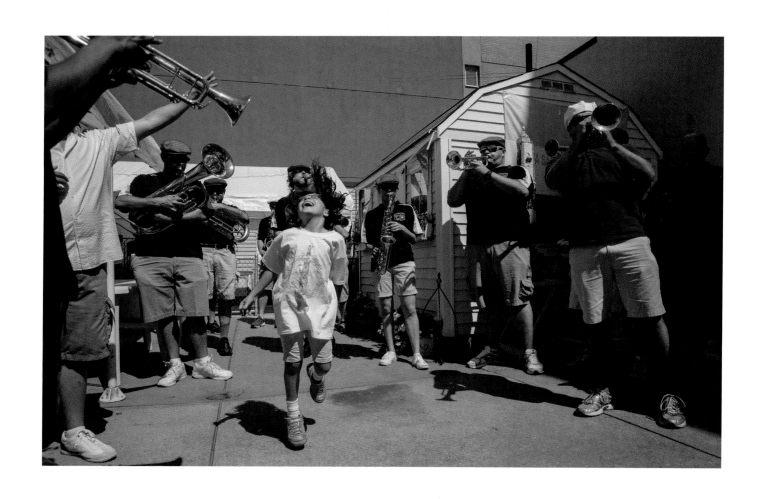

Annemarie de Nonno and the Giglio Band, Williamsburg, Brooklyn, 2014
Damon Winter

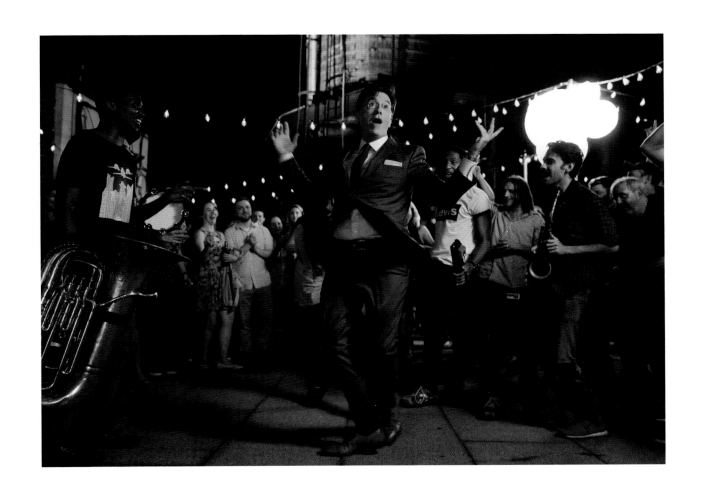

Stephen Colbert, Ed Sullivan Theater, 2015
Damon Winter

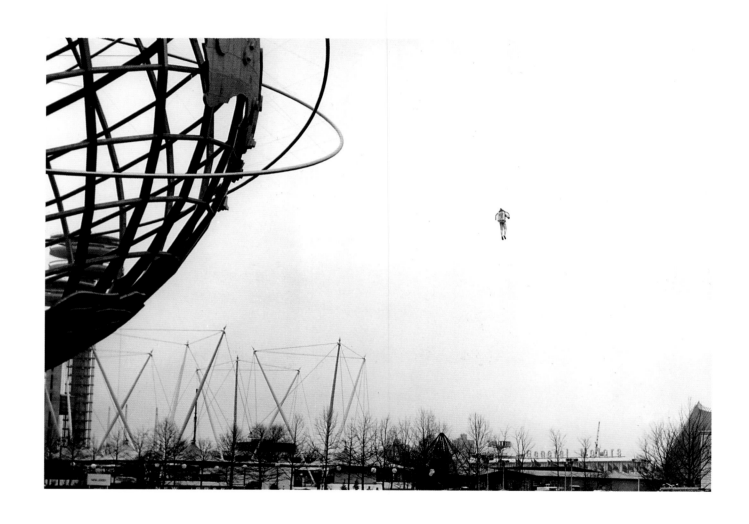

Demonstrating the "Bell Rocket Belt," World's Fair, Flushing, Queens, 1964
The New York Times

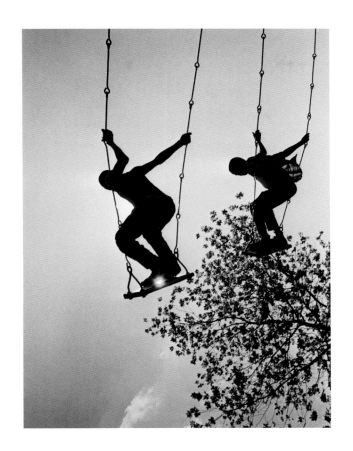

P.S. 121, Manhattan, 1967
Eddie Hausner

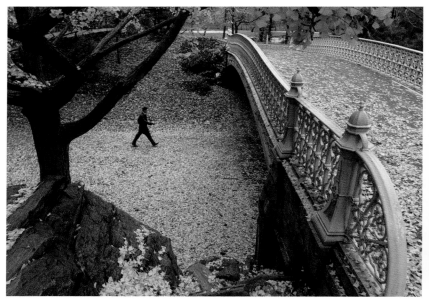

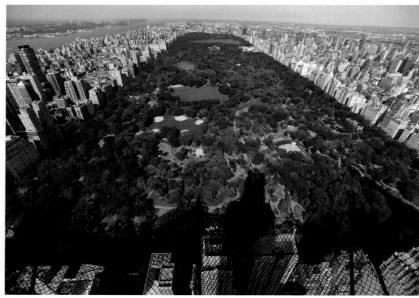

Central Park, late fall, 1997
Dith Pran

One57, North View, 2012
Chang W. Lee

MY CENTRAL PARK
If only God can make a tree
Then Central Park must be heaven
Could I but have my ashes spread
Where my feet had slowly walked
Past Strawberry Fields,
To cheers where bat meets ball
Toward laughter at the zoo
Past picnic chatter
To a bench where I had daydreamed beside cool water
Then lift me to where the Bard holds forth
Toward tennis court and path around the reservoir
Toward sweet scented air
Then settle me on the Great Lawn
Where music plays
For all eternity.

MANNY KUSSACK

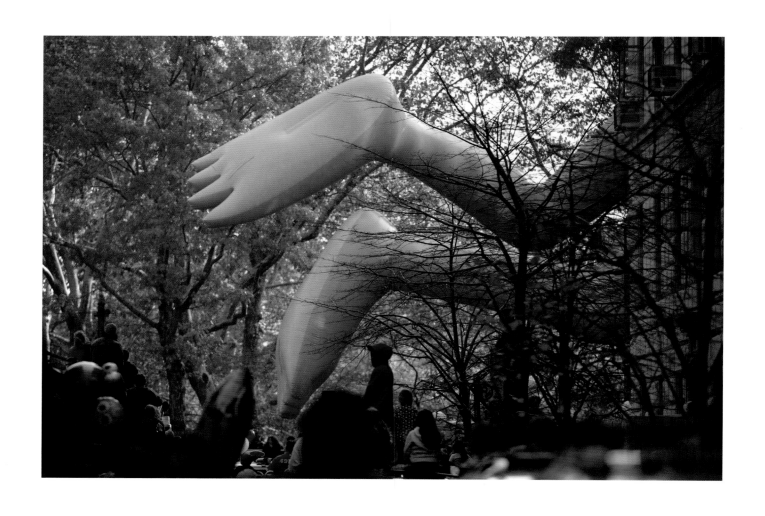

Kermit passing by West 75th Street, 2007
Todd Heisler

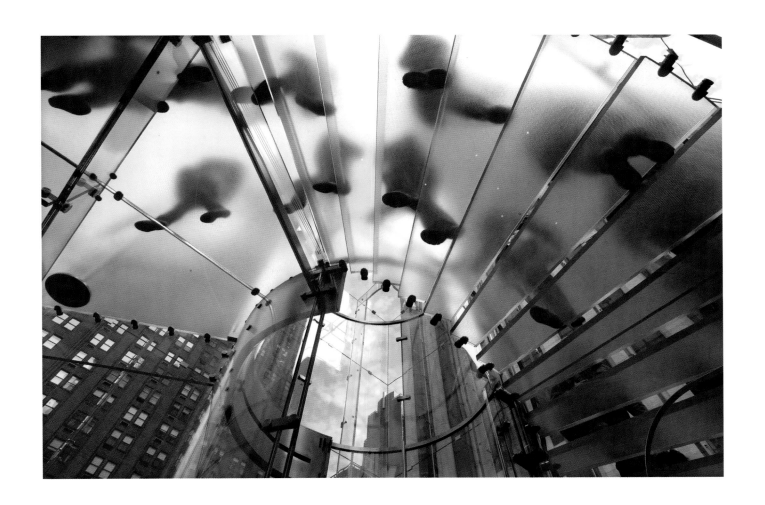

Apple Store, Fifth Avenue and 59th Street, 2009
Nicole Bengiveno

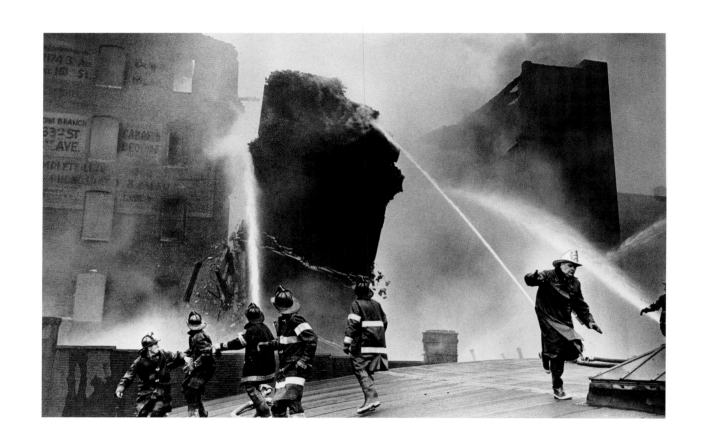

137th Street, Bronx, 1962
Neal Boenzi

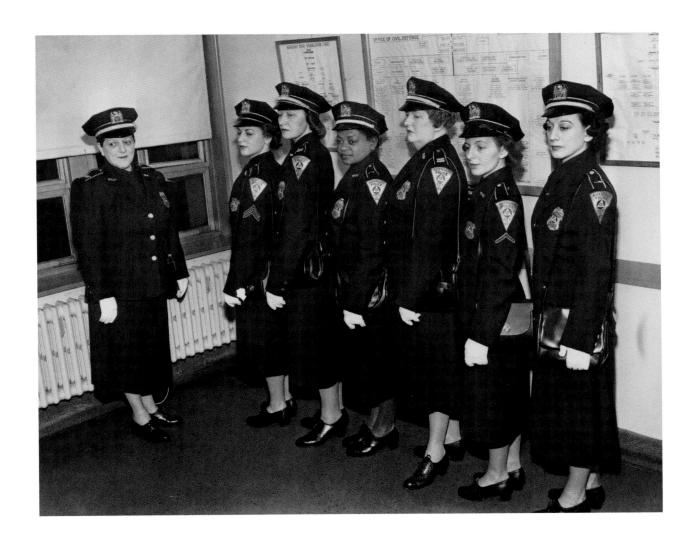

Women's Bureau, Auxiliary Police, Manhattan, 1952
Neal Boenzi

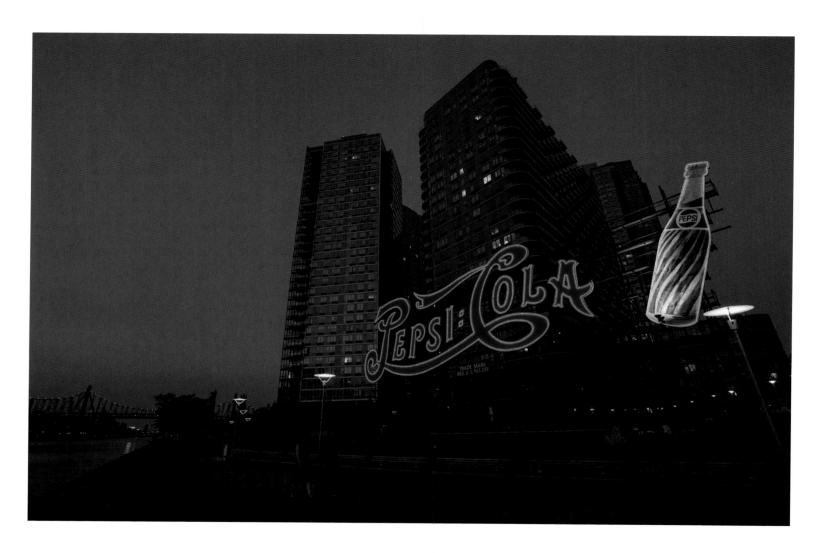

Long Island City, 2015
Hiroko Masuike

Joe and Pat's Pizzeria, Staten Island, 2013
Tony Cenicola

Yankee Stadium, 1965
Ernie Sisto

Mayor Edward I. Koch, City Hall, 1985
Neal Boenzi

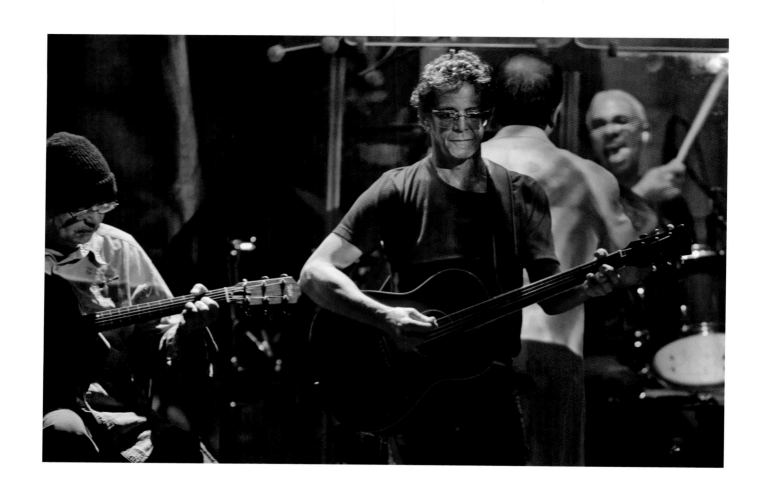

Lou Reed, St. Ann's Warehouse, Brooklyn, 2006
Richard Perry

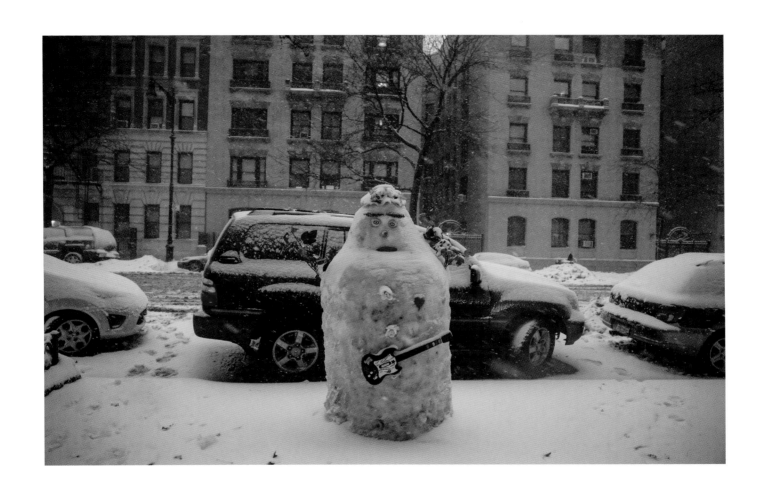

West 106th Street, Manhattan, 2014
Angel Franco

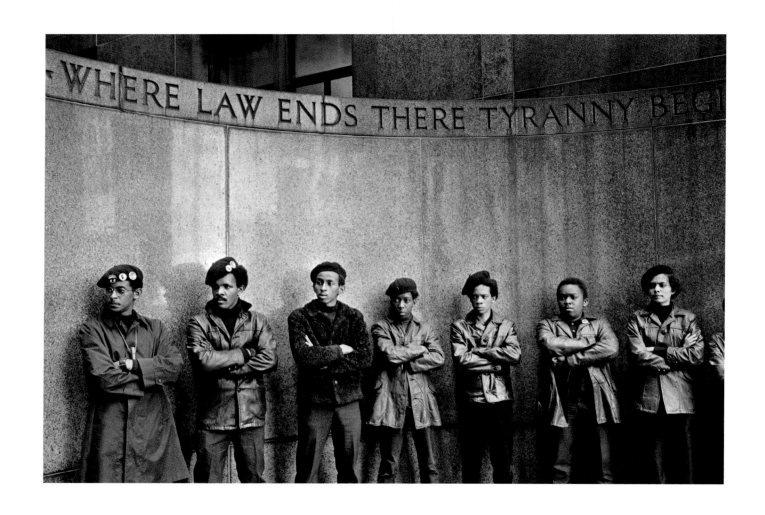

Black Panthers, Manhattan, 1969
Neal Boenzi

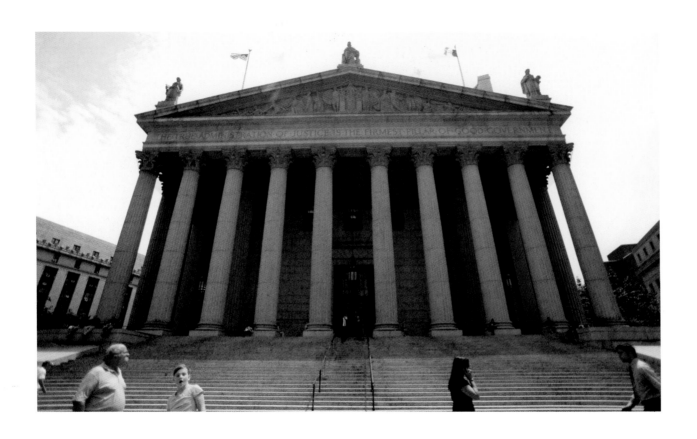

New York State Supreme Court, Manhattan, 2011
Hiroko Masuike

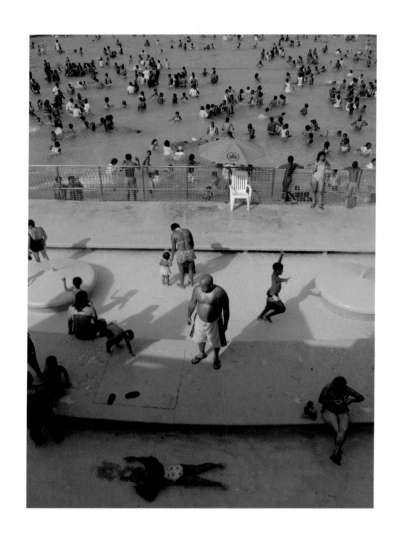

Lasker Pool, Central Park, 2006
Nicole Bengiveno

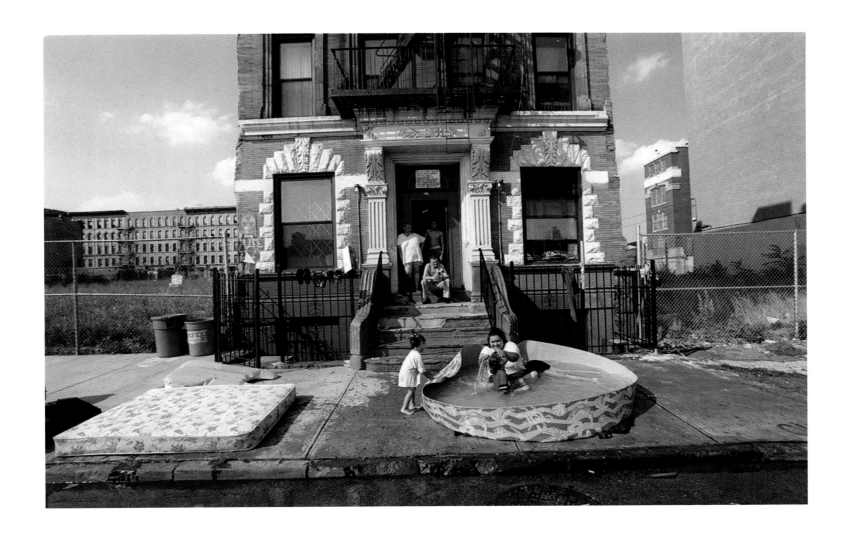

Bronx, 1999

James Estrin

Chinatown, Manhattan, 2006
Chang W. Lee

Flatbush, Brooklyn, 2003
Vincent Laforet

TAXI, TAXI

Thanks to New York cabbies
My travel joys return
Each time I take a taxi
And their origins I learn.
Back to West Africa
Three times I went last week
And Haiti is a regular
For the broken French I speak.
When English is unusable
And the route from A to B
Is indirect with meter racing
Those pleasant feelings flee.

CARLYN PARKER

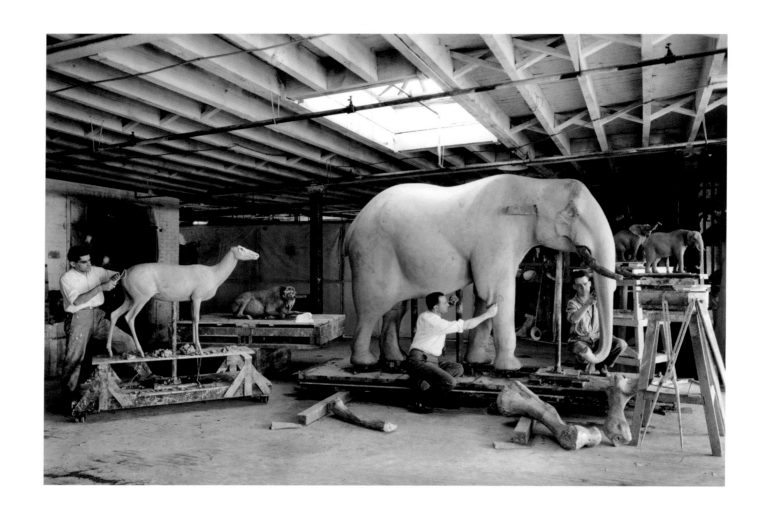

The Museum of Natural History, 1931
The New York Times

Les Troyens, Metropolitan Opera House, 2012
Ruby Washington

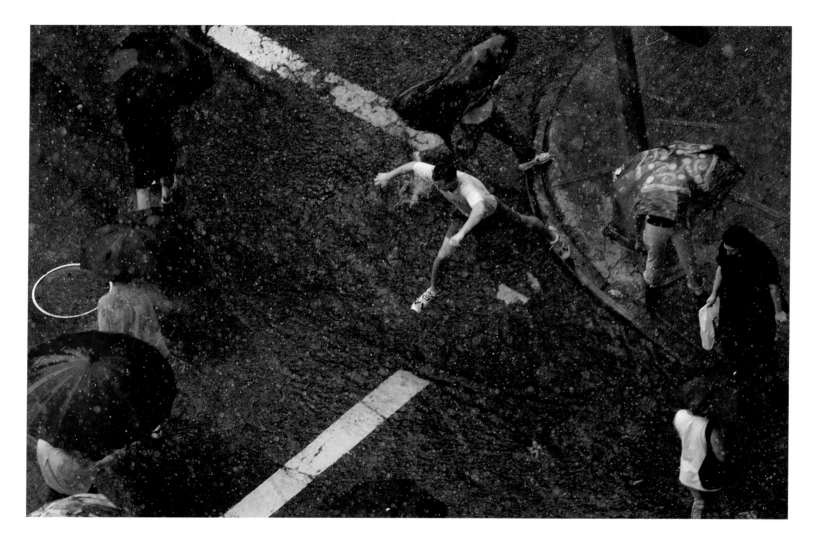

Upper East Side, 2001
Ruth Fremson

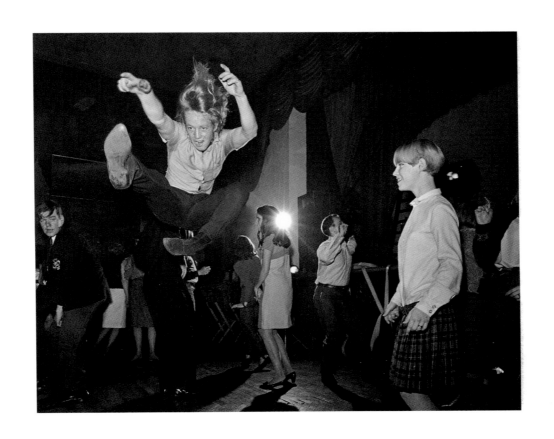

The Dom nightclub, St. Mark's Place, 1966
Larry C. Morris

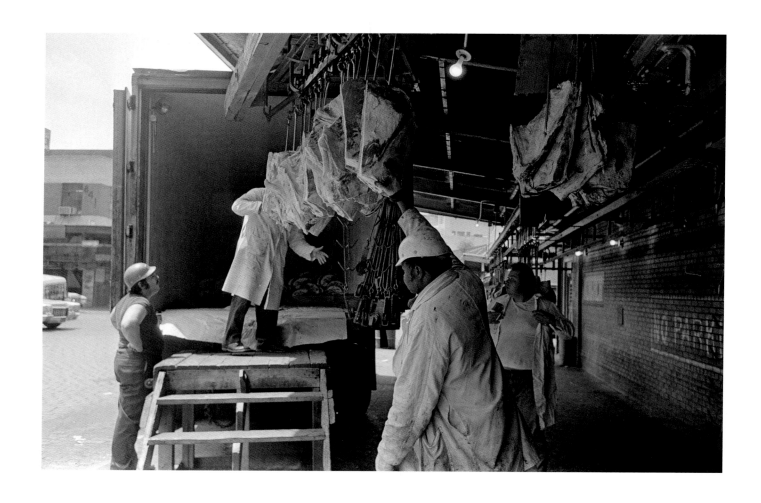

The Meatpacking District , 1973
Neal Boenzi

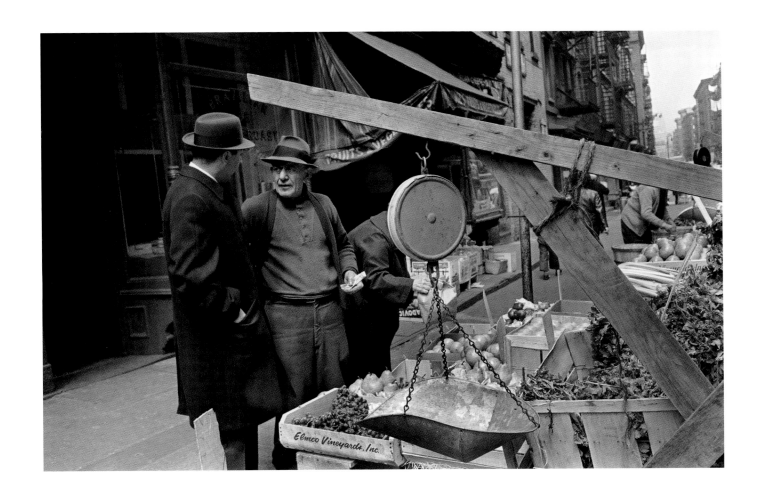

Albert S. Pacetta, commissioner of markets, and Nick Apicalla, fruit vendor, Mott and Hester Streets, 1962
Meyer Liebowitz

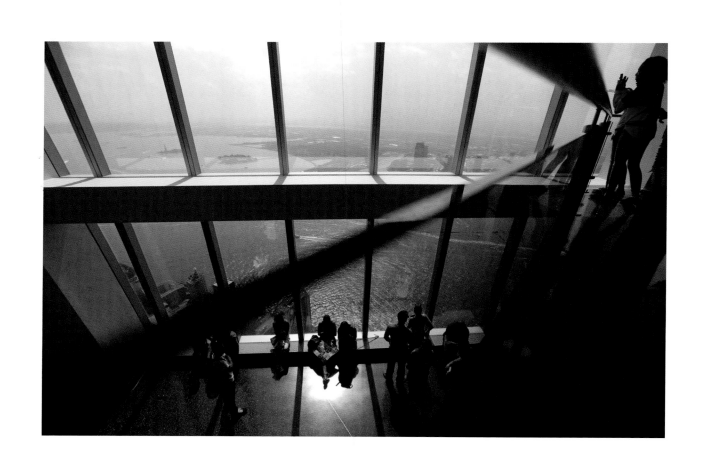

One World Observatory, 2016
Chang W. Lee

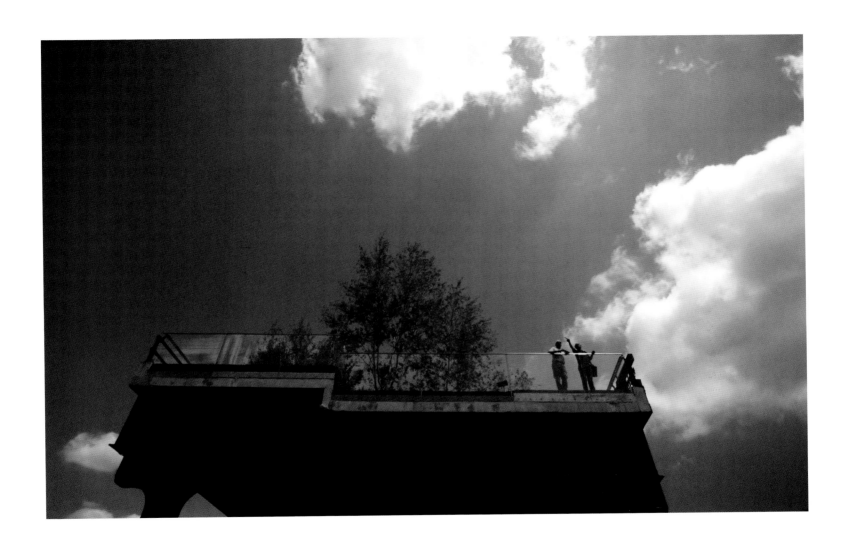

The Highline at Gansevoort Street, 2009
Nicole Bengiveno

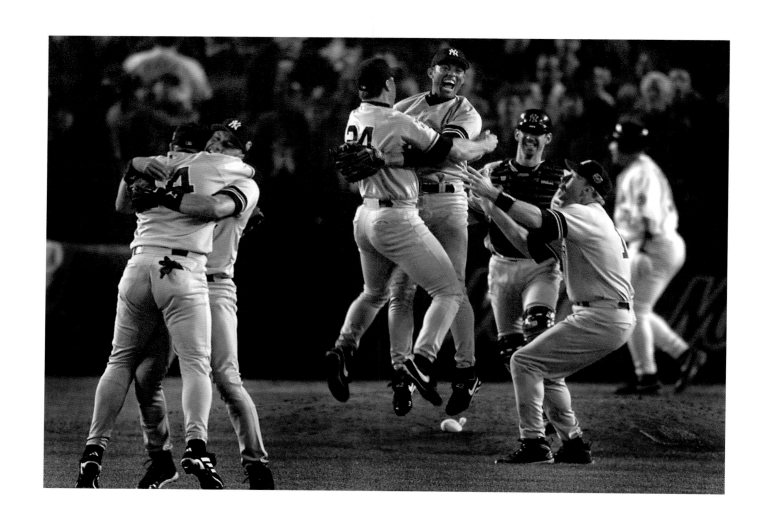

Yankees win the World Series, Shea Stadium, 2000

Chang W. Lee

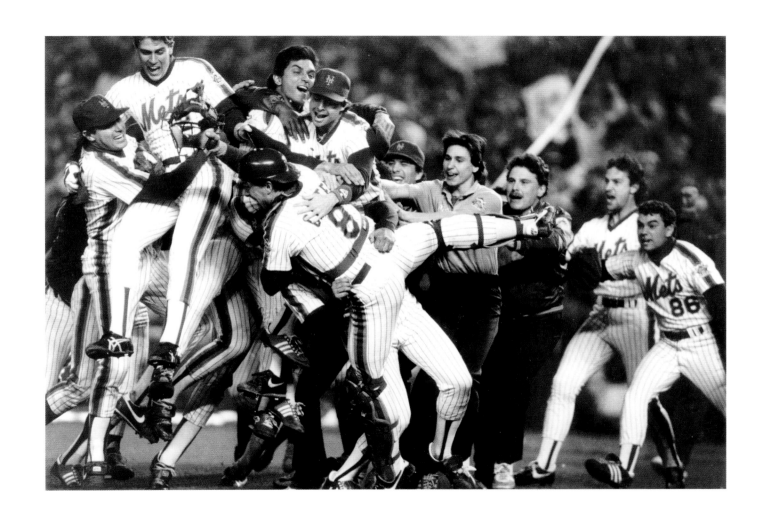

Mets win the World Series, Shea Stadium, 1986
Larry C. Morris

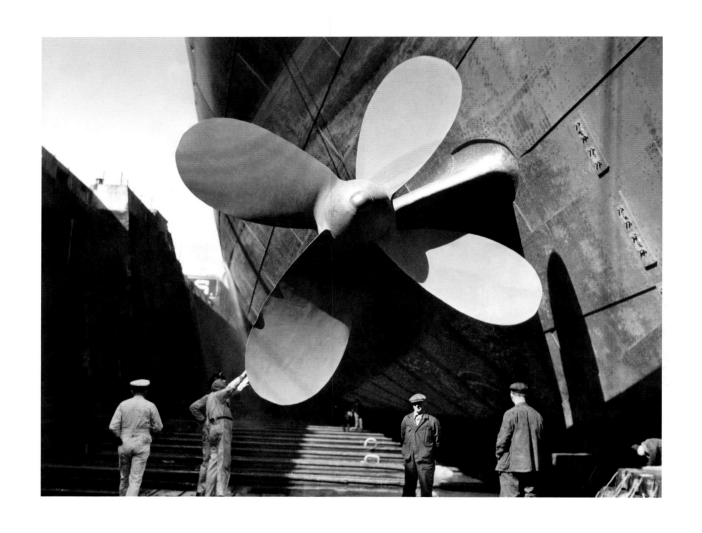

Inspecting propellers of the S.S. *Manhattan*, Brooklyn Naval Yard, 1933
The New York Times

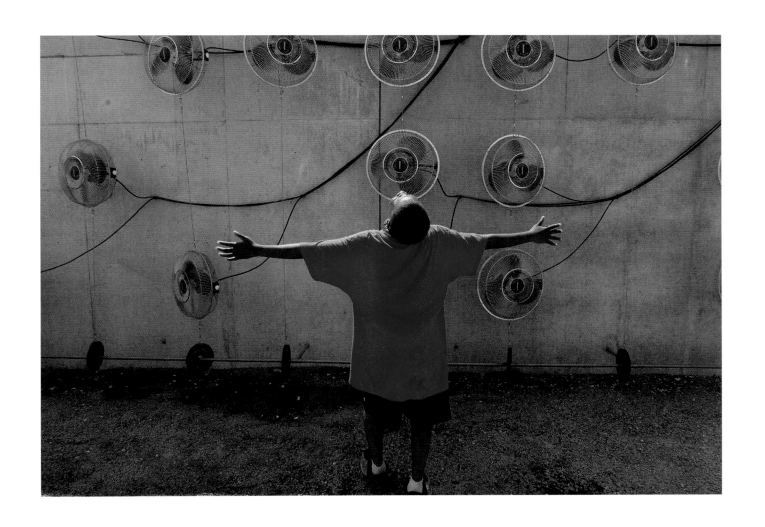

P.S. 1 Contemporary Art Center, Long Island City, 2001
Ruth Fremson

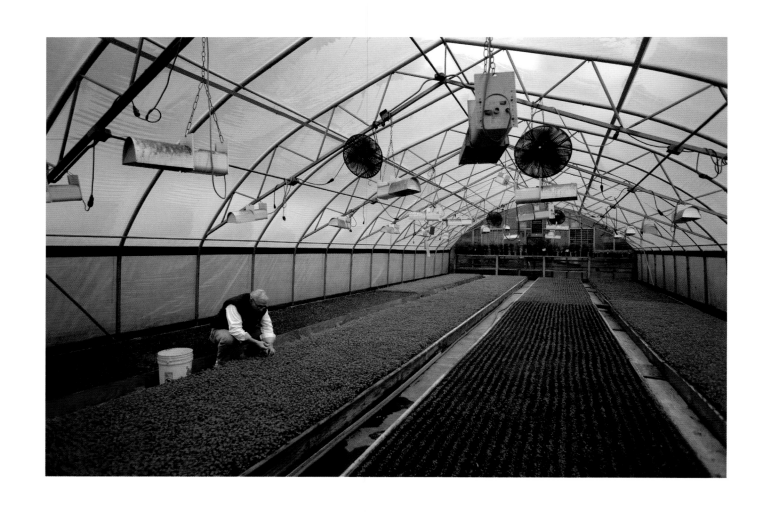

Eli Zabar on The Vinegar Factory rooftop, Upper East Side, 2011
Hiroko Masuike

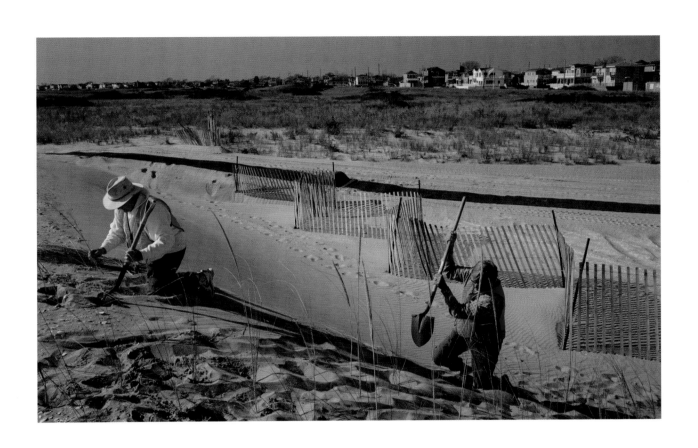

After Hurricane Sandy, volunteers restore the dunes, Breezy Point, Queens, 2013
Damon Winter

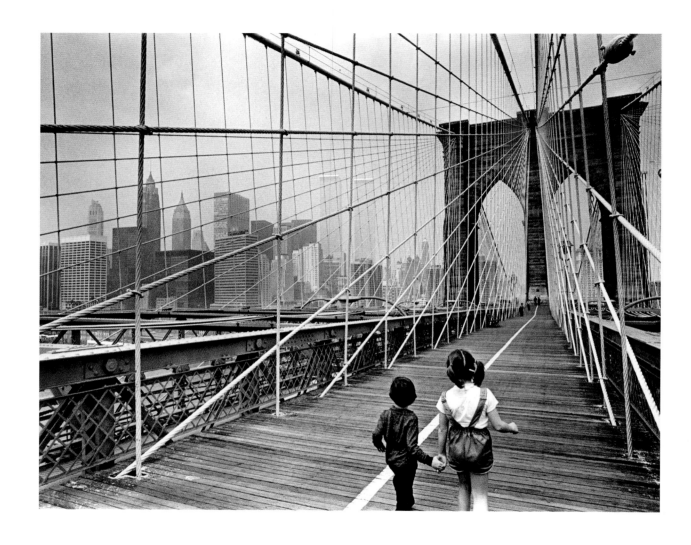

Manhattan-bound on the Brooklyn Bridge, 1979
Neal Boenzi

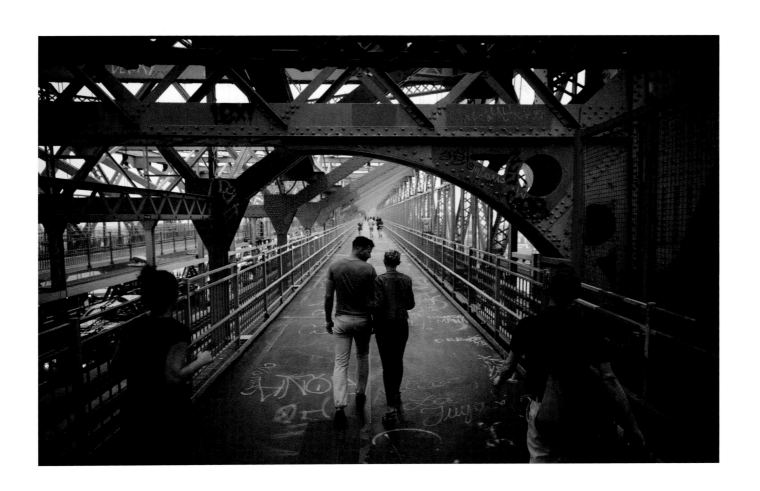

Brooklyn-bound on the Williamsburg Bridge, 2015
Damon Winter

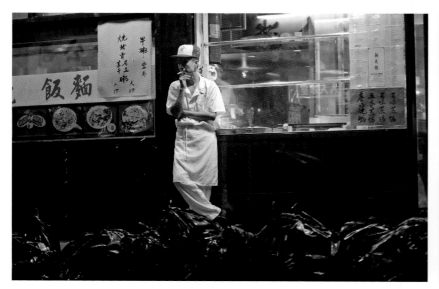

Chinatown, 2007
Andrea Mohin

East Harlem, 2017
Tony Cenicola

The place was the Little King Restaurant in Bayside, Queens. Barbara Burke, who dined there one recent evening, overheard this much of a conversation between two women seated nearby: "So what do you wear to dim sum?"

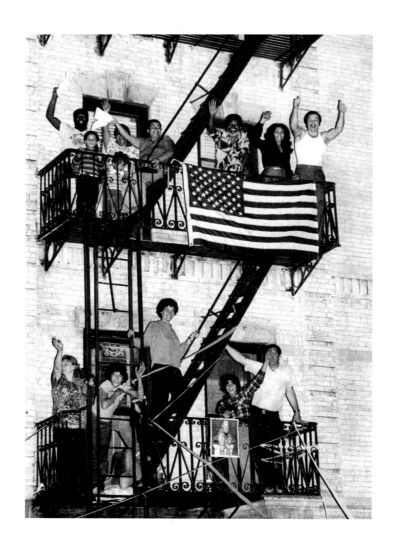

Bronx residents cheer Pope John Paul II's motorcade, 1979
Paul Hosefros

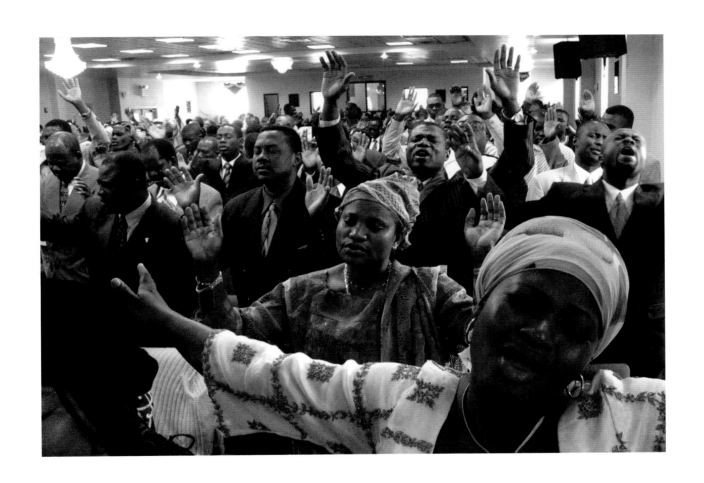

Palm Sunday, Church of the Pentecost, Bronx, 2004
Tyler Hicks

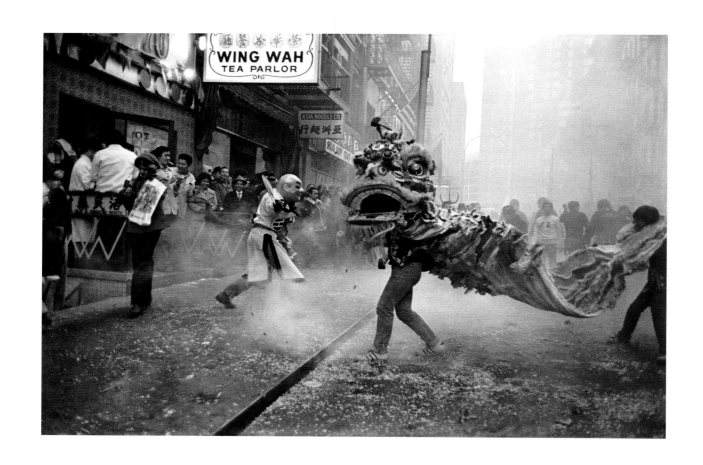

New Year in Chinatown, 1975

Neal Boenzi

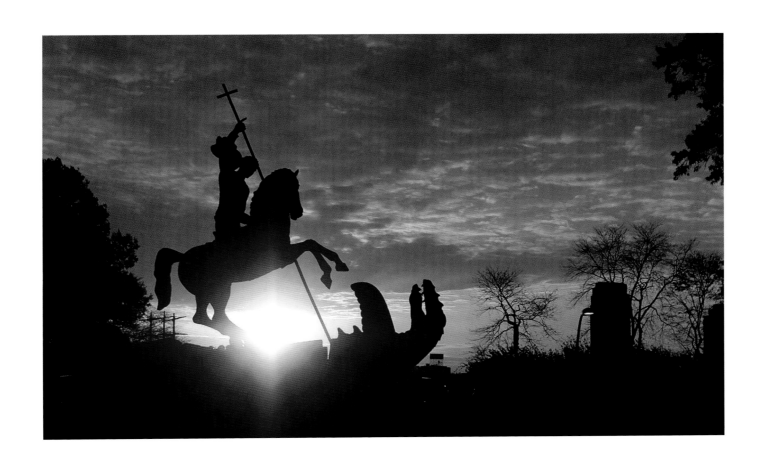

Good Defeats Evil, United Nations, 2001
Chang W. Lee

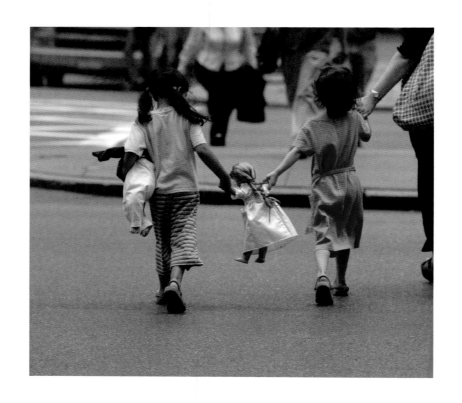

Park Avenue and 52nd Street, 2007
Librado Romero

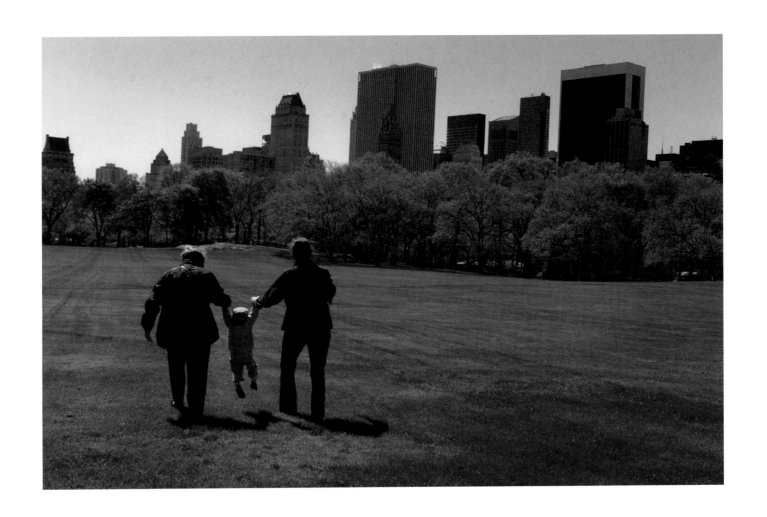

Sheep Meadow, Central Park, 2001
Andrea Mohin

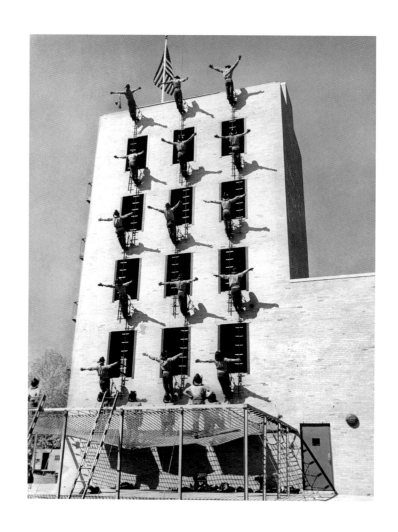

Firefighters in training, Roosevelt Island, 1963
Meyer Liebowitz

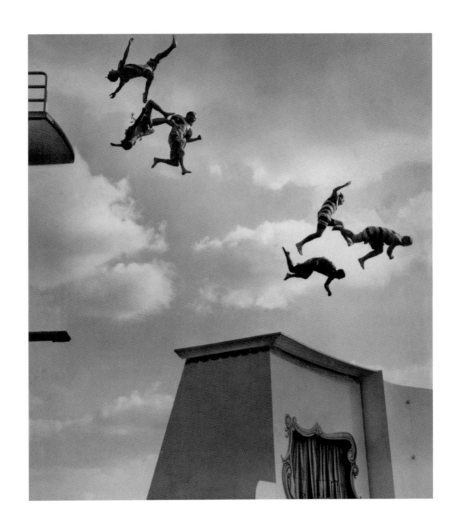

Aquashow, Flushing Meadows, Queens, 1951
Sam Falk

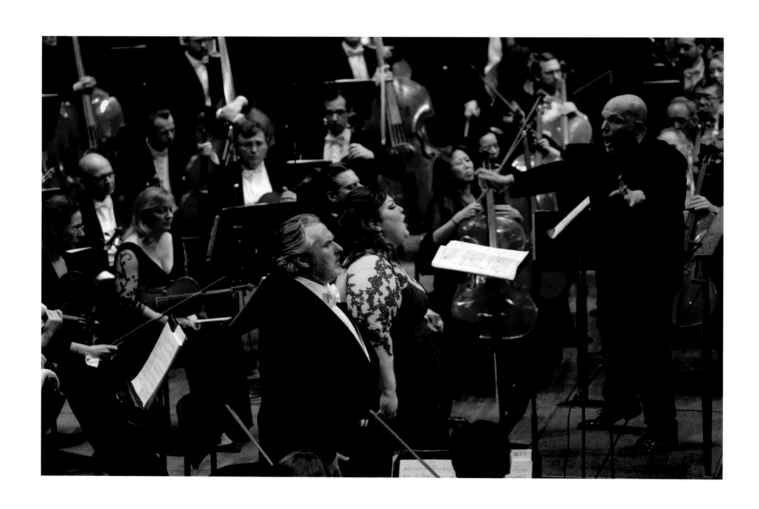

Simon O'Neill, Heidi Melton, and John Relyea with the New York Philharmonic,
Jaap van Zweden conducting, David Geffen Hall, Lincoln Center, 2018
Michelle V. Agins

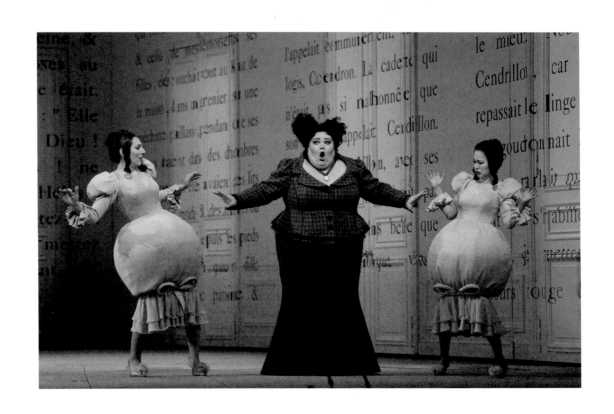

Maya Lahyani, Stephanie Blythe, and Ying Fang in *Cendrillon*,
Metropolitan Opera House, 2018
Sara Krulwich

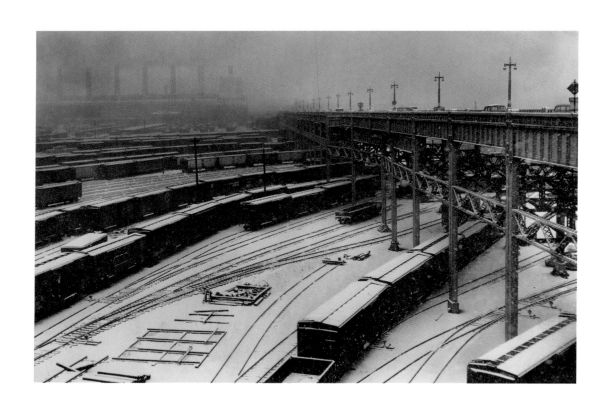

New York Central freight yards, 72nd Street and 12th Avenue, 1952
Todd Heisler

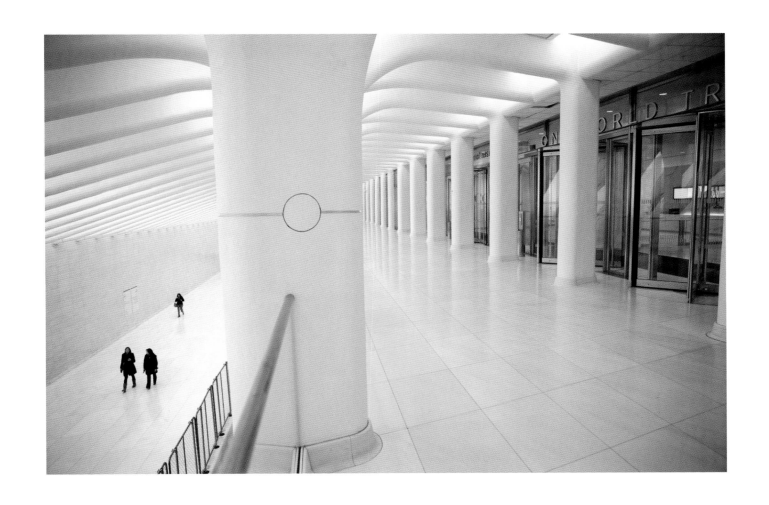

World Trade Center Transit Hub, Lower Manhattan, 2014
Todd Heisler

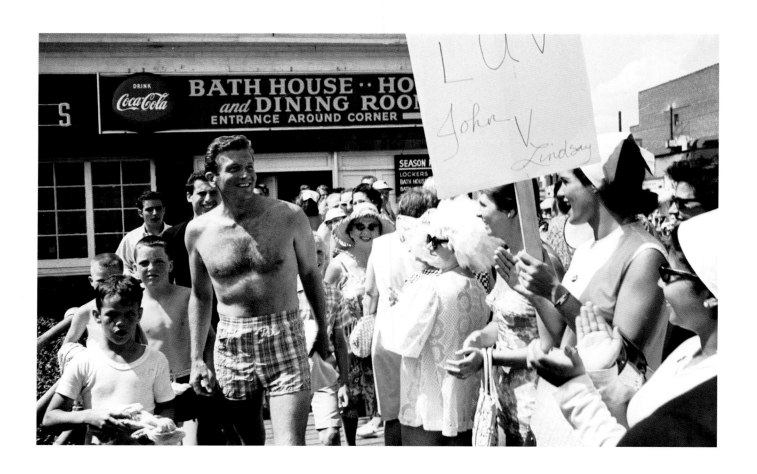

Mayoral candidate John V. Lindsay, Far Rockaway, Queens, 1965
Carl T. Gossett Jr.

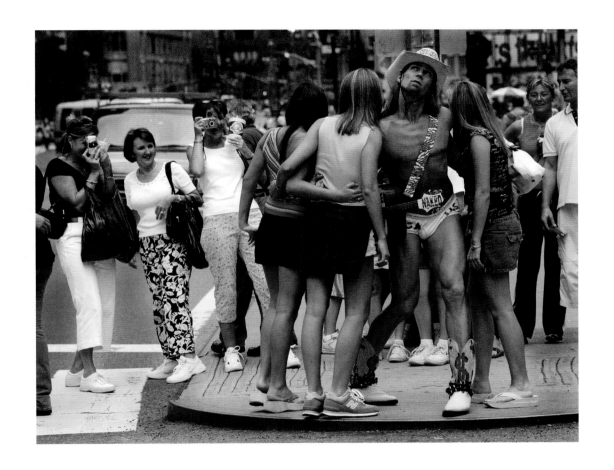

The Naked Cowboy, Times Square, 2003
Ruth Fremson

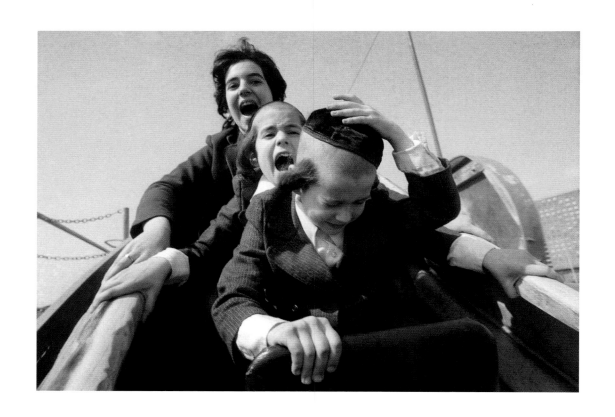

Astroland, Coney Island, 1978
Barton Silverman

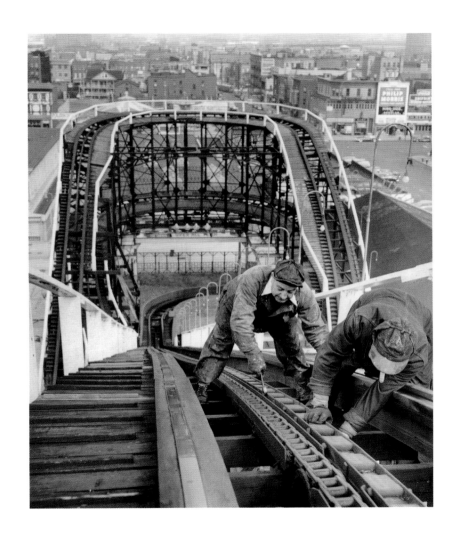

Tuning up the Thunderbolt, Coney Island, 1954
Neal Boenzi

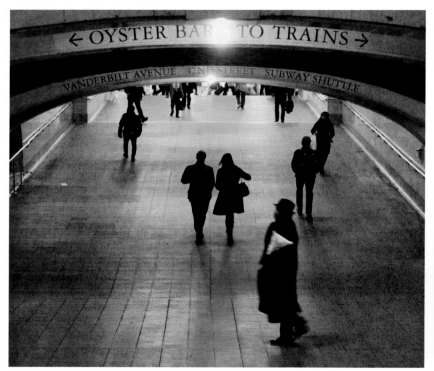

Grand Central Terminal, 2009
Richard Perry

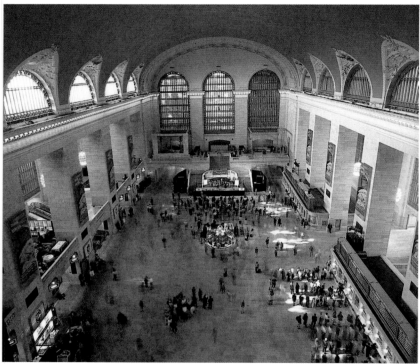

Grand Central Terminal gleams after a refurbishing, 1998
Fred R. Conrad

It is the morning rush hour. Marion Gutmann of Brooklyn is standing on a subway platform at Grand Central Terminal. A train pulls in; a well-dressed woman gets off. Before the doors close, the woman realizes that she is holding only one of her leather gloves. She looks back in the train and spots the matching one on the seat. It is obviously too late to dash back in to retrieve it. With a cavalier shrug, she flings her arm out and, the doors about to close, tosses her glove onto the seat alongside its mate.

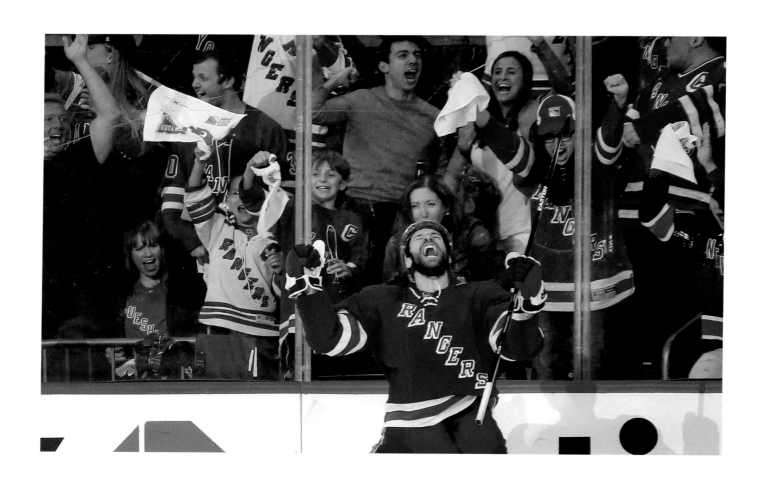

Rangers' Dominic Moore, Madison Square Garden, 2015

Chang W. Lee

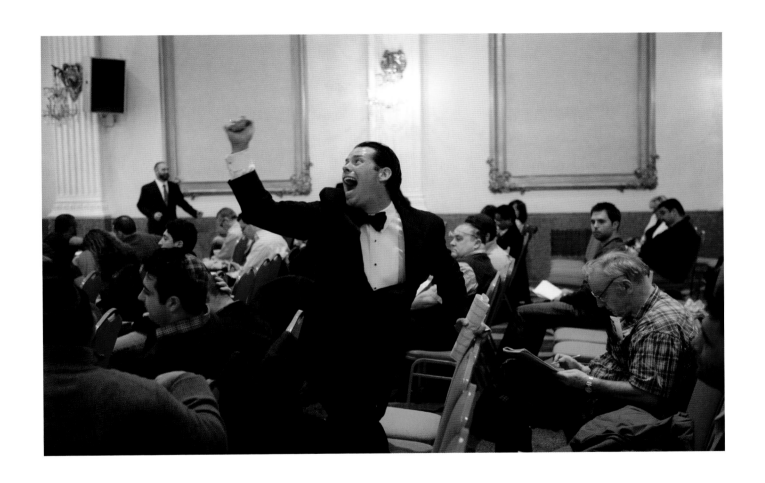

Diamond auction, New Yorker Hotel, Manhattan, 2009
G. Paul Burnett

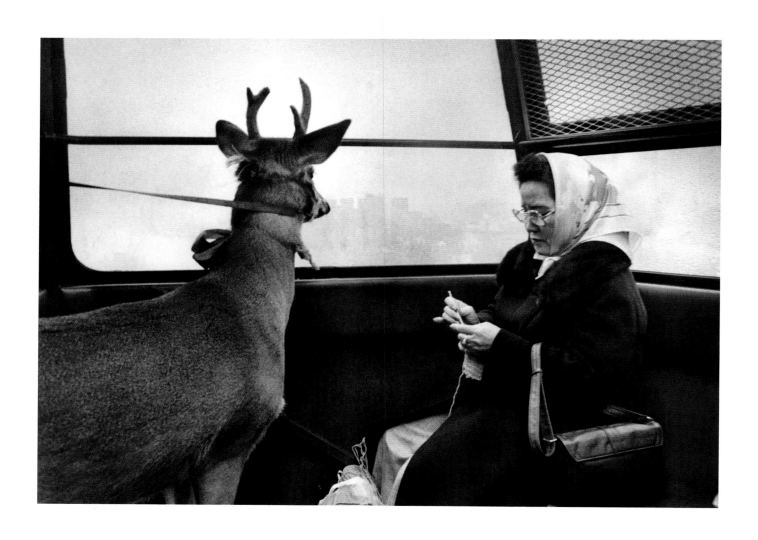

Reindeer Richard, Roosevelt Island Tram, 1977
Chester Higgins Jr.

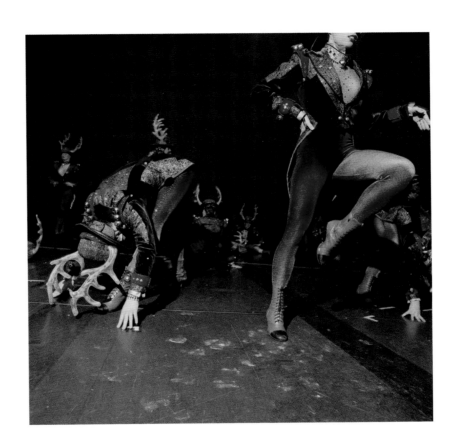

Limbering up backstage for the Christmas show, Radio City, 2006
Fred R. Conrad

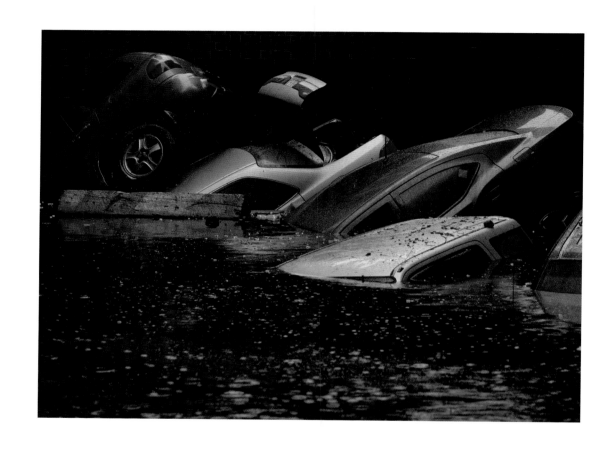

Wall Street parking garage after Hurricane Sandy, 2012
Damon Winter

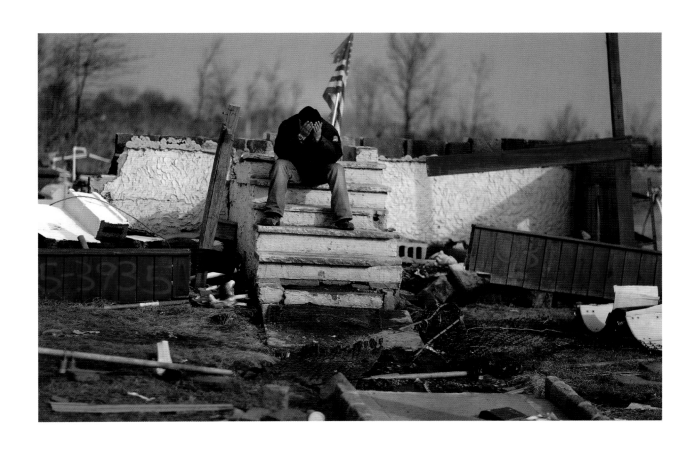

Pete Correa, a Sandy victim, with the remains of his home, Staten Island, 2012
Chang W. Lee

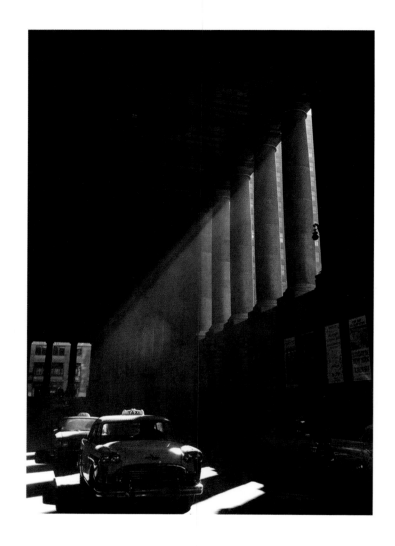

Pennsylvania Station, Manhattan, 1962
Sam Falk

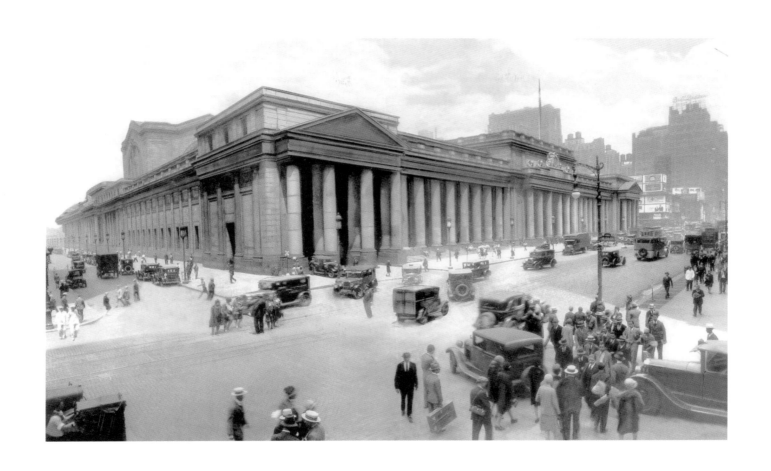

Pennsylvania Station, Manhattan, 1920
The New York Times

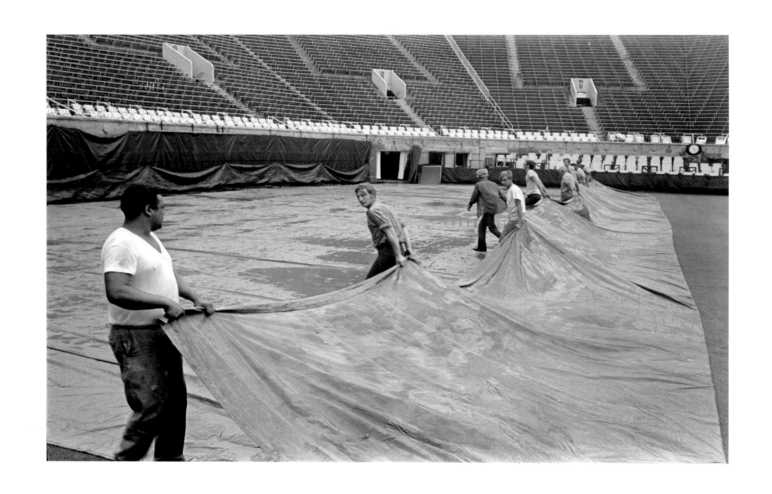

West Side Tennis Club, Forest Hills, Queens, 1969
Carl T. Gossett Jr.

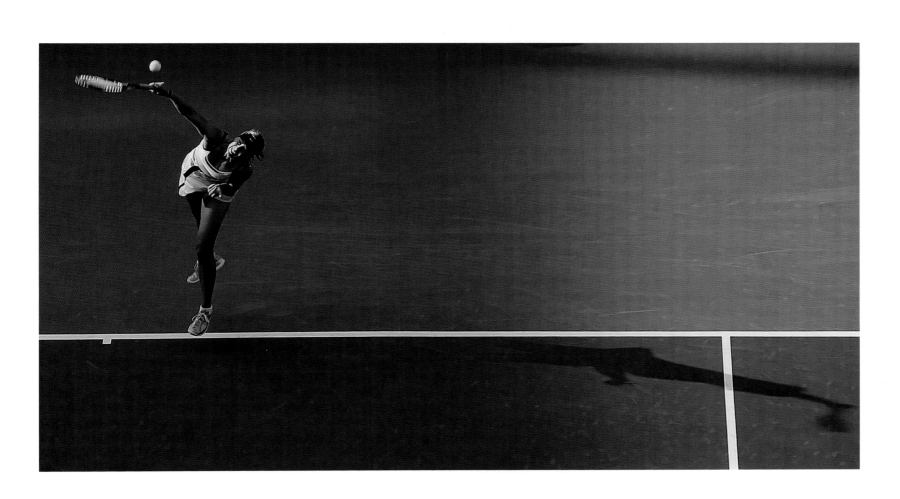

Maria Sharapova serves to Amelie Mauresmo, U.S. Open semifinals,
Arthur Ashe Stadium, Queens, 2006
Chang W. Lee

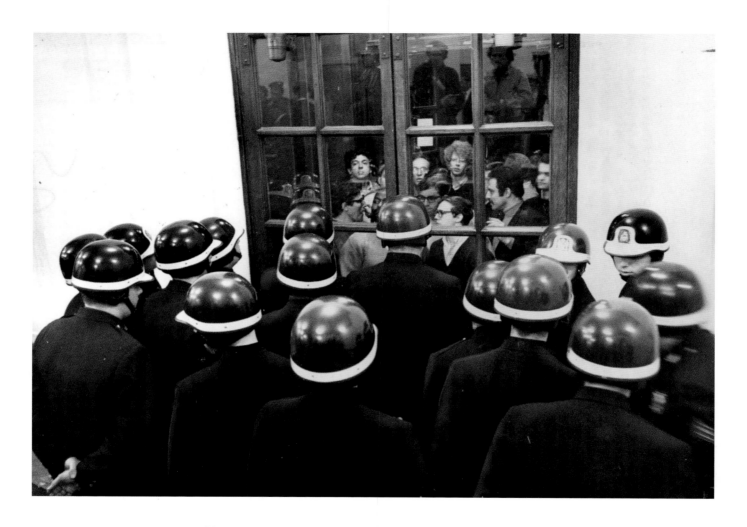

After a monthlong protest, police force students out of Hamilton Hall,
Columbia University, 1968
Larry C. Morris

Jerome Avenue and 190th Street, 1994
Monica Almeida

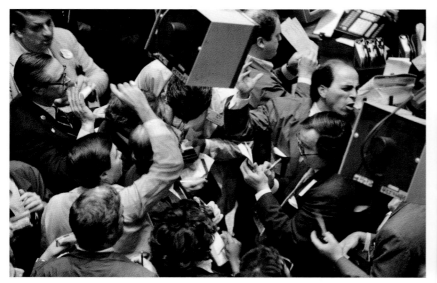

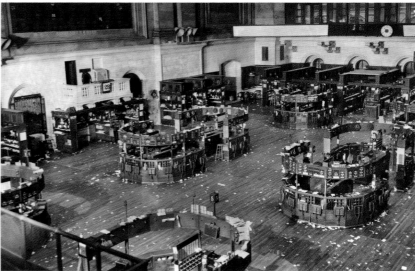

Floor of the New York Stock Exchange during trading, 1987
Jim Wilson

Floor of the New York Stock Exchange after trading, 1951
Patrick A. Burns

Dear Diary:
It's 6:30 P.M. Friday on the M1 bus heading up Madison Avenue. The bus is packed, and a rider, about 30, shoves his way from the back to get off at 61st Street. He gets to the rear door just as the driver locks the doors and is about to pull out. The man lets out an unintelligible scream, causing the other passengers to look around nervously. The bus quickly stops. The driver releases the doors. As the man leaps off, he smiles smugly to another passenger and says softly, "It helps to be a Wall Street Trader."
JEROME C. KATZ

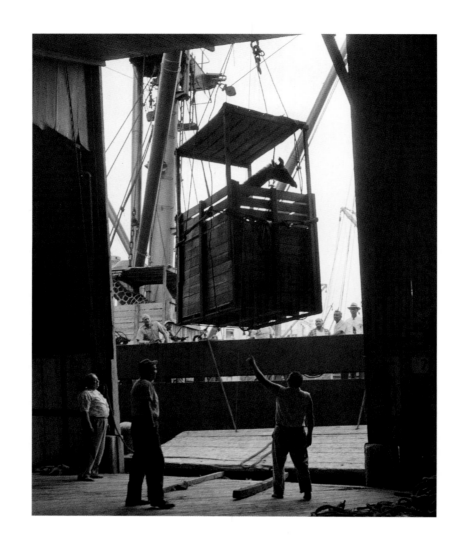

A giraffe from Africa en route to the St. Louis zoo, Pier 1, Brooklyn, 1957
John Orris

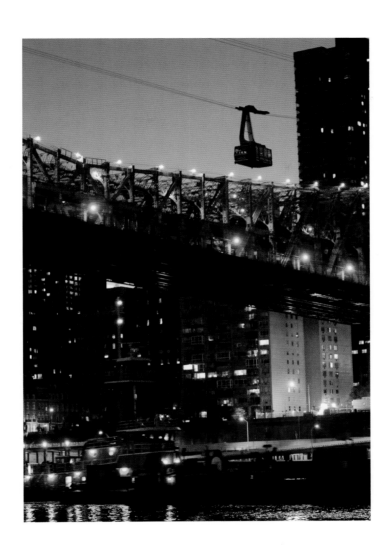

Roosevelt Island Tram, stalled by a power outage, Over the East River, 2006
Richard Perry

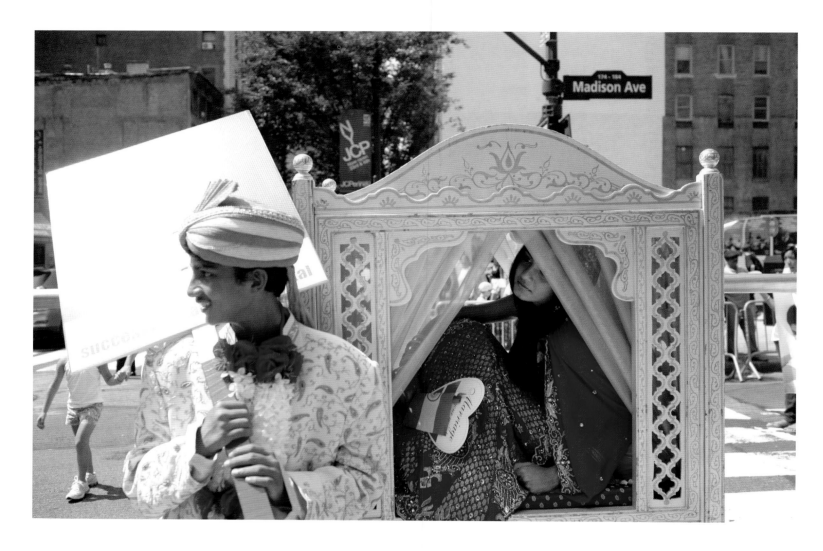

Indian Independence Day parade, Madison Avenue, Midtown Manhattan, 2009
Damon Winter

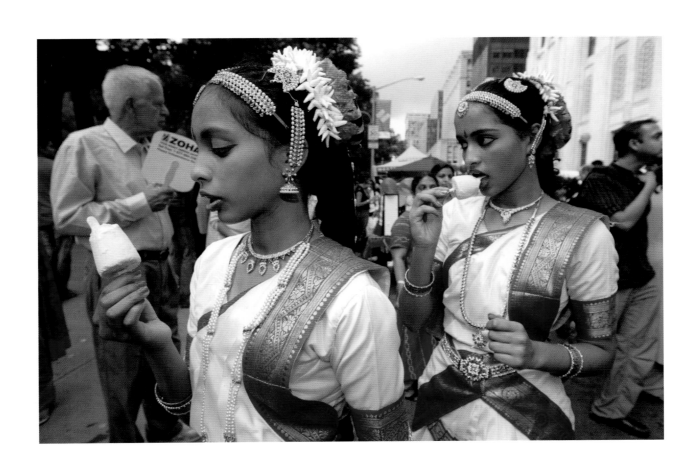

Amulya and Alekhya Vppala, Madison Avenue and 25th Street, 2004
Hiroko Masuike

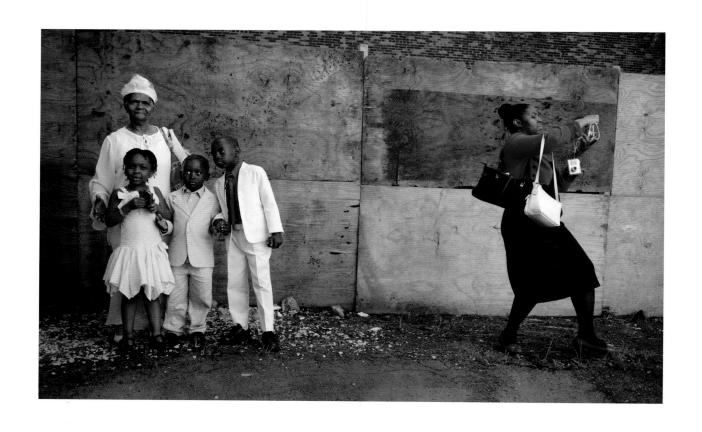

Backyard church service and wedding, Williamsbridge, Bronx, 2008
Todd Heisler

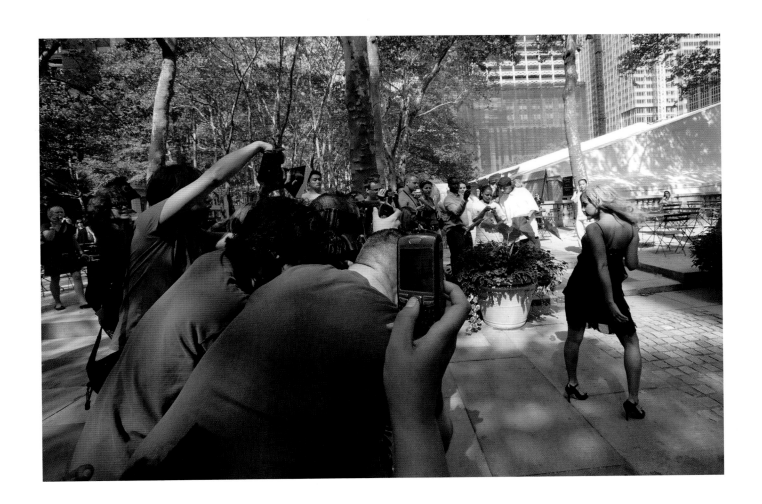

Singer Kat DeLuna during Fashion Week, Bryant Park, 2007
Marilynn K. Yee

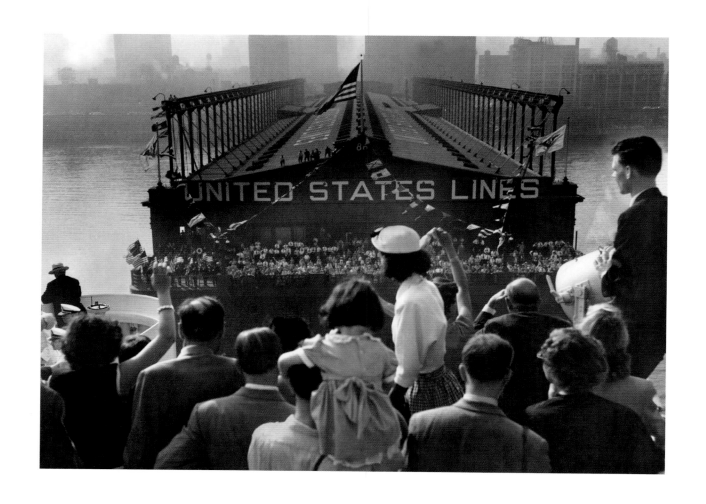

Waiting for the S.S. *United States* to arrive, West Side Piers, 1952
Eddie Hausner

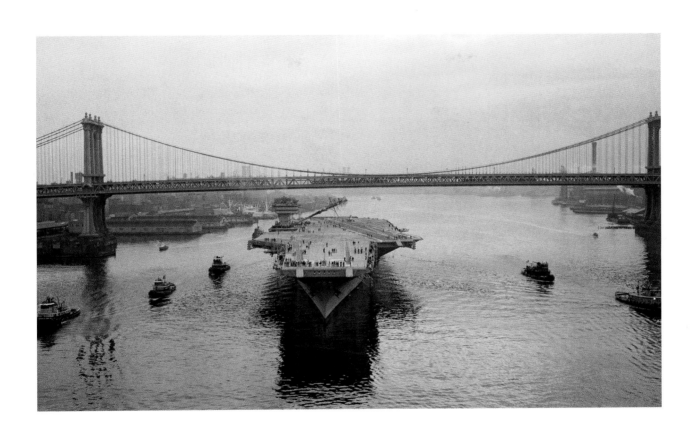

The U.S.S. *Constellation* leaves New York for the first time, East River, 1961
Lou Schifano

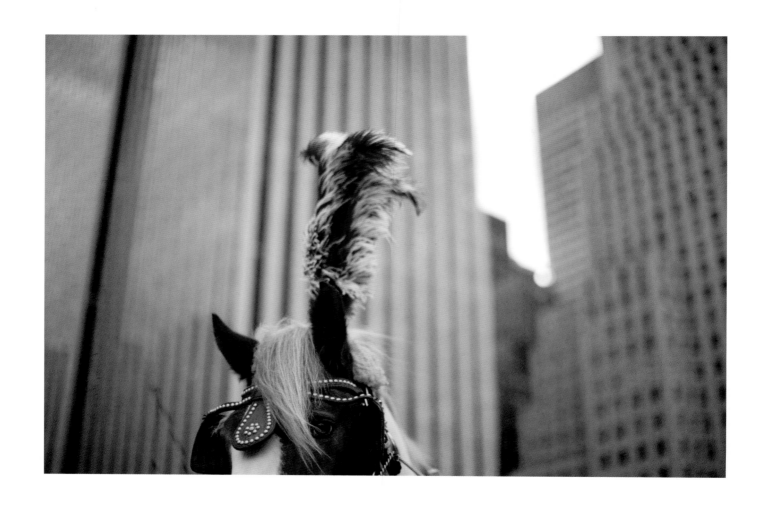

Teddy at his usual spot, 59th Street and Fifth Avenue, 2014

Damon Winter

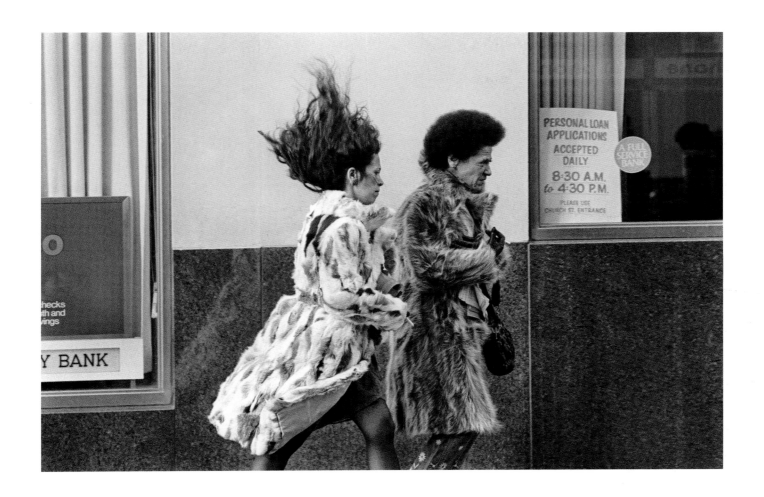

Lower Manhattan, 1974
Eddie Hausner

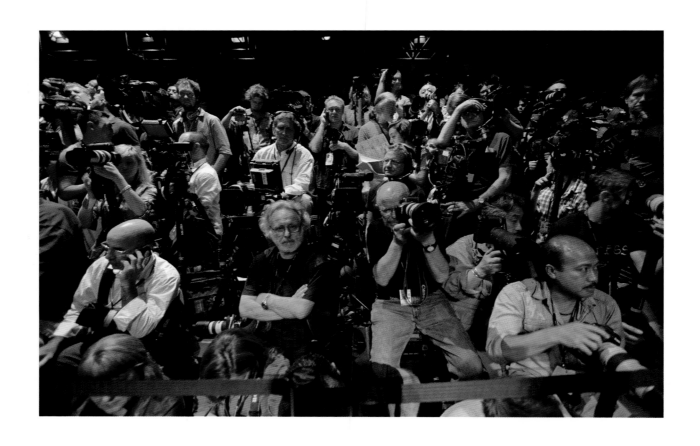

Michael Kors show, Lincoln Center, 2011
Marilynn K. Yee

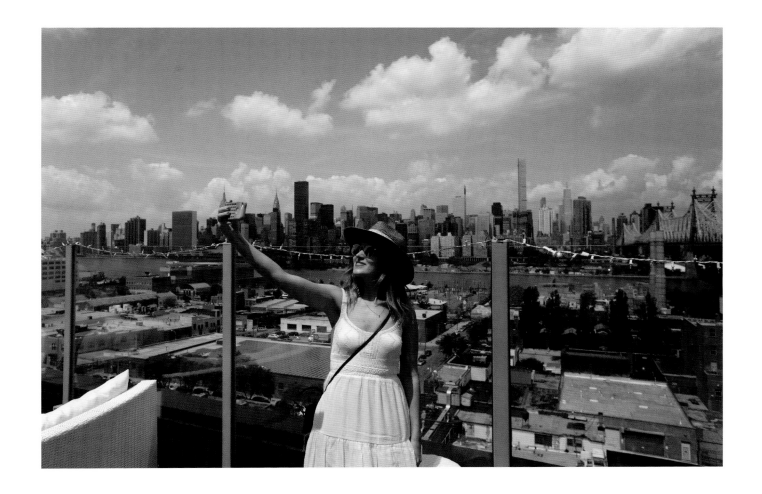

Long Island City, 2015
Nicole Bengiveno

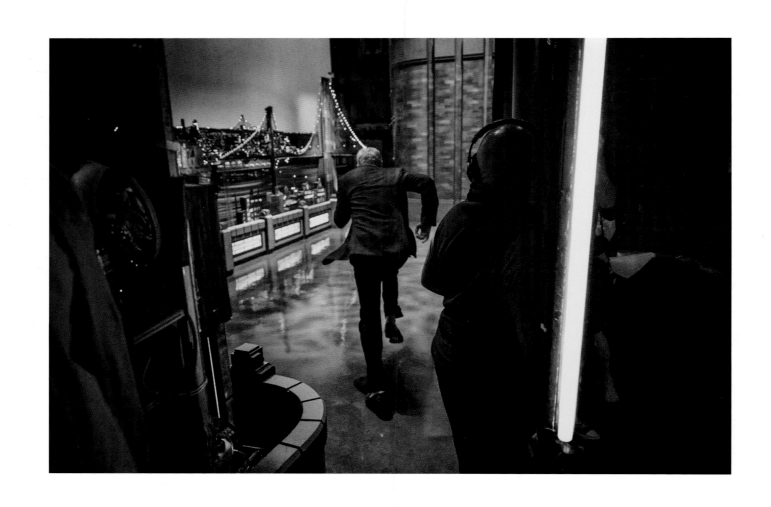

David Letterman, Ed Sullivan Theater, 2015
Damon Winter

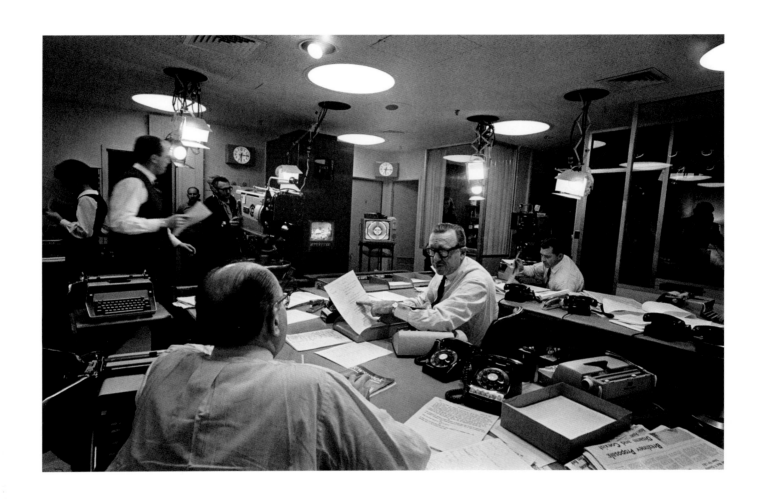

Walter Cronkite, CBS Studios, 1964
Sam Falk

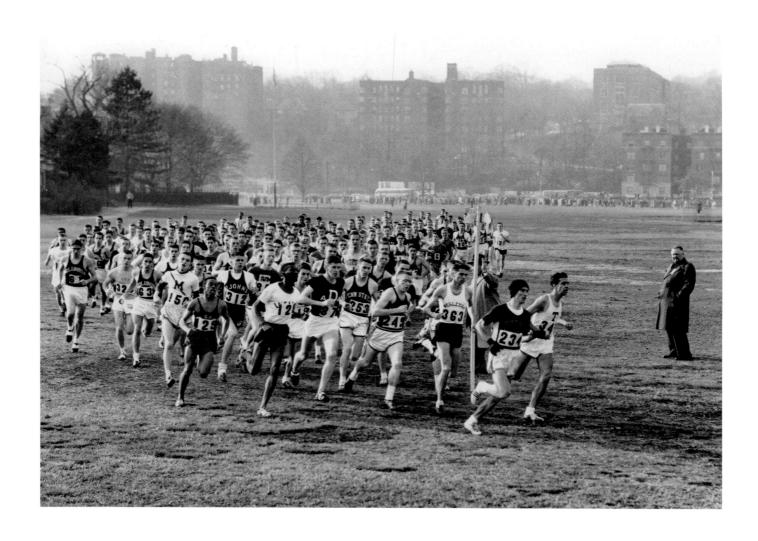

Cross country race, Van Cortland Park, 1956

Eddie Hausner

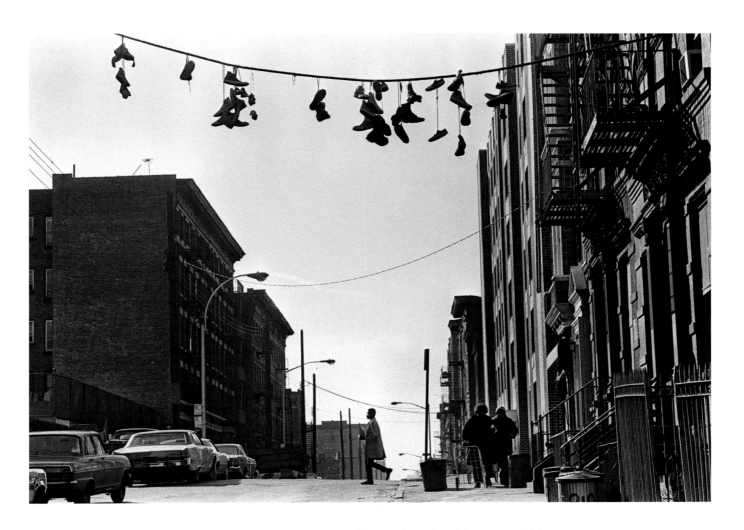

Wire strung from a building without electricity to one with it,
Eagle Avenue and 161st Street, Bronx, 1973
Neal Boenzi

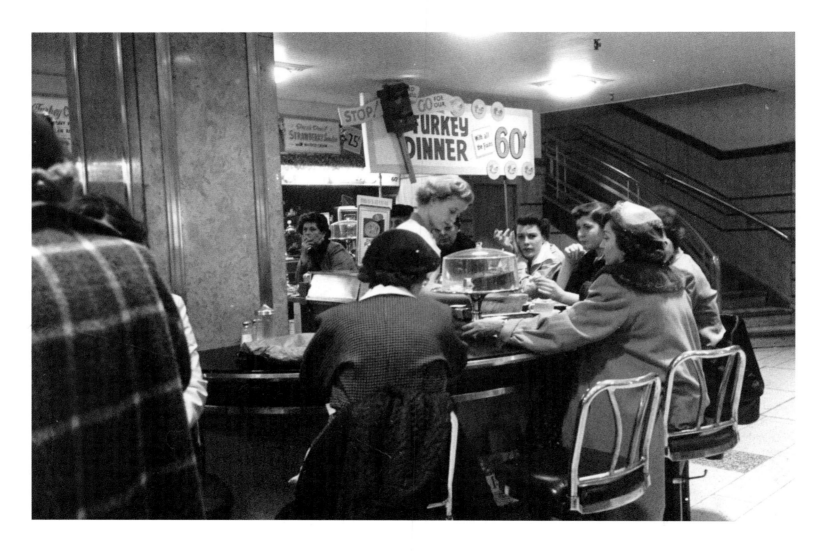

Woolworth's lunch counter, Manhattan, 1954
Sam Falk

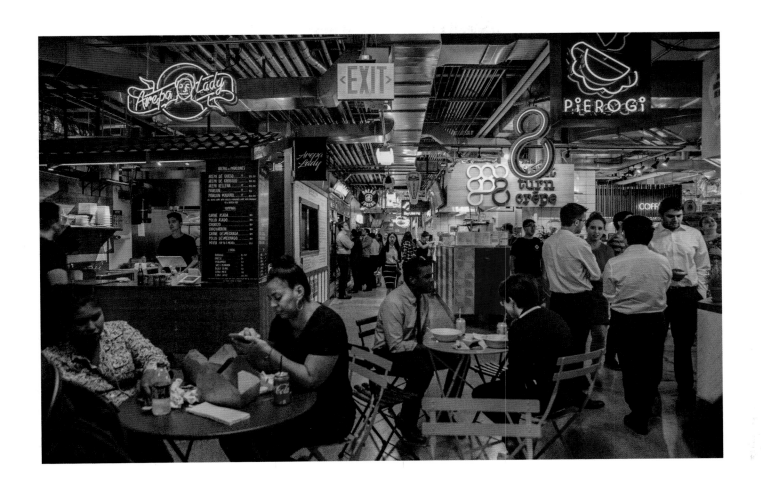

Dekalb Market Hall, Brooklyn, 2017
Hiroko Masuike

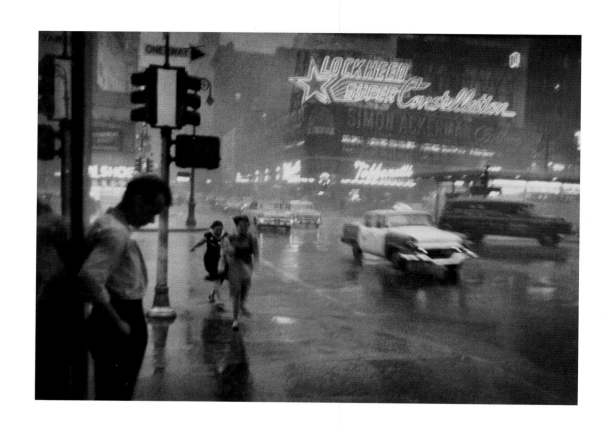

Broadway and 43rd Street, 1959
Carl T. Gossett Jr.

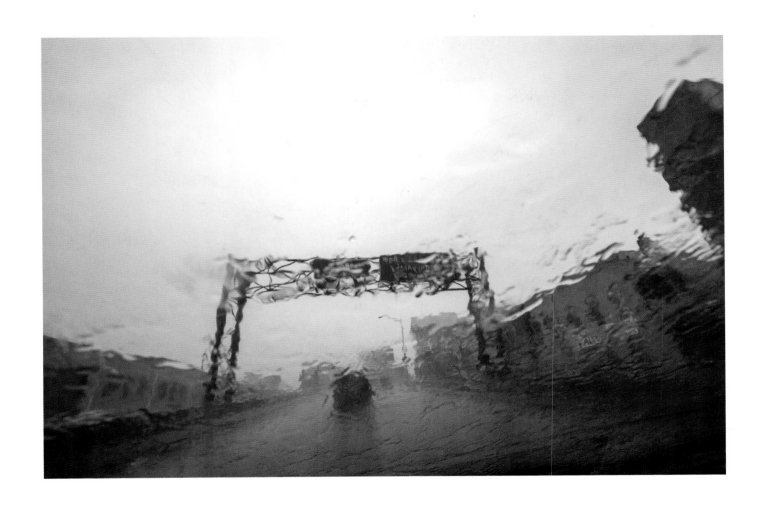

Ramp to the Third Avenue Bridge, Bronx, 2013
Angel Franco

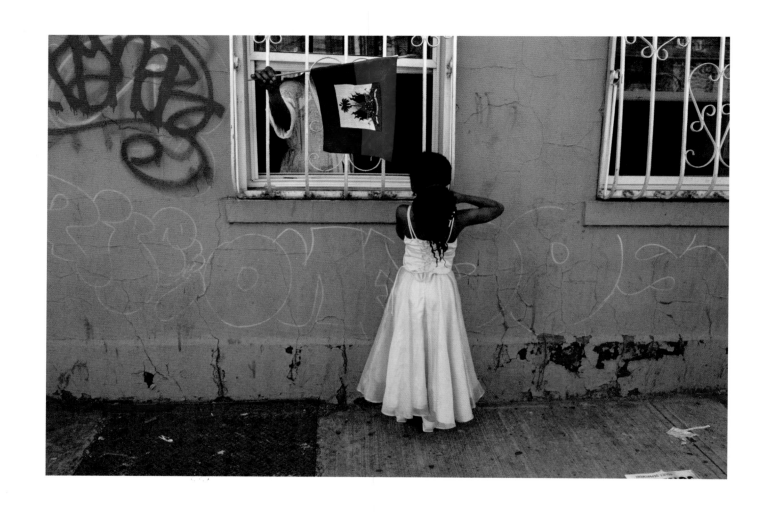

Barbara Jusme at her grandmother's window, Nostrand Avenue, Brooklyn, 2004
Tyler Hicks

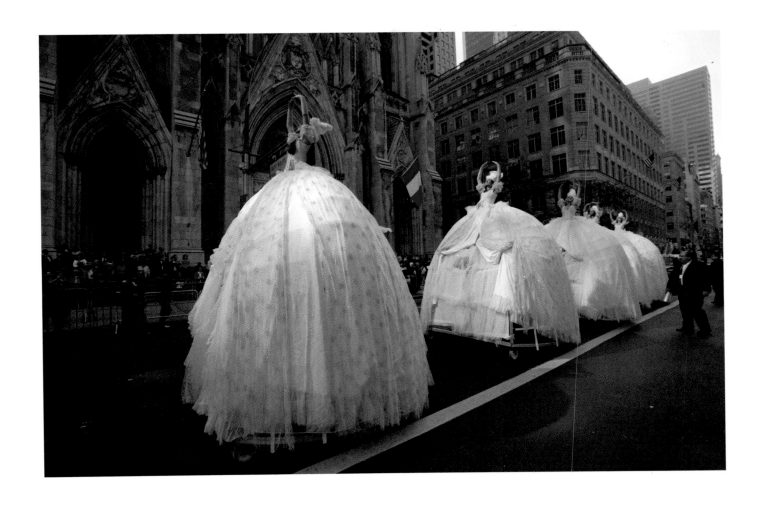

Columbus Day Parade, Fifth Avenue, 2006
James Estrin

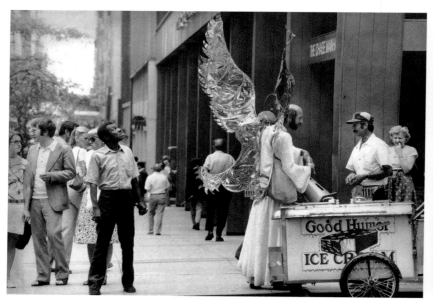

Kendrick Wolf, self-styled "Angelic Janitorial Ramasan,"
42nd Street and Second Avenue, 1976
Paul Hosefros

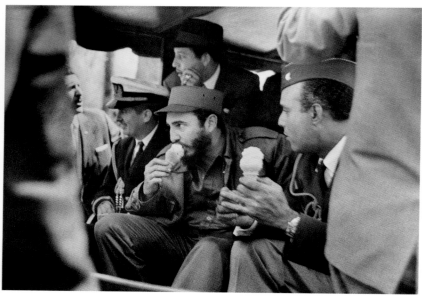

Fidel Castro aboard the Bronx Zoo train, 1959
Meyer Liebowitz

Dear Diary:
Back in New York after several months in the Midwest, I was leaving the Port
Authority terminal when the sound of classical music in the distance stopped me. I
found an orchestra of junior high school students performing in their Sunday best.
I noticed that beside the splendidly dressed conductor was another raggedly dressed
conductor, one who, I suspect, makes his home in the terminal. Side by side, each
conductor was thoroughly engrossed in his work and apparently oblivious
to the other. "Ah," I said to myself, "home again."
KEN BARON

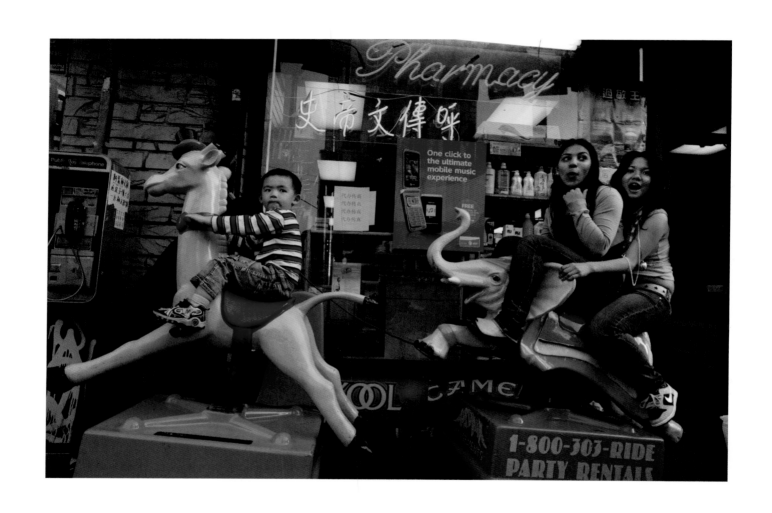

Grand Street near the Bowery, 2007

Todd Heisler

Aqueduct Racetrack, South Ozone Park, Queens, 1973
Barton Silverman

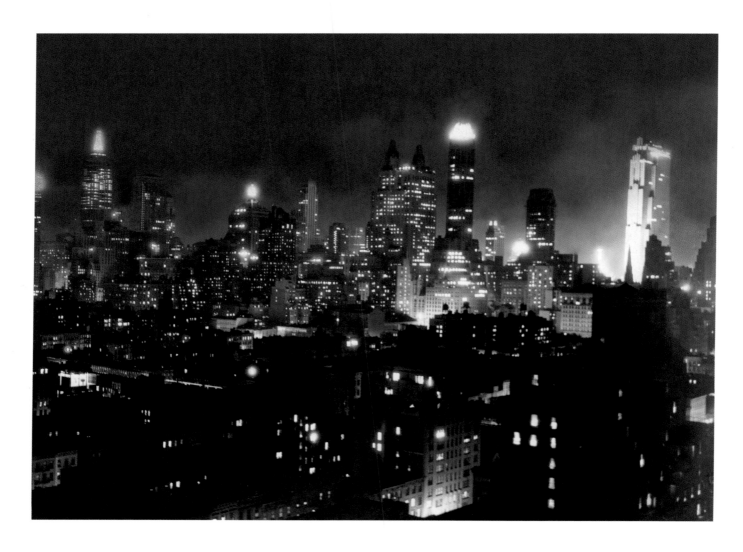

Midtown Manhattan, from East 57th Street, 1940

The New York Times

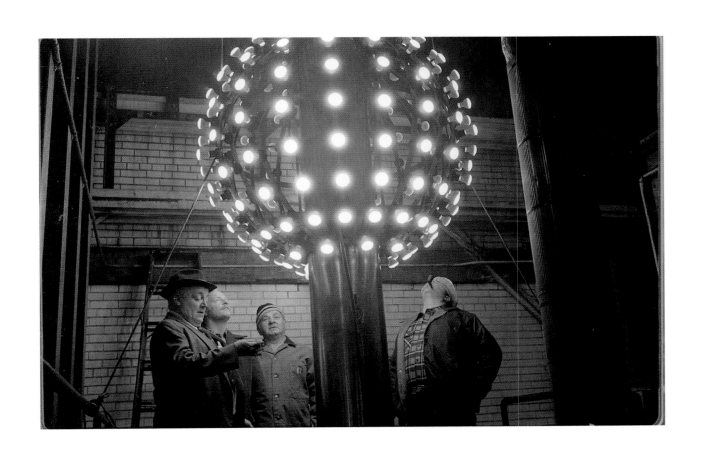

The New Year's Eve ball, 1978
Chester Higgins Jr.

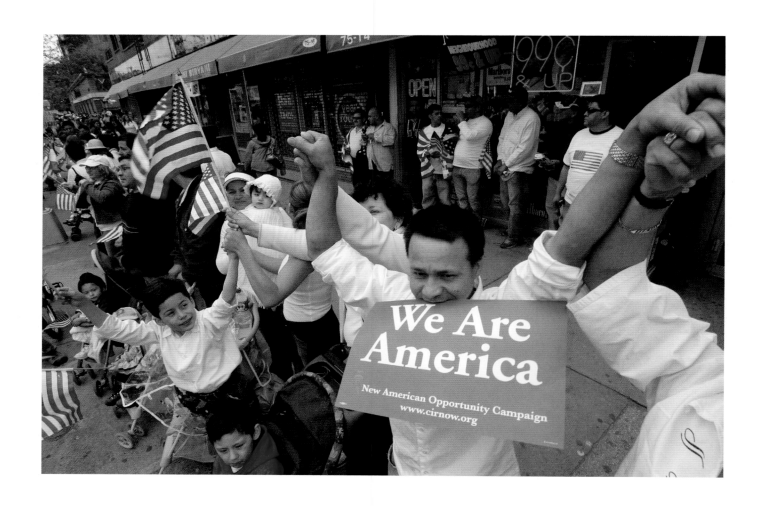

Immigration protest, Jackson Heights, Queens, 2006
James Estrin

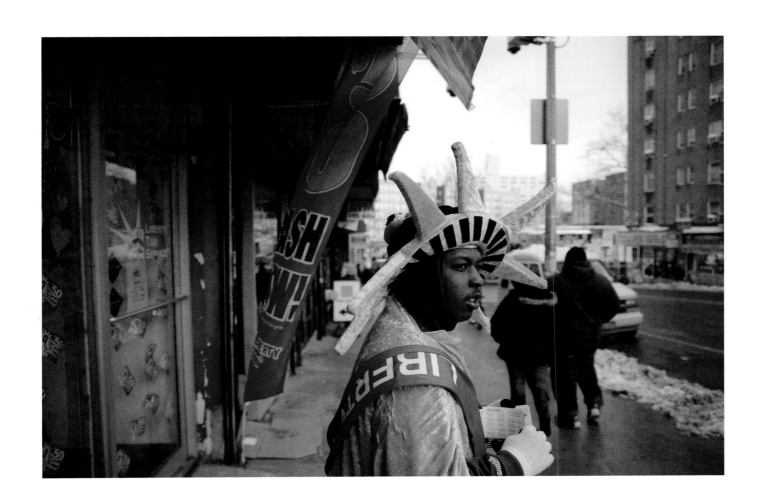

Danny Moreno, 19, at work, Bronx, 2014
Nicole Bengiveno

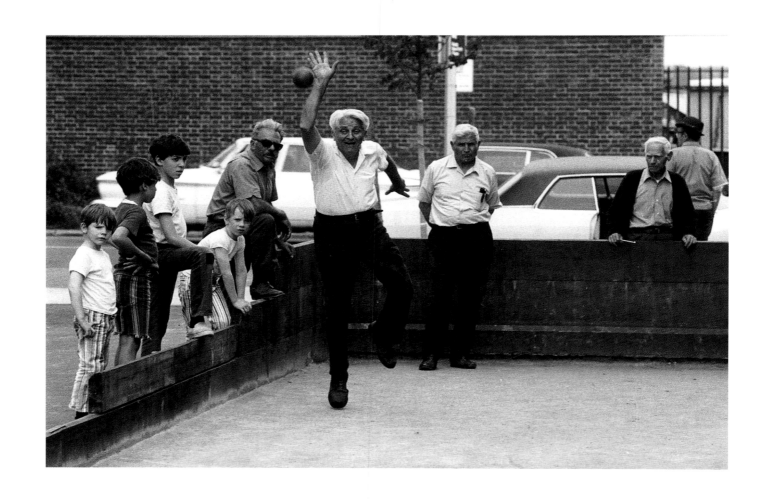

Gravesend Park, Brooklyn, 1972
Barton Silverman

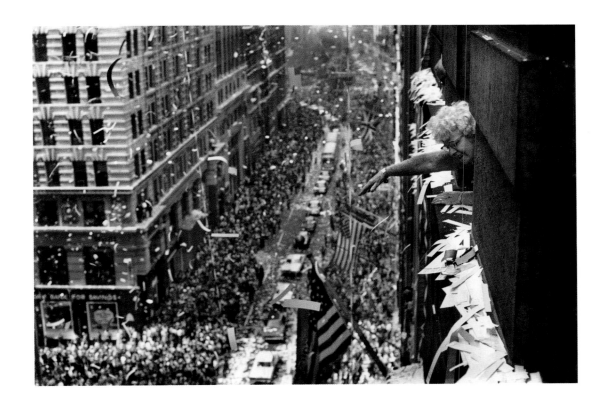

Celebrating the Astronauts, Lower Broadway, 1969
Jack Manning

West 58th Street, 2010
Fred R. Conrad

Fifth Avenue, Brooklyn, 2008
Nicole Bengiveno

Dear Diary:
While shopping in the West Village one recent Sunday I stopped to look at a
selection of Christmas ornaments and came upon a woman having a very difficult time
choosing between two magnificent tree-toppers. She held them up to the light, stared
back and forth between the two and said, with great emphasis, "Oy!"
Robin Kappy

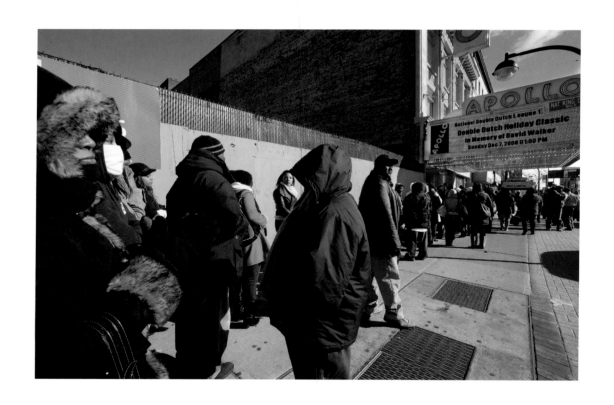

125th Street, Harlem, 2008
Nicole Bengiveno

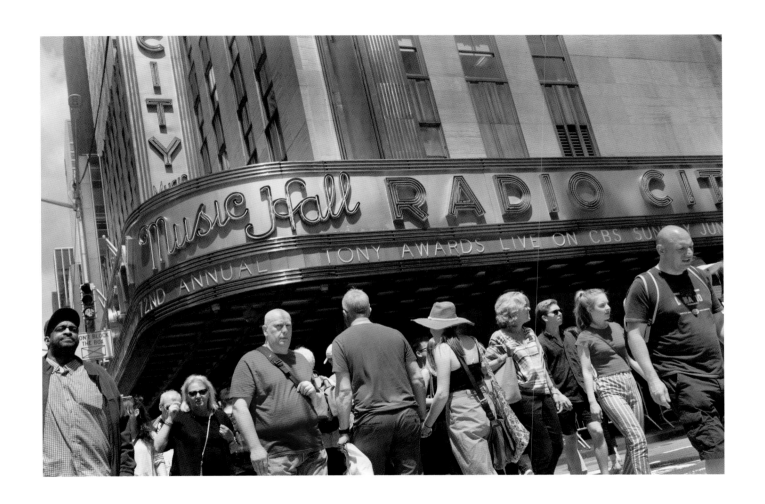

Midtown Manhattan, 2018
Sara Krulwich

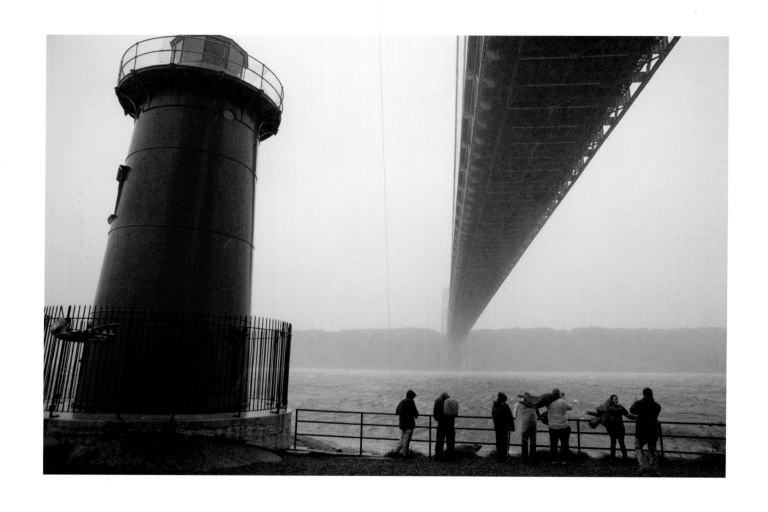

Jeffrey's Hook, Fort Washington Park, 2012
Ozier Muhammad

Verrazano-Narrows Bridge, Staten Island, 2009
Todd Heisler

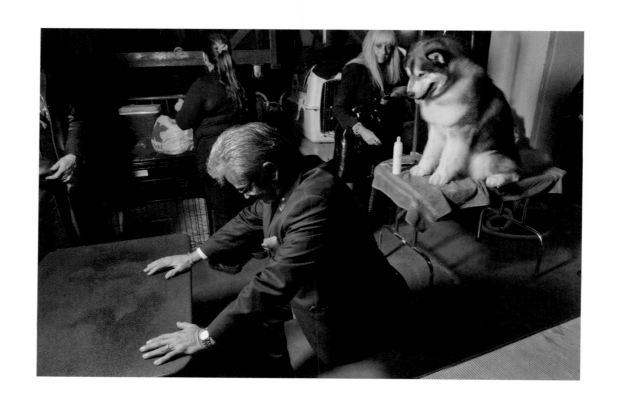

Mike Stone with Rickey, an Alaskan Malamute,
Westminster Kennel Club Show, Madison Square Garden, 2012
Fred R. Conrad

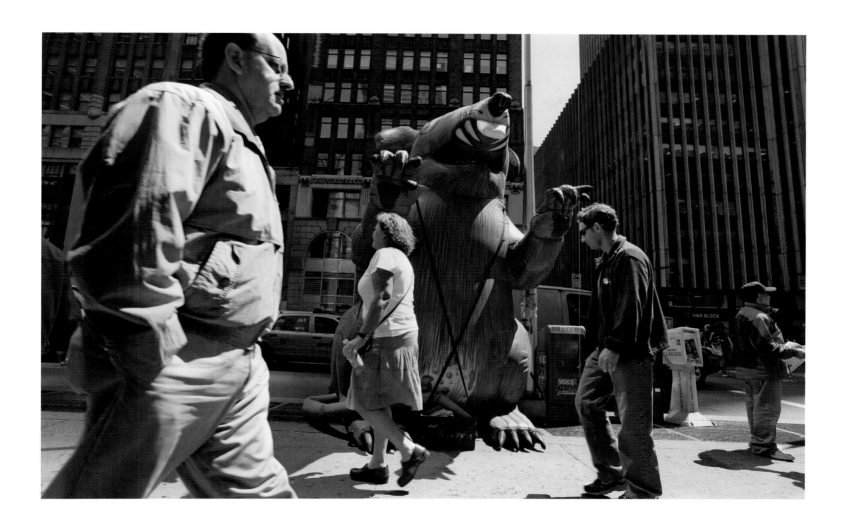

Midtown Manhattan, 2008
Nicole Bengiveno

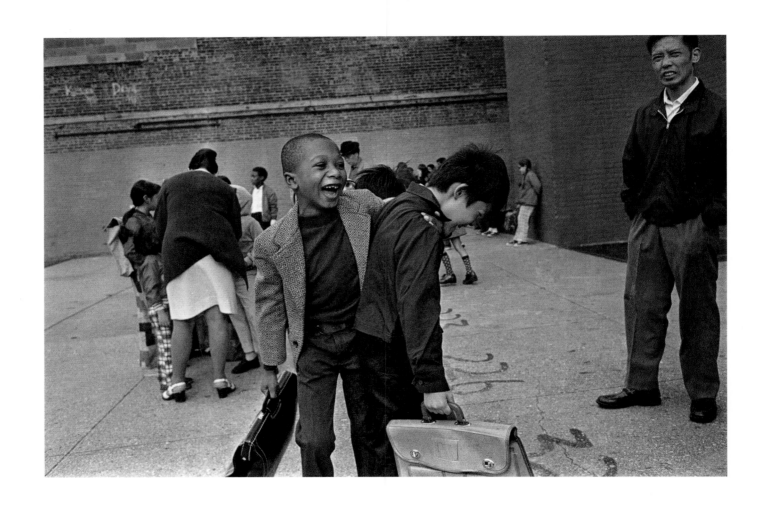

P.S. 51, West 45th Street, 1975
Neal Boenzi

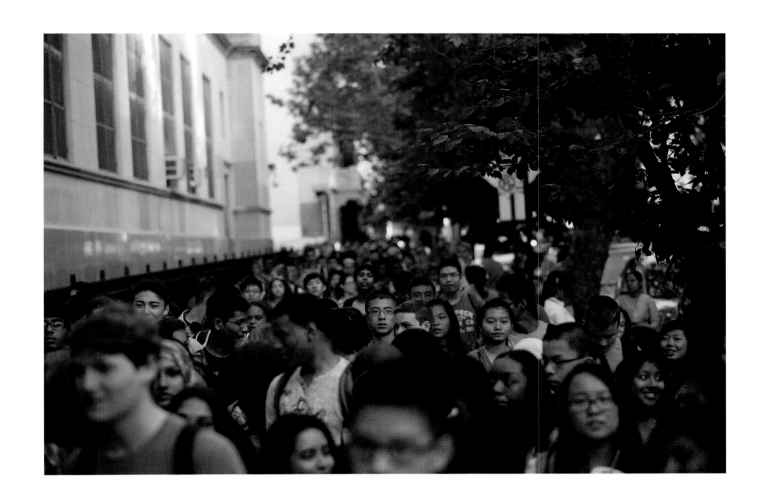

Brooklyn Technical High School, Fort Greene Place, 2014
Ozier Muhammad

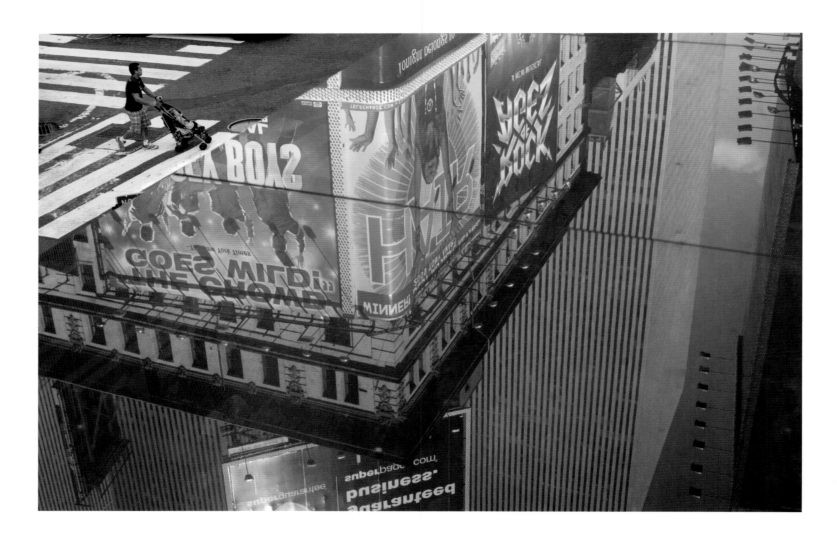

Times Square, 2008
Todd Heisler

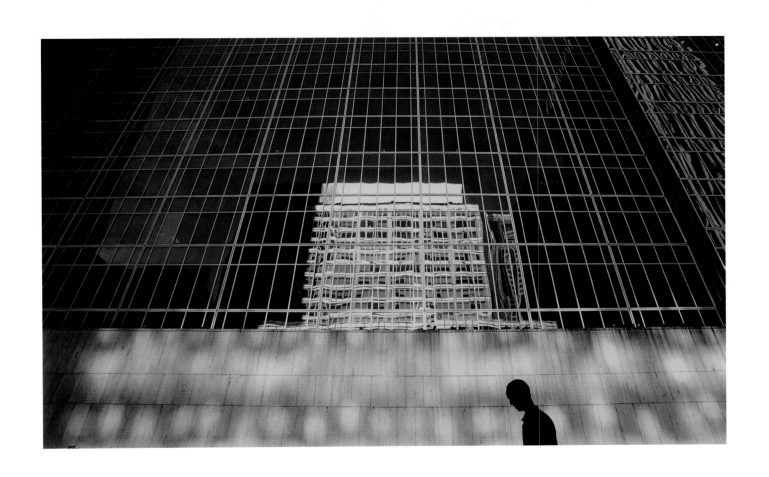

West 43rd Street, 2006
Nicole Bengiveno

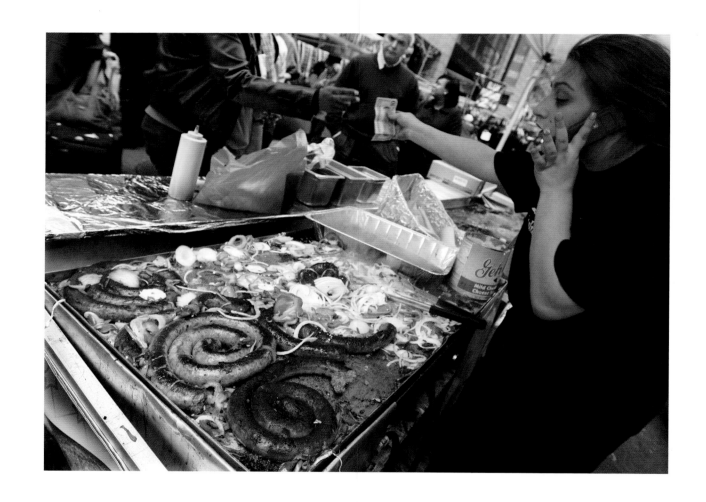

Veterans Day street fair, Manhattan, 2010
Ruth Fremson

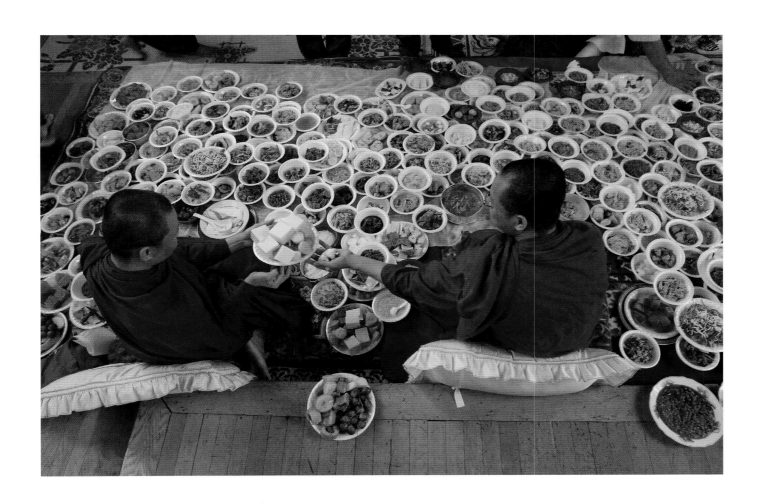

Cambodian Buddhist ceremony, Bronx, 2005
James Estrin

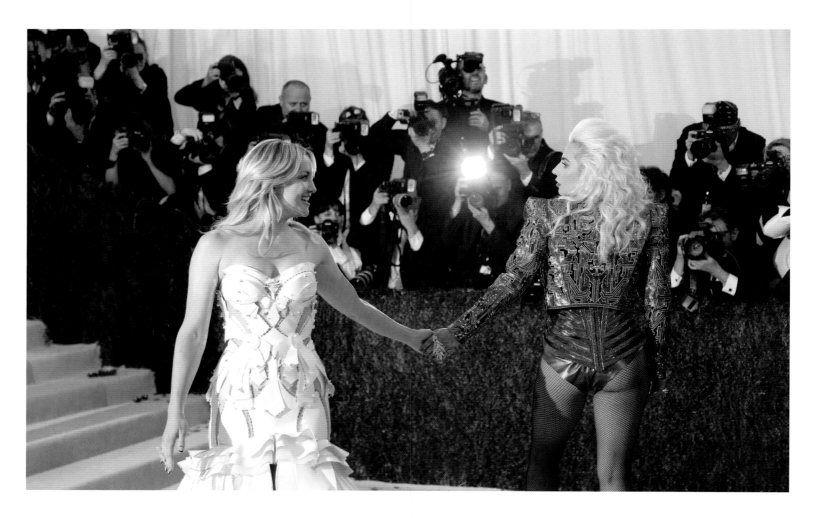

Kate Hudson and Lady Gaga at the Costume Institute Gala,
Metropolitan Museum of Art, 2014
Damon Winter

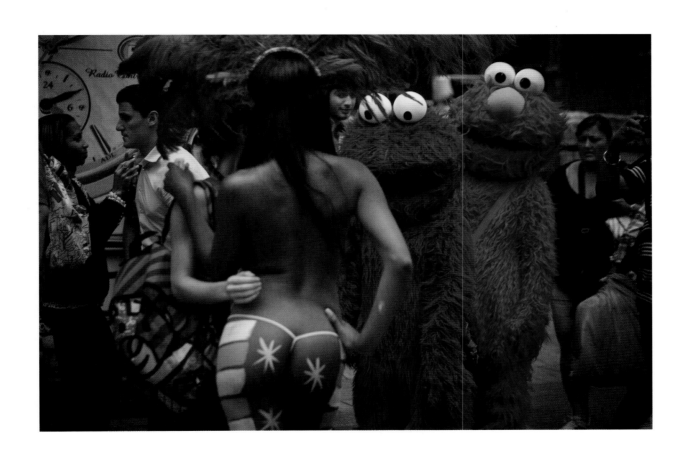

Cookie Monster, Elmo, and less-furry creatures, Times Square, 2014
Damon Winter

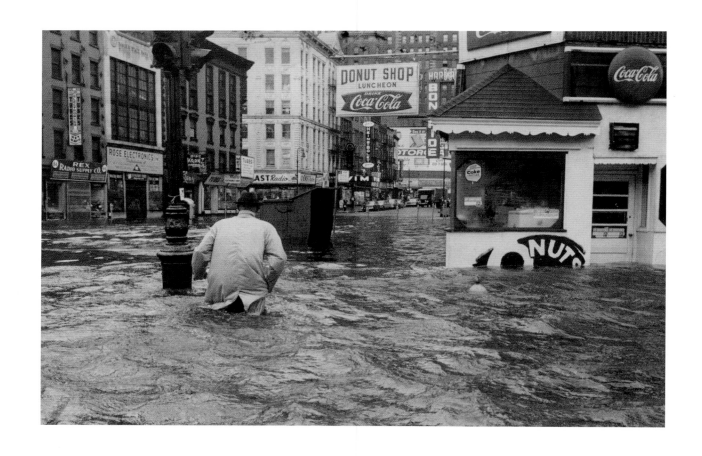

West and Cortland Streets, Manhattan, 1960
Allyn Baum

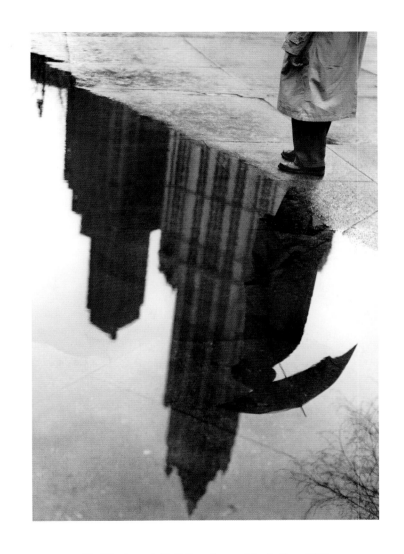

The Woolworth Building, Lower Manhattan, 1950
Arthur Brower

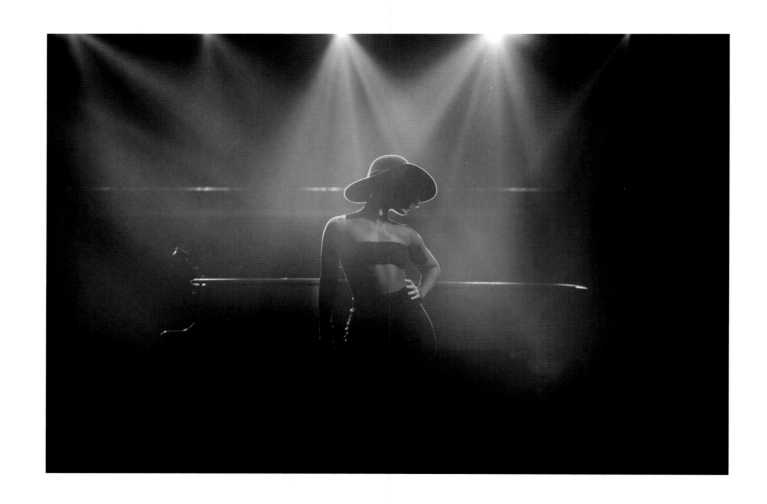

Alicia Keys at Barclays Center, 2013
Richard Perry

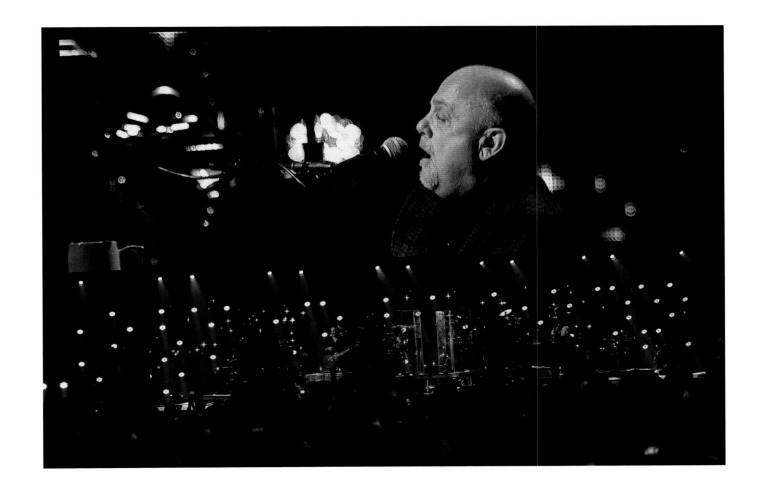

Billy Joel at Madison Square Garden, 2012
Damon Winter

Joe Namath, Shea Stadium, 1966
Barton Silverman

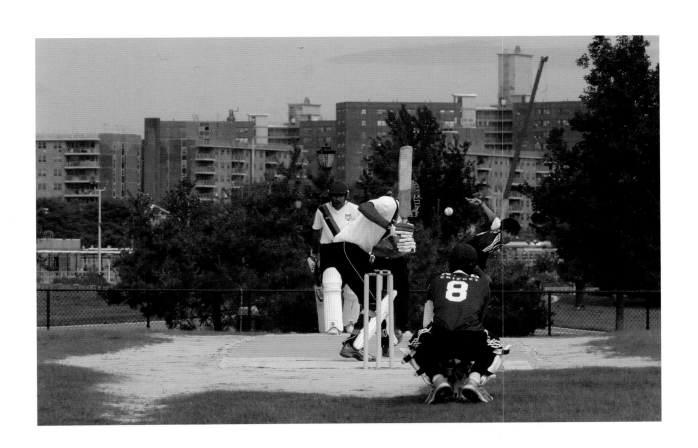

NYPD cricket league, Gateway Cricket Grounds, Brooklyn, 2009
Ruby Washington

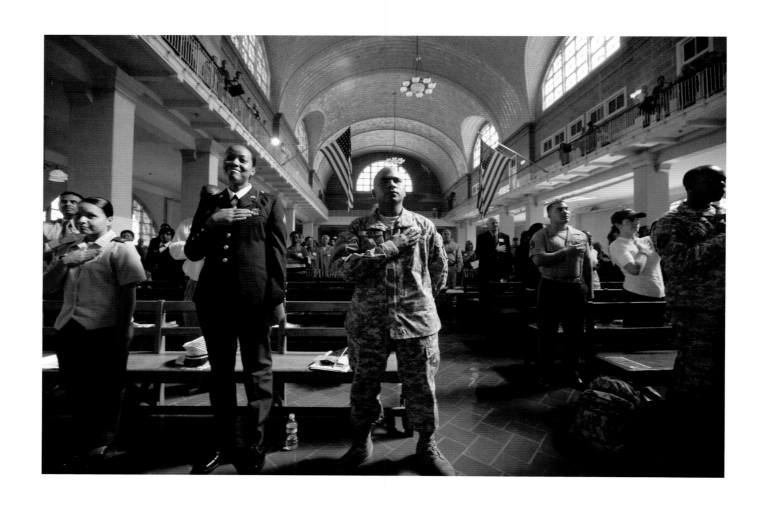

Immigration ceremony, Ellis Island, 2008
Chang W. Lee

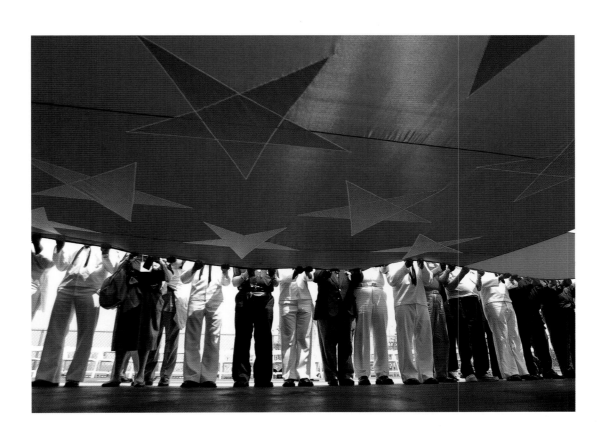

Memorial Day commemoration, Intrepid Sea, Air & Space Museum, Manhattan,
Chang W. Lee

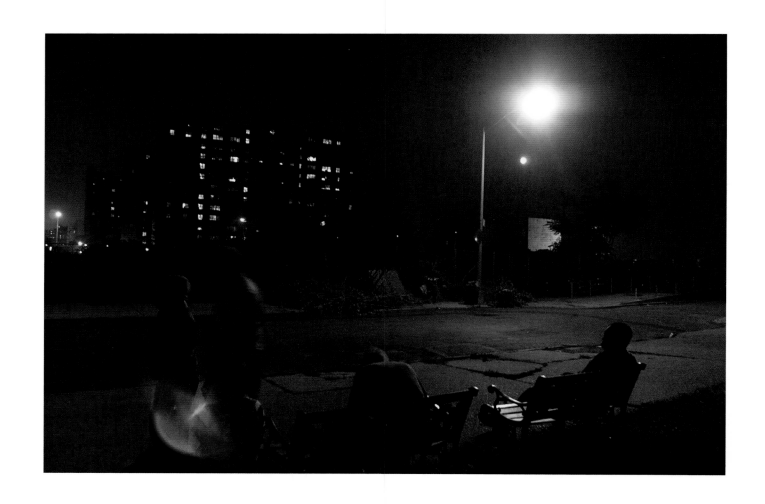

Ocean View Manor, Coney Island, 2001
Nicole Bengiveno

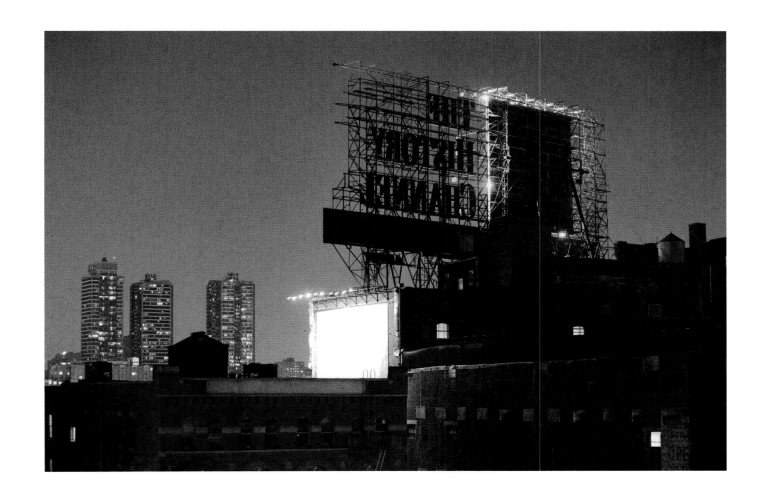

Bronx, 2010
Richard Perry

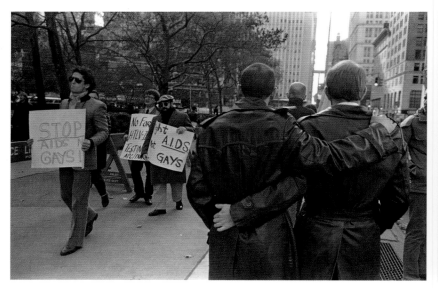

Gay rights protest, Near City Hall, 1985
Neal Boenzi

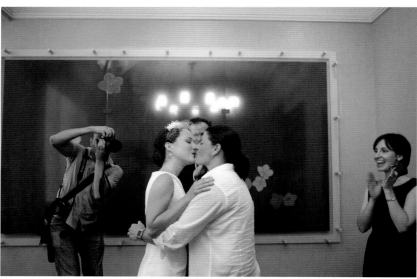

Sephanie Spahr-LaFroscia and Theresa LaFroscia, Manhattan
Marriage Bureau, 2011
Josh Haner

Overheard by Joel Raphaelson in the East 50's, one young man to another: "Let's go to Tiffany's first and get that over with."

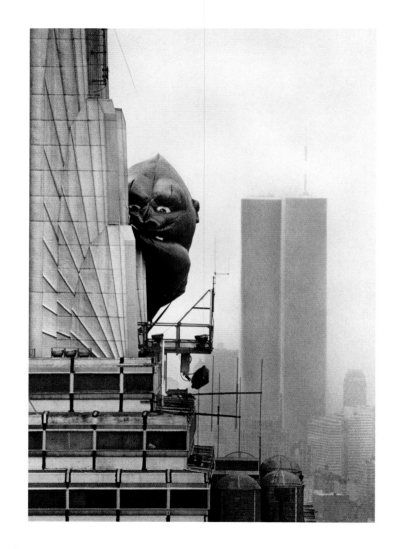

Marking the 50th anniversary of King Kong, 1983
Sara Krulwich

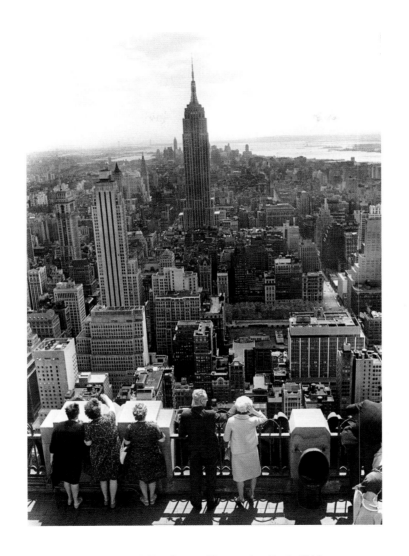

The Rockefeller Center Observation Deck, 1964
Robert Walker

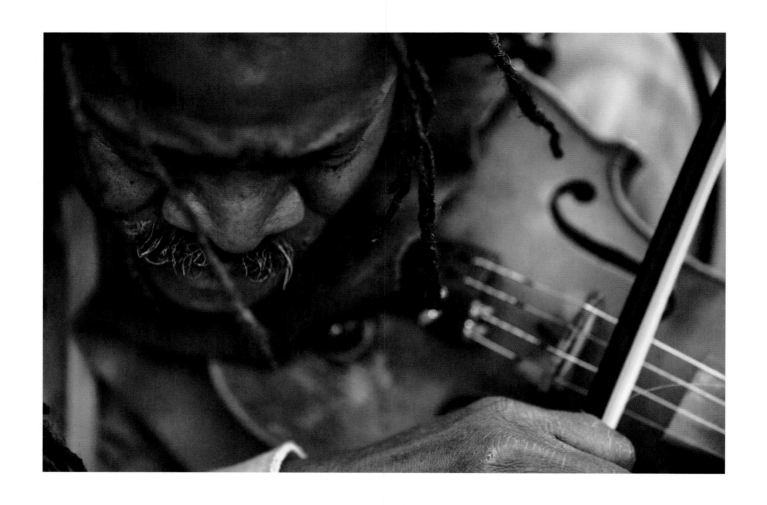

Henrique Prince of The Ebony Hillbillies, Times Square subway station, 2008
Todd Heisler

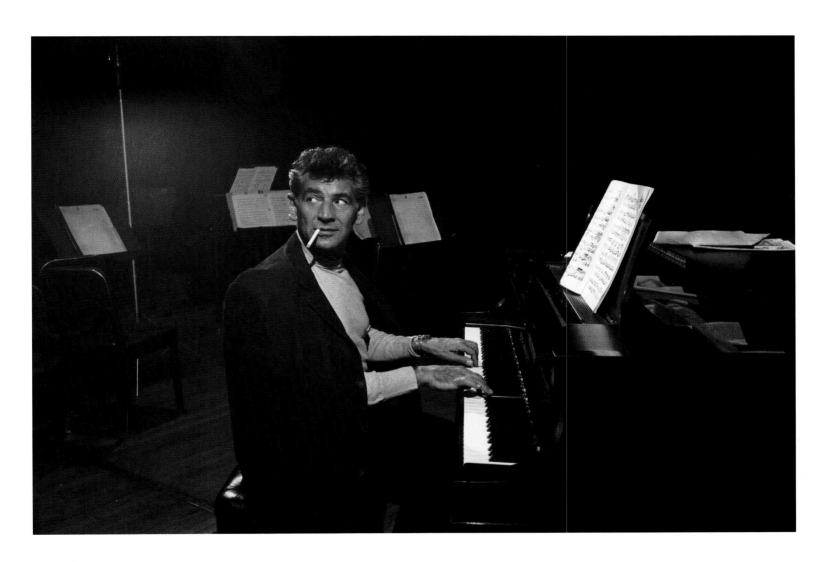

Leonard Bernstein, Manhattan, 1959
Sam Falk

Sunset Park, Brooklyn, 2007
Todd Heisler

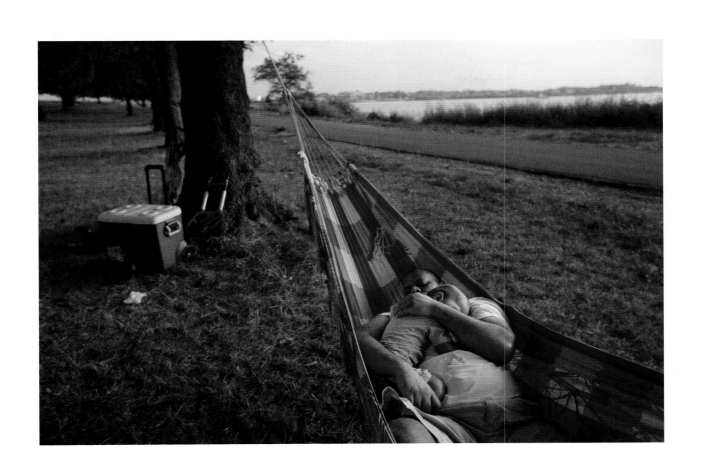

Ram Kissoon and his son Elias, Ferry Point Park, Bronx, 2012
Ruth Fremson

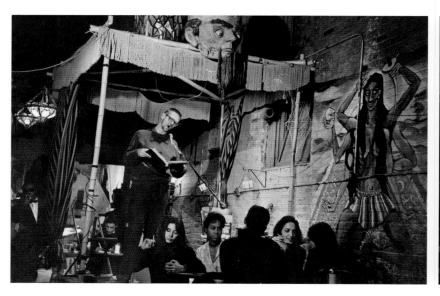

Poetry at The Bizarre coffee shop, Greenwich Village, 1961
Sam Falk

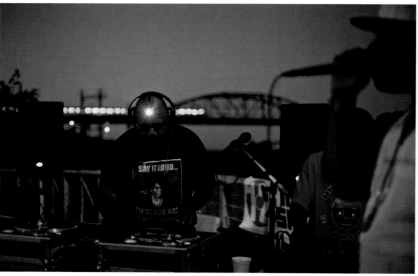

Tools of War Hip Hop Jam, Concrete Park, Bronx, 2014
Todd Heisler

Dear Diary:

Buying a T-shirt at the Pop Shop in SoHo, I asked the cashier what to me was a common question after purchasing an item. "Do you wrap?" The puzzled cashier paused, while I wondered what was so complex about the question. At long last, he replied: "No, but I like listening to it. Why do you ask?"

RICHARD DALTON JR.

141st Street in Harlem, 1957
Robert Walker

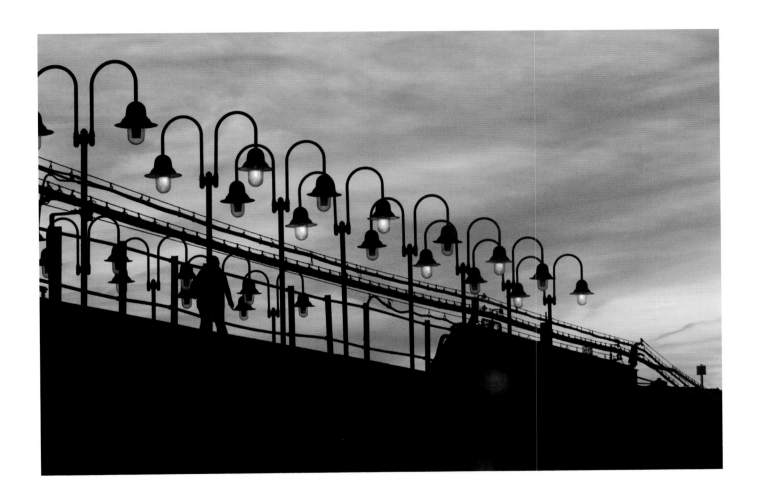

61st Street Station, Woodside, Queens, 2008
Richard Perry

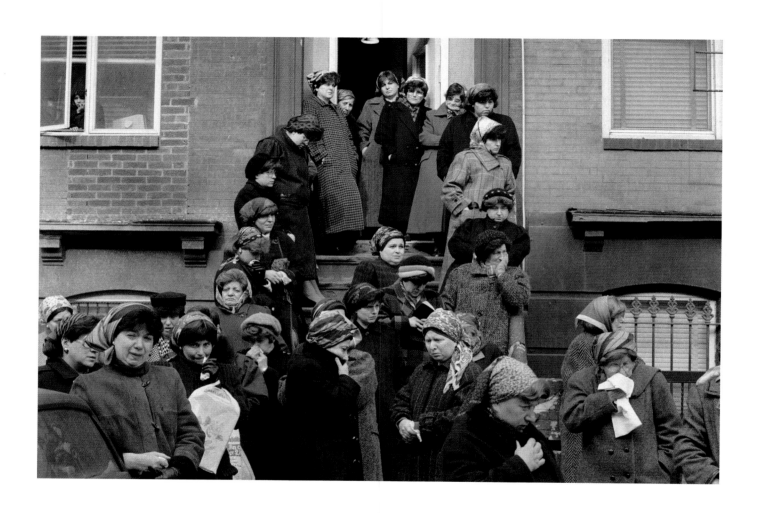

Women watching the service for slain Rabbi Chaskel Werzberger,
Williamsburg, Brooklyn, 1990
Dith Pran

Funeral for Rabbi Joel Teitelbaum, Williamsburg, Brooklyn, 2006
James Estrin

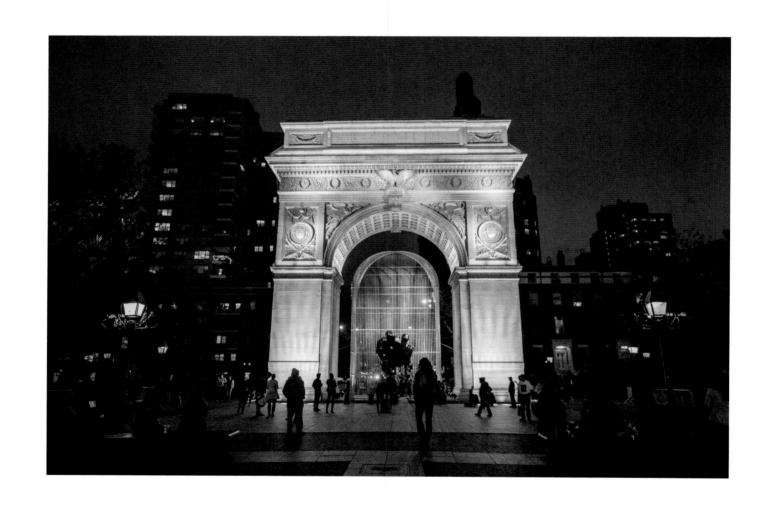

Ai Weiwei's *Good Fences Make Good Neighbors*, Washington Square Park, 2017
Hiroko Masuike

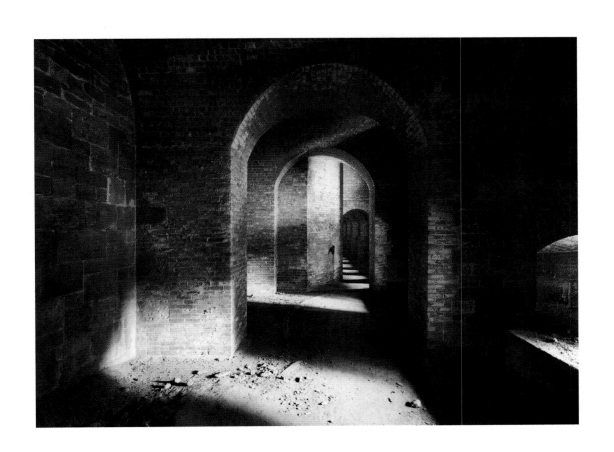

Fort Tompkins, Staten Island, 2008
Fred R. Conrad

Big Apple Circus, Damrosch Park, Manhattan, 1988
Don Hogan Charles

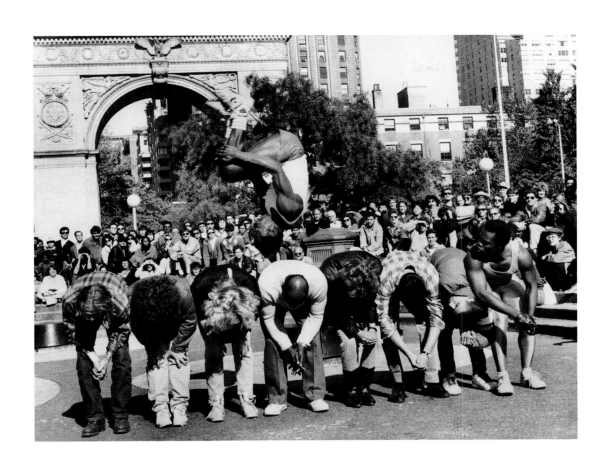

The Calypso Tumblers, Washington Square Park, 1987
Dith Pran

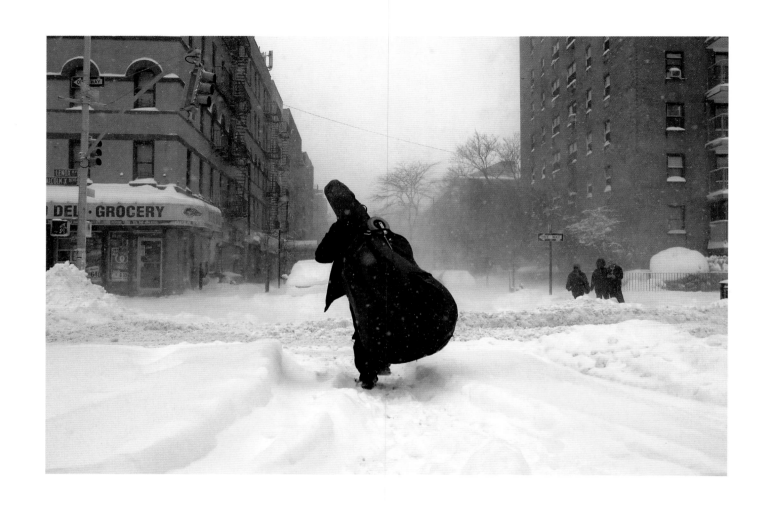

Lenox Avenue, Harlem, 2006
James Estrin

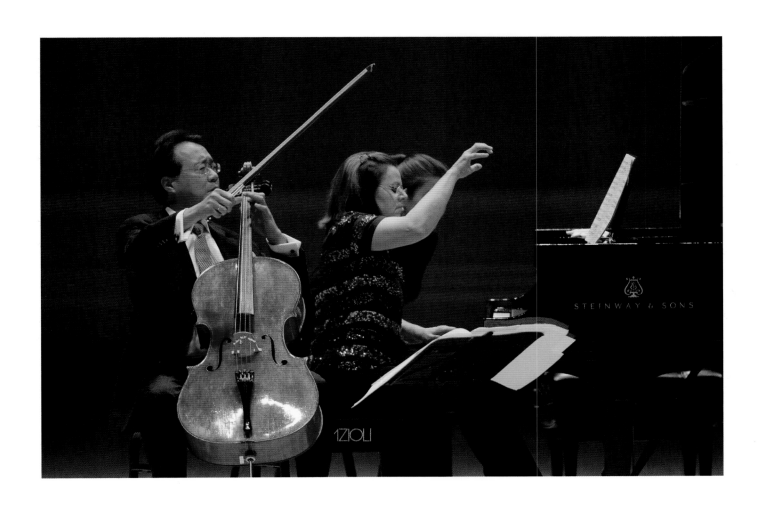

Yo-Yo Ma and Kathryn Stott, Carnegie Hall, 2010
Chang W. Lee

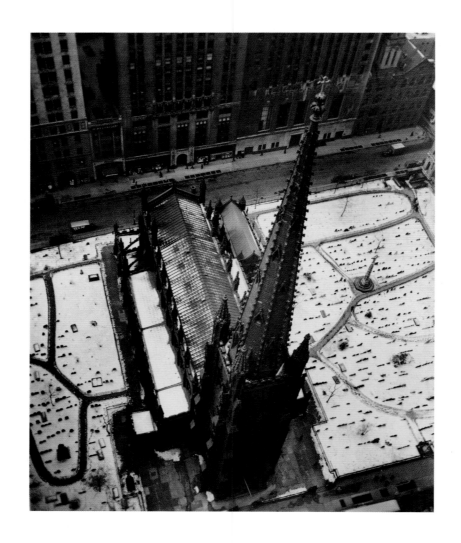

Trinity Church, Lower Manhattan, 1949
Meyer Liebowitz

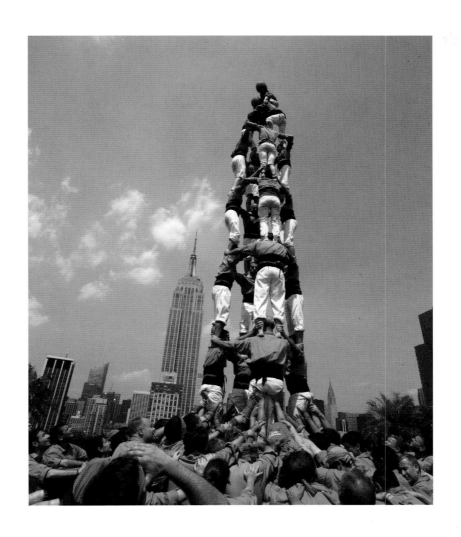

A human tower of Catalonians, Fifth Avenue rooftop, 2012
Librado Romero

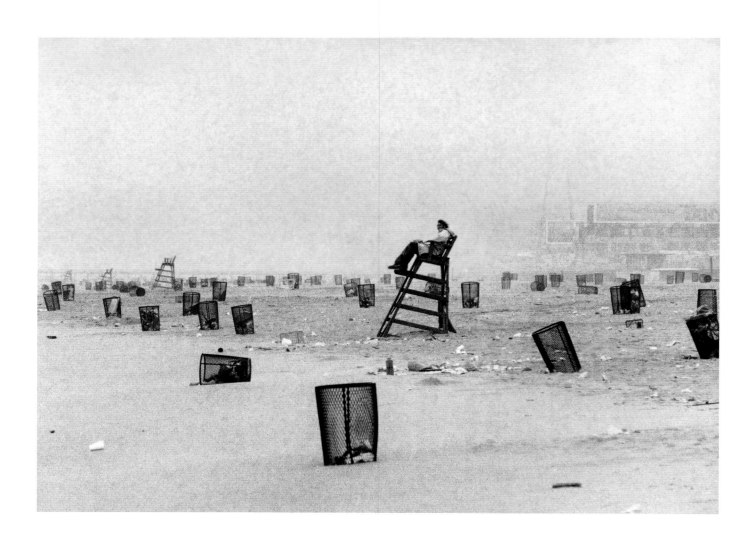

Brighton Beach, Brooklyn, 1972
Barton Silverman

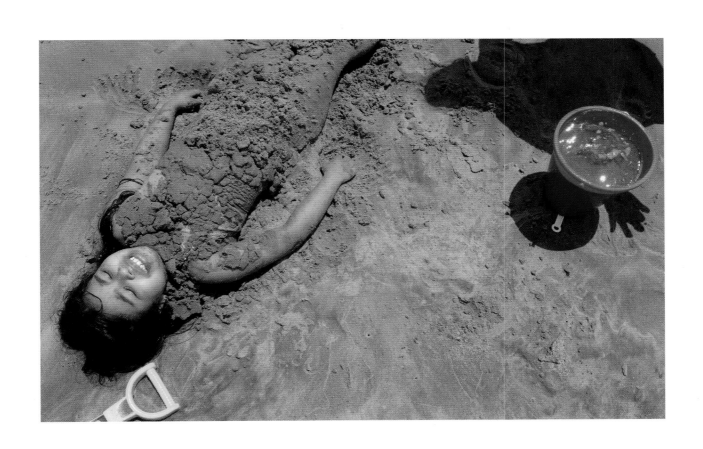

Nadine Colon buries her cousin Emily Colon in the sand, Coney Island, 2005
Tyler Hicks

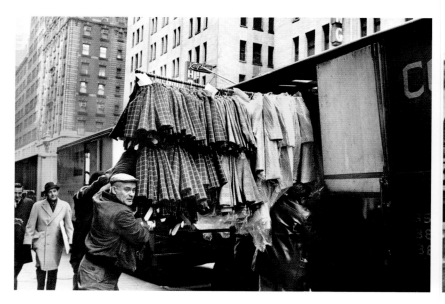

The Garment District, West 36th Street, 1967
Arthur Brower

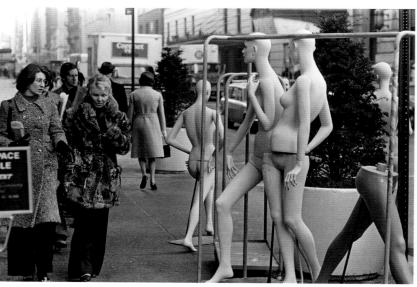

West 58th Street, 1975
Eddie Hausner

Overheard in the lobby of an apartment building in the East 70s:
Concierge to doorman: "20B wants to know if it's a fur coat or cloth coat day."
Doorman to concierge: "For me it's always cloth."

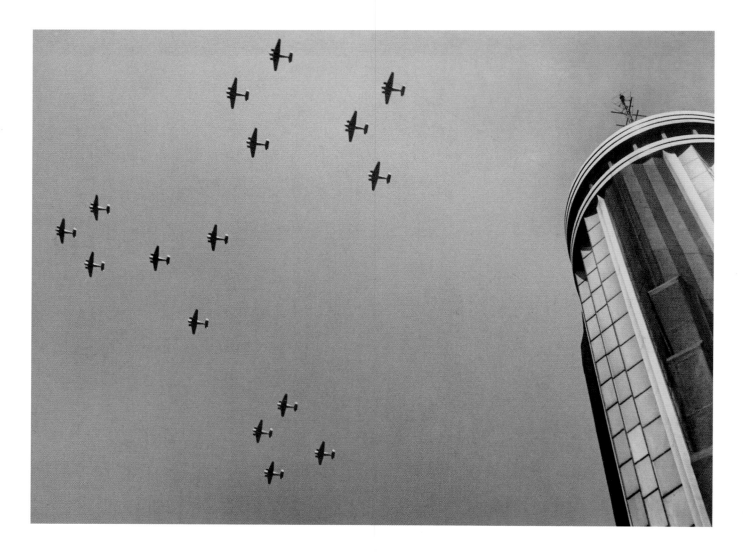

In formation over Midtown Manhattan, 1947
Meyer Liebowitz

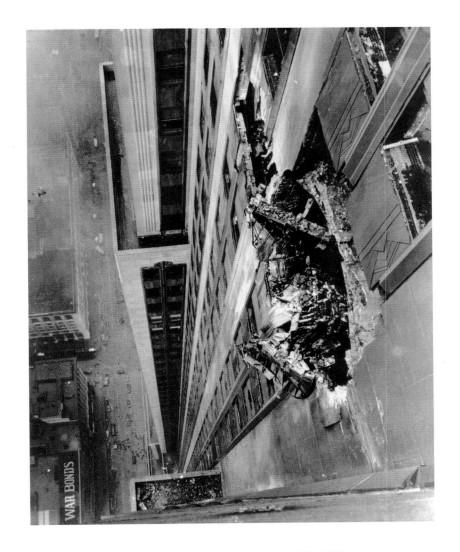

Empire State Building struck by a B-25, 1945

Ernie Sisto

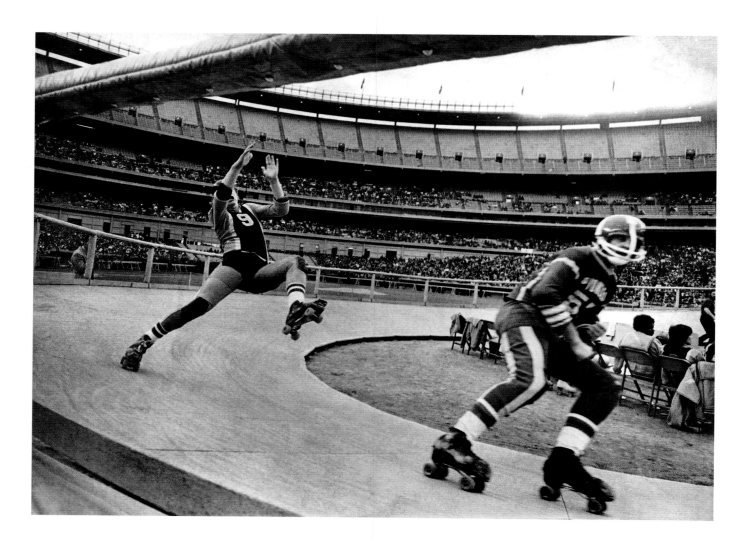

The Pioneers vs. The Jolters, Shea Stadium, 1973
Michael Evans

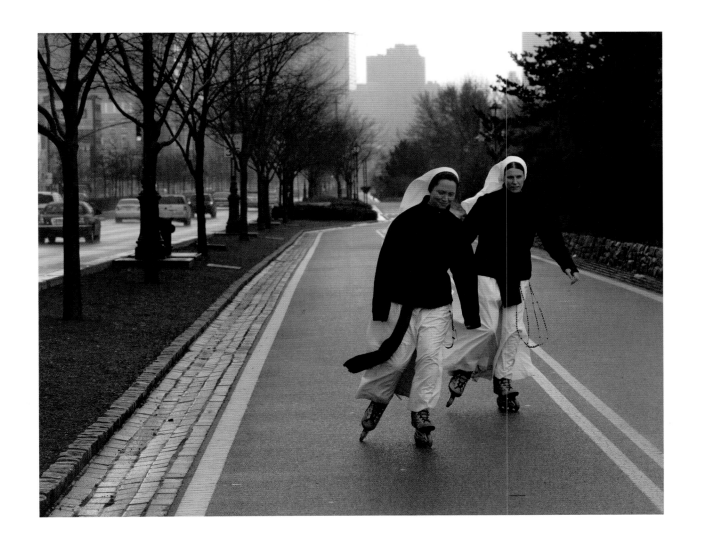

Sister Mary Elizabeth and Sister Immaculata, West Side Highway path, 2006
Tyler Hicks

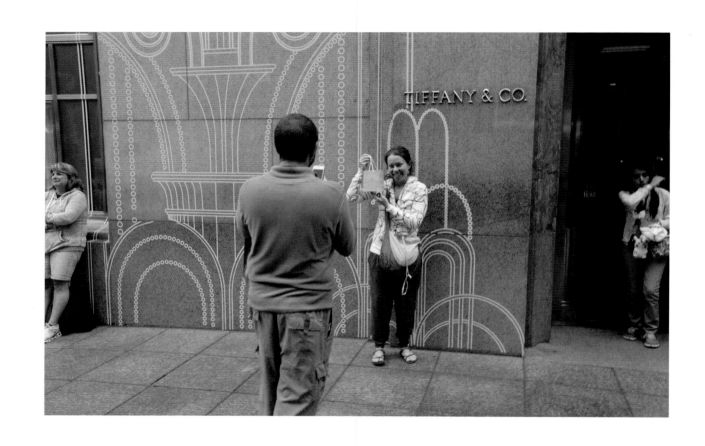

Fifth Avenue and 57th Street, 2013
Ozier Muhammad

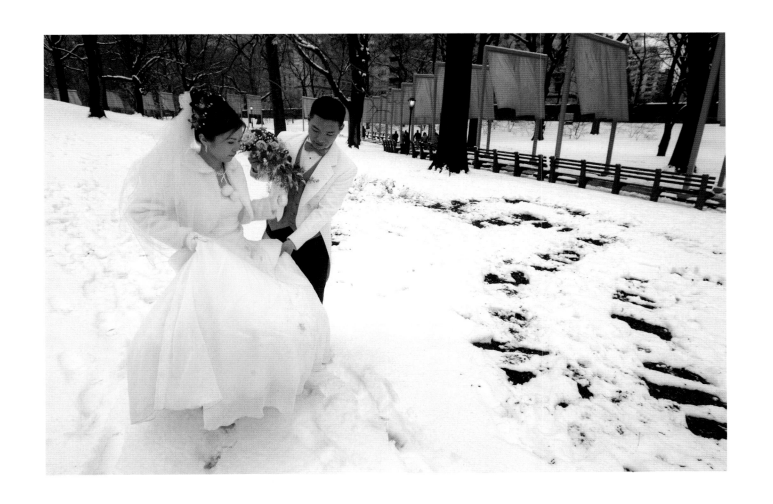

Michael and Ann Zhang, Central Park, 2005
Vincent Laforet

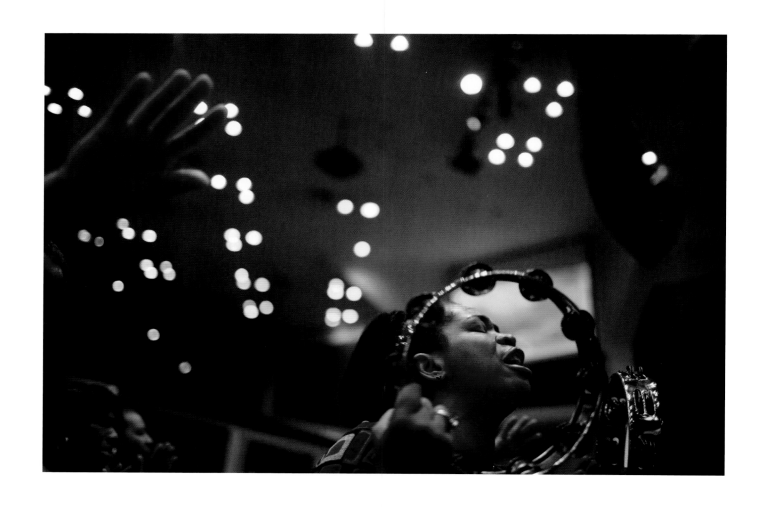

The Christian Cultural Center, Flatlands Avenue, Brooklyn, 2009
Todd Heisler

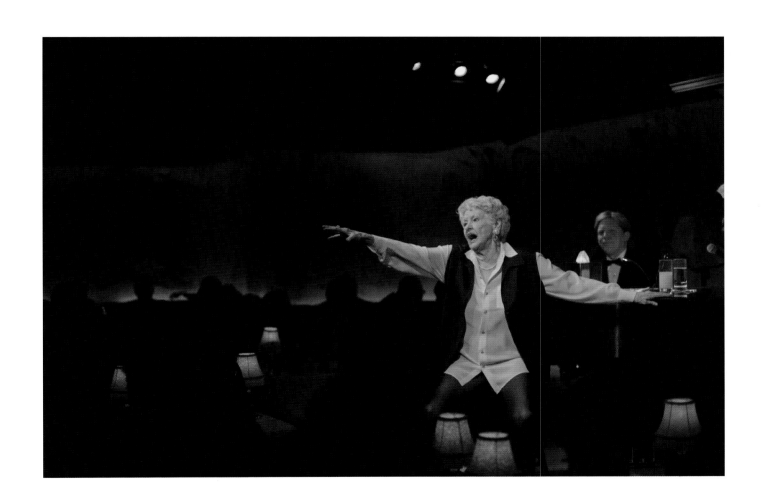

Elaine Stritch at The Carlyle, Upper East Side, 2013
Todd Heisler

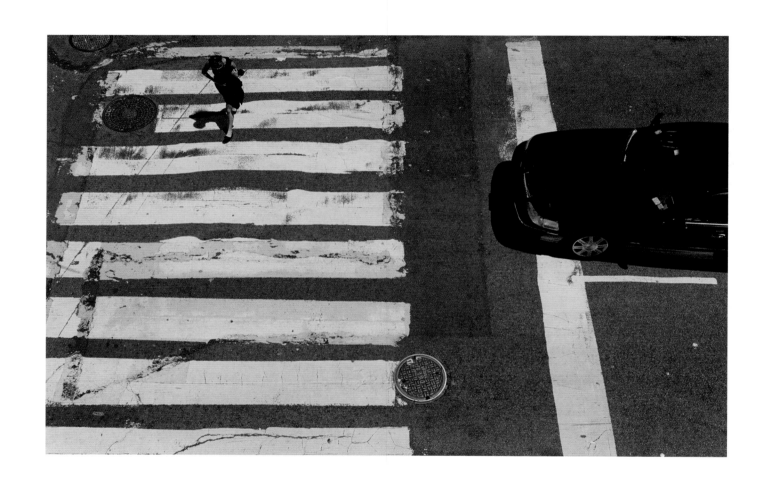

42nd Street near Park Avenue, 2010
Damon Winter

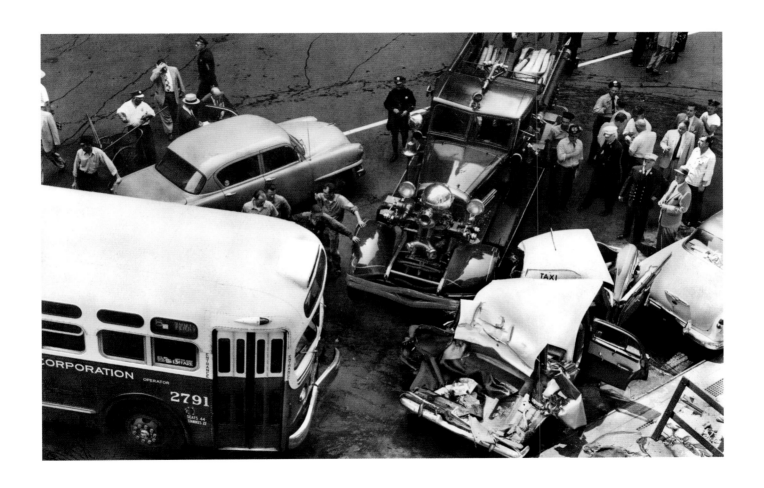

Eight-vehicle collision, Seventh Avenue and 52nd Street, date unknown
Patrick A. Burns

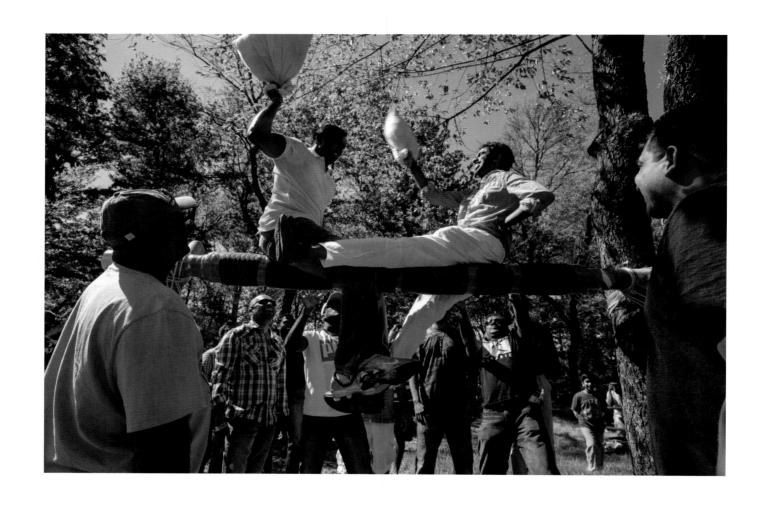

Sri Lankans have a pillow fight, Henry Kaufmann Campgrounds, Staten Island, 2013
James Estrin

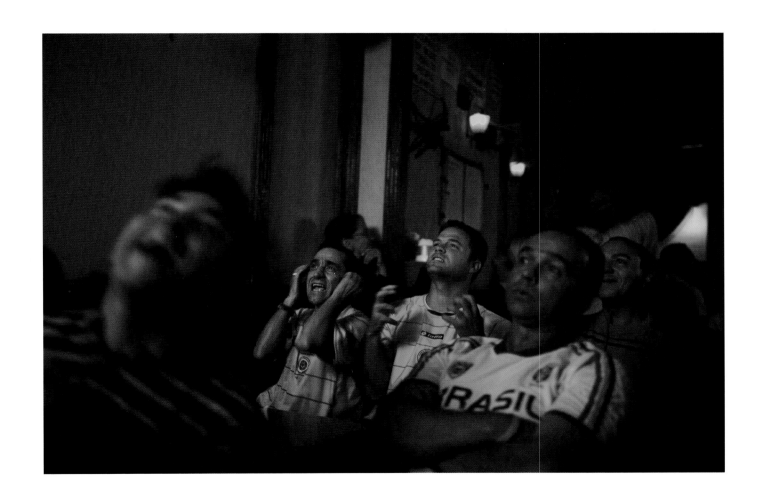

Watching Bolivia vs. Colombia in the World Cup, Café España, Queens, 2007
Todd Heisler

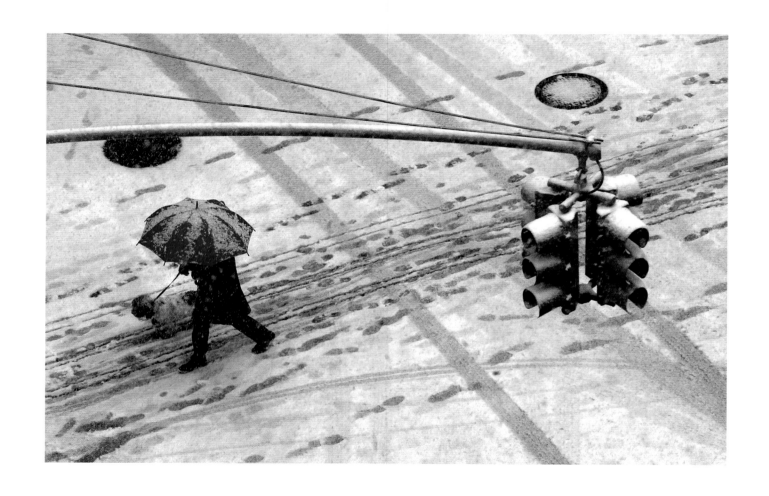

Upper West Side, 2003
Vincent Laforet

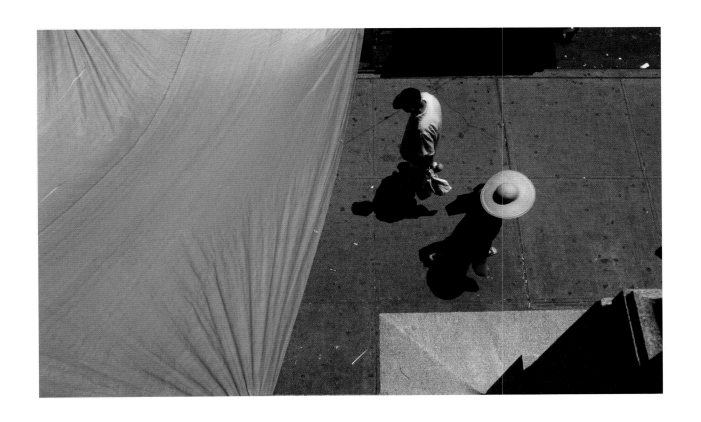

Under the Manhattan Bridge, 2010
Todd Heisler

345

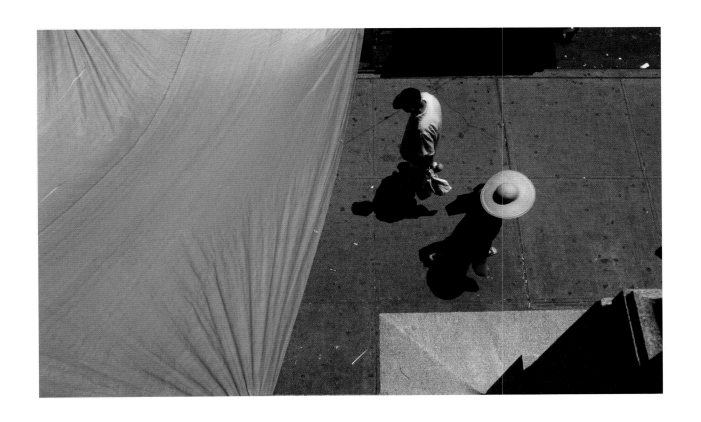

Under the Manhattan Bridge, 2010
Todd Heisler

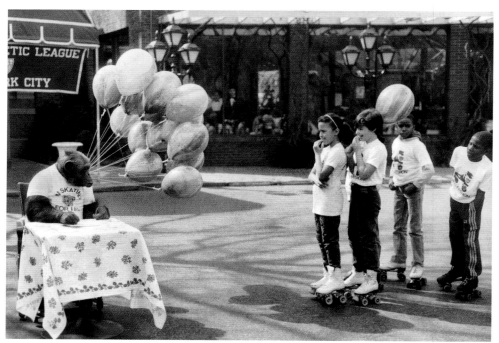

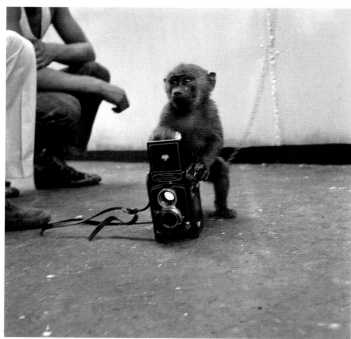

Jiggs the chimpanzee at a Police Athletic League benefit, Tavern on the Green, 1986
Chester Higgins Jr.

Bush Terminal, Brooklyn, 1957
John Orris

On a recent rainy Sunday, Susan Cohen and a friend took their children to the Museum of Natural History. They traveled up and down the crowded elevators and stairs, saw the barosaurus and elephants, dioramas of wetland birds, desert animals and cactuses, an Indian wedding and scenes from Antarctica. They ate lunch in the dark under the whale. Everyone was getting tired. But five-year-old Rebecca had had it. She kept begging to be taken to the "fun floor" but was unable or unwilling to describe what she meant. Wherever she went, it wasn't the fun floor. Finally, in exasperation, she exclaimed, "I'm tired of looking at boring interesting stuff."

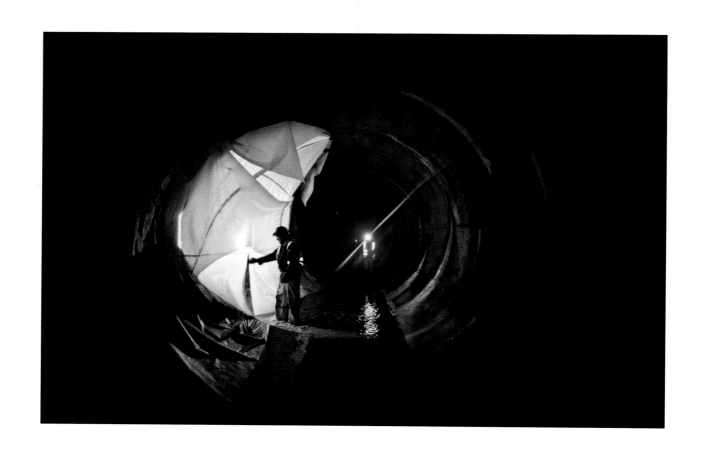

Croton Water Filtration Plant, Bronx, 2011
Fred R. Conrad

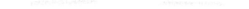

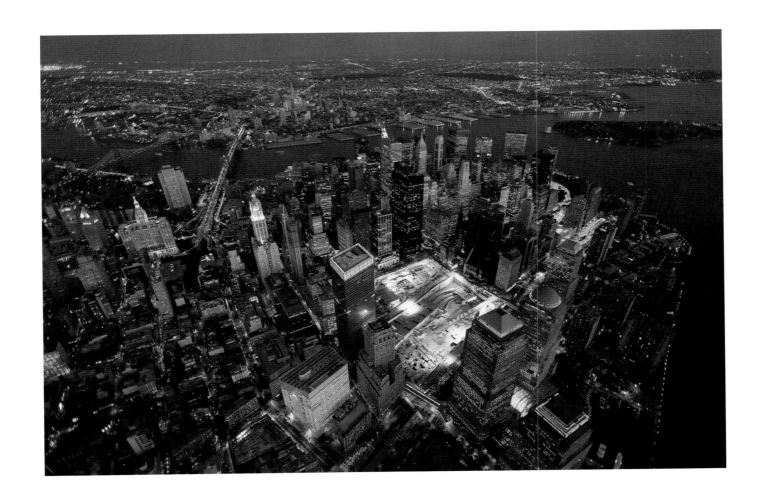

Ground Zero, five years after, 2006
Vincent Laforet

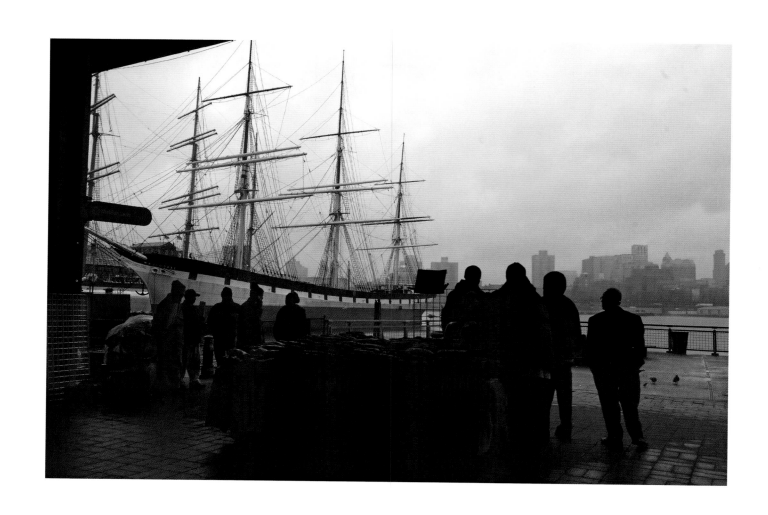

South Street Seaport, Manhattan, 2008
Nicole Bengiveno

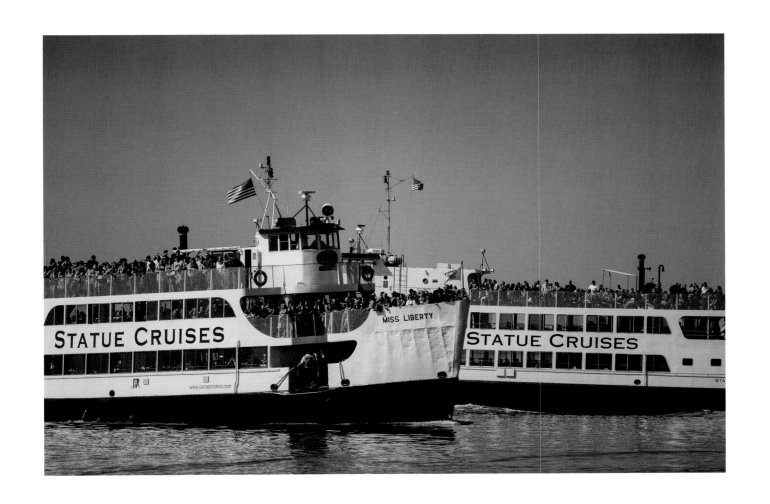

Circle Line tours, West Side Piers, 2015
Todd Heisler

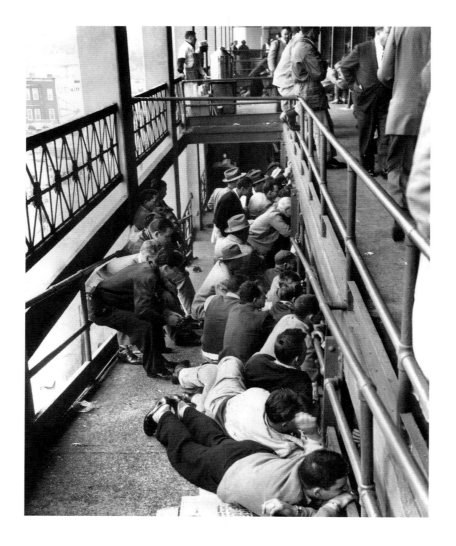

Dodgers vs. Yankees in the World Series, Ebbets Field, 1955
Carl T. Gossett Jr.

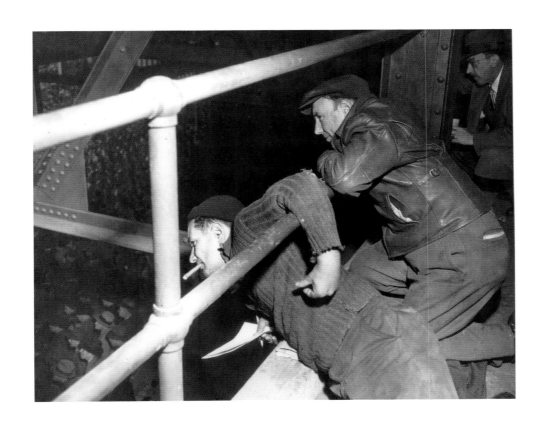

Yankees vs. Dodgers in the World Series, Yankee Stadium, 1947
Sam Falk

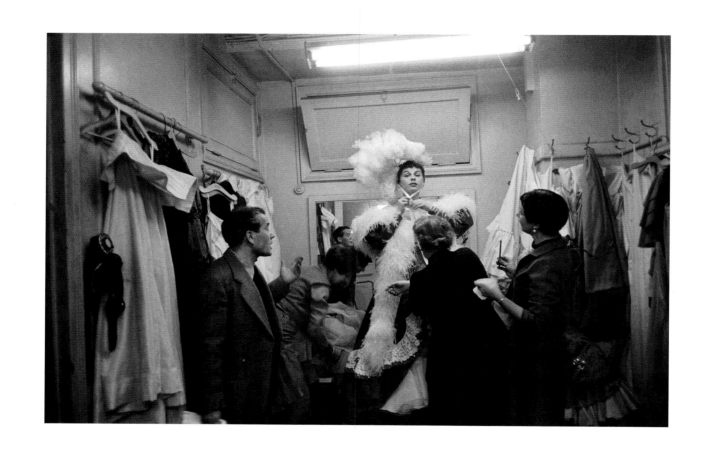

Roberta Peters prepares for *Don Pasquale*, Eaves Costumer, 46th Street, 1955
Sam Falk

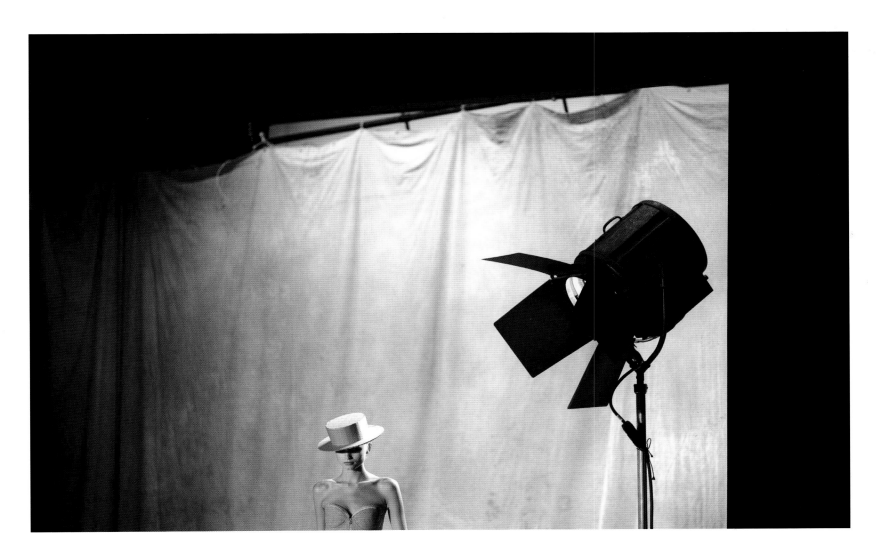

Isaac Mizrahi show, Bryant Park, 2009
Todd Heisler

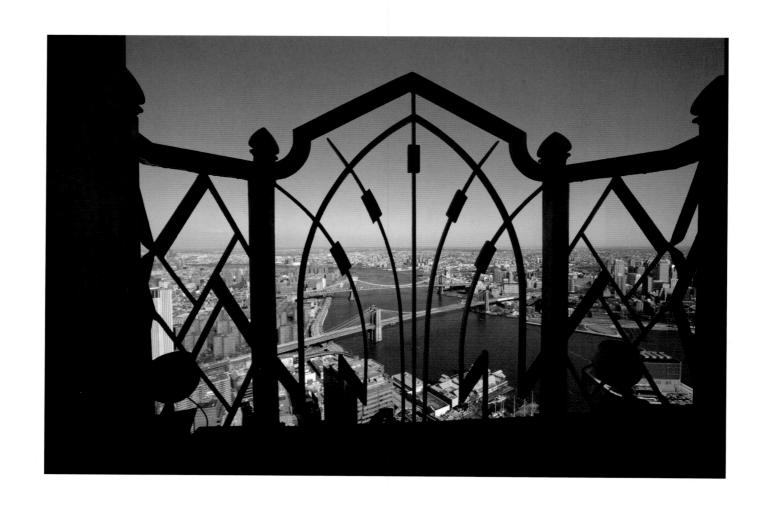

From the observation deck, 70 Pine Street, Lower Manhattan, 2012
James Estrin

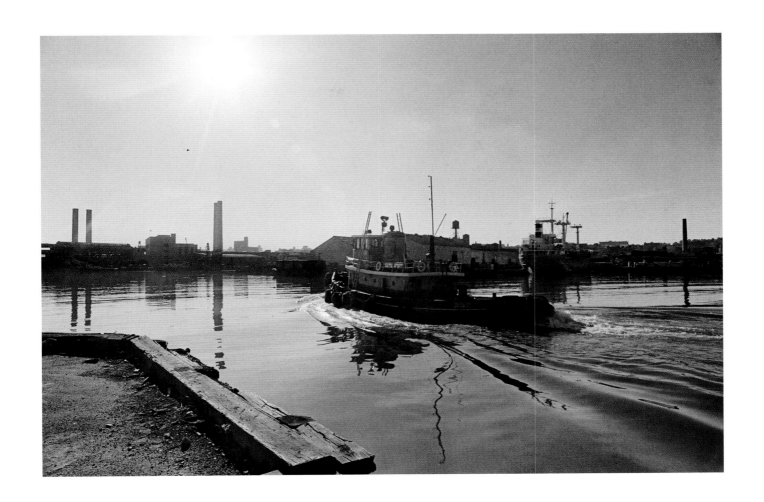

Gowanus Canal, Brooklyn, 1971
Meyer Liebowitz

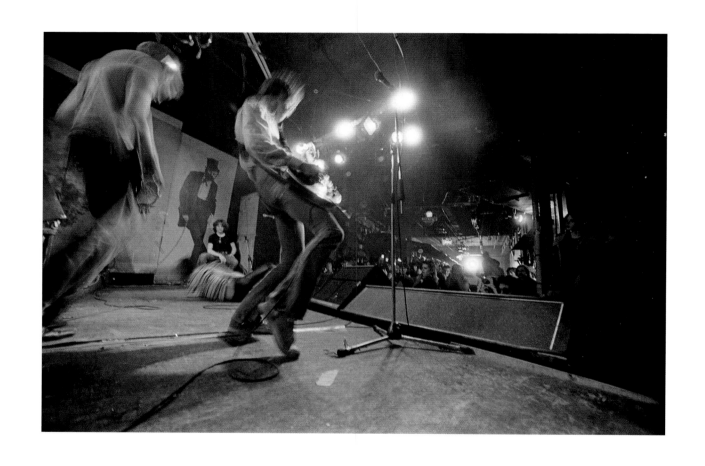

The Dead Boys at CBGB, Bowery and Bleecker Streets, 1977
Fred R. Conrad

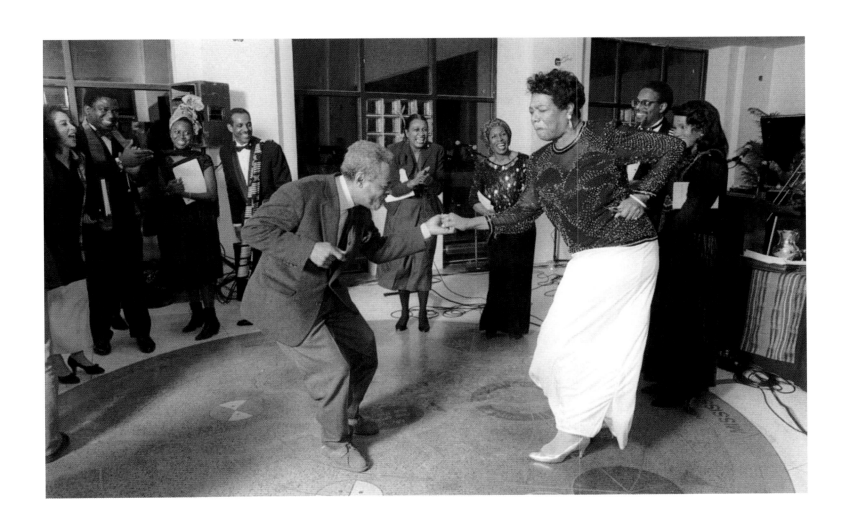

Maya Angelou and Amiri Baraka, Schomburg Library, Malcolm X Boulevard, 1991
Chester Higgins, Jr.

Washington Mews, Greenwich Village, 2017
Hiroko Masuike

The Highline at West 23rd Street, Manhattan, 2015
Hiroko Masuike

Dear Diary:

Overheard on the subway, a conversation between two 20-something women:

First woman: "I'm going to his loft in SoHo tonight. He says it's big—4,000 square feet."

Second woman: "Wow—4,000 square feet is huge!"

First woman: "I don't know. I think it probably just has really high ceilings."

Second woman: "Yeah. You're probably right."

JAY SULLIVAN

Metrocard machines, 42nd Street subway station, 2015
Ruth Fremson

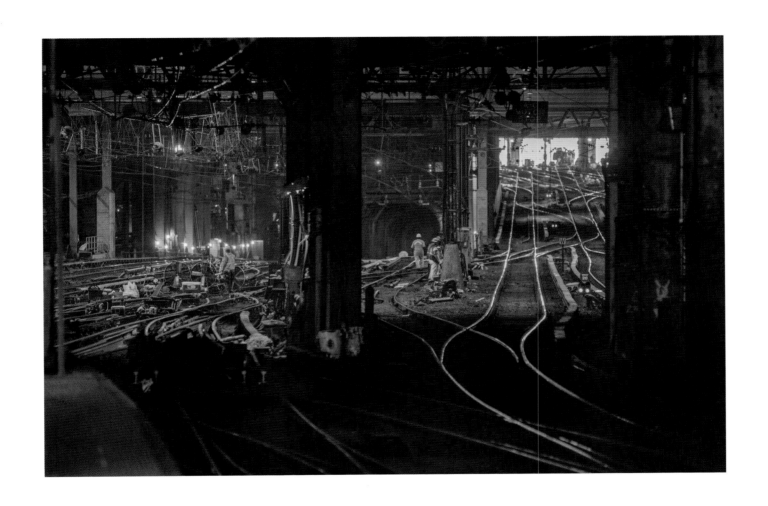

Track work at Penn Station, 2017
Hiroko Masuike

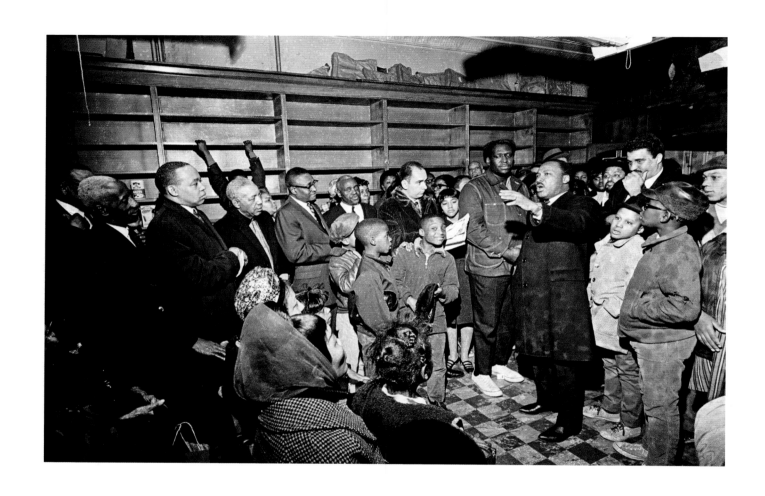

Martin Luther King Jr. in Queens, a week before his assassination,
Northern Boulevard, Corona, 1968
John Orris

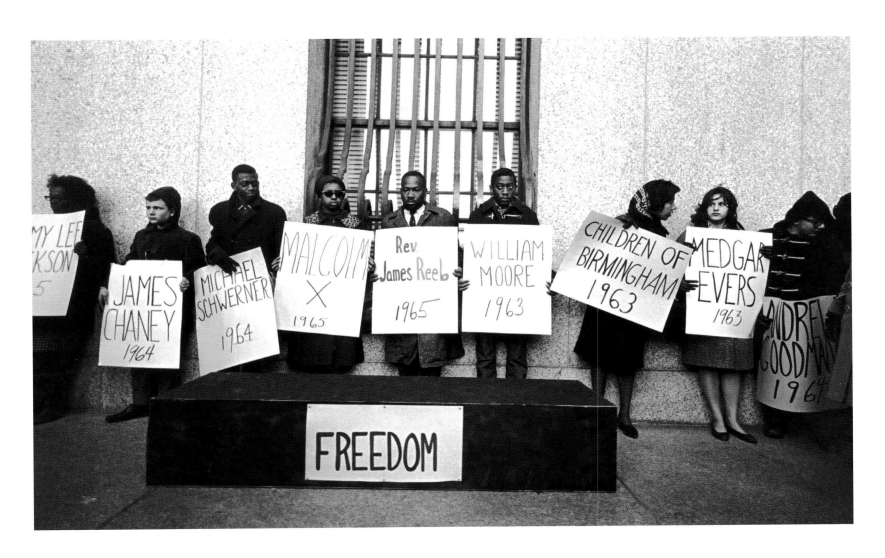

Congress of Racial Equality demonstration, Manhattan, 1965
Jack Manning

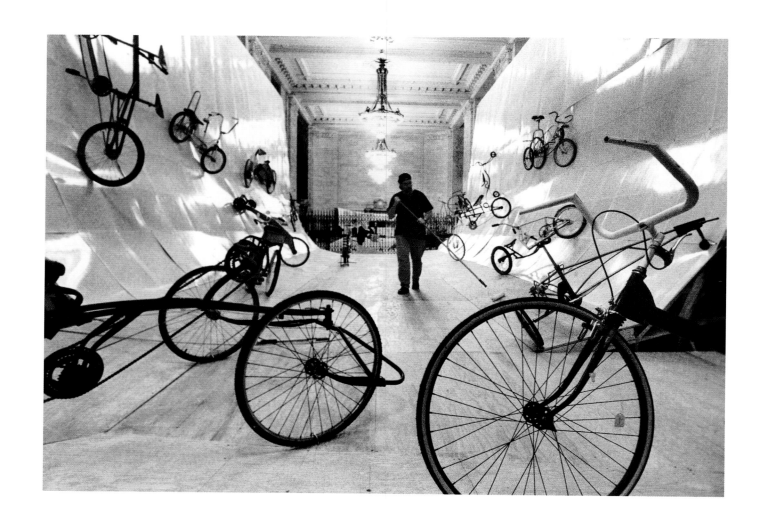

Cycles of Expression exhibition, Grand Central Terminal, 1995
Ruby Washington

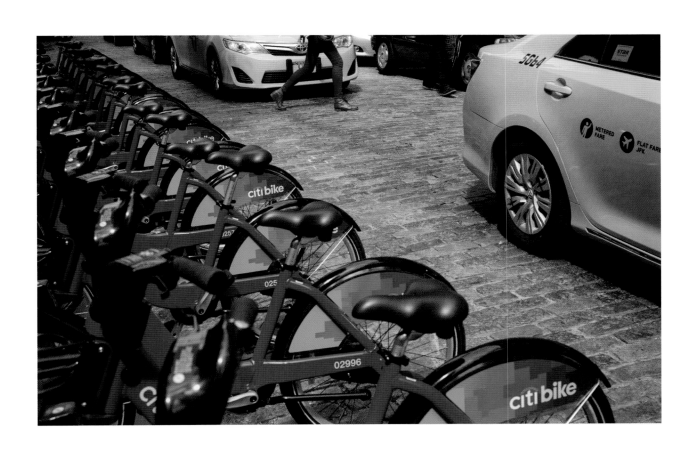

Mercer and Spring Streets, SoHo, 2013
Damon Winter

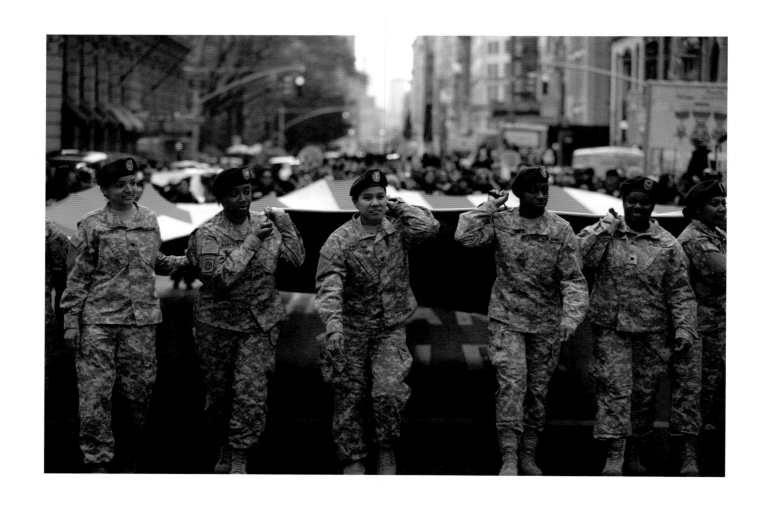

Veterans Day Parade, Fifth Avenue, 2013
Ozier Muhammad

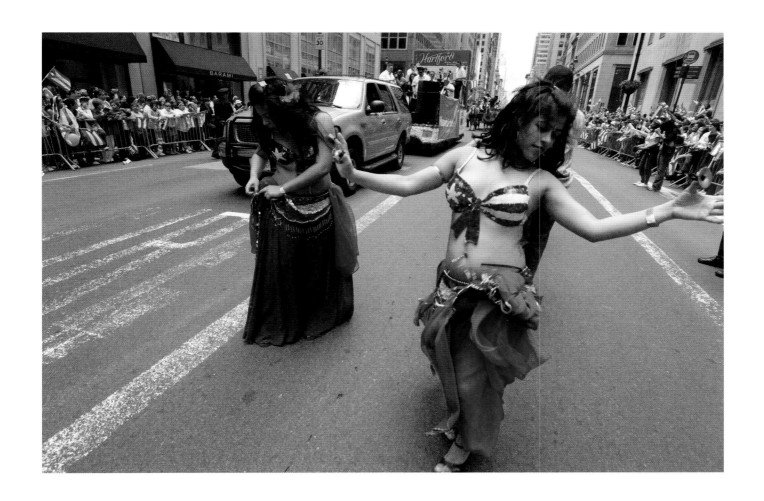

Puerto Rican Day Parade, Fifth Avenue, 2006
Michelle V. Agins

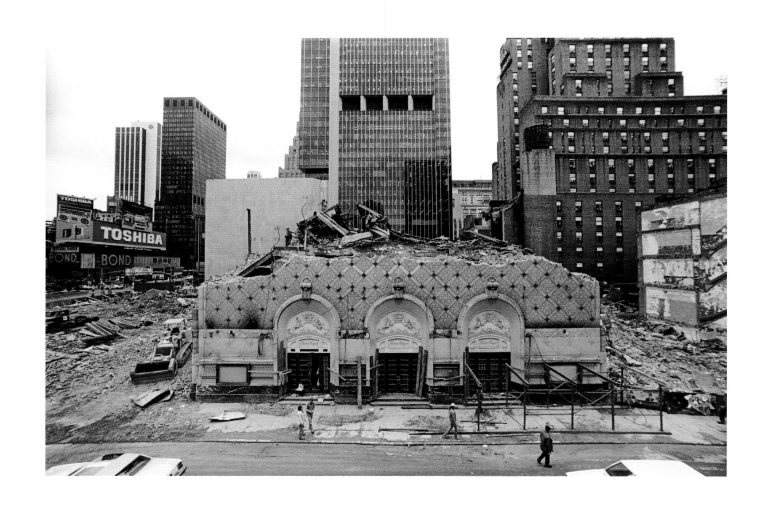

Helen Hayes Theater, West 44th Street, 2001
Fred R. Conrad

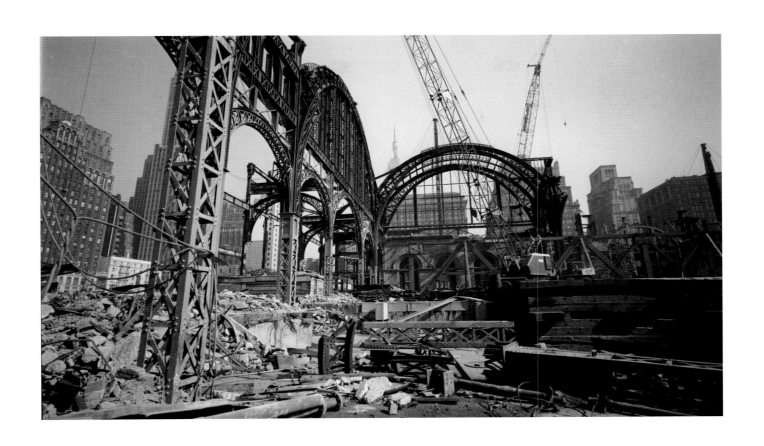

Pennsylvania Station, 1966
Sam Falk

Nick Young and Christine Ko have their engagement photo taken, Broadway and Morris Street, 2008
Todd Heisler

Fifth Avenue and 60th Street, 1971
Don Hogan Charles

Dear Diary:

I was on a crowded 96th Street crosstown bus early one recent evening when several passengers got on at the Fifth Avenue stop, including a couple carrying several large framed pictures in bubble wrap. As the bus was about to cross the park, the male half of the couple reached into a bag he was also carrying and pulled out a small blue Tiffany box, tied with white ribbon. The woman had a giant smile on her face—at first I thought they had bought whatever was in the box together, but the young man handed the little package to his companion and she began opening it expectantly. Nestled on velvet was a diamond ring, and it went right on her finger. The two were smiling as they gazed into each other's eyes. "We met on this bus," the woman explained to her fellow passengers. Taken with the moment, all the other riders applauded.

SHELLEY ANN HAINER

Gotham Scooter Rally, Madison Avenue, 2005
Richard Perry

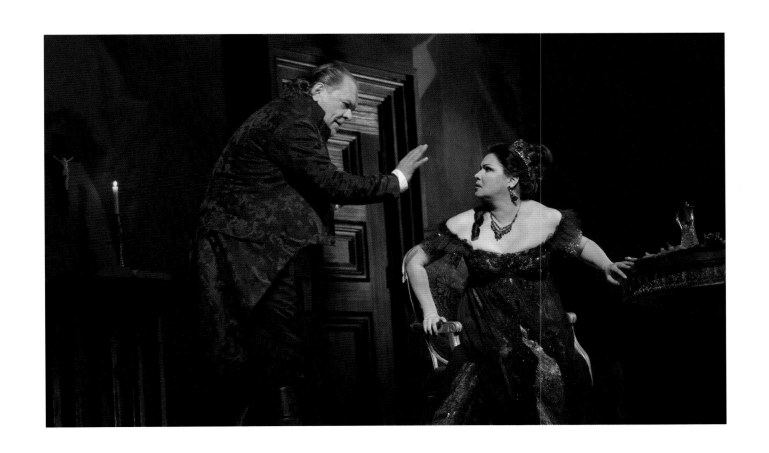

Michael Volle and Anna Netrebko in *Tosca*, Metropolitan Opera House, 2018
Sara Krulwich

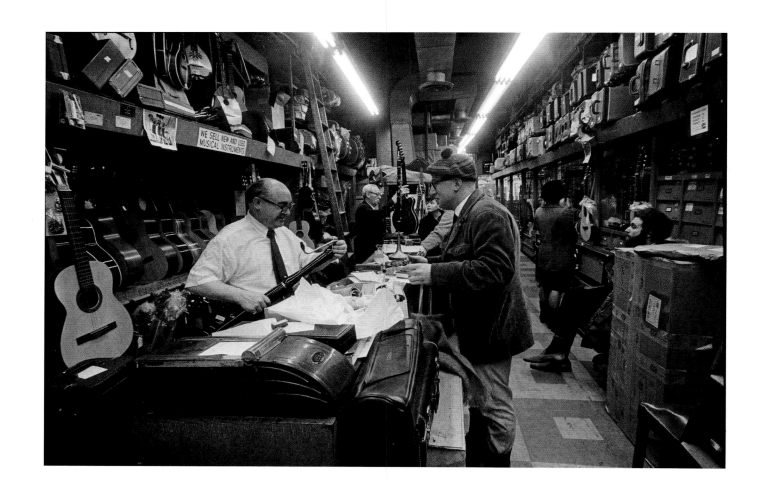

Charles Ponte with a customer at his music store,
West 54th Street, where such stores once flourished, 1968
Patrick A. Burns

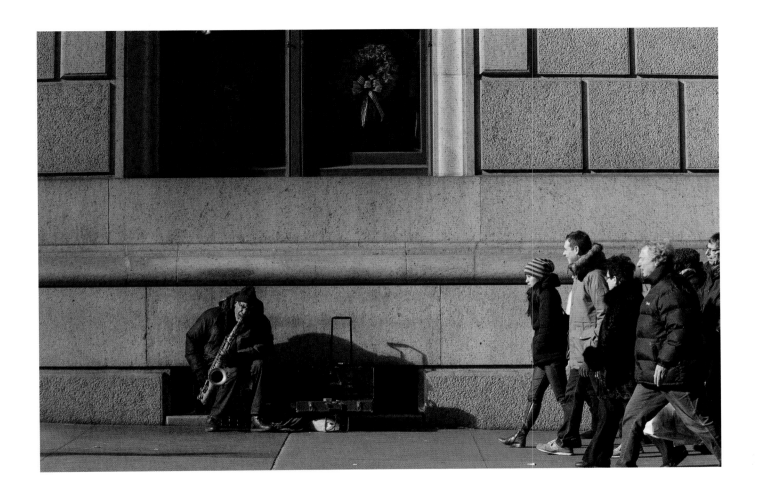

Blowing cool in the cold, Lee Goodson on Fifth Avenue and 54th Street, 2013
Ruth Fremson

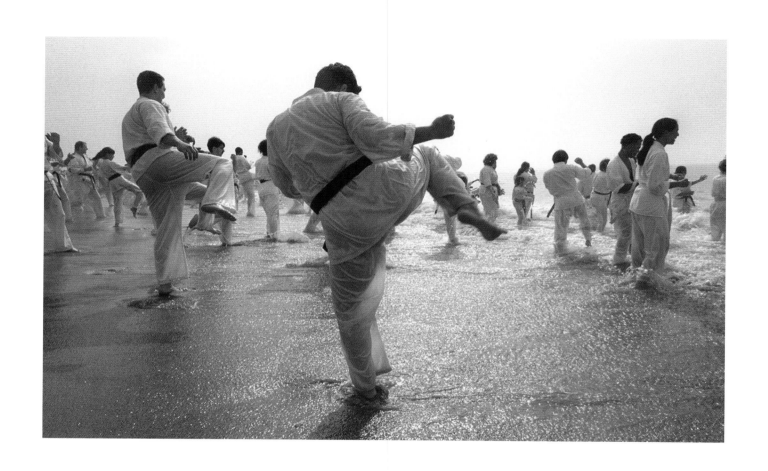

World Seido Karate Organization, Rockaway Beach, Queens, 1999

Librado Romero

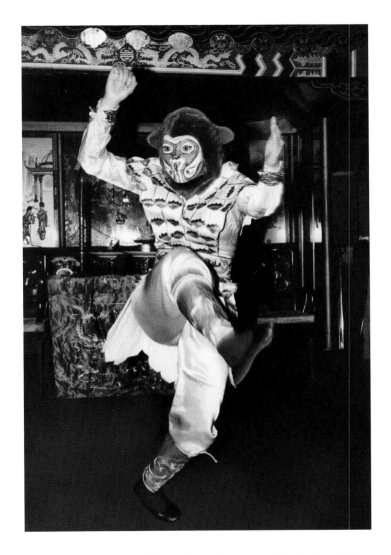

Dance of the Monkey, Flower Drum Restaurant, Manhattan, 1980
Chester Higgins Jr.

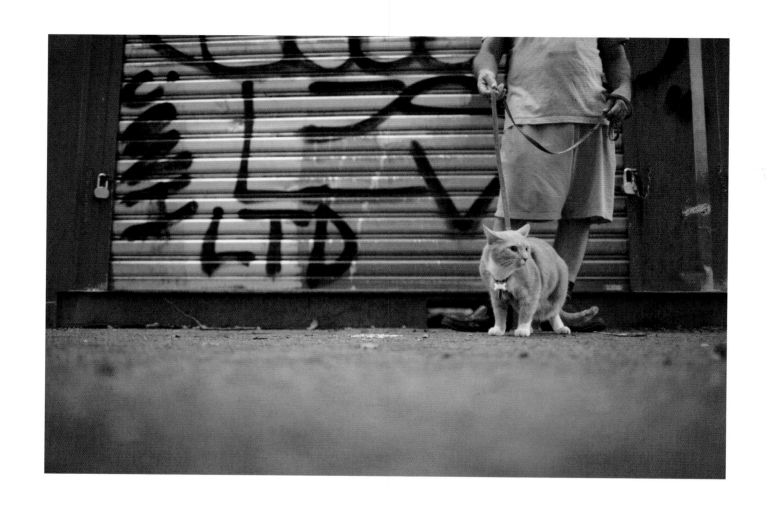

Michael Lechrichia walks Vito Vincent, East River Park, 2013
Todd Heisler

Preparing for a Mardi Gras ball, Sheraton Astor Hotel, 1956
Meyer Liebowitz

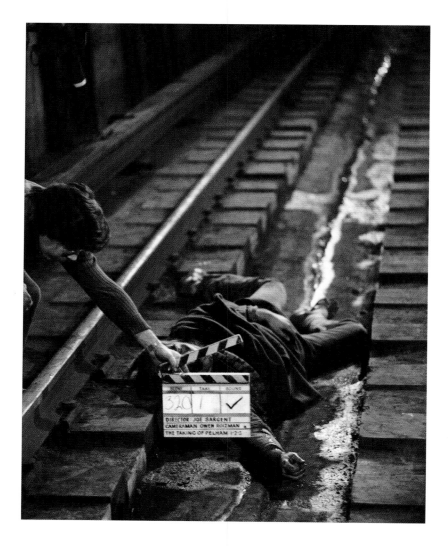

The Taking of Pelham One Two Three on location, Brooklyn, 1974
Larry C. Morris

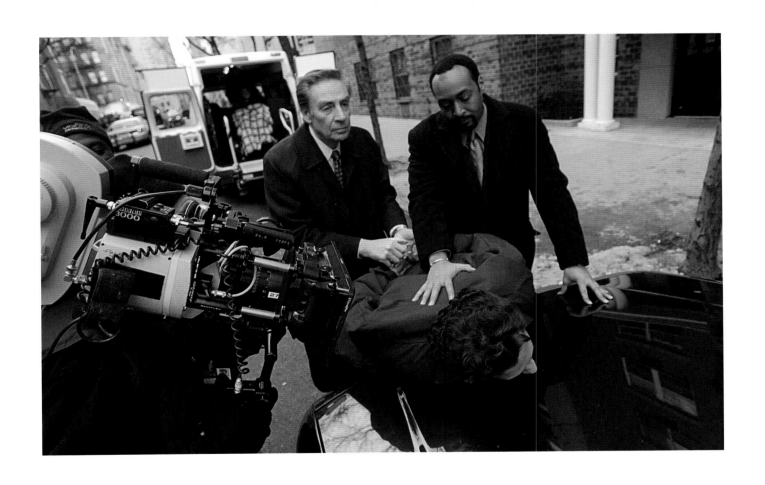

Jerry Orbach and Jesse L. Martin shooting *Law and Order*, West 54th Street, 2004
Librado Romero

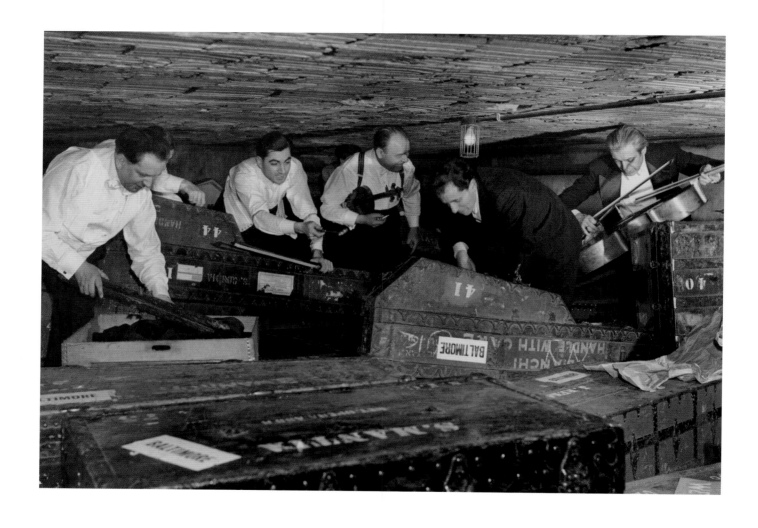

Met Opera Orchestra members pack their instruments, 39th Street and Broadway, 1942

Sam Falk

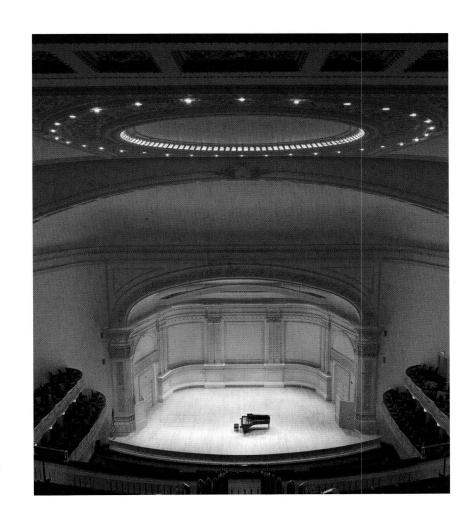

Carnegie Hall stage, Seventh Avenue and 57th Street, 1990
Fred R. Conrad

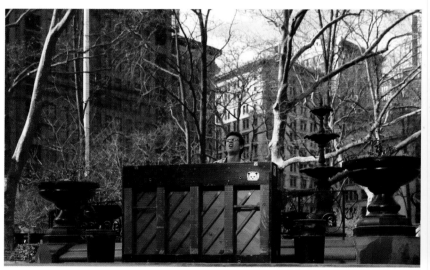

Johnny Marx on the keyboards, Madison Square Park, 2014
Chang W. Lee

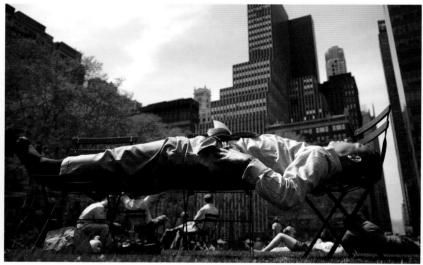

Taking a break from reading in Bryant Park, 2009
Todd Heisler

A MANHATTAN MOMENT

I can tell you
that the yellow turned
to red and I stepped
off the curb
and a car passed inches
from my front shoe.
So bullet-fast.
I can't tell you
about panic
or rage, sorrow
or regret.
All I felt
a minute later
was open-mouthed
amazement,
to be already
thinking about
what to have
for lunch.

Robert K. Johnson

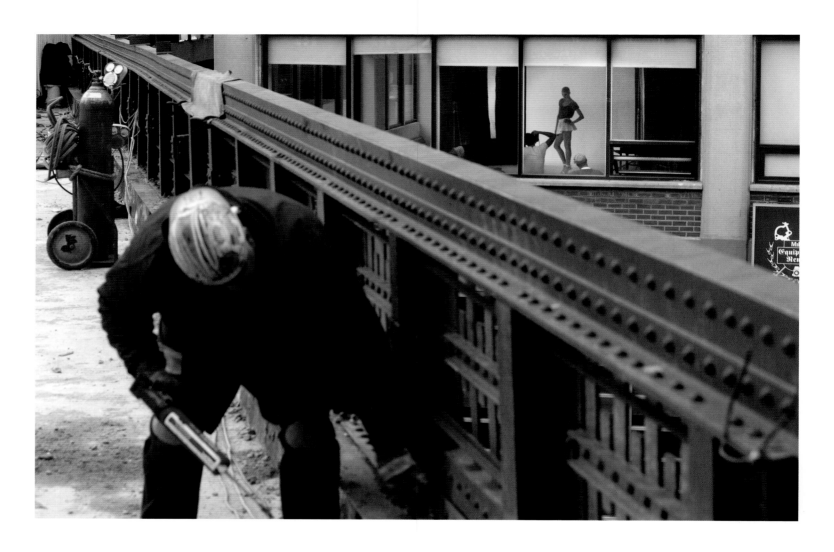

High Line, Manhattan, 2007
Damon Winter

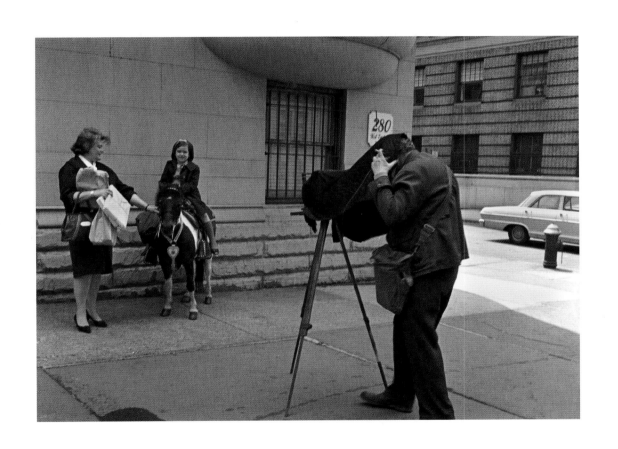

Paul Rosen snaps and Billy poses, Manhattan, 1963
John Orris

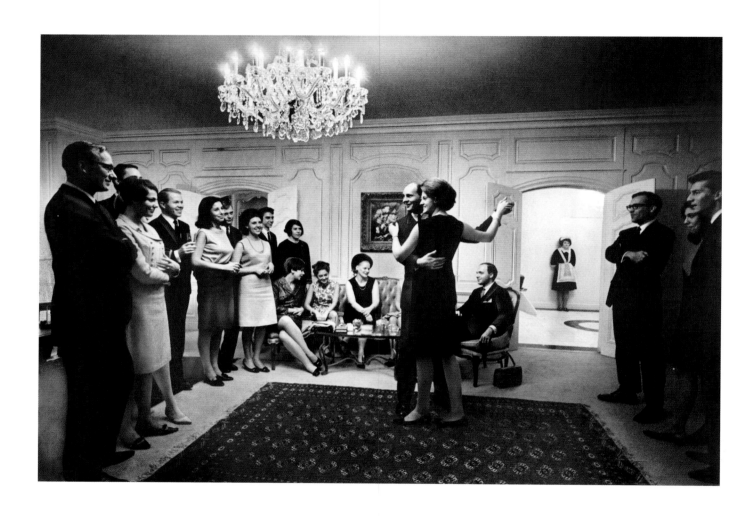

Liselotte Waldheim and Carl Ritter von Rohrer,
Practicing for the Viennese Opera Ball, Fifth Avenue, 1966
Jack Manning

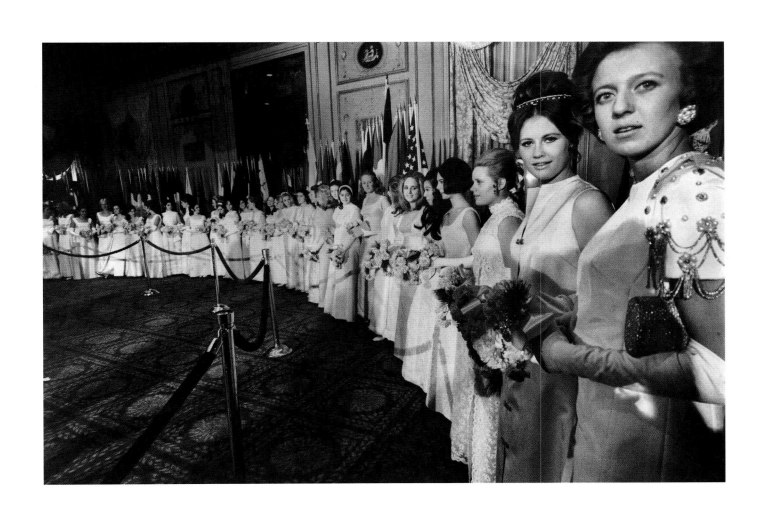

Debutante Ball, Waldorf Astoria, 1968
Larry C. Morris

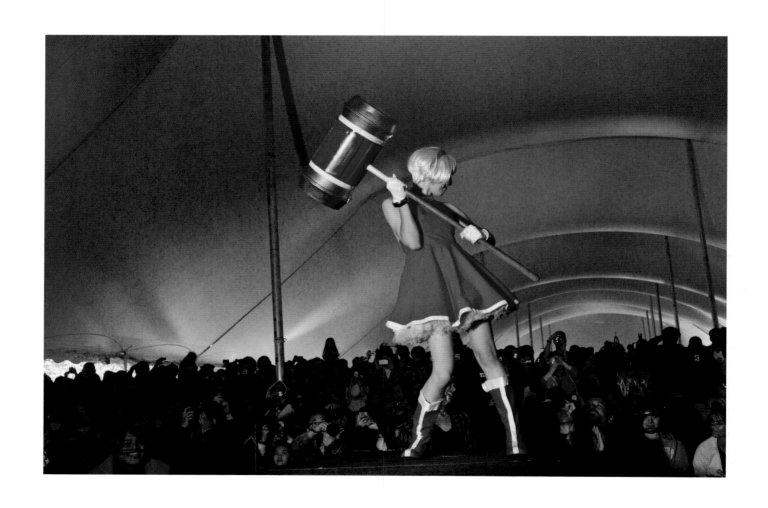

Sakura Matsuri Festival, Brooklyn Botanic Garden, 2012
Fred R. Conrad

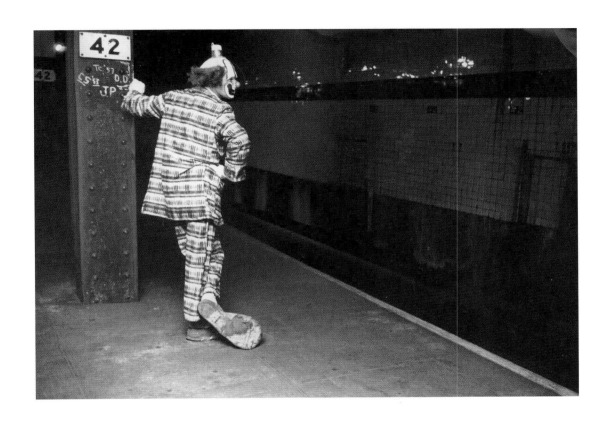

Jazzbo waits for the Rockaway express, Times Square, 1958
Allyn Baum

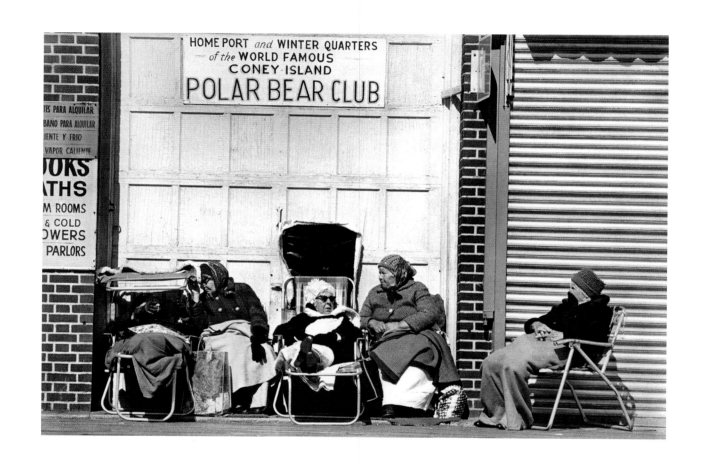

Boardwalk, Coney Island, 1975

Eddie Hausner

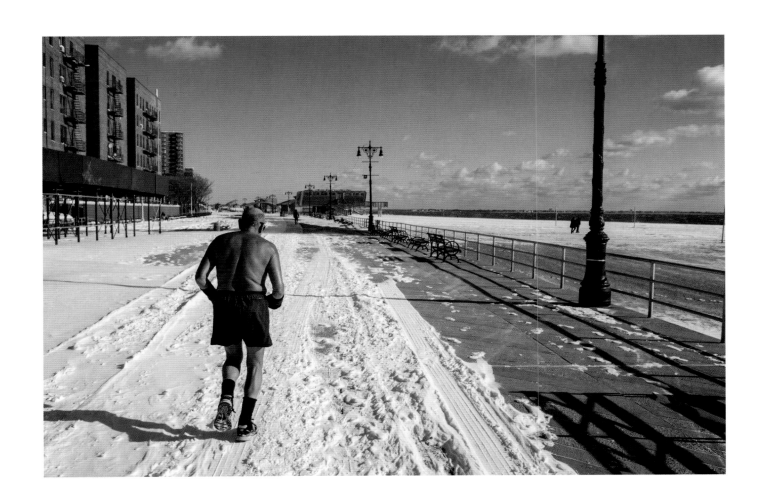

Gary Atlas, Brighton Beach, Brooklyn, 2018
Todd Heisler

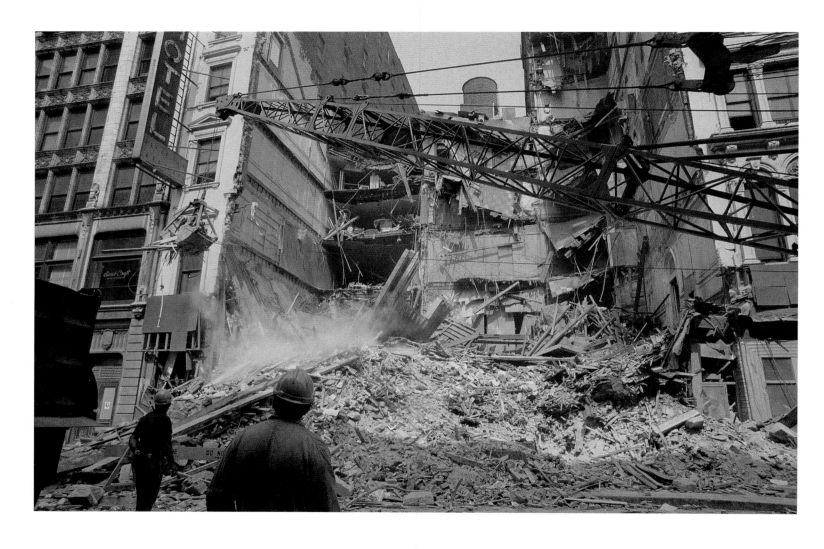

Broadway Central Hotel after its collapse, Broadway near Houston Street, 1973
Meyer Liebowitz

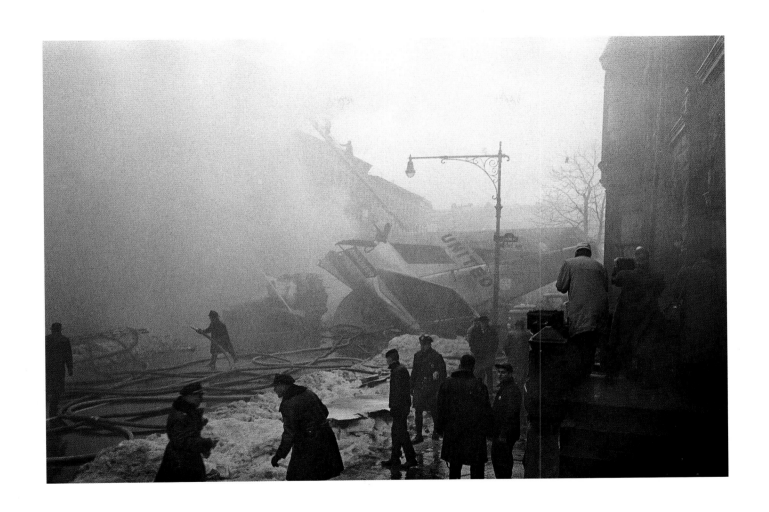

United Airlines plane wreckage following a midair collision, Park Slope, Brooklyn, 1960
Ernie Sisto

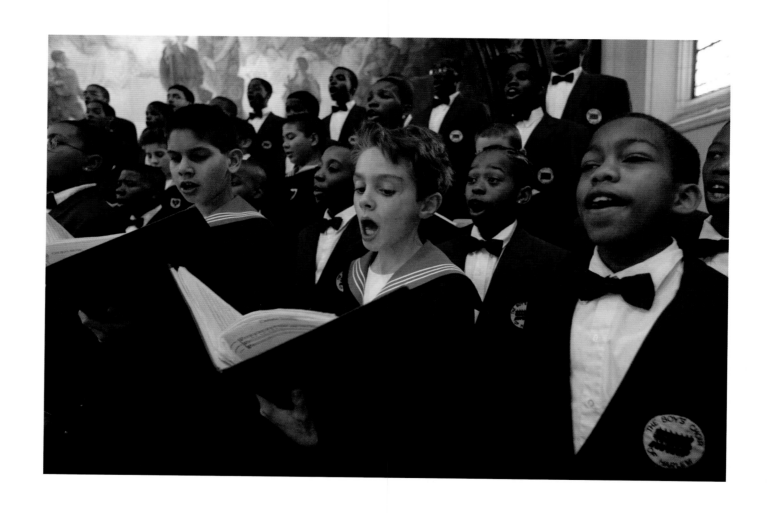

Boys Choir of Harlem and the Vienna Boys Choir, Great Hall, City College, 2002
Suzanne DeChillo

Justice Sonia Sotomayor and the Cardinal Spellman High School band,
Sonia Sotomayor Houses, Bronx, 2010
Todd Heisler

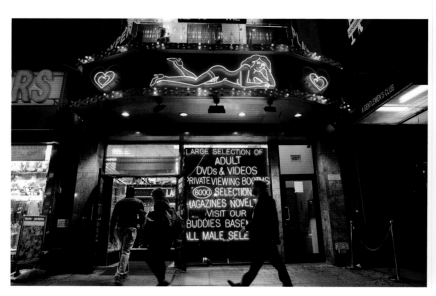

The Playpen peep show, Eighth Avenue, 2014
Richard Perry

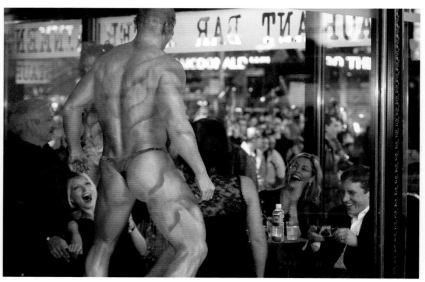

New Year's party, Times Square, 2002
Richard Perry

They used to call it Hell's Kitchen,
But now that it's starting to cook,
(And gaining in fame)
They'll be changing its name
And calling it Hell's Breakfast Nook.
MICHAEL WINSHIP

Hong Kong Dragon Boats, Flushing Meadows, Queens, 2010
Suzanne DeChillo

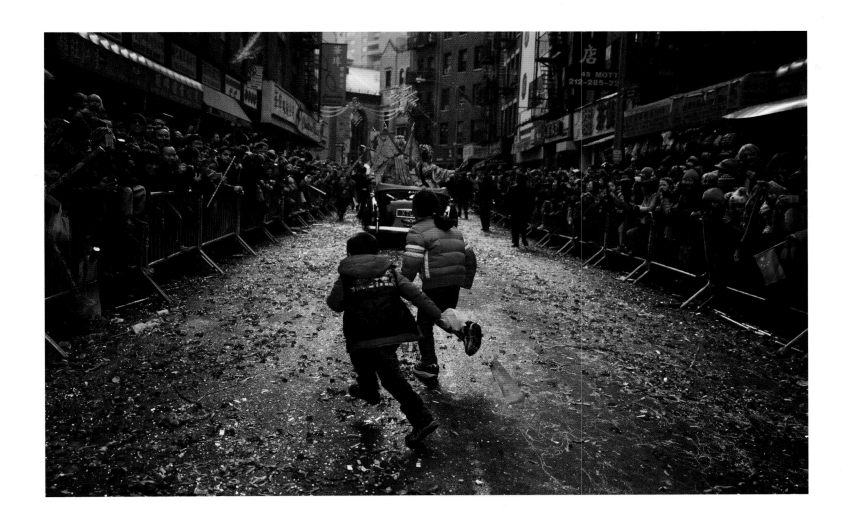

Chinese New Year parade, Mott Street, 2014
Damon Winter

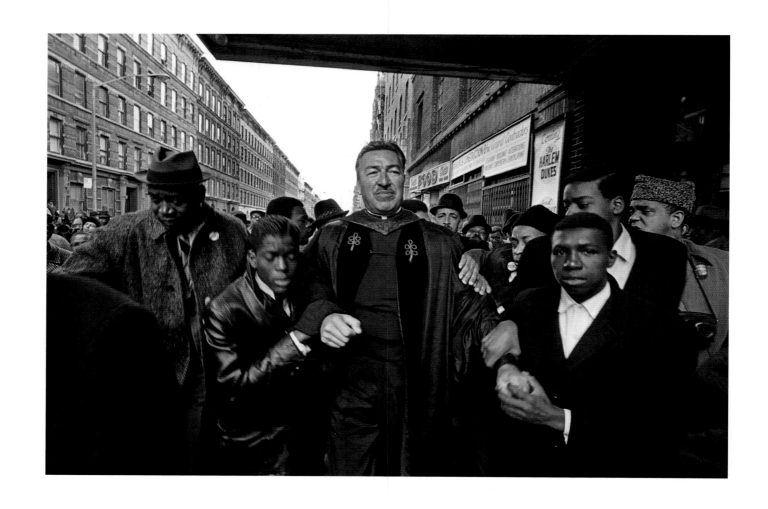

Adam Clayton Powell Jr. and followers, Seventh Avenue, Harlem, 1968
Don Hogan Charles

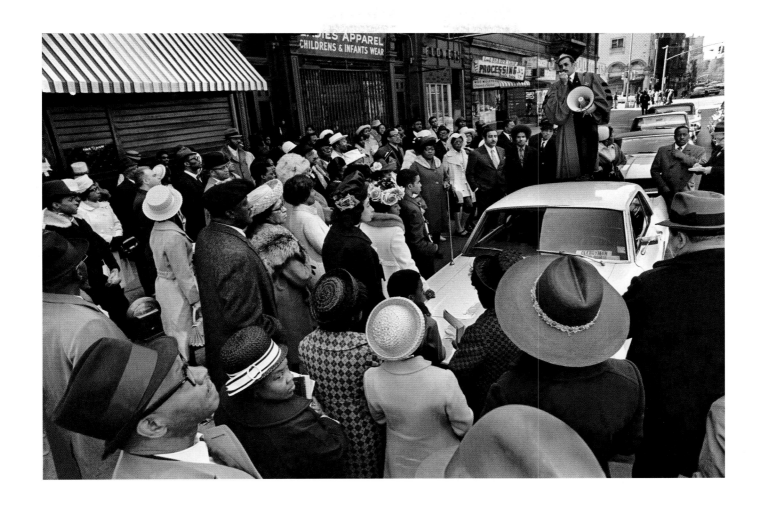

Rev. Wyatt T. Walker speaks to parishioners, 116th Street, Harlem, 1970
Michael Evans

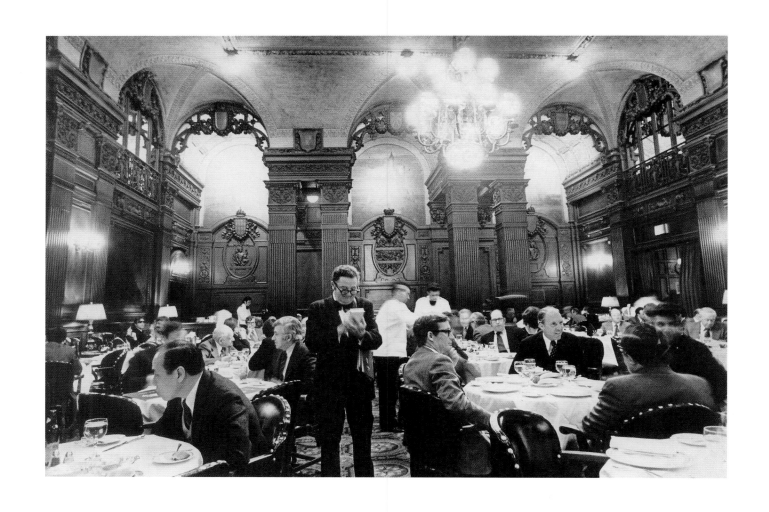

The Oak Room, Plaza Hotel, 1974
Paul Hosefros

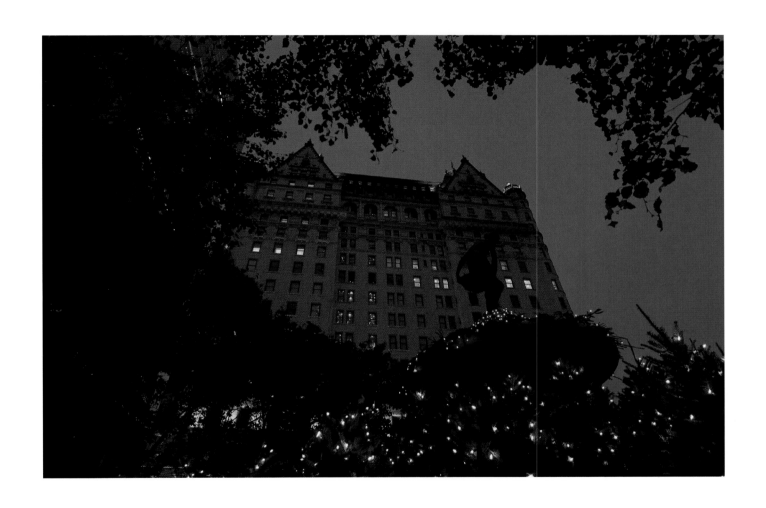

Plaza Hotel, Fifth Avenue and 60th Street, 2011
Ruth Fremson

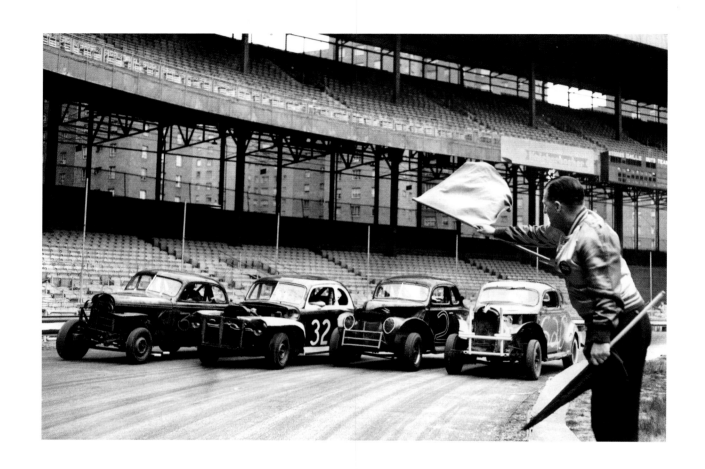

Prepping for the "Grand National" stock car race, Polo Grounds, 1959
Ernie Sisto

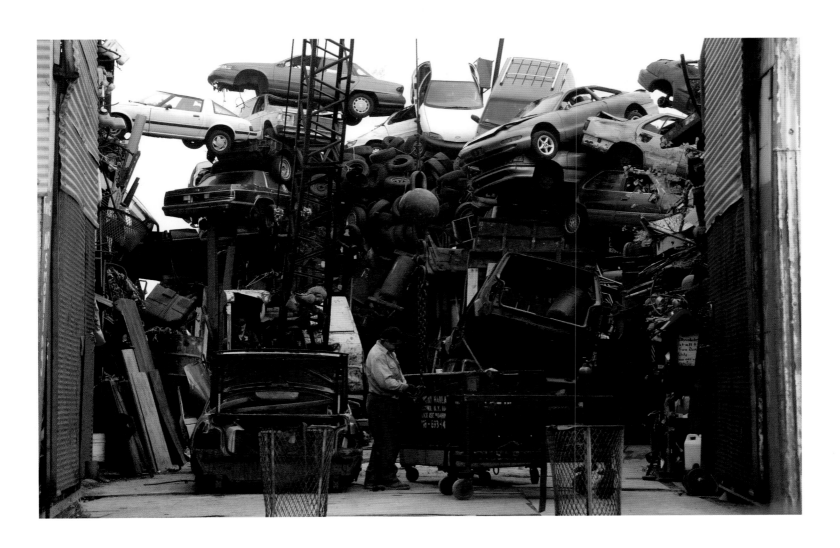

Oak Point Avenue, Bronx, 2003
Joyce Dopkeen

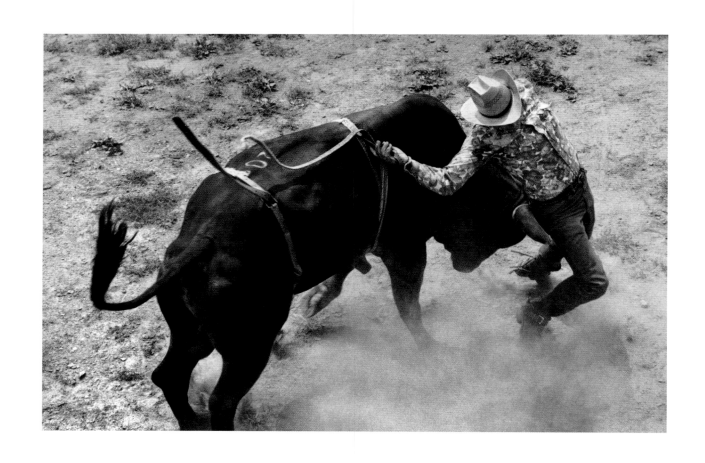

Bull rider Jack Sogen, Weissglass Stadium, Staten Island, 1970
Barton Silverman

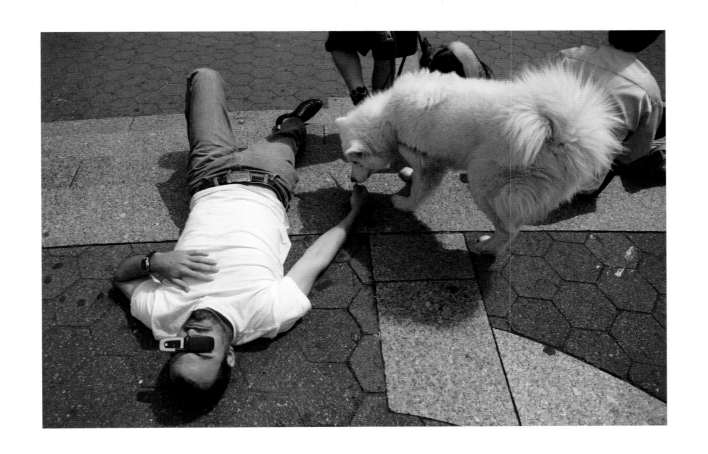

Union Square Park, 2009
Damon Winter

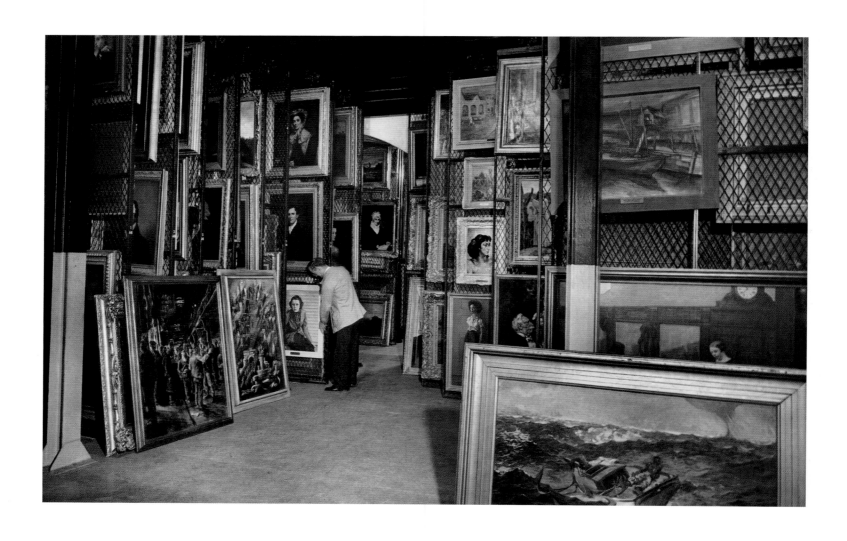

In the Catacombs of the Metropolitan Museum of Art , 1946

The New York Times

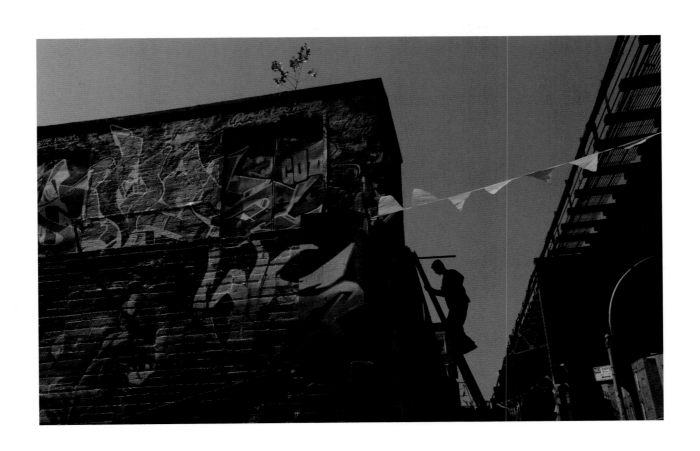

Jonathan Cohen, aka Meres One, Five Pointz, Long Island City, 2015
Todd Heisler

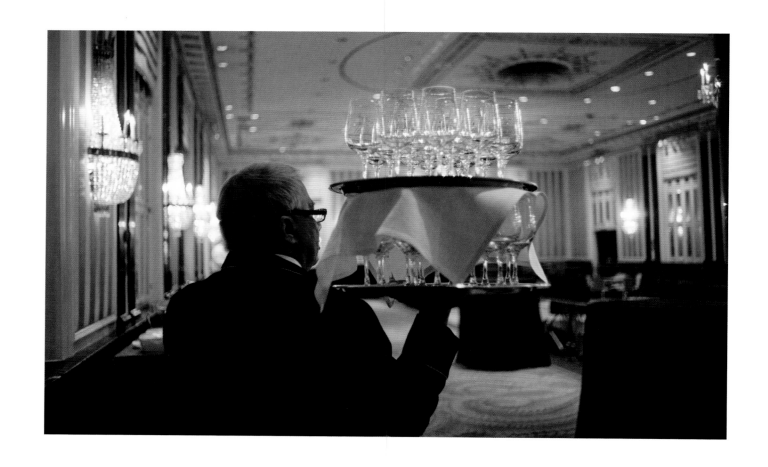

Victor Sala, banquet waiter, Waldorf Astoria, Park Avenue, 2015
Todd Heisler

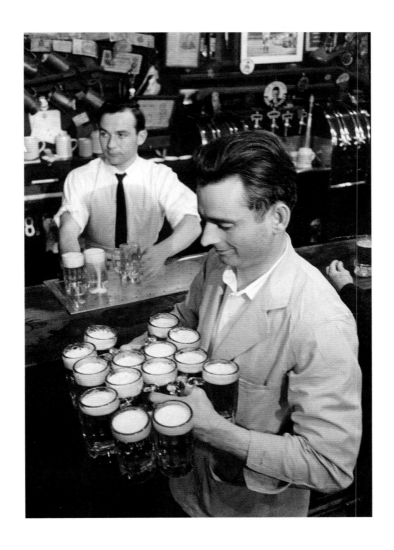

McSorley's Old Ale House, East Seventh Street, 1966
Sam Falk

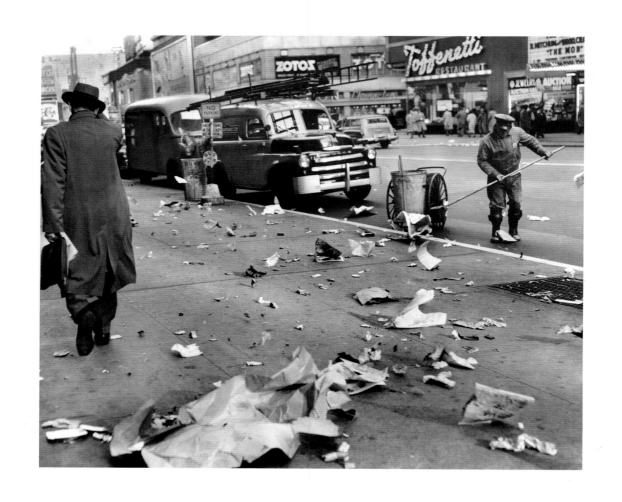

Times Square, 1953
Neal Boenzi

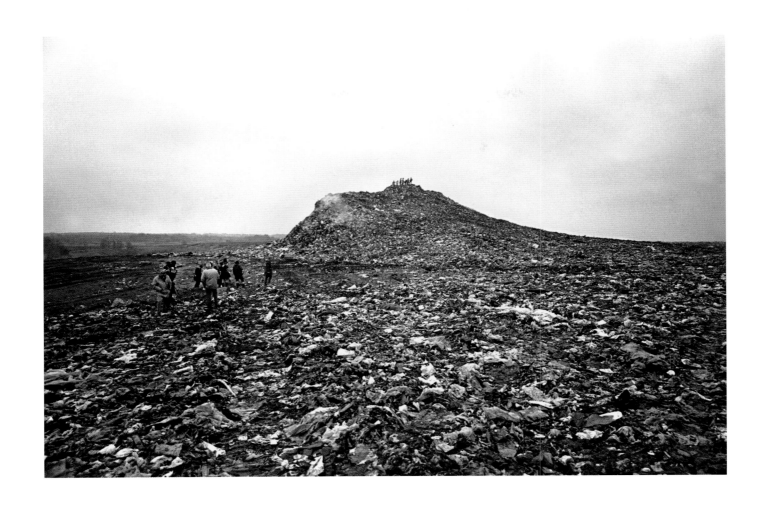

Fresh Kills landfill, Staten Island, 1972
William E. Sauro

Whitney Museum of American Art, Gansevoort Street, 2015
Damon Winter

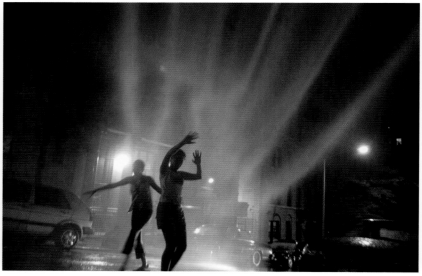

Hamilton Heights, Manhattan, 2001
Chang W. Lee

THE AVENUE DESERTED
Roller-
skating in the rain, the best
of fellows in the worst of times,
he has a butterfly chic in his elbows.
Such dissection of a puddle is pure dash.
The water leaps up behind him
with the obedience that usually
follows a taxi.
It really looks like something
More than love, or the late, wet hour
That makes him lurch so beautifully
Down the street -
He doesn't look banished or even damp.
This must be his profession.

C.L. KEYWORTH

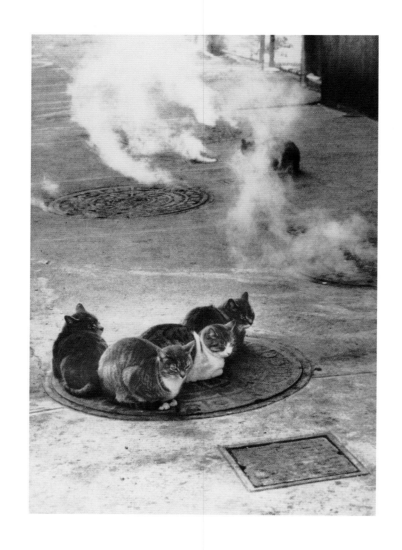

Meatpacking District, Manhattan, 1970s
Carl T. Gossett Jr.

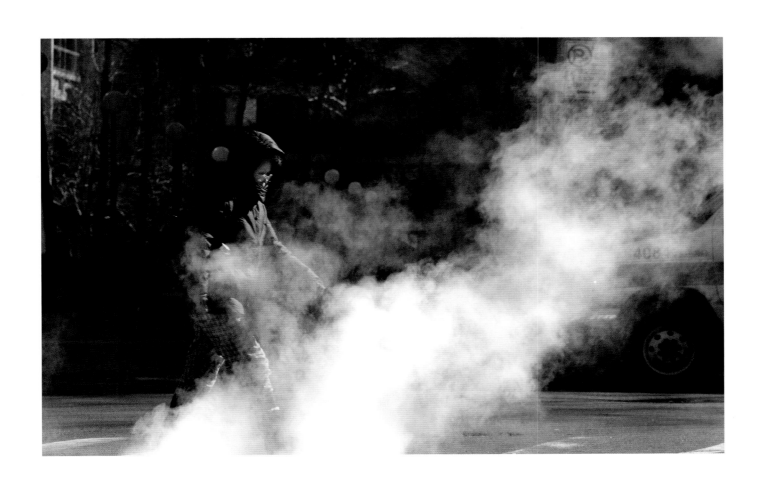

Gold Street, Lower Manhattan, 2006
Tyler Hicks

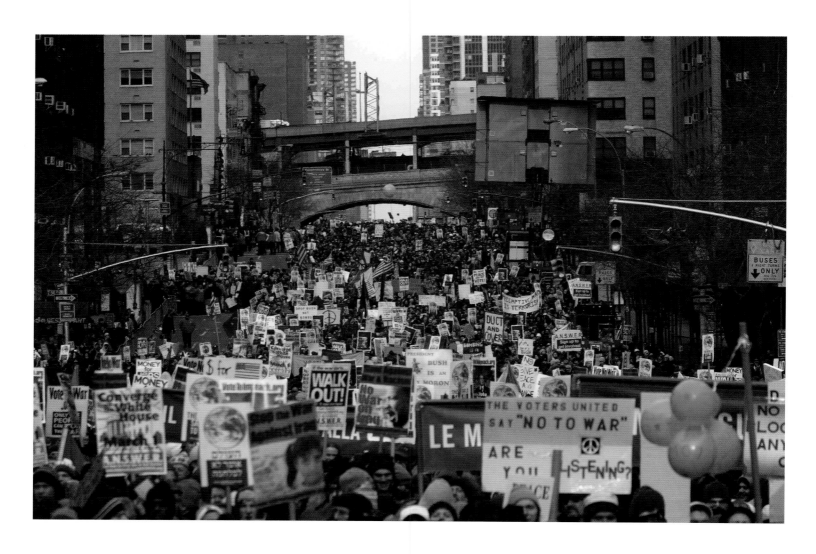

Antiwar demonstration, First Avenue near the United Nations, 2003
Suzanne DeChillo

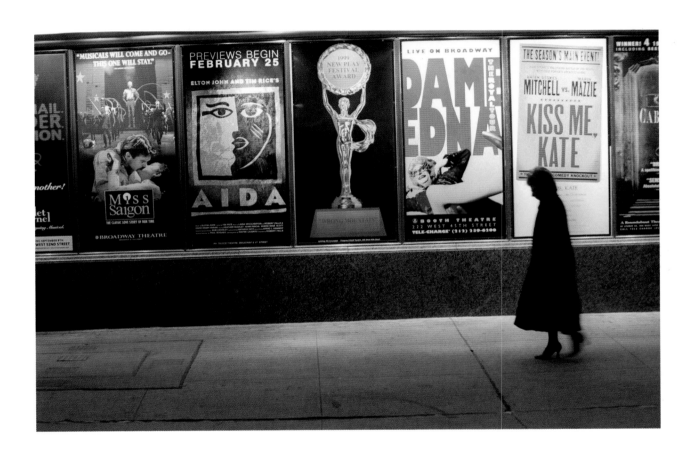

Theater District, 1999
Richard Perry

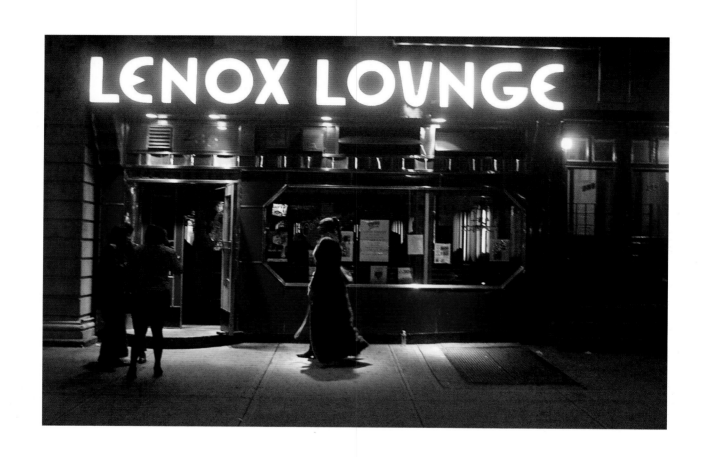

Harlem, 2000
Chang W. Lee

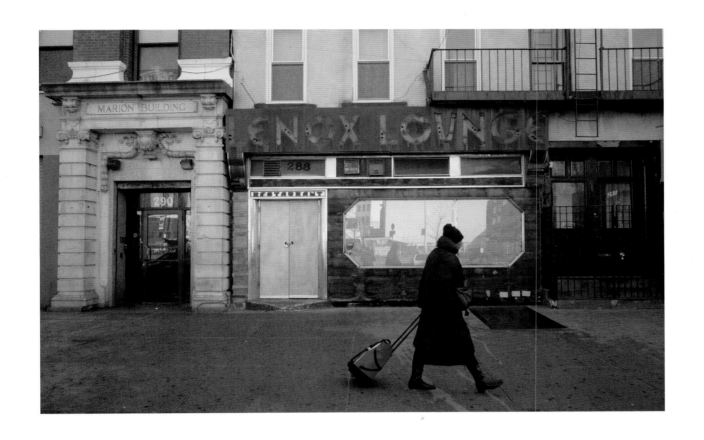

Harlem, 2013
Ozier Muhammad

Fifth Avenue and 101st Street, 2010
Ruth Fremson

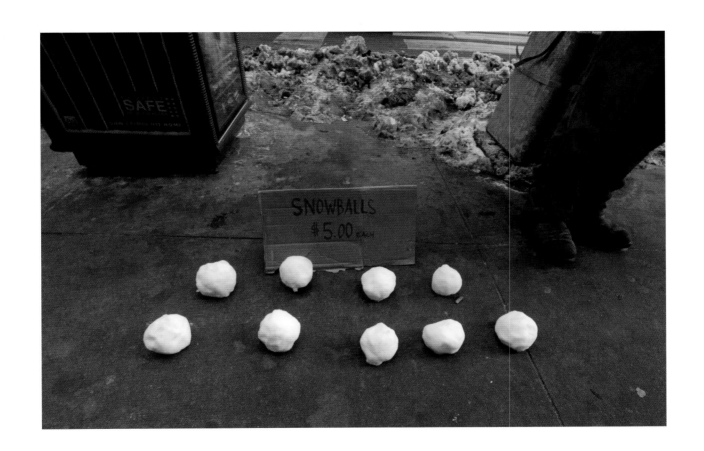

Times Square, 2004
Don Hogan Charles

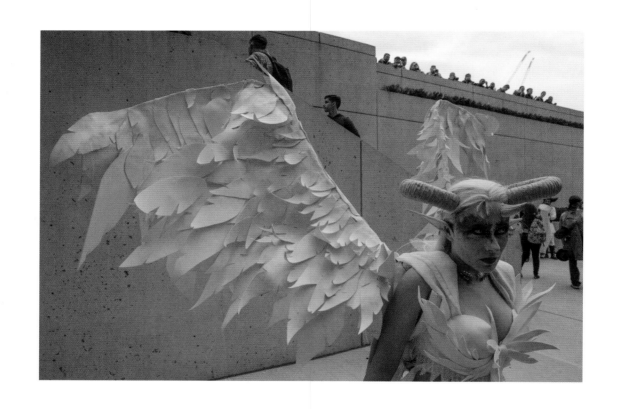

Comic Con, Javits Center, Manhattan, 2014
Fred R. Conrad

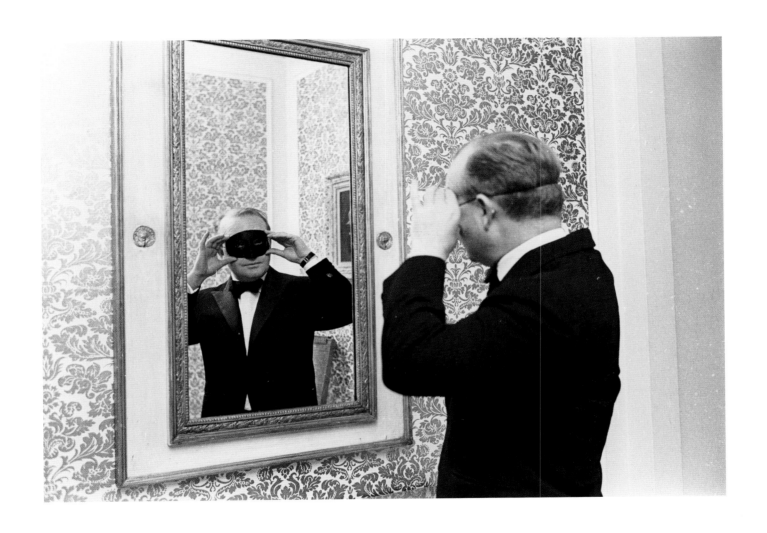

Truman Capote at the Black and White Ball, Plaza Hotel, 1966
Barton Silverman

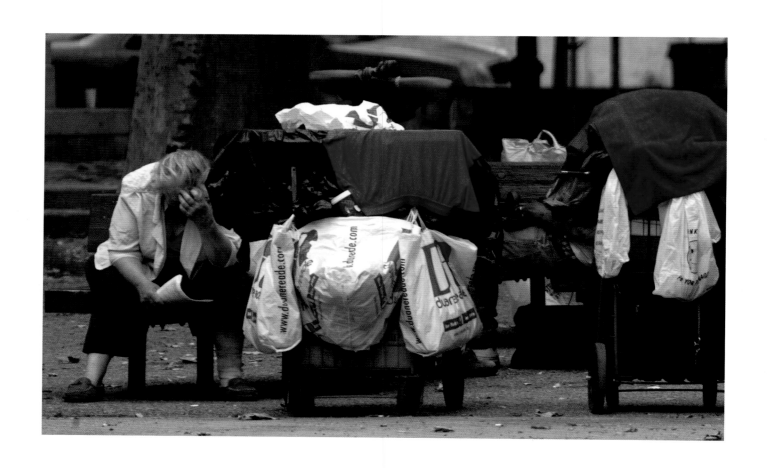

Ninth Avenue and 28th Street, 2003
James Estrin

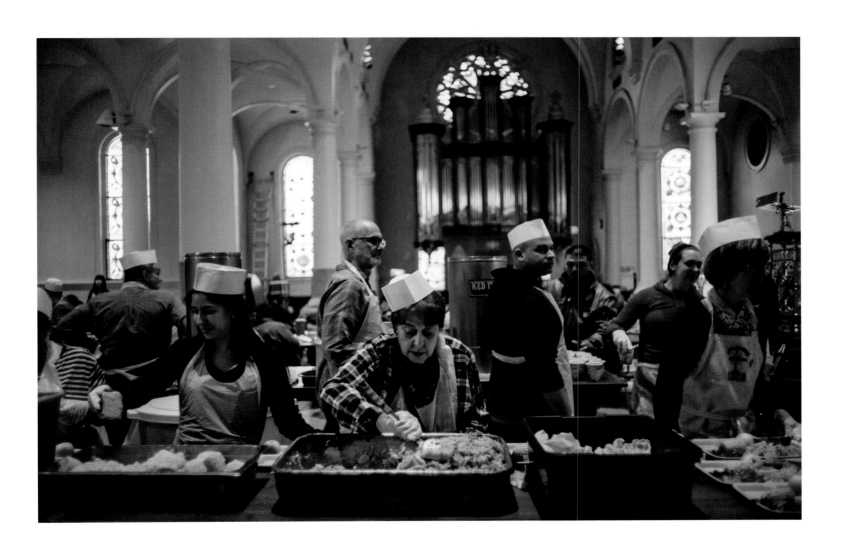

Church of the Holy Apostles, Ninth Avenue near 29th Street, 2015
Todd Heisler

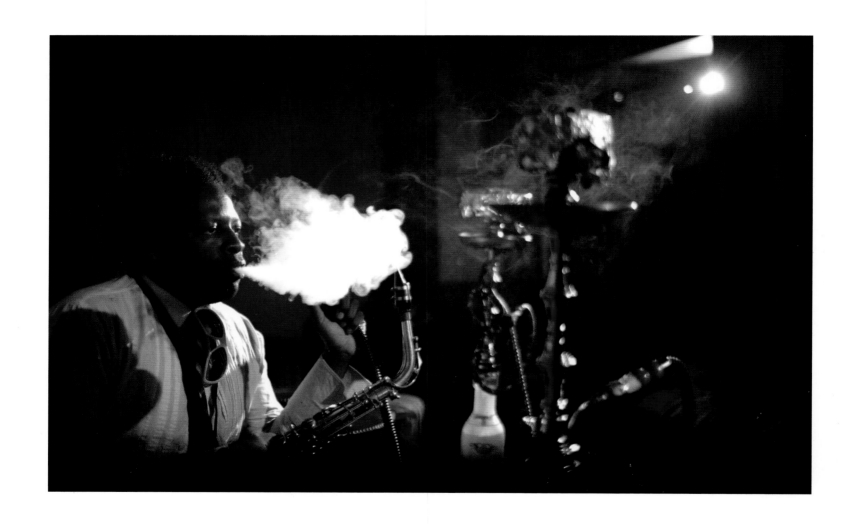

Alto saxophonist Micah Gaugh, Café Khufu, East Village, 2010
Ozier Muhammad

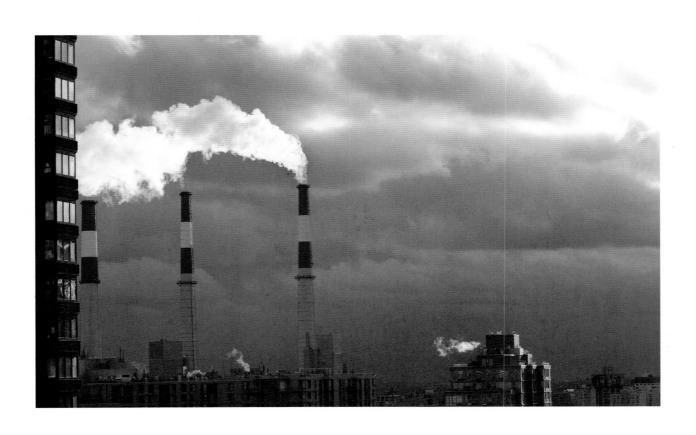

Astoria Generating Station, Queens, 2012
Ruth Fremson

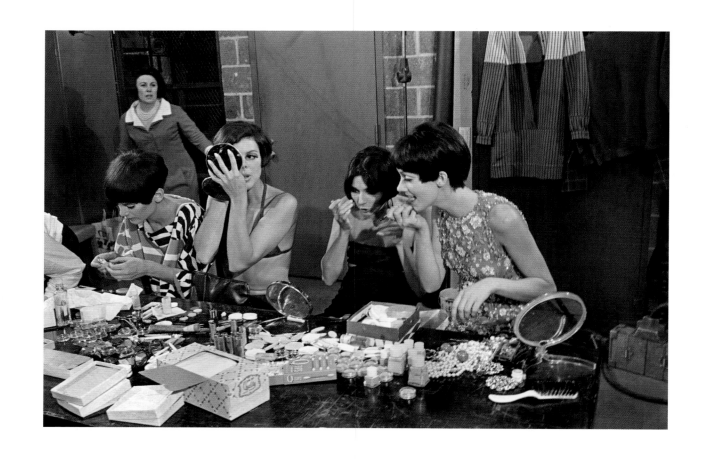

Coty Awards Show, Metropolitan Museum of Art, 1966
Robert Walker

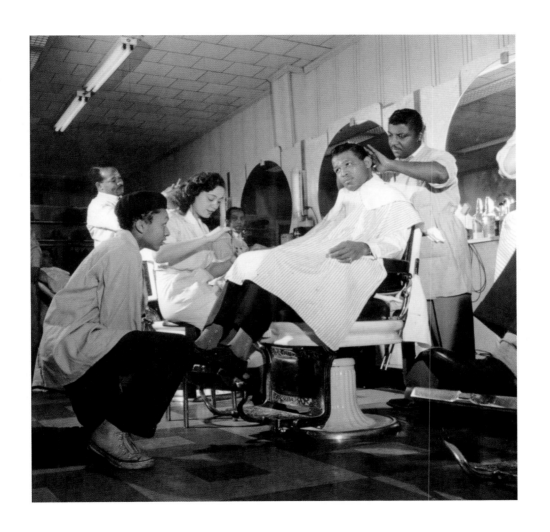

Sugar Ray Robinson, 123rd Street, Harlem, 1951
Sam Falk

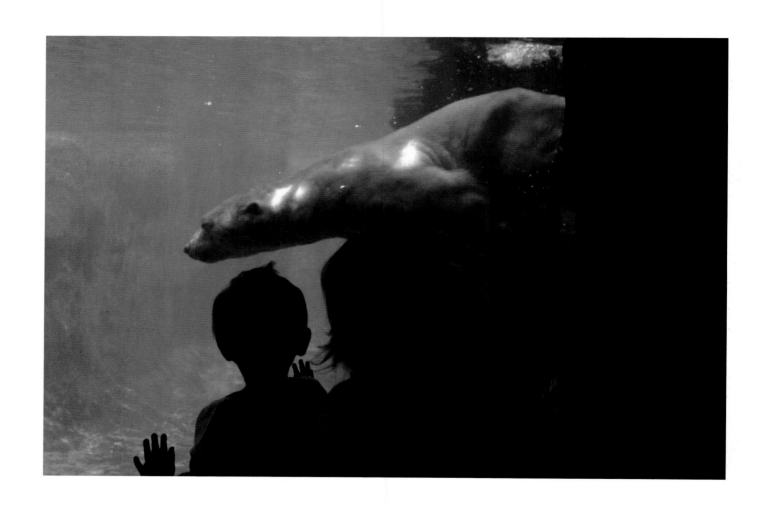

Gus the polar bear, Central Park Zoo, 2011
Hiroko Masuike

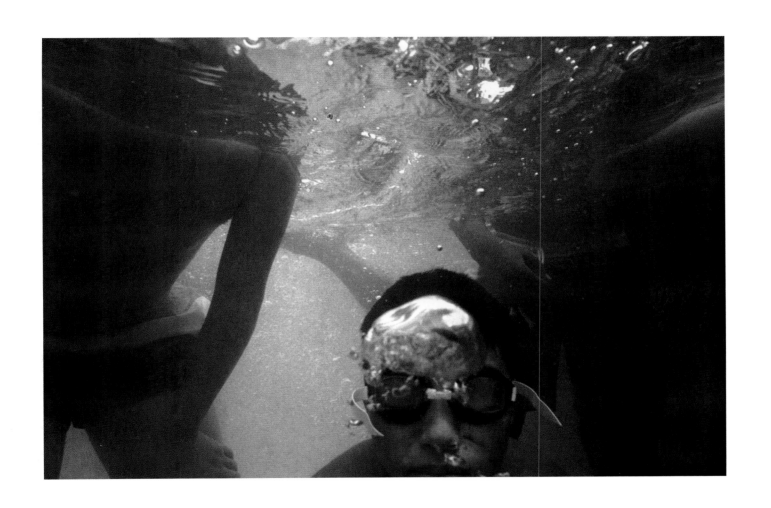

Hamilton Fish Pool, East Village, 1992
Angel Franco

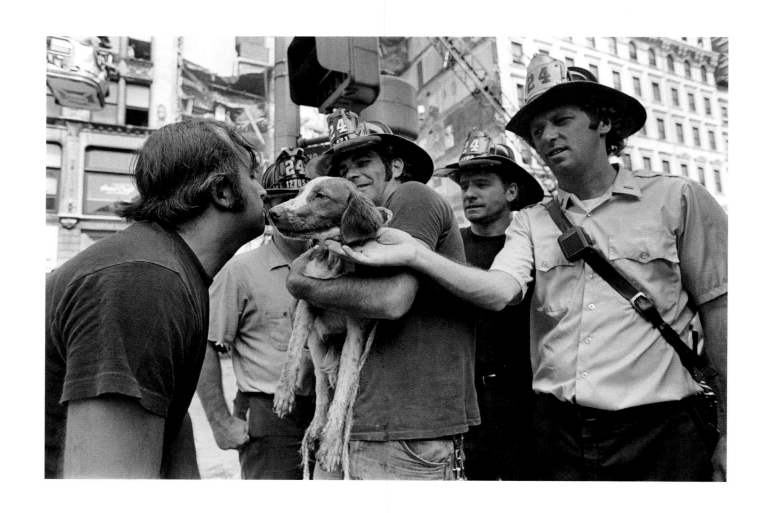

Olive is rescued, Broadway near West Third Street, 1973
Neal Boenzi

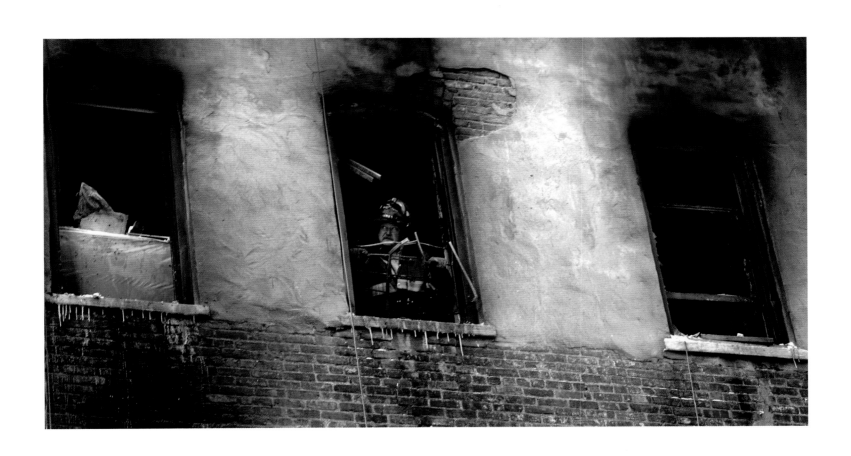

A scorched building in which two firefighters died, East 178th Street, Bronx, 2005
Vincent Laforet

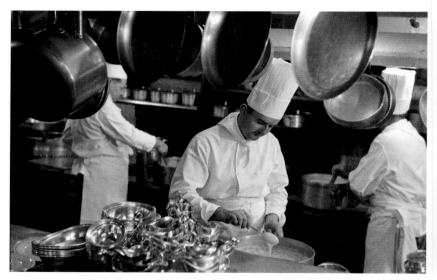

Chef Roger Fessaguet, La Caravelle restaurant, West 55th Street, 1962
Sam Falk

Food cart in the Wall Street area, 2008
Nicole Bengiveno

Sign, spotted by Edwin Kennebeck, in the window of the C & S Pizza Parlor on Eighth Avenue: NO FOOD OR DRINK ALLOWED IN STORE

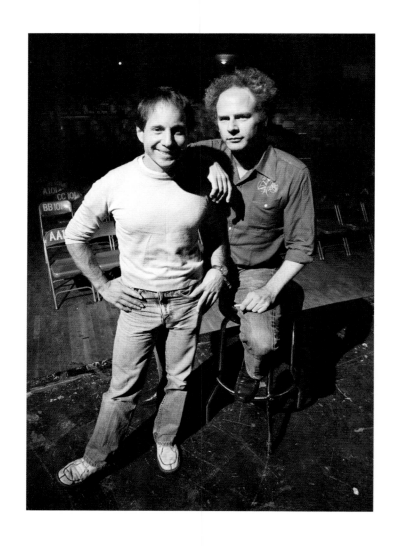

Paul Simon and Art Garfunkel, Palladium, East 14th Street, 1981
Fred R. Conrad

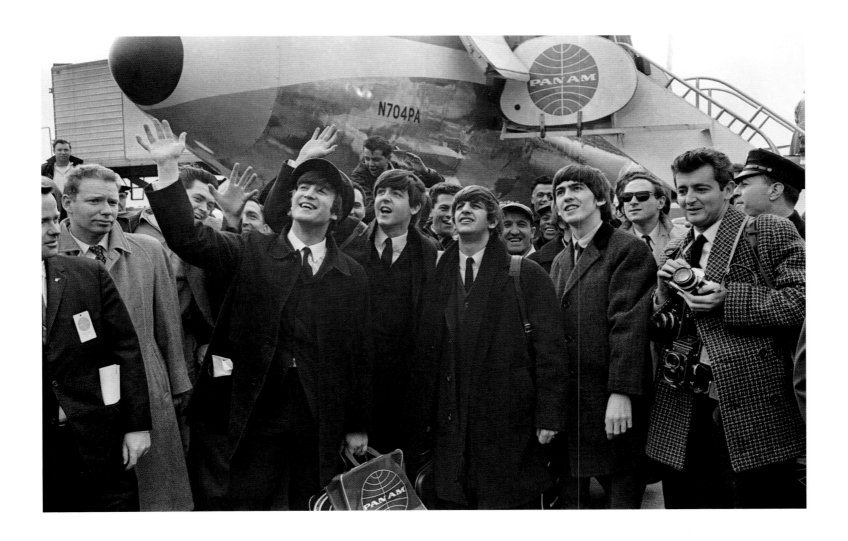

The Beatles arrive, John F. Kennedy International Airport, Queens, 1964
Carl T. Gossett Jr.

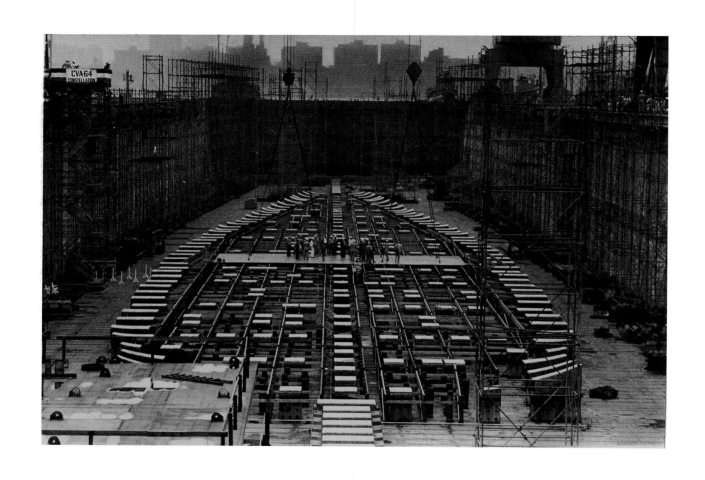

The USS *Constellation*, Brooklyn Naval Yard, 1957
Neal Boenzi

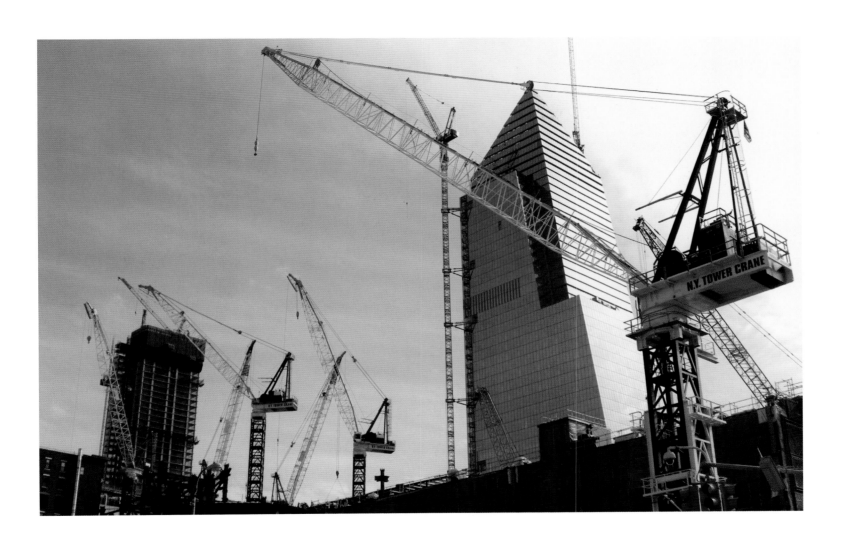

Hudson Yards redevelopment, Manhattan, 2016
Chang W. Lee

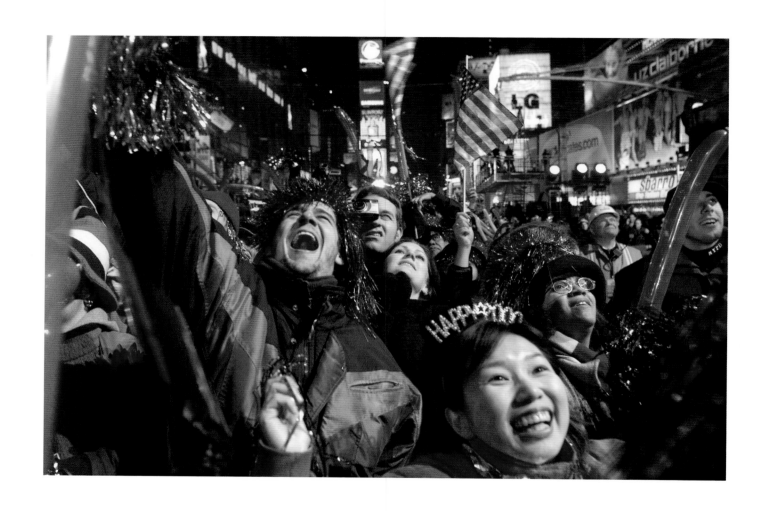

Millennium celebration, Times Square, 2000

Nicole Bengiveno

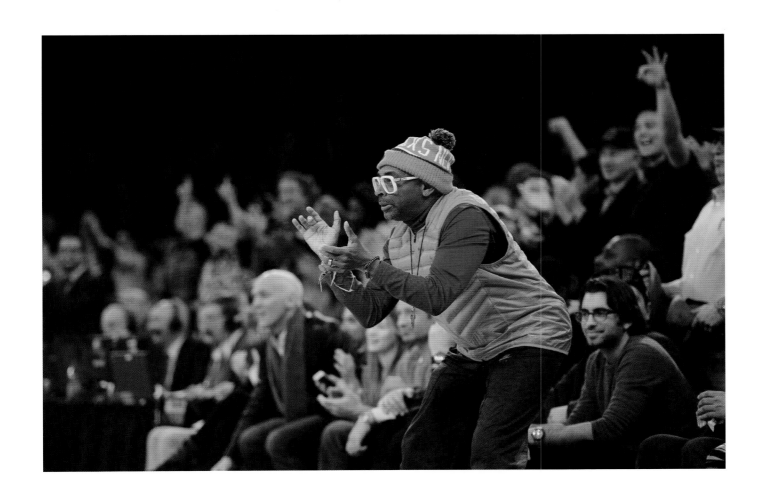

Spike Lee roots for the Knicks, Madison Square Garden, 2009
Barton Silverman

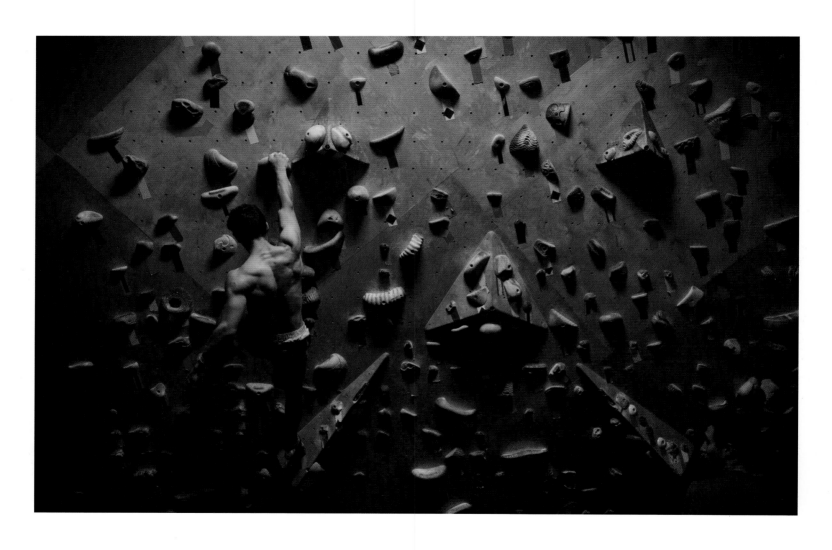

Brooklyn Boulders climbing gym, Gowanus, Brooklyn, 2014
Damon Winter

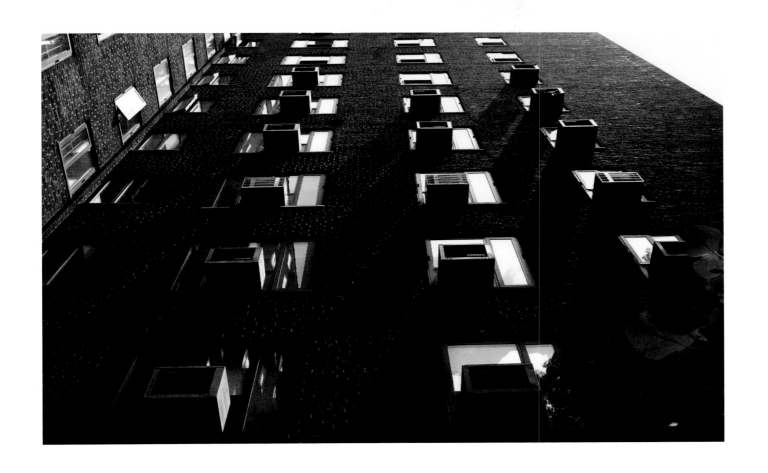

The Garment District, Manhattan, 2013
Hiroko Masuike

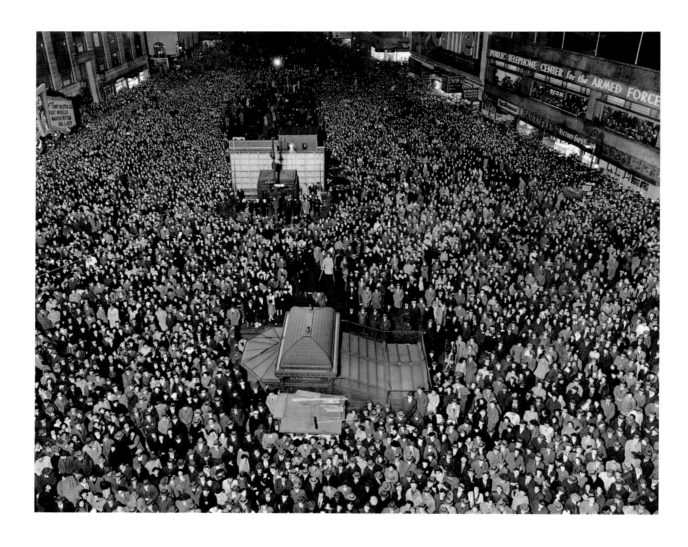

Watching election results in Times Square, 1944

Ernie Sisto

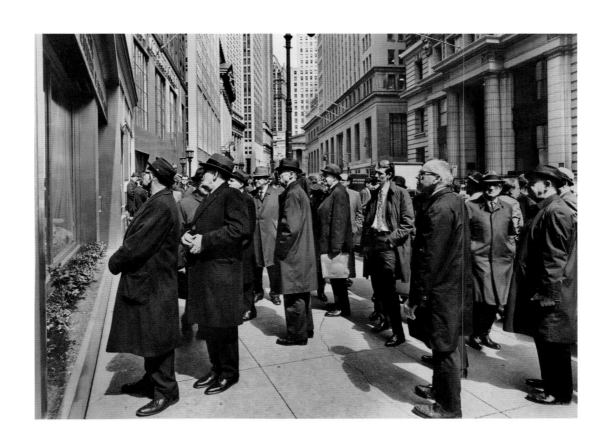

Checking on the stock market, Broad Street, Manhattan, 1968
William E. Sauro

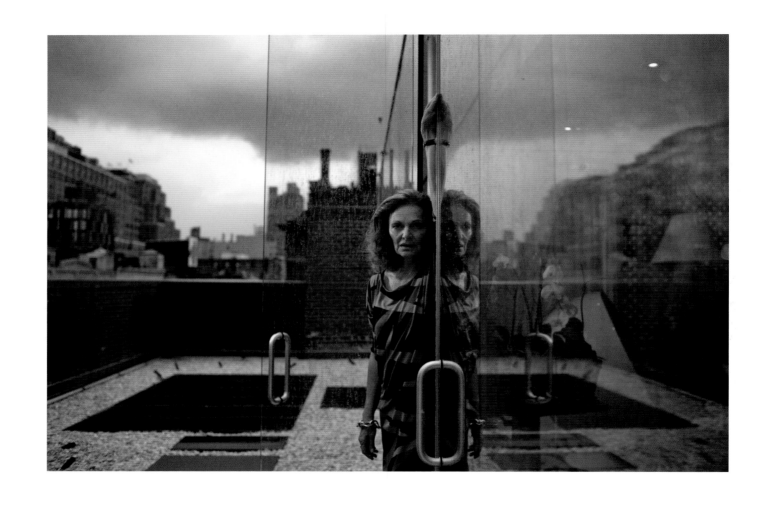

Diane von Furstenberg, Manhattan, 2009
Todd Heisler

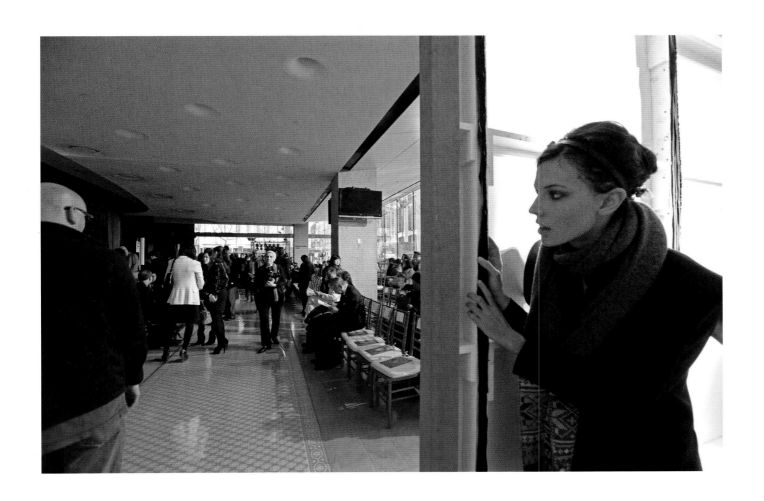

At the Tory Burch fall show, Alice Tully Hall, Lincoln Center, 2012
Marilynn K. Yee

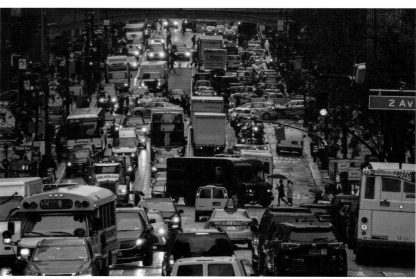

Roosevelt Avenue, Queens, 2008
Richard Perry

42nd Street, Manhattan, 2018
Todd Heisler

"Several weeks ago," writes Ethel Davis, "I was racing down West End Avenue toward 66th Street to catch the bus that was approaching that corner. As I got on the bus, the driver looked at me and said, 'I don't know why you're getting on this bus for, lady. You're making much better time than I am.'"

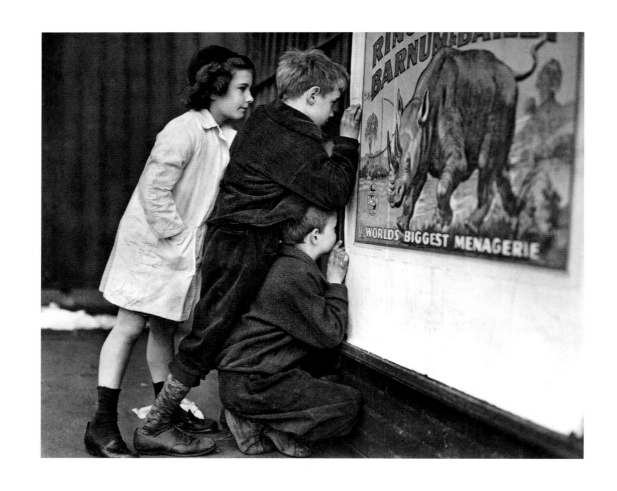

Sneaking a preview of the circus, Eighth Avenue and 50th Street, 1946
Ernie Sisto

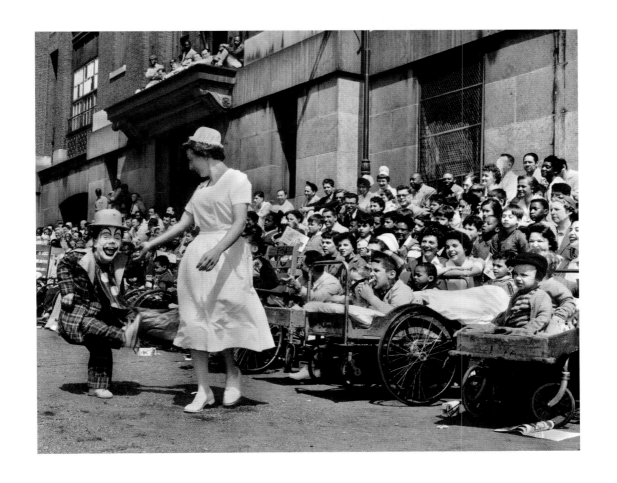

Jimmy Armstrong the clown with Nurse Anneliese Zassoda,
Bellevue Hospital, Manhattan, 1955
Fred Sass

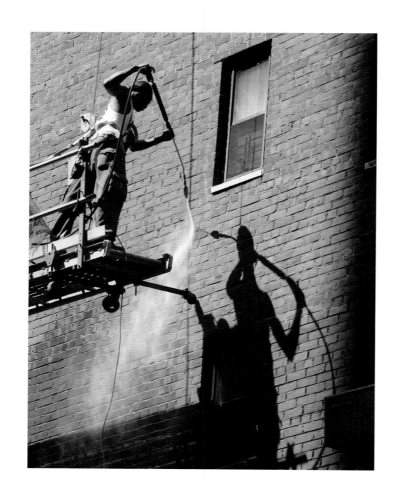

Power-wash day, East 62nd Street, Manhattan, 2005
Ruth Fremson

Near Erie Basin Park, Brooklyn, 2010
Nicole Bengiveno

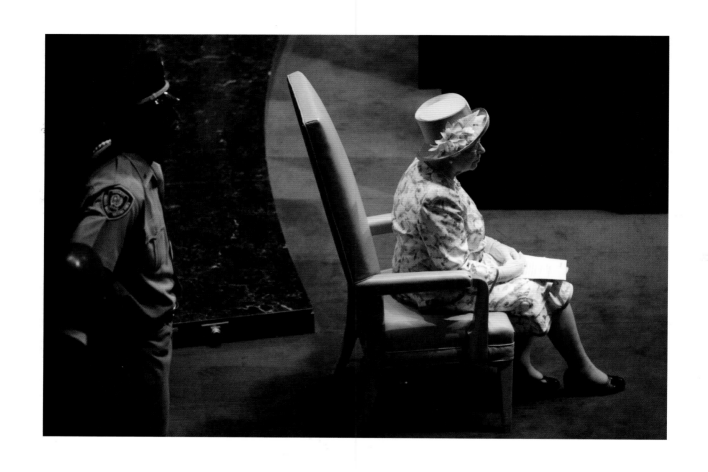

Queen Elizabeth, United Nations General Assembly, 2010
Todd Heisler

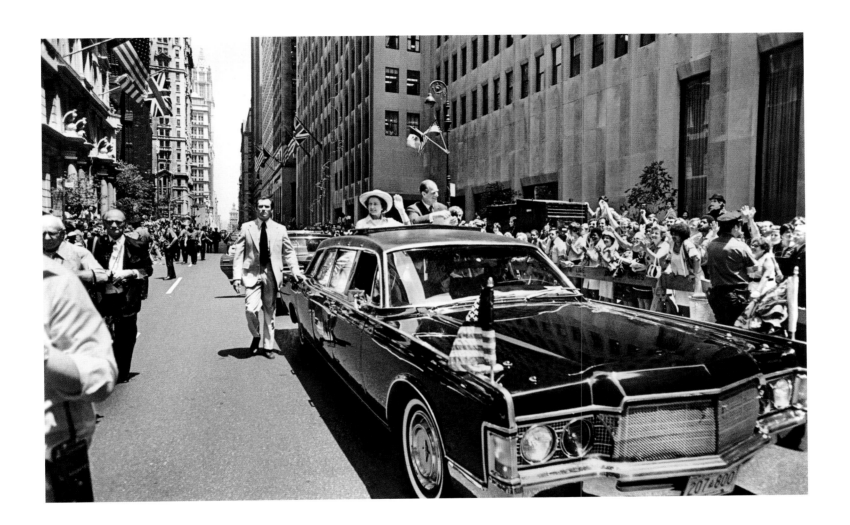

The Queen and the Duke of Edinburgh, Broadway, 1976
Tyrone Dukes

Ninth Avenue and 41st Street, Manhattan, 2016
Richard Perry

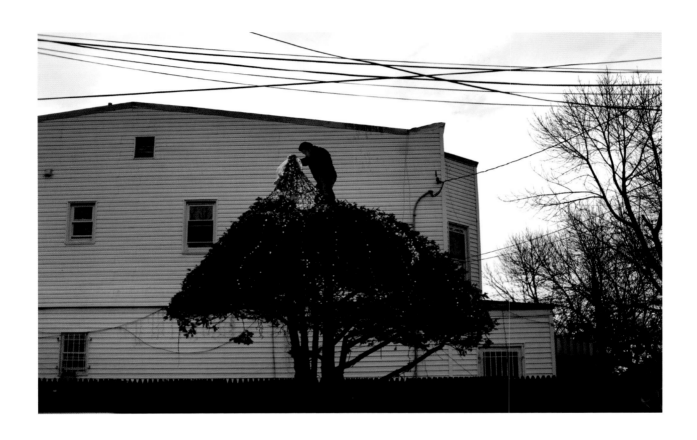

Segundo Minchala hangs Christmas lights, Queens, 2007
Todd Heisler

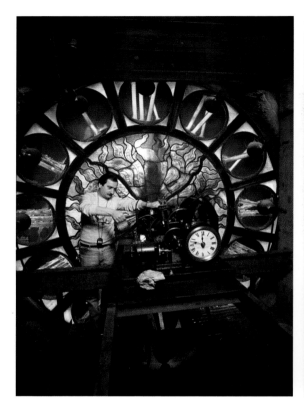

Nino D'Eramo checks the Grand Central
Terminal clock, Date unknown
Keith Meyers

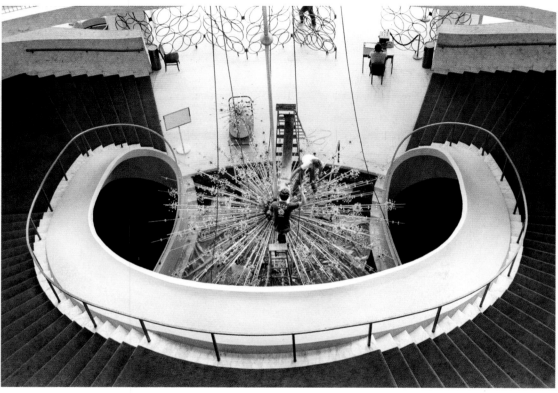

Cleaning the lobby chandelier, Metropolitan Opera House, 1981
Jack Manning

The scene is the lobby of the New York State Theater during the first intermission of a recent *La Bohème*. One woman to another, overheard by Joe Morrone: "All the doctors seem younger these days, and the police officers, too." Pause. "And now the opera singers!"

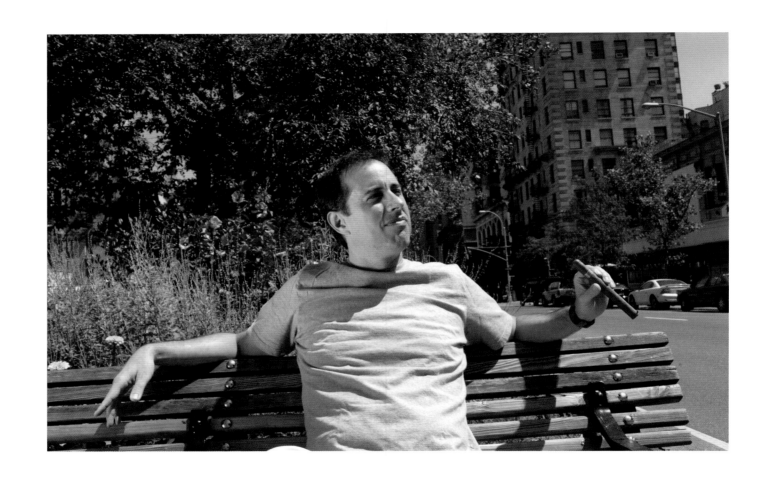

Jerry Seinfeld, 79th Street and Broadway, 2002
Chester Higgins Jr.

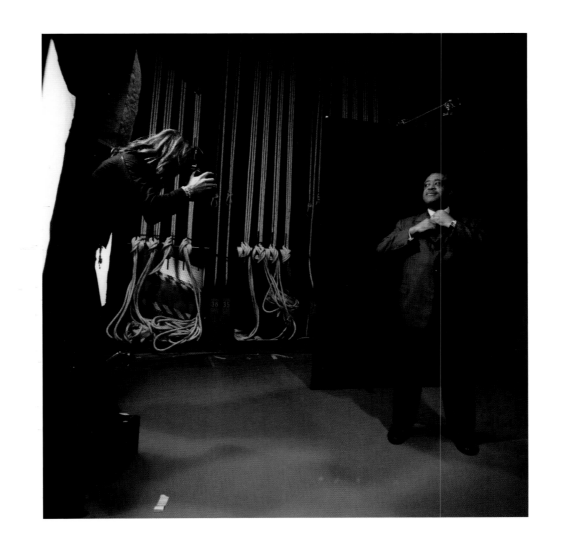

Al Sharpton, NBC Studios, 2003
Fred R. Conrad

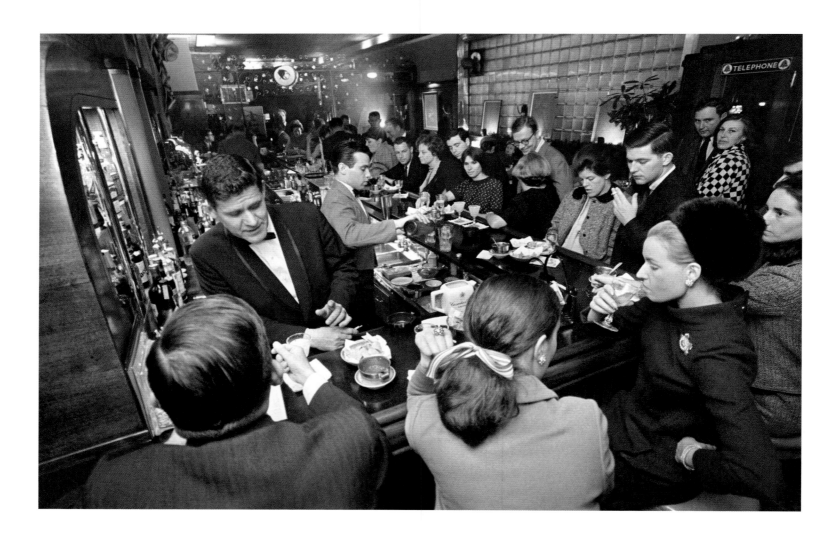

El Parador, Manhattan, 1966
Larry C. Morris

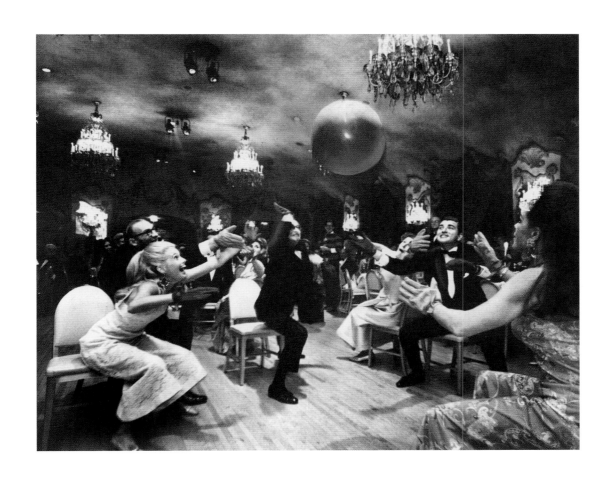

St. Regis Hotel roof, Fifth Avenue, 1968
Larry C. Morris

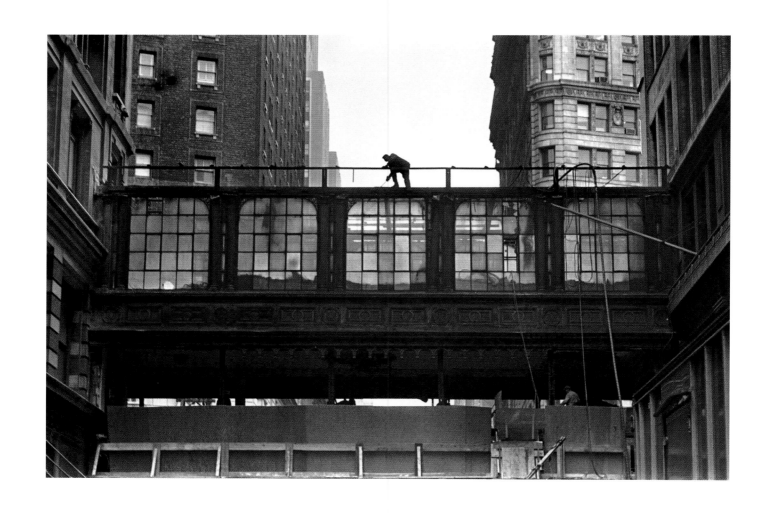

Dismantling the Gimbels-Saks connector, Above 33rd Street, Manhattan, 1966
Robert Walker

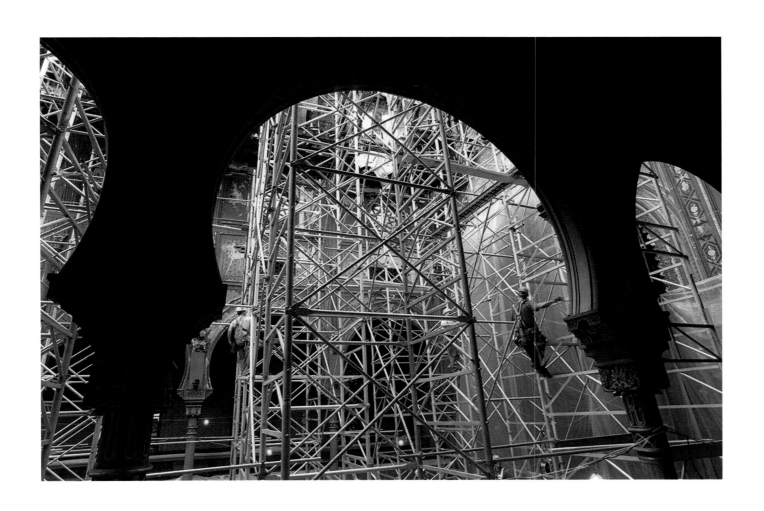

Central Synagogue after it was badly damaged by a fire, Midtown Manhattan, 1998
Suzanne DeChillo

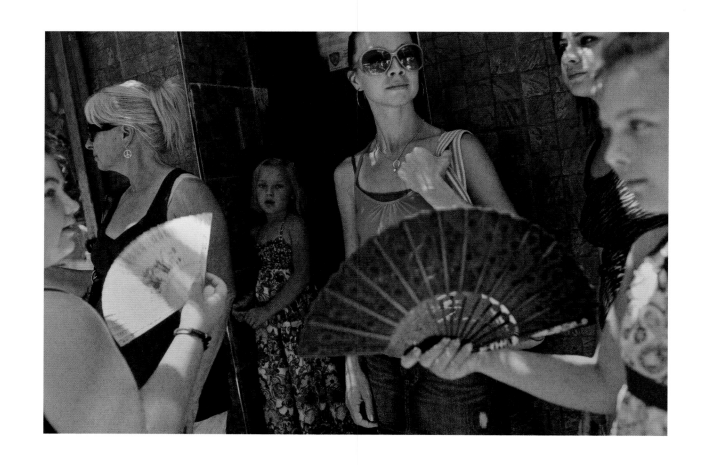

In a Chinatown store, Manhattan, 2010
Marcus Yam

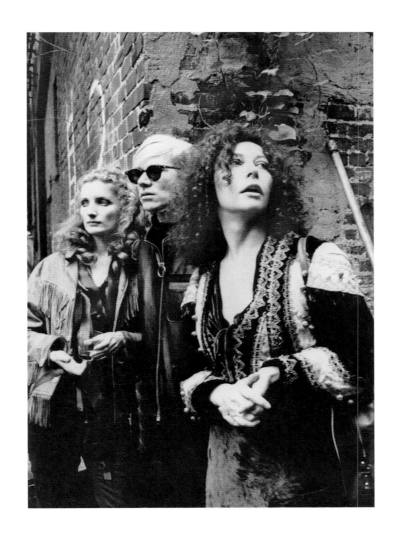

Viva, Andy Warhol, and Ultra Violet, Location unknown, 1968
Sam Falk

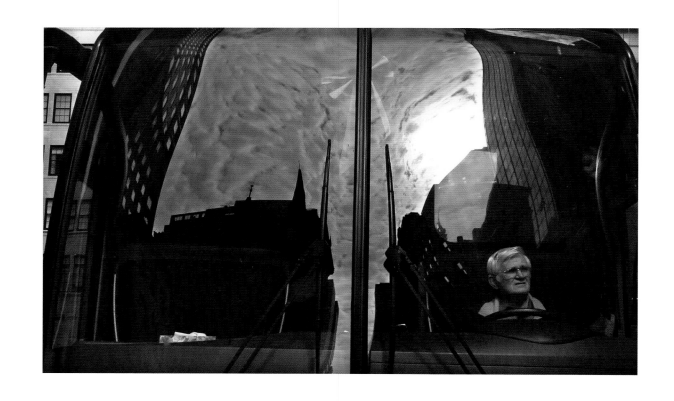

Tour bus driver, Fifth Avenue in Midtown Manhattan, 2008
Nicole Bengiveno

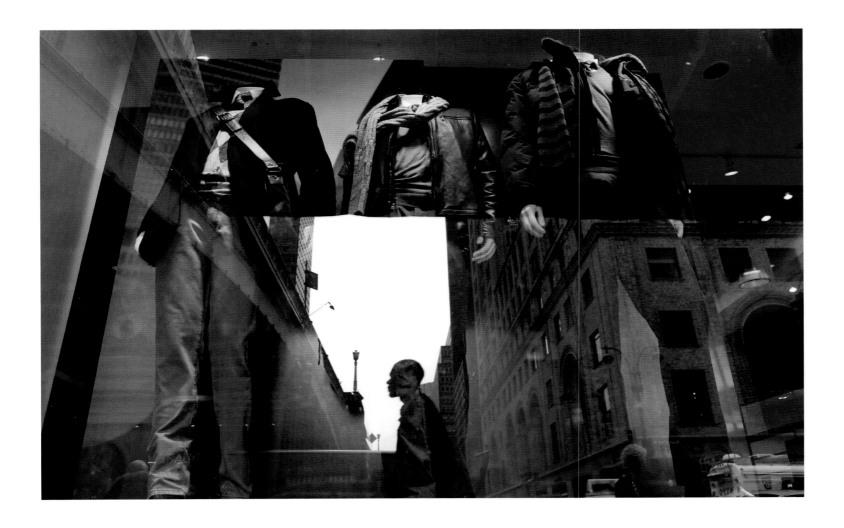

Manhattan, 2008
Nicole Bengiveno

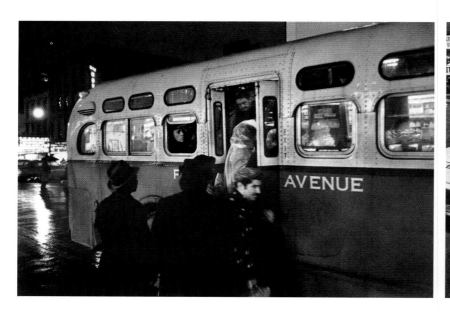

Eighth Avenue and 42nd Street, Manhattan, 1957
Eddie Hausner

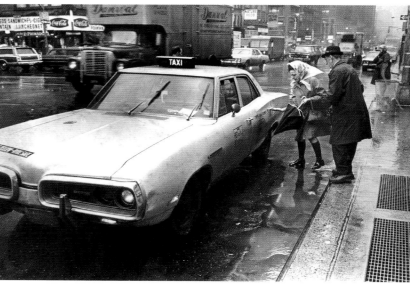

Eighth Avenue and 40th Street, Manhattan, 1970
Patrick A. Burns

Standing on the corner of Avenue of the Americas and Minetta Lane after a theater performance recently, Jimmy Nicholas, a New York printing executive, flagged a taxi to take his wife and a friend to dinner. As the taxi approached, so did a giant waterbug, that scourge of New York summers. As the women watched in horror, the bug veered from a puddle and scurried toward the door of the taxi. Mr. Nicholas squashed it.

"I had to," he told the crowd at the corner, which burst into applause.

"It was trying to steal our cab."

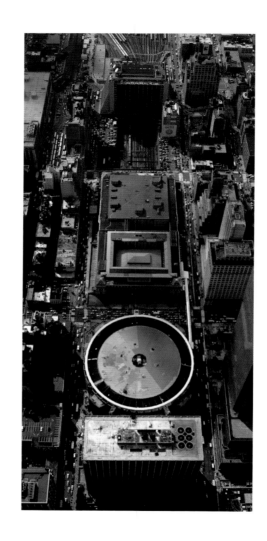

Madison Square Garden, 2004
Vincent Laforet

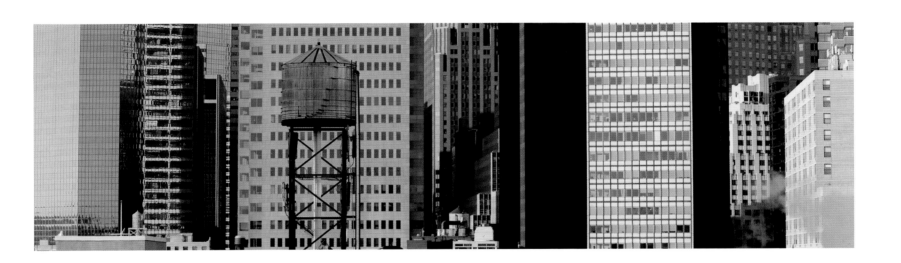

Lower Manhattan, 2013

Librado Romero

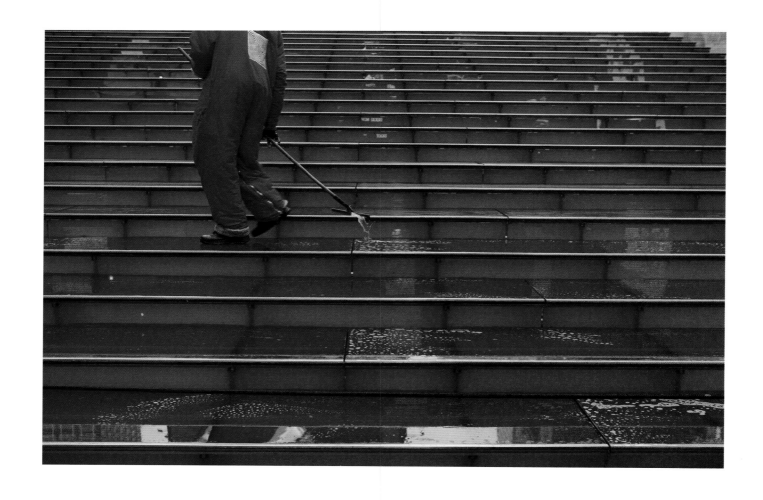

The steps at TKTS, Times Square, 2011
Damon Winter

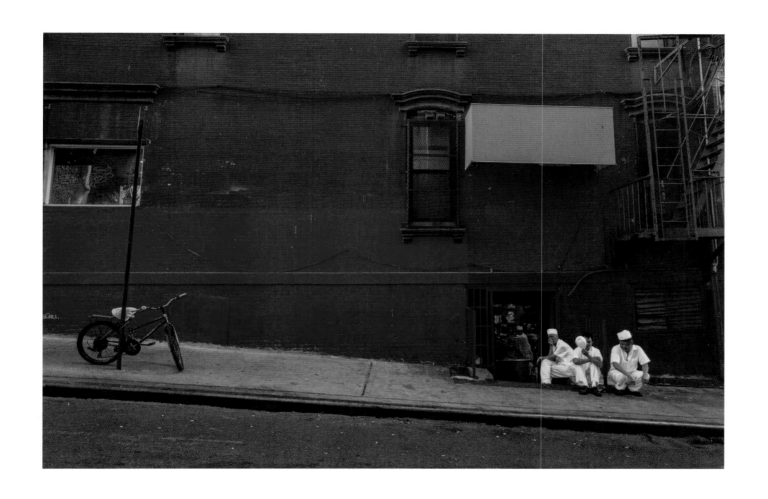

Mott and Mosco Streets, Manhattan, 2016
Hiroko Matsui

481

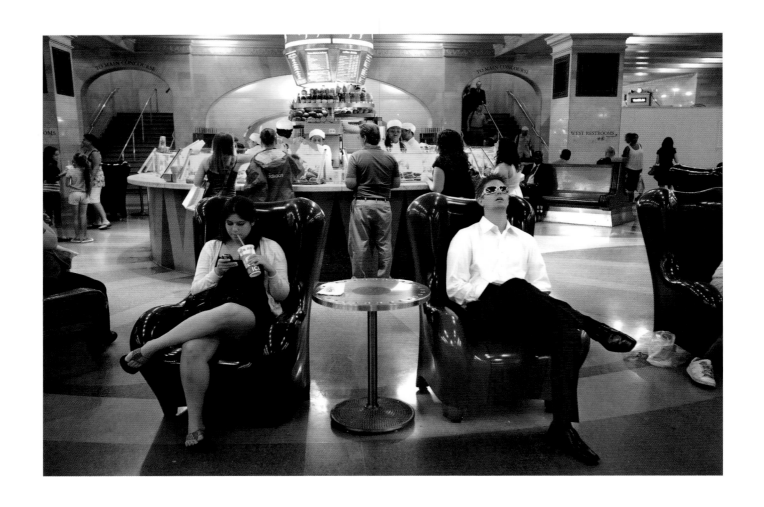

Metro North waiting room, Grand Central Terminal, 2006
Nicole Bengiveno

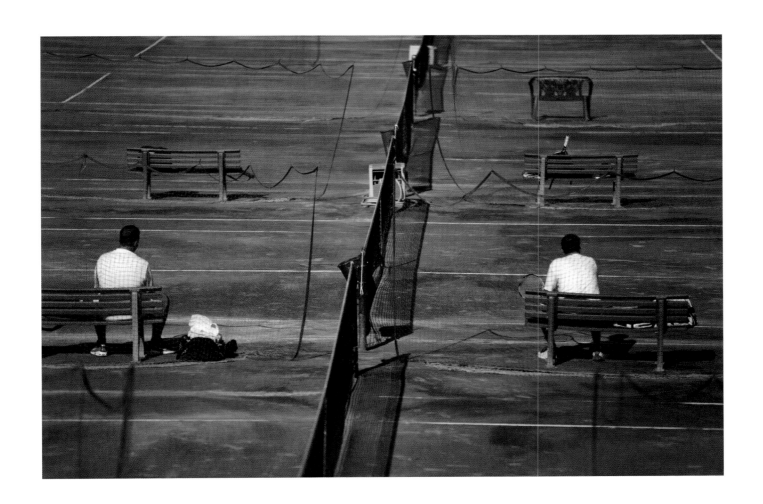

Prospect Park Tennis Center, Brooklyn, 2011
Nicole Bengiveno

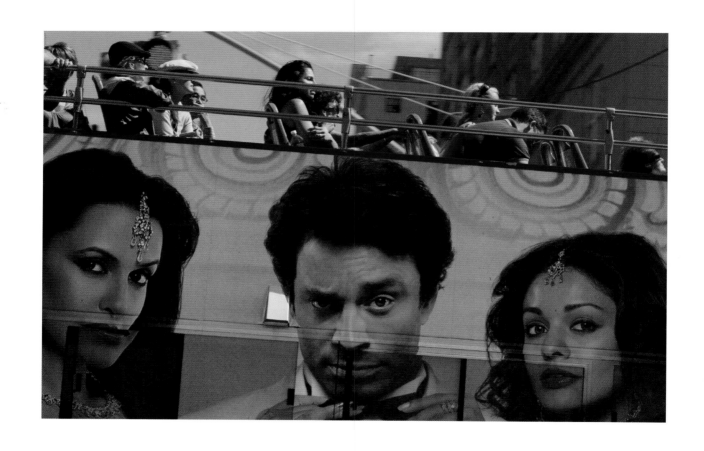

Manhattan, 2009
Librado Romero

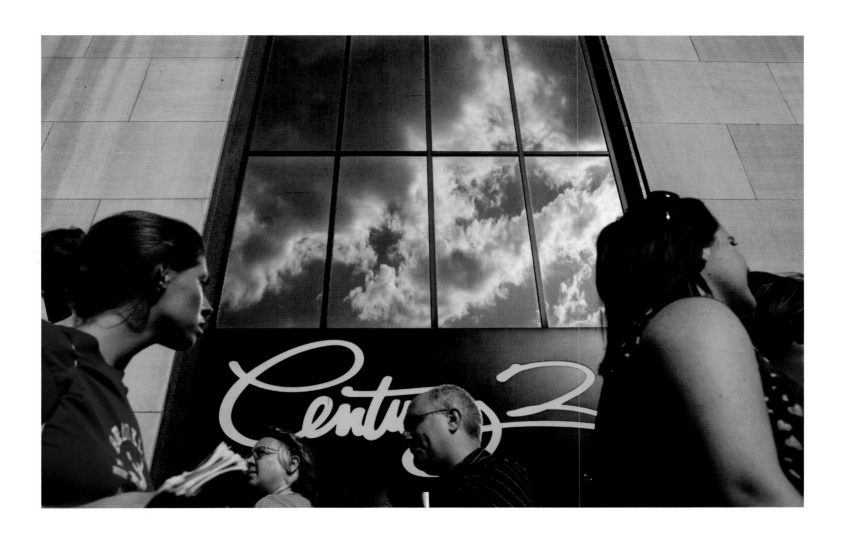

Lower Manhattan, 2009
Damon Winter

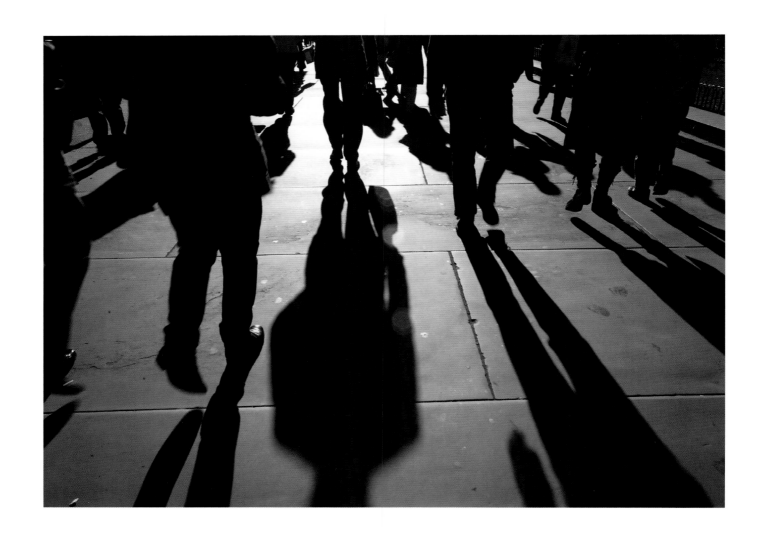

Fifth Avenue, Manhattan, 2008
Nicole Bengiveno

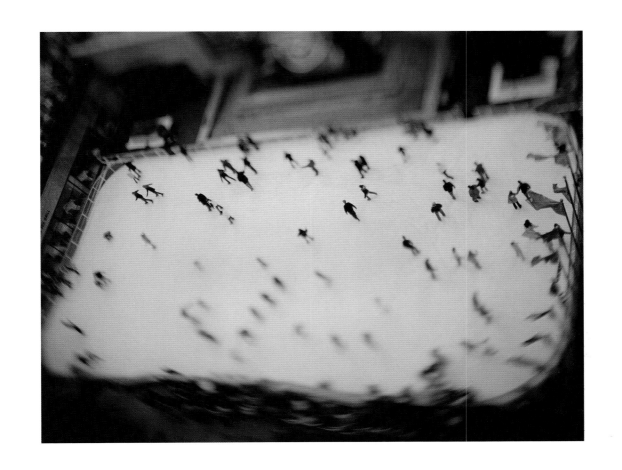

Rockefeller Center, 2006

Fred R. Conrad

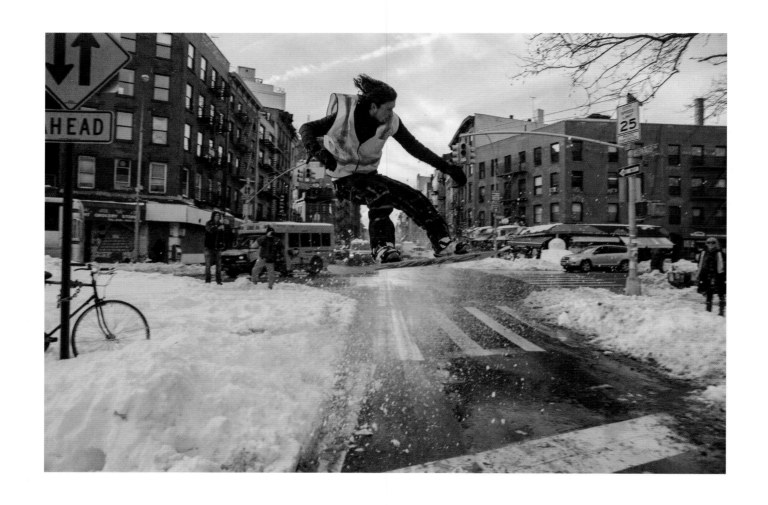

Matt Cruz, Lower East Side, 2016
Hiroko Masuike

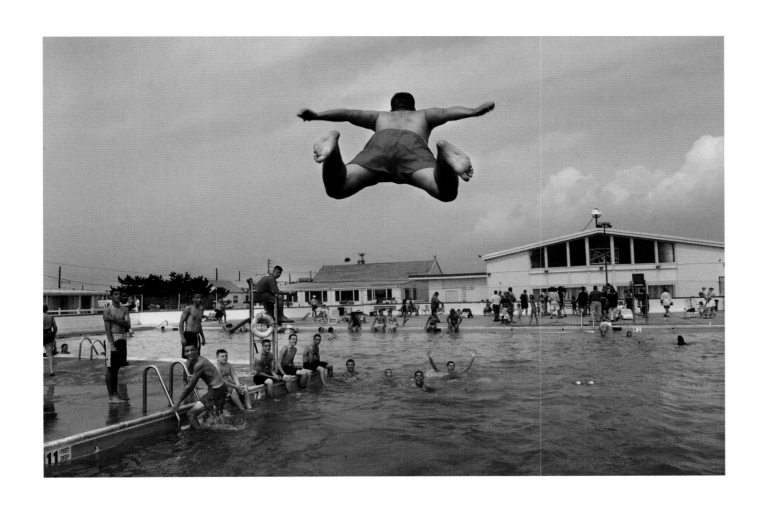

Breezy Point Surf Club, Queens, 2000
Nicole Bengiveno

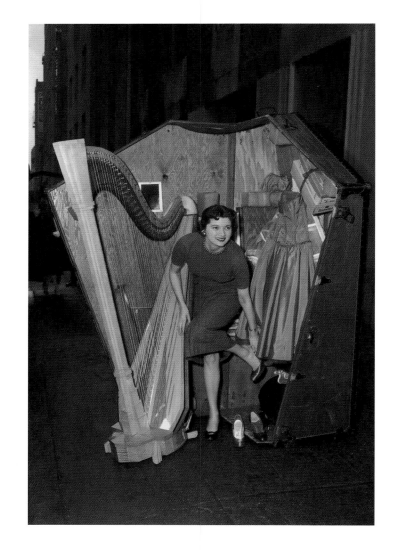

Harpist Carol Baum makes a shoe change, Park Avenue, 1955
Fred Sass

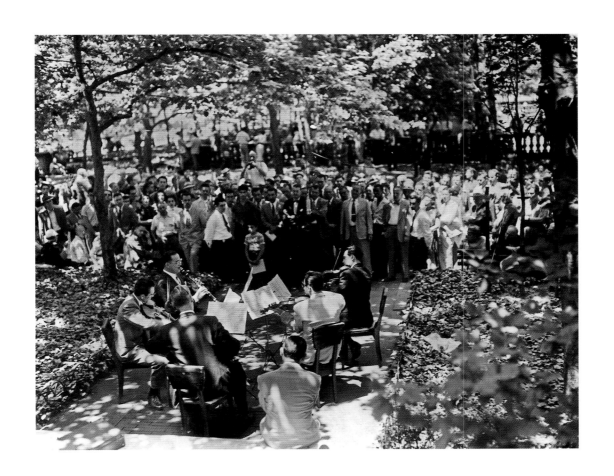

Benny Goodman and the New Music String Quartet, Bryant Park, 1952
Meyer Liebowitz

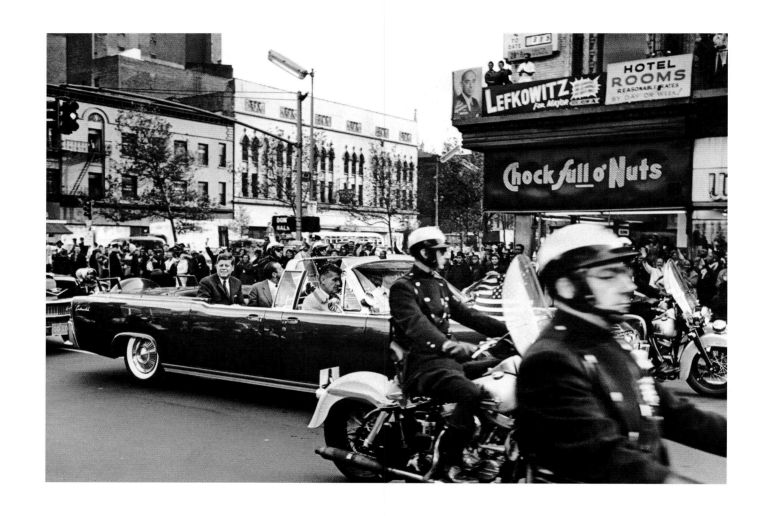

President John F. Kennedy with Mayor Robert Wagner, Midtown Manhattan, 1961
Carl T. Gossett Jr.

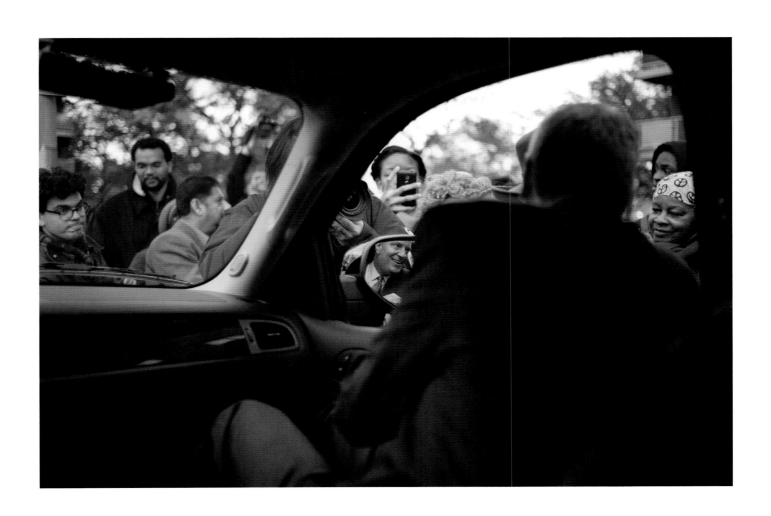

Mayoral candidate Bill de Blasio on the stump, Jamaica, Queens, 2013
Damon Winter

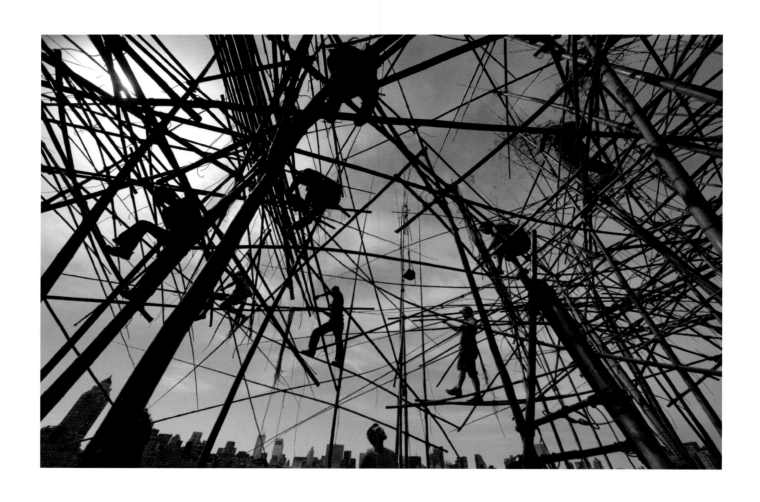

Rock climbers assembling an art installation,
Metropolitan Museum of Art roof garden, 2010
Librado Romero

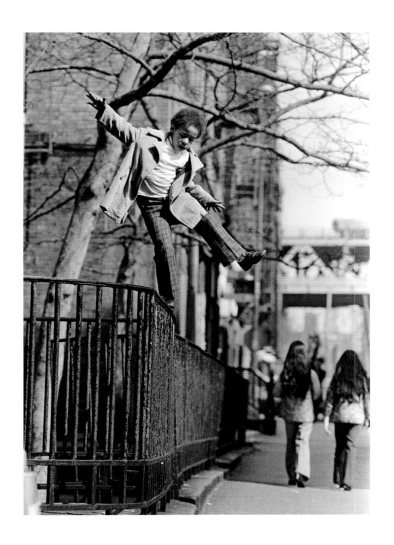

Oliver and Henry Streets, 1974
Neal Boenzi

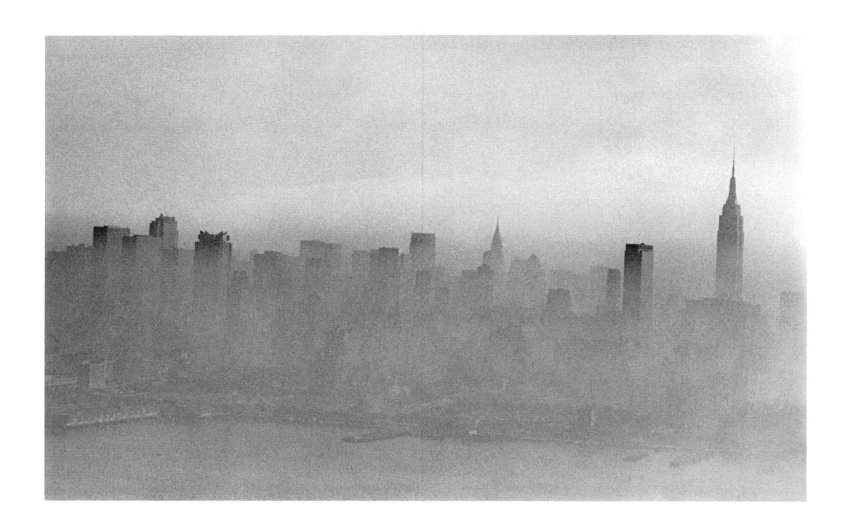

Midtown Manhattan, 1973
Don Hogan Charles

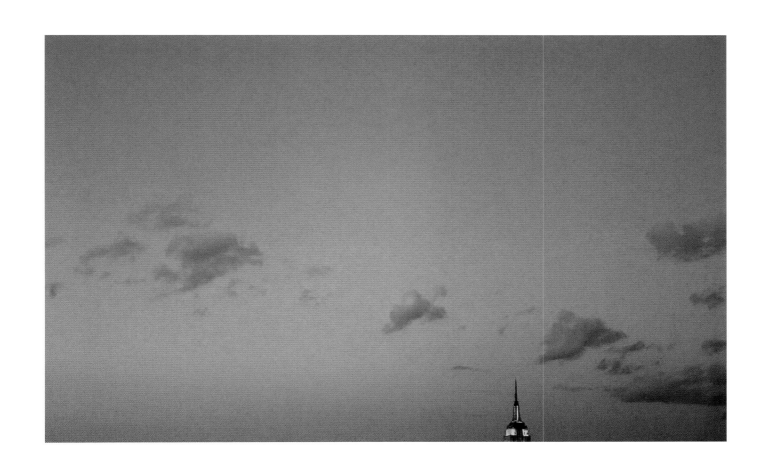

Empire State Building, 2008
Nicole Bengiveno

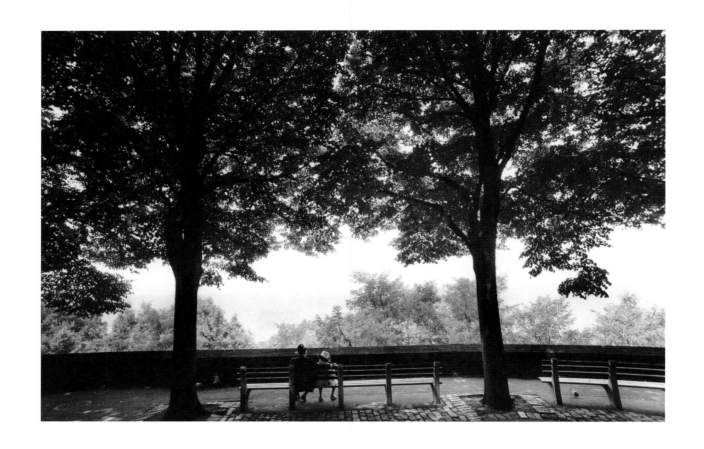

Fort Tryon Park, Manhattan, 1991
Angel Franco

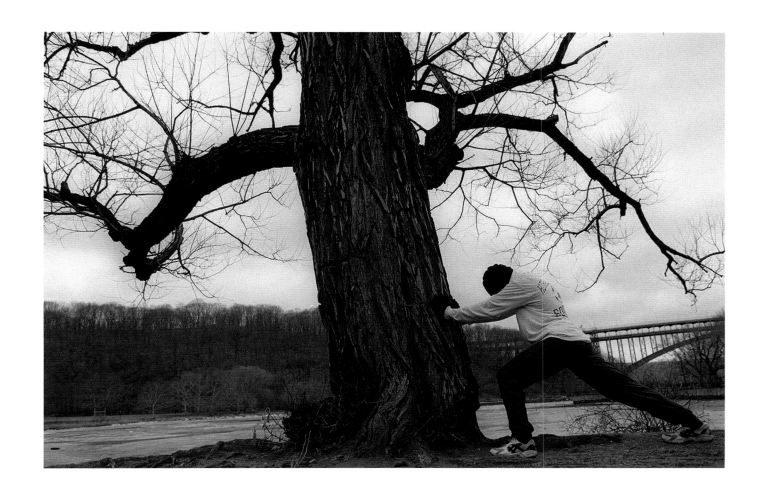

Johanna Krauss, Inwood Hill Park, Manhattan, 1997
Suzanne DeChillo

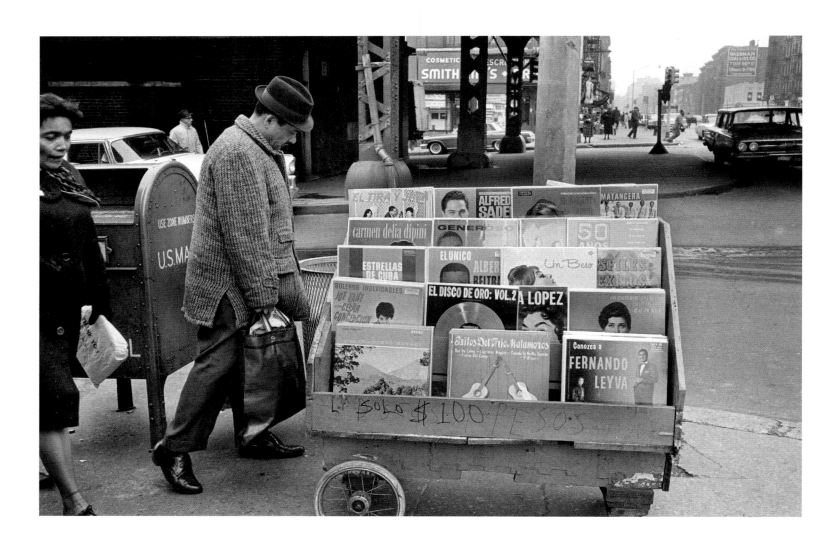

Spanish Harlem, 1964
Sam Falk

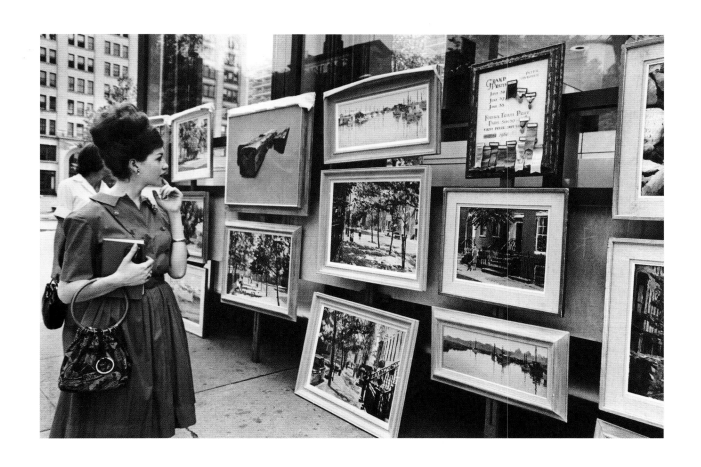

Washington Square art bazaar, 1963
Sam Falk

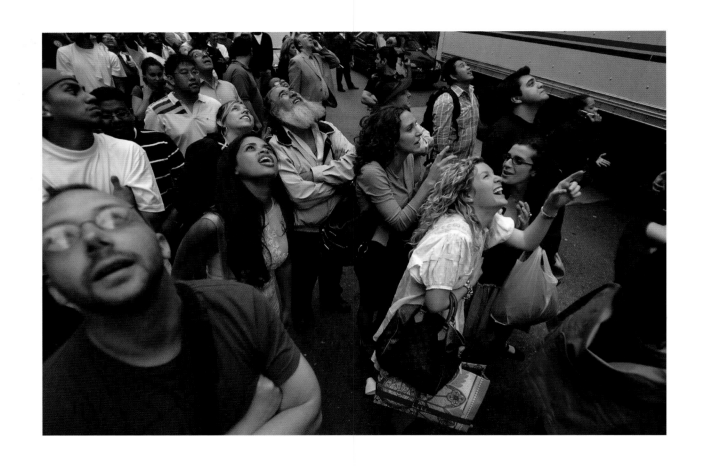

Watching the second of two uninvited climbers scale
The New York Times Building, West Side, Manhattan, 2008
Ruby Washington

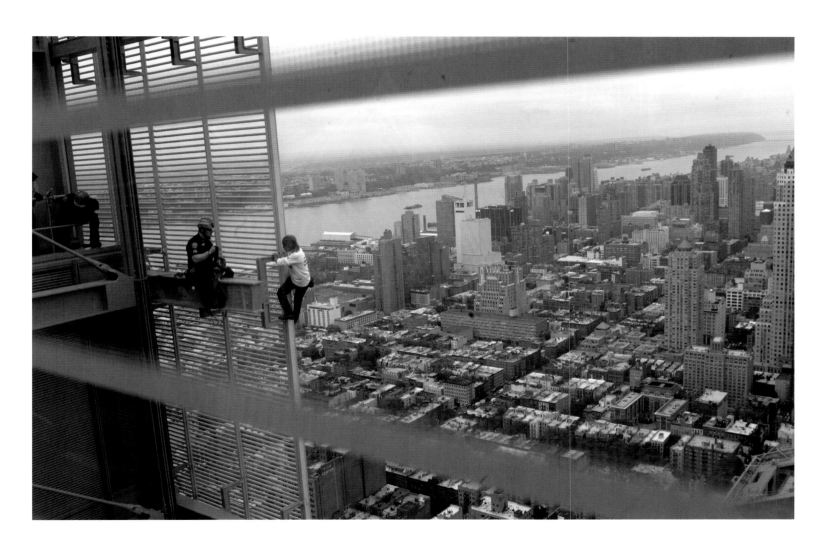

The first climber, Alain Robert, aka Spiderman, is met by a policeman at the top, 2008

David Scull

503

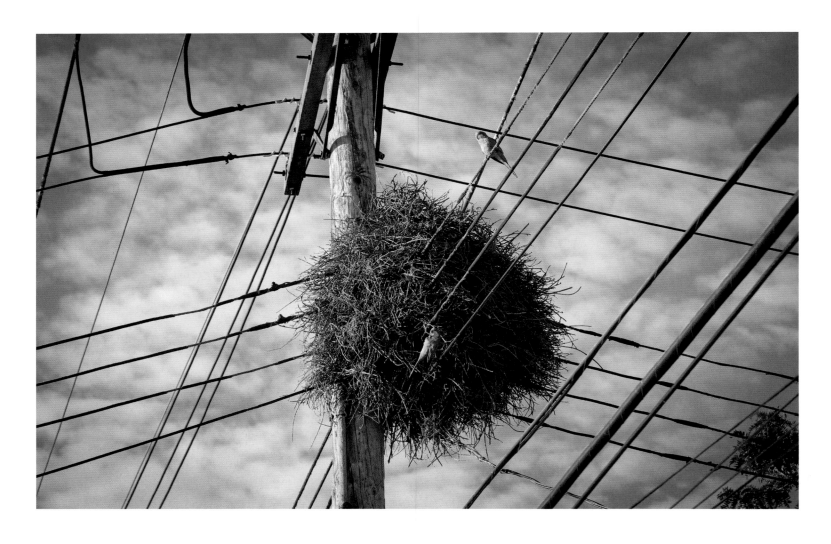

Monk parrots and their nest, Howard Beach, Queens, 2014
Angel Franco

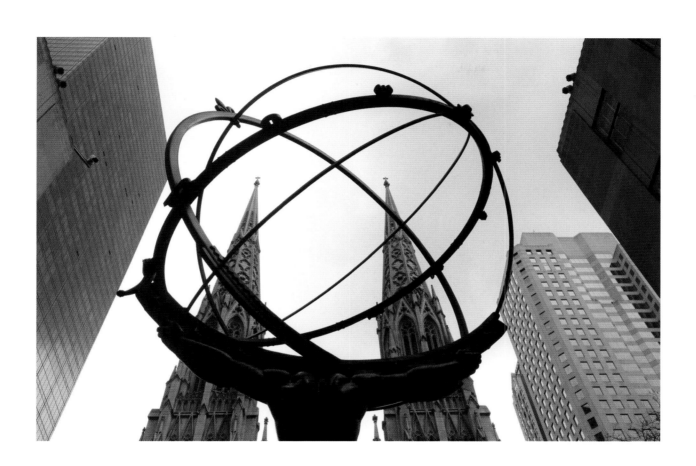

Spires of St. Patrick's, seen through the sphere of Atlas, Midtown Manhattan, 2010
Ruth Fremson

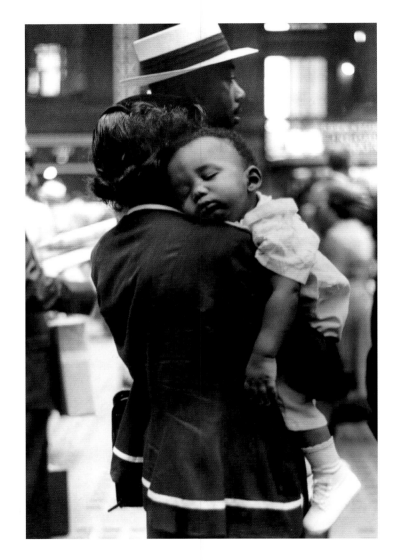

Weary traveler, Pennsylvania Station, 1955
Larry C. Morris

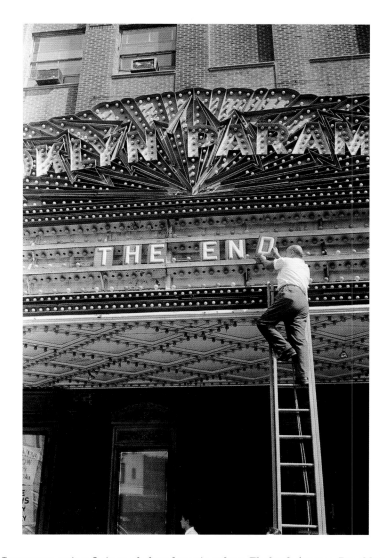

Ray Cannavaro writes finis to a beloved movie palace, Flatbush Avenue, Brooklyn, 1964
Patrick A. Burns

Acknowledgments

Profound thanks for this book go first and foremost to those whose work is on display in its pages. They are, or were, staff photographers for *The New York Times*, a publication long referred to as The Gray Lady, which, translated, meant 'not particularly visual.' That label has happily disappeared, but this book is a vivid reminder that our photographers were always a talented bunch. So extraordinary were their efforts, in fact, that it took those of us involved several more years than expected to assemble this collection. Part of the reason was the sheer wealth of wonderful material, and part was dealing with an enormous archive of negatives and prints that was undergoing the process of digitization.

The list of those responsible for assembling what you are now holding begins with Vin Alabiso, who initiated the early research, and ends with Darcy Eveleigh, an indispensable asset to any venture into *The Times* photo archive, who skillfully and tirelessly saw it to completion. David W. Dunlap, the paper's informal historian (and institution), provided sage advice and good humor. Other helpful *Times*folk were archivist Jeffrey P. Roth and William P. O'Donnell in the photo lab. Joseph Han, Alex Klein, Andy Liang and the remarkably creative design team at Pentagram endured our daily whims to create a striking volume, and Charles Miers and James Muschett at Rizzoli lent excellent suggestions and patient support.

In the interest of full disclosure, two items: Though this book advertises itself as a visual Valentine to the crowded, maddening, friendly, crazy, funny, scary, sleep-deprived five-borough agglomeration we are so fond of, there is one photo that was taken beyond the city limits. (Clue: it's on Page 119 and the location is Connecticut, probably near Stamford.) And though the subtitle promises 500 moments, there are actually 502. But who's counting?

Alex Ward

The Photographers

Michelle V. Agins
Monica Almeida
Allyn Baum
Nicole Bengiveno
Neal Boenzi
Arthur Brower
G. Paul Burnett
Patrick A. Burns
Tony Cenicola
Don Hogan Charles
Fred R. Conrad
Suzanne DeChillo
Joyce Dopkeen
Tyrone Dukes
William C. Eckenberg
James Estrin
Michael Evans
Sam Falk
Angel Franco
Ruth Fremson
D. Gorton
Carl T. Gossett Jr.
Josh Haner
Eddie Hausner
Todd Heisler
Tyler Hicks
Chester Higgins Jr.
Paul Hosefros
Edward Keating
Sara Krulwich
Vincent Laforet
Chang W. Lee
Jack Manning

Meyer Liebowitz
Jack Manning
Hiroko Masuike
Keith Meyers
Andrea Mohin
Larry C. Morris
Ozier Muhammad
Dan Neville
John Orris
Richard Perry
Dith Pran
Librado Romero
Fred Sass
William E. Sauro
Lou Schifano
David Scull
Barton Silverman
Ernie Sisto
John Sotomayor
Robert Walker
Ruby Washington
Earl Wilson
Jim Wilson
Damon Winter
Marcus Yam
Marilynn K. Yee

Published by Universe Publishing, a division of
Rizzoli International Publications, Inc.
300 Park Avenue South
New York, New York 10010
www.rizzoliusa.com

The New York Times
Editor: Alex Ward
Photo Editor: Darcy Eveleigh

Design by Pentagram
Natasha Jen, Joseph Han, Maurann Stein, Boqin Peng,
Karming Wong, Ena Yun, Andy Liang, Jisoo Eom,
Sammie Purulak, Veronica Höglund, Alex Klein

2019 2020 2021 2022 / 10 9 8 7 6 5 4 3 2 1

Printed in China

ISBN-13: 978-0-7893-3655-2
Library of Congress Control Number: 2018963149